KT-230-514

York St John

...rv and Information ...s

...w (if
...s),

Americ

Praise for the first edition:

> 'Something of a godsend ... as a teaching resource this book is second to none ... achieves levels of multiplicity rarely, if ever, reached by others.'
>
> *Borderlines: Studies in American Culture*

This much-needed second edition of *American Cultural Studies* has been updated throughout to take into account the developments of the last seven years. It provides an introduction to the central themes in modern American culture and explores how these themes can be interpreted.

Chapters in the book discuss the various aspects of American cultural life such as religion, gender and sexuality, and regionalism. Updates and revisions include:

- a new introduction engaging with current debates in the field
- an all-new chapter on foreign policy
- thorough discussion of globalization and Americanization
- new case studies
- updated further-reading lists.

*American Cultural Studies* is a core text on the reading lists for American studies students.

**Neil Campbell** and **Alasdair Kean** teach American Studies at the University of Derby.

WITHDRAWN

17 JUN 2024

York St John

3 8025 00506338 6

# American Cultural Studies

An introduction to American culture

Second Edition

Neil Campbell and
Alasdair Kean

YORK ST. JOHN
COLLEGE LIBRARY

 Routledge
Taylor & Francis Group

LONDON AND NEW YORK

First published 1997
by Routledge
2 Park Square, Milton Park, Abingdon, Oxon OX14 4RN

Simultaneously published in the USA and Canada
by Routledge
270 Madison Ave, New York, NY 10016

Second edition published 2006

*Routledge is an imprint of the Taylor & Francis Group, an informa business*

© 1997, 2006 Neil Campbell and Alasdair Kean

Typeset in Palatino by
Florence Production Ltd, Stoodleigh, Devon

Printed and bound in Great Britain by
The Cromwell Press, Trowbridge, Wiltshire

All rights reserved. No part of this book may be reprinted
or reproduced or utilised in any form or by any electronic,
mechanical, or other means, now known or hereafter invented,
including photocopying and recording, or in any information
storage or retrieval system, without permission in writing
from the publishers.

Every effort has been made to ensure that the advice and
information in this book is true and accurate at the time of
going to press. However, neither the publisher nor the authors
can accept any legal responsibility or liability for any errors
or omissions that may be made. In the case of drug
administration, any medical procedure or the use of technical
equipment mentioned within this book, you are strongly
advised to consult the manufacturer's guidelines.

*British Library Cataloguing in Publication Data*
A catalogue record for this book is available from
the British Library

*Library of Congress Cataloging in Publication Data*
Campbell, Neil, 1957–
    American cultural studies : an introduction to American
    culture / Neil Campbell and Alasdair Kean. — 2nd ed.
        p. cm.
    Includes bibliographical references and index.
    1. United States – Civilization – 20th century – Study and
    teaching.   I. Kean, Alasdair, 1947–   II. Title.
    E169.1.C235 2006
    306.0973 – dc22                                    2006002172

ISBN10: 0–415–34665–7 (hbk)
ISBN10: 0–415–34666–5 (pbk)
ISBN10: 0–203–62455–6 (ebk)

ISBN13: 978–0–415–34665–8 (hbk)
ISBN13: 978–0–415–34666–5 (pbk)
ISBN13: 978–0–203–62455–5 (ebk)

# Contents

# Plates

# Acknowledgements

This is a revised second edition of the book first published in 1997. We would like to thank, retrospectively, Will Kaufman for all his productive comments on that edition and subsequently all those anonymous readers who advised us on alterations to this second version. We hope it meets some of their needs.

We would like to thank our colleagues, Dave Holloway and Simon Philo, and students at the University of Derby who have been involved in many classes in which these ideas have been worked out and whose voices may be heard echoing in these pages. We would also like to thank our respective families for their forbearance and encouragement. Love goes, as always, to Jane for her support and tolerance during the revision of this book. Love, too, to Trish, for continuing to give real meaning to the concept of 'new beginnings' and to Alex, Hannah, Oliver, and Daniel for being there.

All efforts have been made to contact copyright holders, but if any have been inadvertently overlooked, the publishers will be pleased to make the necessary arrangements at the first opportunity.

# Introduction

At a time when the United States of America is at the centre of world events, engaged in a global 'war on terror', and coming to terms with the many effects of the terrorist attacks of September 11th, 2001, there has, perhaps, never been a more important period in which to study 'America'. At this time ever-popular concepts in American history like 'nation', 'empire', 'homeland', 'freedom', and 'patriotism' have been given new meanings and interpretations, contested from the perspectives of those critical to the political project of President George W. Bush and celebrated by those who support him. American Studies can be the focus for these debates, able to critique and analyse the discourses that have shaped and continue to shape a nation and its complex relations with the world. Contrary to some who have argued for the decline of the nation-state, it now appears vital to any discussion of global events, with the United States of America as a dominant world force, guarding its borders whilst engaging in the policing of those of other nations, defining a form of new imperialism that must be at the very heart of our critical understanding. The American Cultural Studies employed in this book is, therefore, interdisciplinary and international, exploring a range of ways to study American culture, in order to encourage students, who may have little experience either of America or interdisciplinary work, to develop their engagement with both of these in tandem. Our focus is largely on the twentieth- and twenty-first-century experience, but where appropriate, for instance, in the chapter on regions or on African Americans, we have included material from earlier periods in order to provide an important context or sense of continuity.

## AN EXCEPTIONAL PLACE OR WHAT IS AMERICA?

Since its inception in the 1930s, American Studies, as an approach to the study of the culture and history of the United States, has, been preoccupied with certain key themes. One is what Michael Denning has described as the founding question of the subject area, 'What is

American?' (Denning 1986: 360). Although often phrased in different ways, the question is concerned with the meaning of American national identity, and the ways in which America might be distinguished from other nations. A particular answer to this question has been to define the uniqueness or 'exceptional' quality of the American experience in the form of a 'national narrative' – a story of agreed principles, values and myths that gives the country a coherent sense of identity, an 'image repertoire productive of the U.S. national community . . . through a recitation of the key terms in the national meta-narrative' (Pease 1994: 4). In other ways, however, examining the 'Americanness' of the USA has deep roots within American history itself. J.H. St John de Crevecoeur's famous question, 'What, then, is the American, this new man?', first posed in 1782, has echoed down subsequent generations of social and political commentary by both Americans and foreigners addressing the question of American identity. From Alexis de Tocque-ville in the 1830s and 1840s through the founding fathers of American history like Frederick Jackson Turner, to post Second World War cultural critics like David Riesman and Christopher Lasch, a considerable liter-ature has built up dedicated to defining American character. American Studies, therefore, as the search for 'American exceptionalism', for some sense of the differences between American culture and other cultures, has come out of a deep-seated preoccupation with national self-definition. Even if American culture, on analysis, may turn out to be less distinctive from other modern societies than was once thought, one feature of it remains the durability of questions about a national identity. Indeed, as some commentators have argued, the centrality of the debate about American distinctiveness in America may in itself be a key component of American identity: 'The search for an American character is part of that character' (Wilkinson 1988: 2).

Simultaneously, there have been those set on contesting any coherent national narrative or essentialised sense of identity as ideological frame-works that exclude too much of the genuine experience of the USA. Criticisms of 'American exceptionalism' have tended to focus on two central weaknesses in many earlier attempts to define national differ-ence. There is, first, the tendency to reduce questions of national identity to some essential singularity and in doing so to give undue weight to the experience of specific groups and traditions in explaining America, at the expense of other groups whose experience is, as a result, forgotten or marginalised. Second, there has been a tendency to study American society in isolation and from 'within', and in so doing to downplay those experiences the United States might have in common with other societies or that enable a comparative perspective to emerge.

If we turn to the first major criticism, then the difficulties of gener-alising about national identity become evident. Americans, it has been

overwhelmingly argued over the last forty years, have been marked by division and opposition, rather than by agreement and consensus. Traditional conceptions of a unified American culture when examined turn out to be partial and selective views of what America has been or ought to be, grounded in the privileged status accorded to a white, male, middle-class, heterosexual perspective. America has presented itself as a classless society, marked by a powerful degree of consensus and a low level of conflict only because historians and cultural critics had tended not to emphasise those factors that indicated deep-seated divisions in American life, such as class, ethnicity, race and gender. Once these latter factors have been duly acknowledged, then, at the very least, it becomes much more difficult to accommodate them adequately within traditional notions of a seamless national identity. Americans, it is argued, are in the end divided as much as they are united. Where unity is apparent, this is only possible because difference has been hidden by the practice of power. The dominance of specific groups and perspectives in American life has obscured the fact that other groups were subordinate, and played little part in creating an American identity. As Elizabeth Fox-Genovese wrote in 1990, 'the last two decades have ... witnessed a growing restiveness with any complacent assumptions that the culture of a privileged few could adequately represent the specific beliefs and practices of the many varieties of Americans' (Fox-Genovese 1990: 7). The construction of an American identity could thus no longer rely on a few privileged categories; Americans were 'female as well as male, black as well as white, poor as well as affluent, Catholic or Jewish as well as Protestant, and of diverse national and ethnic backgrounds' (ibid.).

A second major source of criticism has focused on a tendency in American Studies to examine American culture on its own without very much attention to cross-cultural comparison.[1] The emphasis here tended to be on what set the United States apart from other cultures rather than what it might share with them. This approach, in turn, both fed off and encouraged that long-held belief in American history that the country had a special mission to fulfil, a mission which in the past had a strong religious, economic or racial gloss (as the 'errand into the wilderness' or 'manifest destiny'), but which has been given renewed vigour by America's ideological role as the leader of the free world in the Cold War, and subsequently in its global 'war on terror'. There are links between this argument and the tendency to underplay conflict in the American past for, as Giles Gunn has commented, 'wherever concern for American uniqueness was seen to wax, critical comprehension of its own inner divisions as well as its cultural complexity and contextual relations seemed to wane' (Gunn 1987: 151). Again, this tendency drew on an understandable strain in American culture which sought to explain

the country's identity in American terms. Frederick Jackson Turner's elaboration of his Frontier thesis is only the most well-known attempt to provide an explanation of American development in terms of conditions within the country itself (see Chapter 5).

What these various criticisms of 'American exceptionalism' suggest are the problems involved in generalising about the American experience. This is not to deny that the national dimension of historical and cultural analysis is significant, nor is it to dismiss the extensive literature on the American character, which, in any case, was rather more sensitive to matters of region and ethnicity than has sometimes been argued. It is, however, to emphasise that students, in seeking to understand American culture, need to take into account both internal variation and division as well as international and cross-cultural comparison. As we shall see later, one of the strongest themes in recent discussions of American Studies has been on the need to 'internationalise' it, to relate it to the world and to global exchanges and transnational processes. One of the aims of this book, then, is to encourage students both to become aware of these internal divisions and at the same time to consider how they relate to conventional or accepted definitions of American identity.

## WHAT IS AMERICAN STUDIES?

If the problematic nature of national identity is one major concern which recent inquiry in American Studies has addressed, a second is the process of interdisciplinary work. It may be helpful here to say something about what we mean by interdisciplinarity and in so doing to identify some of the benefits as well as potential problems involved in this kind of approach. American Studies, as practised both in the United States and abroad, has long advocated movement beyond traditional disciplinary boundaries and encouraged efforts to establish more open and cooperative projects between academic areas. As might be expected, however, such an enterprise has had a controversial and much disputed life, for a whole range of reasons, particularly in the last thirty years when the very nature of what we mean by an academic discipline has come under scrutiny from a number of different directions.[2] It is not our intention here to provide a review of this work; students who wish to follow its contours may be guided by the material in the notes and further reading, or follow the debates in the *American Quarterly* over the last fifteen years. Rather, we want to open up areas of debate, and thus possible avenues of cultural exploration for students to develop in their own projects. In the individual chapters which follow, rather than providing interpretative overviews of the topics concerned, our aim is to suggest a range of potential approaches to American culture. What follows, then,

by way of discussion of interdisciplinary issues, is a starting-point or a place of departure.

Central to any interdisciplinary enterprise is the relationship between texts to be studied and the contexts from which they come. There are two main issues to examine here. One is what we mean by 'texts'. Traditional approaches based on the study of literature, history and politics, tended to favour certain kinds of texts at the expense of others, presenting an established canon of great works (often by Dead White Men, it is said) from which might be distilled the essence of American culture. Certain kinds of texts, such as *The Scarlet Letter* (1850) or *The Ambassadors* (1903) were appropriate for sustained examination while others, like popular films or detective novels were not. The debate over what should be included in the canon has been hotly contested in recent years and is clearly related to the issues raised in the opening stages of this introduction. Whose America is reflected in any specific list of texts for close study? Can the works of key writers in themselves provide an adequate guide to the complexities of a culture as varied and as divided as that of the United States? Are certain kinds of texts worth more than others because they are more complex or contain particular revelatory or inspirational qualities? Can the USA only be represented from within? In attempting to come to terms with these questions, our approach has been to retain an emphasis on the importance of certain forms of literary and artistic production which seem to us to require sustained and careful reading, but at the same time not to limit ourselves to what has been traditionally included in such a category. For one thing, what might be defined as 'elite' or 'high' culture has clearly changed over time. Lawrence Levine's work on the emergence of cultural distinctions in nineteenth- and early twentieth-century America is a salutary reminder that the status of texts and writers is not fixed but has varied according to the pressure of specific historical events (Levine 1988).

If we define culture at its broadest as 'a way of life', then it also becomes clear that to restrict the study of cultural products to a small handful of approved texts runs the risk of omitting a great deal. One recent suggestion takes the opposite position; texts are simply 'those stories that Americans tell one another in order to make sense of their lives' (Mechling 1989: 4). According to this definition, then, a whole range of cultural products and artefacts become available for analysis. It may still be that in such a scheme of study there remains room for qualitative judgement, that some stories carry greater conviction and resonance than others, but the possibilities for making connections between different aspects of the wider culture are greatly extended. The opening up of different kinds of texts for scrutiny, too, may yield surprising results. Listening closely to the stories they tell and how those stories fit or jar with other stories in the culture may reveal specific texts

in the popular domain which repay close study, and which are as questioning and as complex as more ostensibly 'serious' works. In this collection, therefore, while retaining a strong emphasis on the works of a range of established writers from Edgar Allan Poe to Toni Morrison, we have also juxtaposed them with material from other sources including popular culture, photography, art, music, film and material artefacts. Moreover, in making connections between different texts, it might be argued that new kinds of texts are created which themselves can be read and interpreted. An example here might be the description of the city as a text, which can be read in a range of different ways, but which itself is made up of a range of different texts or stories.

If the concept of a text is open to redefinition, then so too is the concept of context or 'history'. The implications of cultural theory for the discipline of history are considerable and remind us that written history is shaped and crafted in order to represent events to the reader, just as fiction is. Conventional notions of history as an empirically based quest for the truth about the past have been criticised as having an unquestioning and innocent approach to methodological and epistemological issues. Many of these criticisms are undoubtedly polemical in tone, and in their determination to make a theoretical case tend to ignore the sophistication, range and depth of much recent historical work. Ironically, they sometimes rely on particular versions of the past or models of historical interpretation which that work has undermined.[3] Despite this tendency, however, it is nevertheless helpful to identify some of the central points in recent work on the philosophy of history, for they suggest ways of encouraging links between history and other disciplines in the humanities in a way which opens doors to interdisciplinary work.[4] These points may be summarised as follows:

1   There is a critical distinction between 'the past' and 'history'.
2   History in the end is made by historians, defined here to include not just professional historians but all those who are interested in making some sense of the past. For example, an American historian like Frederick Jackson Turner established a narrative of Western history that sought to explain not just that region of the nation, but the entire make-up of a national character.
3   History as a discourse is a construct which cannot comprehend the whole of the past. The past, in its totality, is simply too big, too various, to encompass in any one account.
4   History, therefore, is made up of a range of different and contesting accounts of the past and we come to the past through its different histories, and it is these histories which we must weigh against each other as we seek to make sense of the past. There is no accurate and unchanging historical record of the past out there against which we

can check our stories for their truth. Thus new feminist or ethnic histories must be explored against the more 'traditional' male-centred constructions of historians like Jackson Turner.

5  Because history is a partial account of the past, it is subject to the same pressures as other stories; it is written according to certain conventions and rules, and employs a range of narrative devices, which may be explicit or implicit. The historian communicates by employing a range of strategies which are commonly thought of as the province of the novelist, such as metaphor, repetition, personification, closure and others. The same is true, of course, of the documentary materials which the historian consults.

6  These narratives are themselves contested, that is, they are in a dynamic relationship with each other. Particular kinds of narratives may have predominated at specific times, because they were the expression of dominant cultural forms or political systems. Other narratives remained unconstructed or silenced because they were not admitted into the dominant culture. Thus, until recently, Native Americans and African Americans have been silenced in history by a process that has denied them an authoritative historical voice.

7  Histories are written by historians who themselves are located in a specific social context, and whose observations, interpretations and judgements are partly shaped by the conceptual categories they bring to their task.

8  American history is part of a global system and cannot be viewed in isolation; it is *trans*-national.

It now may be possible to see how issues to do with the concept of an unproblematic national culture and identity mesh with methodological questions over what kinds of texts are worthy of scrutiny, and how these texts in turn link with the process of historical inquiry. An openness to a range of textual material – to include, for instance, popular and high culture, imaginative and documentary material, novels or films and histories – may in turn open up questions of national identity and its construction, move us beyond conventional disciplinary boundaries, and posit a range of alternative, competing discourses as the focus of analysis. Thus an event like the quincentennial of Columbus in 1992 was contested by different interpretations of the meanings of the 'discovery/conquest' of America (see Chapter 1).

As Shelley Fisher Fishkin put it recently in her call to redefine the field, 'The goal of American studies scholarship is not exporting and championing an arrogant, pro-American nationalism but understanding the multiple meanings of America and American culture in all their complexity' and to 'provide the nuance, complexity, and historical context to correct reductive visions of America' (Fishkin 2005: 20).

## USING THE BOOK

In what follows we have not used the same mode of analysis in each chapter, since investigations of different themes or topics clearly demand different approaches. This book is not, as we have stressed, a survey or an attempt to write a textbook with all the answers. As Michael Fischer has written, 'the text is not hermetically sealed, but points beyond itself' (Clifford and Marcus 1986: 201) and this book points to many other areas of study, avenues of exploration and research. Thus Chapter 6 on 'The American City' takes what might be described as a post-structuralist approach to the city as a text whose meanings are constantly shifting and unfixable, whereas Chapter 7 analyses the ways in which gender has defined power relations at work in America. We have, however, developed a self-conscious and explicit description of the practices we have adopted in the various chapters, as part of those chapters themselves. We have also included discussions of texts in a little more detail than a conventional survey would allow, again in an attempt to suggest possible approaches to a range of interdisciplinary textual material. The texts chosen for this purpose are not meant to be representative but, rather, to be helpful examples of what can be done through this kind of work.

At the end of each chapter we have provided concrete suggestions for follow-up work that will allow students to develop their own approaches to the topics concerned. Works cited in each chapter indicate a range of textual materials which might be used for further study. What we would encourage in these chapters, then, is what Fred Inglis described as 'the theory of open-mindedness' (1993: 227) which honours the plurality of perspectives, relishes the varieties of intellectual experience, acknowledges the location and uncertainty of old knowledge itself. At the same time, however, we also want to encourage students to explore some of the ways in which difference is connected to issues of power expressed through history, that 'the inherited notion of American culture is the product of historical struggles that have been won by some and lost by others' (Fox-Genovese 1990: 27) and that it is important to study the interaction between differing individuals and forces.

## CRITICAL APPROACHES

For the remainder of this introduction, we will present, in more detail, some of the approaches and terms we see as informing the chapters that make up this book. It is our intention to begin with an overview of some of the concepts that structure and influence individual chapters and provide a certain amount of explanation and context for these approaches. We have tried to explain them in the particular contexts in

which they will be used in this book and we provide, through the notes and reading lists, ways of continuing the process started here through individual projects. It is important to emphasise, however, that individual chapters, with their specific applications of these critical approaches, will put the flesh and bones onto the skeleton assembled here.

## Myth and ideology

American national myths, like the promised land or Turner's frontier thesis, 'attempt to put us at peace with ourselves and our existence' (Storey 1993: 74) by confirming certain qualities and attributes. These could become the focus for attempting to define the 'national character' and aspirations by suggesting that all people held these beliefs as common and shared. American Studies has often followed and explored, even helped to define, some of these mythic frameworks. Critical studies such as R.W.B. Lewis's *The American Adam* (1955) or Henry Nash Smith's *Virgin Land* (1950) are examples of texts that help to enunciate American mythic sensibility by reinforcing specific notions of the nation as Edenic or as wilderness. In one sense, the purpose of myth is to make the world explicable, to magically resolve its problems and contradictions. 'Mythical thought always progresses from the awareness of oppositions toward their resolution' (Levi Strauss 1963: 224). Ronald Wright adds that, 'Myth is an arrangement of the past . . . in patterns [that] create and reinforce archetypes so taken for granted, so seemingly axiomatic, that we live and die by them' (Wright 1992: 5).

Thus myths are the stories we tell each other as a culture in order to explain complexities and to banish contradictions, thus making the world seem simpler and more comfortable for us to inhabit. For example, if America was a 'virgin land', a wilderness, it was 'free' to be civilised and occupied by the pioneers, irrespective of the indigenous population. Roland Barthes warns against such complacency and reminds us to be vigilant and willing to interrogate the 'falsely obvious' (1973: 11) because 'By myth Barthes also means ideology understood as a body of ideas and practices which defend the status quo and actively promote the values and interests of the dominant groups in society' (Storey 1993: 78). For Barthes, myths alter the past by endowing the shifting, complex processes of history with the appearance of something 'natural' and 'eternal'. Myth is 'depoliticised speech' because it is as if the complexities that we recognise in speech have been hollowed out until all that remains is 'what goes without saying', the 'taken for granted' – a simple version denuded of political debate and difference.

Thus myths are ideological because they are concerned primarily with the ways in which particular images of the world are conveyed

and reinforced through texts and practices. Ideology can be explained as those modes of feeling, valuing, perceiving and believing that exist within and inform our everyday lives and connect us to wider structures of power in society in ways that contribute to the maintenance and reproduction of social power (Eagleton 1983). Such ideological myths exist everywhere in American culture, helping to shape the way people think and write about the nation, its history and its life, and they need to be interrogated and critiqued. For example, the idea of America as a new Eden, a place of new birth, mission and promise has been perpetuated in various forms throughout its history. Through interrogating these myths and ideologies we see the lines of power that have structured and given preferred meanings to particular renditions of the past and privileged certain groups as a result. This is not, however, a simple corrective, for that would imply that a 'myth' can be opposed by a 'truth', when, in fact, culture is more usefully viewed as a series of dynamic and contested ideological forces and interpretations. In this sense, these concepts need to be carefully related to that of 'discourse' (discussed below), as both myth and ideology contribute to the formations of discourse that construct 'America'.

**Interdisciplinary studies**

The term 'Interdisciplinary studies' suggests being at the boundary of the individual disciplines, where they begin to merge and intermingle, clash and jar, and relates to the condition of being at the margins of the normalised, accepted and official culture of America. These positions, both the abstract academic one and the real, ideological one, can be productive and invigorating. Being at these 'boundaries' or 'borders' can provide a new way of seeing a culture like the Unites States, because one is pushed beyond the centre where the world is defined, ordered and laid out, and permitted to see from a different perspective, through the decentered 'lens of alterity', as Paul Giles has termed it (2002: 255), including views from those excluded and marginalised by mainstream, dominant American culture. Here, a shift takes place giving a 'sense of disorientation, a disturbance of direction . . . an exploratory, restless movement' (Bhabha 1994: 1) because the established, safe sense of the 'real' has been questioned and replaced by an 'awareness of the subject positions – of race, gender, generation, institutional location, geopolitical locale, sexual orientation – that inhabit any claim to identity in the modern world' (ibid.: 1). At the boundaries of American culture, there is a multicultural, multiperspectival, transnational way of seeing, from where one might gain both these new perspectives and grasp 'the possibility of a cultural hybridity that entertains difference without an assumed or imposed hierarchy' (ibid.: 4). This latter concern with cultural

hybridity will be discussed later with regard to ethnicity and pluralism (see Chapter 2).

As a meeting place or 'crossroads', as Fishkin writes, of many cultures, systems of ritual and belief, America can be seen as a vast borderland or 'contact zone' where, in the words of Mary-Louise Pratt, 'disparate cultures meet, clash and grapple with each other' and 'subjects are constituted in and by their relations to each other . . . in terms of co-presence, interaction, interlocking understandings and practices' (Pratt 1995: 6–7). Interdisciplinary studies, which both interconnects *and* transgresses boundaries as a method of exploration, provides a suitable methodology through which to engage with and critique these dominant voices, and to appreciate and listen to other voices, recognising their mutual struggles to be heard.

## Multicultural and multi-perspectival

The development of critical cultural studies has been largely promoted by groups on the margins of power, excluded from the mainstream: women, ethnic minorities, gays and others. Through their exploration of new critical approaches, old systems of representation and power have been interrogated and resisted, such as from within post-colonial studies (see Singh and Schmidt 2000; and Madsen 2003). For example, multi-culturalism, that is, the belief that a healthy culture is made up of many different people with diverse systems of belief and practice, has encouraged the analysis of relationships of domination and oppression, social stereotyping, and focused upon resistance to domination, the need for self-definition and the assertion of difference. Similarly, feminism has analysed the relations of power, finding many connections with the struggles of ethnic groups in America (see Adrienne Rich's work discussed in Chapter 7), but also contributed to the new critical voices that urge reconsideration, revision and the interdisciplinary search for new approaches beyond the simplistic 'either/or' mentality of thinking that suggests there are only opposites and no complex, negotiated terrains. Such terrains give voice to what Foucault calls 'subjugated knowledges' (1980: 81), that is, to buried or marginalised cultural forms that have to be heard as part of the complex field of society. He emphasises the need to combine the 'erudite knowledge' with 'popular', 'local, regional . . . differential knowledge incapable of unanimity' (ibid.: 82), because in this mix there is a fuller picture of the multi-layered cultural climate that we would associate with the United States. A multi-dimensional view of culture fostered by these new social movements has enabled approaches to texts that are challenging because they demand that we ask new questions about who speaks, who defines, who controls and who is included or excluded from this process. As Desmond

and Dominguez put it, American Studies must 'move beyond a monocular vision to one refracted by numerous simultaneous perspectives . . . as a body of scholarship on an "area" defined in dynamic relation to other "areas"' (Desmond and Dominguez 1996: 5).

## A CULTURE OF MANY VOICES

For various reasons, certain groups have sought to present America as a single nation and have played down its diverse components. This is typified by the significance of Noah Webster's dictionary and his call for a common language in the 1790s. As Mikhail Bakhtin recognised, there are many voices running through language and literature, as in culture itself, and these must be acknowledged in an ideally 'heteroglossic' (many voiced) formulation of society:

> at any given moment of its historical existence, language is heteroglot from top to bottom: it represents the co-existence of socio-ideological contradictions between the present and the past . . . these 'languages' of heteroglossia intersect each other in a variety of ways, forming new socially typifying 'languages'.

> (Bakhtin 1990: 291)

Post-structuralist thinking (see Chapter 6) has recognised that texts are not closed, but plural with 'an endless play of signifiers which can never be finally nailed down to a single centre, essence or meaning' (Eagleton 1983: 138). To impose a single meaning or to attempt to find one is to misrepresent the complexity of the text (or nation) itself, and it is our contention that a variety of readings across the disciplines is one method of exploring the fullness of both the text and the nation, to hear the many voices that Bakhtin describes.

This reveals issues of power too; of whose voice is 'normally' heard in culture, what it enunciates and how it frames society in particular ways. These are the questions that emerge when we approach texts from different positions. Diversity, difference, contest, dialogue are the watchwords of this approach, but crucially too, a willingness to acknowledge the 'links and interrelationships' across what Bakhtin called 'the borderlines' (1984: 29), brings us back to our concern for the interdisciplinary method.

This book will pay attention to many voices and how they have recorded their lives, and recognise how history is always in a process of revision concerned with the analyses of power, ideology and representation. America, a nation of differences, has to be examined with close consideration of the ways in which those differences relate to those who have the loudest voices, the most authority, status and wealth, and those

who do not. Furthermore, such systems must be explored in order that such hierarchical structures are revealed and explained.

## CULTURAL POLITICS/CULTURAL STUDIES

America, like all cultures, is multi-faceted and ever changing, and therefore it has to be constantly questioned and examined using the most appropriate tools available. In recent years, cultural studies has provided new analytical approaches through which many traditional attitudes towards 'culture' have shifted, allowing a wider interpretation of the word. Rather than just 'high' culture – the best thought and written, with eternal values and authority – there has been a perceived need to include other forms of cultural expression, drawn from popular culture, mass media (referred to in the past as 'low' culture) and to broaden what could be studied to include not just traditional forms of expression, but new forms (film, television, comics) and a fuller definition of the concept of text. In this definition, culture is 'the ensemble of social processes by which meanings are produced, circulated and exchanged' (Thwaites *et al.* 1994: 1), and all these 'social processes' can be 'read', interpreted, and contested as texts. A useful way of envisaging this is to see culture as 'an assemblage of texts, loosely and sometimes contradictorily united' (Clifford 1988: 41) which constitute meanings, ideologies and subjectivities as they weave together, collide and merge.

This leads us through a series of vital questions about cultural formation, power, ideology and representation:

> Whose culture shall be the official one and whose shall be subordinated? What cultures shall be regarded as worthy of display and which shall be hidden? Whose history shall be remembered and whose forgotten? What images of social life shall be projected and which shall be marginalized? What voices shall be heard and which be silenced? Who is representing whom and on what basis?
>
> (Jordan and Weedon 1995: 4)

Hence, in American terms, such questions reveal how certain non-white cultures have been 'hidden', or women's histories have been erased in favour of the dominant male stories of the nation. Through the close study of cultural expressions, texts and practices we can raise these questions and begin to see the ideological positions that are registered socially in cultural institutions such as the family, education, the media, the churches, the law and language. These are termed *discourses* that constitute – rather than simply describing or reflecting – reality, and form our concepts about our identity and about what the world means. Discourses organise statements, define texts, promote meanings,

representations and stories, position subjects, and are endlessly in competition for our attention as they *construct* our sense of what is right and wrong, normal and abnormal, important or not worthy of our attention. These competing discourses can at any one time achieve greater authority within the cultural system, and become *dominant discourses*, carrying more status, power and social significance. For example, a discourse of American patriotism in a time of war might be a gathering of texts such as the flag, emotional music, images of heroism and sacrifice and speeches of resolution and determination from the White House. Together these are discursive formations that construct patriotism as logical, acceptable and 'natural' – as if it is a timeless and eternal condition of all normal, good Americans. Anyone criticising these discursive elements would be seen as unpatriotic and threatening, as in some of the reactions post September 11th.

The influence of such discursive formations within culture is immense, structuring power and influence, attitudes, beliefs and identity. After all, the effect of discourse is to *position us* in relation to a variety of social forces. It *subjects us*. So, using our example of patriotic discourse, Japanese Americans in the Second World War were imprisoned because they were perceived as a threat to the 'American' cause. They were 'subjected' and 'positioned' by this patriotic discourse and defined as dangerous outsiders. This is precisely the contested terrain into which cultural studies goes in order to debate these issues of and assumptions about identity, gender, class, the family, education, ethnicity, the environment, religion, and technology. In so doing, it reveals how power and ideology work to legitimate social inequalities, but it also explores how forms of resistance emerge as part of this complex cultural contest. For just as dominant discourses emerge in culture, so can resistant, counter-discourses, which struggle to be heard in the cultural arena and attempt to alter the received and dominant modes of expression and definition. This is a central interest in this book, as in much cultural studies, for it is through these resisting voices that new and interesting critical challenges are made to the centralised and established order.

## POWER, POSITION, HEGEMONY

America is a powerful nation, some would say an 'empire', with immense wealth, military strength and global influence, and this is how it likes to represent itself to the world. But how is this power achieved, by whom, for whom, and at what cost to others? It is vital that such assumptions and representations are questioned since power exists in different ways throughout culture and can be seen in all practices that have meaning. In their creation of meaning and our relation to that meaning, we are positioned, that is, we are 'hailed' or 'buttonholed' (Barthes 1973:

124–5) into a position which includes (or excludes) us in the relation-ship. The effect of this is ideological, for it serves to orient people in social contexts towards accepting certain values as natural, obvious and self-evident, and embodying these ideologies to such an extent that they appear to resolve contradictions and represent values which do not necessarily cohere with their lived experiences.     Vietnam

To modify an example from Barthes (1973) and Jordan and Weedon (1995), consider an image of an African-American child, hand on heart, gazing on the Stars and Stripes at the beginning of the school day and reciting the Pledge of Allegiance. The child is 'hailed' as one of the people and a part of an ideological system from which 'history evapor-ates' (Barthes 1973: 117) for the 'long story' of slavery, segregation and lack of civil rights has been emptied out and replaced by a simple 'myth'; 'a rich, fully experienced, spontaneous, innocent, *indisputable* image' (ibid.: 118). This particular example stresses 'One nation under God' and therefore promotes and makes 'natural' the ideology of a united and coherent America, 'with liberty and justice for all'. We may feel comfortable with these myths and values, and may go along with the positions they appear to offer us, or we may resist them and their attempts to place and define us. The power of discourse can contribute significantly to the formation of powerful notions of 'Americanness' or national identity. To reduce the image of the child to a single meaning is to denude it of possibility and to ignore the contradictory and com-peting meanings that have constructed it. Of course, in a particular situation the image could be read simply as a signifier of patriotism, loyalty and equal opportunity – with an emphasis upon racial harmony, unity and the American dream. This could be the dominant reading of the meanings on offer, fixed by social circumstance, cultural background, education, and so on, and reinforced through powerful institutions (school, family, the media, etc.). Such subject positionings are difficult to resist for they anchor the image's meanings in very specific ways, but by adopting alternative perspectives one can provide different ways of seeing, redefine identities and present new forms of resistance. Cultural studies seeks to listen to marginal voices and to the perspectives they bring to the debates about power, authority and meaning. These forces are connected to a term used throughout this book – *hegemony*. This is a term that helps explain the way that power works within culture that is in itself 'free and democratic', like America. Hegemony refers to the ways in which a dominant class 'doesn't merely rule but leads a society through the exertion of moral and intellectual leadership' (Storey 1993: 119) so that a consensus is established in which all classes appear to support and subscribe to its ideologies and cultural meanings, incorpor-ating them into the existing power structure. Hegemony's embracing of consensus means that any opposition can be 'contained and channelled

into ideologically safe harbours' (ibid.) not through imposition, but through negotiation. So subordinate groups are not ignored, but given a certain 'place', a position within the embrace of the dominant group, and their views articulated to a degree within the master-narrative. A master-narrative is the grand story told by the dominant groups to legitimate and justify their actions and policies. It attempts to encompass and totalise by a process of selection and exclusion of alternative, often critical, perspectives. For example, in America African Americans have been 'placed' within a dominant white cultural narrative, but through political struggle, cultural self-assertion and intervention they have developed an increasing role in the mainstream. Hegemony asserts cultural struggle and is best defined as 'a contested and shifting set of ideas by means of which dominant groups strive to secure the consent of subordinate groups to their leadership' (Strinati 1995: 170).

## DIALOGISM

As we noted earlier, cultural anthropology and cultural studies have recognised the importance of the work of Mikhail Bakhtin and in particular his call for dialogism. Based on the study of linguistics and language use, Bakhtin's work can be very useful in the analysis of American culture. As Reising commented, it 'provides the basis for a new appreciation of the heterogeneity of American [culture], a heterogeneity often blurred or denied by the polarization of canonical/ noncanonical, major/minor, aesthetic/social' (Reising 1986: 234). Language is dialogical, interacting self and other in a constant process of 'intermingling of diverse points of view' (ibid.: 234), and culture can be seen as functioning in a similar manner, as 'an open-ended, creative dialogue of subcultures, of insiders and outsiders, of diverse factions' (Clifford 1988: 46). In adopting this approach to American Studies, 'the intention is to dialogize dominant monologues, indeed, to show that dialogue is not an abstract ideal . . . but that it is everywhere' (Krupat 1992: 237) and that in examining this dialogue we can move closer to 'a textured sense of being American' (Fischer 1986: 230). As in a dialogue, culture is always in a process of negotiation, with positions and identities shifting, with official voices being parodied and satirised, with power being contested.

To summarise, we would agree that American 'culture is contested, temporal and emergent' (Clifford and Marcus 1986: 19) and through cultural studies we can examine these elements, both to identify patterns of power, inequality, domination and resistance, and also to see the possibilities for change and development in the future. America has always been a place of invention and of dreams, and this book will attempt in various ways to explore the possibilities that still exist within

American culture. To borrow from the anthropologist James Clifford, there is still a 'persistent hope for the reinvention of difference' within America (Clifford 1988: 15) which takes a variety of forms in its cultural life and energy. These 'histories of emergent differences require other ways of telling . . . there is no single model' (ibid.: 17), but as this book examines its various topics there are recurrent concerns about new forms revealed in interdisciplinary ways. The recognition and awareness of America as a still emerging, creative and dynamic place in which new, hybrid identities are ever possible are still prominent; but they are seen in the context of the histories and stories already told and often hidden, revealing a darker reality that has created the present from which anything new must emerge.[5]

## TRANSNATIONALISM

Gunter Lenz has called for a 'dialogics of International American Culture Studies' (1999: 18) and Paul Giles 'to rearticulate the [. . .] field dialogically and comparatively' (2002: 284), and at the core of both arguments is the need to view American Studies as part of a complex, transnational dialogue that breaks down older, persistent notions of exceptionalism and essentialism by drawing on the disjunctions and similarities between cultures, challenging mythic unity with diversity and critique. Dialogues across and between cultures transform how America is viewed, decentering and rupturing the seamless 'cultural insiderdom' often associated with old school 'consensual' American Studies, whether from the 'borderlands' perspective of the US southwest as shown by Gloria Anzaldúa's or José David Saldivar's work, or from the 'transatlantic' perspectives of Paul Gilroy or Joseph Roach. This 'transnational turn' traces alternative spaces and modes of belonging that are not defined by the nation-state and reconceives immigration as diasporic, multidirectional movements (see Kaplan 2004, Fishkin 2005). In breaking out of the 'charmed circle' of representation from within the US, transnational perspectives work 'to reveal the circumference of national formations and thus to empty out their peremptory claims to legitimacy' (Giles 2002: 2, 17), raising important questions about established myths, values and hierarchies through re-defining America as part of a global 'exchange'. In other words, it not enough, as once thought, to simply incorporate more voices to the grid of American national identity and expand the canon, for this simply maintains the tradition of inclusiveness. Instead one has to find 'external points of reference' to 'relativise' the whole field and to interrupt this circle of national representation. One consequence of such transnational (or postnational) thinking is to continually re-examine the idea of nation and its romantic attachment to 'roots' and essential, fixed identity, and supplement it with a sense

of 'routes' – the multiple, fluid formation of identity through contact, motion, diaspora and hybridity. And perhaps in this, as Amy Kaplan has stated, American Studies can be engaged in the important work of 'translation', to 'contest the universalism of American exceptionalism and to participate in the "strain and stress of the world", which is interconnected in many more complex ways than through the military reach of empire' (Kaplan 2004: 15–16).

## THE CONTINUOUS 'PLAY' OF CULTURE, HISTORY AND POWER

This book will examine these identities, their constructions, their representations and their relationships to power and authority and show, through the attention to specific themes and texts, how and why America is a complex 'symbol in contention' (Trachtenberg 1982: 8) rather than a single, fixed 'given'. If one of the central functions of historians is to 'lock up and unlock memory' (Appleby *et al.* 1994: 155), then this book is involved in the latter part of this process, engaged in the unlocking and 'dethroning' (ibid.: 3) of certain long-held versions and myths of American culture and the 'simplified story that was told about the nations past' (ibid.: 294). Hence, the Wild West has given rise to immensely influential national myths and, through their interrogation, we can unlock relations of power that excluded women, blacks and Hispanics, attempted to erase the Indian and ravaged the land. We are concerned with ideologies, representations, power, discourse, hegemony and identity as constant factors in the construction of America as a broad, multi-faceted and 'imagined community' whose cultural identity is

> a matter of 'becoming' as well as of 'being' . . . [and] belongs to the future as much as to the past . . . not something that already exists, transcending place, time, history and culture . . . fixed in some essentialised past, [but] subject to the continuous 'play' of history, culture and power.
>
> (Hall 1990: 225)

It is within these contexts that this book will show 'a living mix of varied and opposing voices' (Bakhtin 1990: xxviii), constructed of many stories, told by many people from different positions and for different purposes. They change in value, worth and power, are argued for and against, are denied, hidden or celebrated, become official or remain unofficial, but taken together, in all their multiplicities, they construct and represent America, and it is this 'living mix' of stories that is the concern of this book.[6]

## NOTES

1   For a forceful statement of this view see G. Gunn (1987) 'American Studies as Cultural Criticism', in *The Culture of Criticism and the Criticism of Culture*, Oxford: Oxford University Press.

2   For reviews of this debate see: R. King, 'The Eighties' in M. Bradbury and H. Temperley (eds) (1989) *Introduction to American Studies*, London: Longman, especially pp. 377–81. A very helpful and wide-ranging guide to recent work relevant to the interdisciplinary approach to American Studies is T.V. Reed (1992) 'Theory and Method in American Studies: An Annotated Bibliography', *American Studies International*, vol. 30, no. 2, April, pp. 4–34, updated (2001) at http://www.wsu.edu/%7Eamerstu/tm/bib.html.

3   For an attack by a mainstream historian on this tendency in recent cultural criticism and cultural theory, see A. Marwick, 'Introduction', in A. Marwick (ed.) (1990) *The Arts, Literature and Society*, London: Routledge.

4   K. Jenkins (1991) *Re-Thinking History*, London: Routledge, provides a concise overview of recent work. See also D. Goodman (1993) 'Postmodernism and History', *American Studies International*, vol. 31, no. 2, October, pp. 17–23.

5   Hybridity is a much discussed term within cultural studies and in particular post-colonial studies and it is an issue we discuss more in Chapter 2 in relation to American immigration and ethnicity.

6   An associated concept to that of stories that we use in the book, is that of cultural scripting, or the idea that identity can be scripted through discourse, through power and ideology in ways that appear to pre-define and limit the agency of the self and its capacity to 'write' its own script. For more on this, see Chapter 7.

## REFERENCES AND FURTHER READING

Anderson, B. (1991) *Imagined Communities*, London: Verso.

Anzaldúa, G. (1987) *Borderlands/La Frontera*, San Francisco: Aunt Lute Books.

Appleby, J. *et al.* (1994) *Telling the Truth About History*, London: WW Norton.

Bakhtin, M. (1984) *Rabelais and His World*, Bloomington: Indiana University Press.

—— (1990) *The Dialogic Imagination*, Austin: University of Texas Press.

Barthes, R. (1973) *Mythologies*, London: Paladin.

Bhabha, H.K. (1994) *The Location of Culture*, London: Routledge.

Brantlinger, P. (1990) *Crusoe's Footprints: Cultural Studies in Britain and America*, London: Routledge.

Clayton, J. (1993) *The Pleasures of Babel: Contemporary American Literature and Theory*, Oxford: Oxford University Press.

Clifford, J. (1988) *The Predicament of Culture: Twentieth Century Ethnography, Literature and Art*, Cambridge, MA: Harvard University Press.

Clifford, J. and Marcus, G. (eds) (1986) *Writing Culture: The Poetics and Politics of Ethnography*, Berkeley: University of California Press.

Denning, M. (1986) 'Marxism and American Studies', *American Quarterly*, vol. 38, no. 3, p. 360.

Desmond, J.C. and Dominguez, V.R. (1996) 'Resituating American Studies in a Critical Internationalism' accessed from http://xroads.virginia.edu/~DRBR2/desmond.html. Original in *American Quarterly*, vol. 48, no. 3 (1996), pp. 475–90.

Eagleton, T. (1983) *Literary Theory*, Oxford: Blackwell.

Fender, S. (1993) 'The American Difference', in M. Gidley (ed.) *Modern American Culture*, London: Longman.

Ferguson, R. *et al.* (eds) (1990) *Out There: Marginalization and Contemporary Cultures*, Cambridge, MA: MIT Press.

Fischer, M.M.J. (1986) 'Ethnicity and the Postmodern Arts of Memory', in J. Clifford and G. Marcus (eds) *Writing Culture*, Berkeley: University of California Press.

Fishkin, Shelley Fisher (2005) 'Crossroads of Cultures: The Transnational Turn in American Studies – Presidential Address to the American Studies Association, November 12, 2004', *American Quarterly*, vol. 57, no. 1, March, pp. 17–57.

Foucault, M. (1980) *Power/Knowledge: Selected Interviews and Other Writings 1972–77*, London: Harvester Wheatsheaf.

Fox-Genovese, E. (1990) 'Between Individualism and Fragmentation: American Culture and the New Literary Studies of Race and Gender', *American Quarterly*, vol. 42, no. 1, March, pp. 7–34.

Geertz, C. (1993) *The Interpretation of Cultures*, London: HarperCollins.

Giles, P. (2002) *Virtual Americas: Transnational Fictions and the Transatlantic Imaginary*, Durham: Duke University Press.

Gilroy, P. (1993) *The Black Atlantic: Modernity and Double Consciousness*, London: Verso.

Giroux, H. and McLaren, P. (1994) *Between Borders: Pedagogy and the Politics of Cultural Studies*, London: Routledge.

Gunn, G. (1987) 'American Studies as Cultural Criticism', in *The Culture of Criticism and the Criticism of Culture*, Oxford: Oxford University Press.

Hall, S. (1990) 'Cultural Identity and Diaspora', in J. Rutherford (ed.) *Identity, Community, Culture, Difference*, London: Lawrence and Wishart.

Inglis, F. (1993) *Cultural Studies*, Oxford: Blackwell.

Jameson, F. (1984) 'Periodizing the Sixties', in S. Sayres *et al.* (eds) *The 60s Without Apology*, Minneapolis: University of Minnesota Press.

Jenkins, K. (1991) *Re-Thinking History*, London: Routledge.

Jordan, G. and Weedon, C. (1995) *Cultural Politics*, Oxford: Blackwell.

Kaplan, A. (2004) 'Violent Belongings and the Question of Empire Today – Presidential Address of the American Studies Association, October 17, 2003', *American Quarterly*, vol. 56, no. 1, March, pp. 1–17.

Kaplan, A. and Pease, D. (1993) *Cultures of United States Imperialism*, Durham: Duke University Press.

Kellner, D. (1995) *Media Culture: Cultural Studies, Identity and Politics Between the Modern and the Postmodern*, London: Routledge.

King, R. (1989) 'The Eighties', in M. Bradbury and H. Temperley (eds) *Introduction to American Studies*, London: Longman.

Krupat, A. (1992) *Ethnocriticism: Ethnography, History, Literature*, Berkeley, CA: University of California Press.

Lenz, G.H. (1999) 'Towards a Dialogics of International American Culture Studies: Transnationality, Border Discourses, and Public Culture(s)', *Amerika-studien/American Studies*, vol. 44, no. 1, pp. 5–23.

Levine, L. (1988) *Highbrow/Lowbrow: The Emergence of Cultural Hierarchy in America*, Cambridge, MA: Harvard University Press.

Levi-Strauss, C. (1963) *Structural Anthropology*, New York: Basic Books.

Lipsitz, G. (1990) 'Listening to Learn and Learning to Listen: Popular Culture, Cultural Theory, and American Studies', *American Quarterly*, vol. 42, no. 4, December, p. 616.

—— (2001) *American Studies in a Moment of Danger*, Minneapolis: University of Minnesota Press.

Lowenthal, D. (1985) *The Past is a Foreign Country*, Cambridge: Cambridge University Press.

Madsen, D. (ed.) (2003) *Beyond the Borders: American Literature and Post-Colonial Theory*, London: Pluto Press.

Marwick, A. (1990) 'Introduction', in A. Marwick (ed.) *The Arts, Literature and Society*, London: Routledge.

Mechling, J. (1989) 'An American Culture Grid, with Texts', *American Studies International* vol. 27, April, pp. 2–12.

Pease, D. (ed.) (1994) *National Identities and Post-Americanist Narratives*, Durham: Duke University Press.

Pease, D. and Wiegman, R. (eds) (2002) *The Futures of American Studies*, Durham: Duke University Press.

Pratt, M.-L. (1995) (first 1992) *Imperial Eyes: Travel Writing and Transculturation*, London: Routledge.

Reising, R. (1986) *The Unusable Past: Theory and the Study of American Literature*, London: Methuen.

Roach, J. (1996) *Cities of the Dead: Circum-Atlantic Performance*, New York: Columbia University Press.

Rutherford, J. (ed.) (1990) *Identity, Community, Culture, Difference*, London: Lawrence and Wishart.

Saldivar, J.D. (1997) *Border Matters: Re-mapping American Cultural Studies*, Berkeley: University of California Press.

Sayres, S. *et al.* (eds) (1984) *The 60s Without Apology*, Minneapolis: University of Minnesota Press.

Singh, A. and Schmidt, P. (eds) (2000) *Postcolonial Theory and the United States*, Jackson: University of Mississippi.

Smith, S. (1993) *Subjectivity, Identity and the Body*, Bloomington: Indiana University Press.

Storey, J. (1993) *An Introductory Guide to Cultural Theory and Popular Culture*, London: Harvester Wheatsheaf.

Strinati, D. (1995) *An Introduction to the Theories of Popular Culture*, London: Routledge.

Tallack, D. (1991) *Twentieth Century America: The Intellectual and Cultural Context*, London: Longman.

Thwaites, T., Davis, L. and Mules, W. (1994) *Tools for Cultural Studies: An Introduction*, Melbourne: Macmillan.

Trachtenberg, A. (1982) *The Incorporation of America: Culture and Society in the Gilded Age*, New York: Hill and Wang.

Wilkinson, R. (1988) *The Pursuit of American Character*, New York: Harper and Row.

Wright, R. (1992) *Stolen Continents: The 'New World' Through Indian Eyes*, Boston: Houghton Mifflin.

# Chapter 1

# New beginnings
## American culture and identity

> Identity marks the conjuncture of our past with the social, cultural and economic relations we live within.
>
> (Rutherford 1990: 19)

Stuart Hall has written that cultural identity is not a 'fixed essence . . . lying unchanged outside history and culture', and is 'not [a] once-and-for-all . . . to which we can make some final and absolute Return', but is 'constructed through memory, fantasy, narrative and myth . . . made within the discourse of history and culture' and hence cannot be simply defined or 'recovered' like some lost, authentic being (in Rutherford 1990: 226). To grapple with the idea of cultural identity, therefore, is to examine the lines and discourses of its construction and to recognise the existence within it of many meanings. As the introduction suggested, America is a place where different identities mix and collide, an assemblage, a multiplicity, constantly producing and reproducing new selves and transforming old ones and, therefore, cannot claim to possess a single, closed identity with a specific set of values. Some Americans, however, prefer the notion of identity to be hegemonic, fixed and clearly surrounded by distinct boundaries and definitions. For example, some would care to think of white, male and heterosexual as the standard measure of 'Americanness', with a deep respect for the flag and a strong sense of regional identity, say, to the South or to Louisiana or Boston. However, these are ideological positions that are not shared or representative of the nation as a whole; indeed, no set of beliefs or values can be, and this is precisely the point. Instead, America has to be interpreted or 'read' as a complex, multifaceted text, like a novel or film, with a rich array of different characters and events, within which exist many voices telling various and different stories. And as with any such text, there are internal tensions, dramas and contradictions which contribute, indeed, constitute what might be called its identity.[1]

Postmodern and post-structuralist thinking have recognised these kinds of knowledges and approaches, and begun from the point of

distrusting any 'meta-' or 'grand narratives', that is those totalising stories that claim to speak for all and explain all. For example, to argue that America is exceptional and that its history was divinely ordained and destined to follow a set course is to read America as a limited and 'closed' text through a controlling meta-narrative or 'master-story'. Rather than seek out the controlling, organising single meaning, it is more important to follow the different stories, however disjunctive they might be, that constitute the threads of the text – its texture, to persist with the metaphor. America is constructed from these threads which are diverse, divergent, coherent, contrary and competing, crossing and separating, clashing and merging, weaving in and out of one another, forming and de-forming, gathering and fraying all at the same time.

Of course, these metaphors are helpful only up to a point, for we must recognise the nature of the historical and political realm in which this American 'text' has formed. Certain stories are preferred and achieve greater status and power, whilst others are derided or erased. Traditionally in America, male, white, heterosexual stories and versions of history have emerged as prominent and therefore have formed what we might term the dominant regime of representation or dominant ideological culture. These have tended to define American 'national identity'.

The rapid growth of industrialisation and urbanisation – the outward signs of modernity – encouraged the articulation of the nation as whole and unified in order that production and economic growth could develop around common goals, shared beliefs and a sense of cohesion. If in reality this consensus never existed, there was still a persistent emphasis upon the 'melting pot' as a way of bringing people together into the American nation. However, with the questioning of modernity and its values and the increasing rediscovery of ethnic, marginalised and minority histories in America, this semblance of unity has had to be revised. 'E pluribus unum' – out of many one – is a more controversial slogan for America today, for it suggests, on one level, the possibility of integration, of melting the parts into a universal whole, when in fact the parts may prefer to remain distinct and un-melted or multiply attached to different cultures, such as Mexican *and* American (see Chapter 5). There exists a tension between the conventional discourses of American identity, a complex set of statements, myths and ways of seeing that constitutes a core of values that equal 'America' to the people and the world, and a series of counter-discourses that question and resist the neatness and stability of such a view of national identity. The following chapter will explore some of the key elements of the myth of national identity and suggest other, counter-discourses, at work in American culture. In particular, the following examples, deliberately drawn from diverse sources, offer differing perspectives on America's concern with

beginnings and the 'dream' and how these have been used by both the right and left in creating persistent and competing notions of identity.

## READING COLUMBUS

One means by which America has unified itself is through an imagined communal mythology that all could share and that provided a cluster of beliefs through which the nation could be articulated, both to itself and to the world. The issue of how the five hundredth anniversary of Christopher Columbus's voyage of 1492 was commemorated is revealing here. Traditional mythology about Columbus's 'discovery' of the New World and the way in which it led to the republican and democratic values embedded in the history of the United States may be traced back to Joel Barlow's epic *Columbiad* (1807) and Washington Irving's A *History of the Life and Voyages of Christopher Columbus* (1828). In the nineteenth century Columbus became widely adopted as the basis of many American place names, and Columbus Day became part of the litany of national days of celebration. The Chicago World's Fair of 1893, marking the four hundredth anniversary of the first voyage, reinforced the narrative link between discovery and the power and progress of the United States at the end of the nineteenth century. Columbus thus became integrated into Manifest Destiny, the belief that America's progress was divinely ordained. As part of this process the Columbian myth became anglicised, but it could also act as a symbol for immigrant groups like Italians as to the role they could play in contributing to America's historic mission. What became clear by the 1980s, however, as preparations were made for the 'Quincentenary Jubilee', was that many Americans found it hard, if not impossible, to see the anniversary as a 'jubilee'. There was nothing to celebrate in the legacy of Columbus. According to many of his critics, he had been the harbinger not of progress and civilisation, but genocide, slavery and the reckless exploitation of the environment. Leading the accusations were those minority groups who felt that the coming of the Spanish to America had brought an imperial project which had delivered not civilisation but catastrophe. This reversal of the nineteenth-century myth of Columbus is revealing because it shows how the revival of concern for the interests of racial and ethnic minorities is closely linked to the reading and rewriting of American history. It is also significant in that it brings into focus some of the problems which emerge when one myth is discredited only to be replaced by another. At issue here, to some extent, is a debate about the functions of history. Some of the participants in the Columbus controversy assumed either that rewriting the Columbus myth would allow the 'truth' to emerge, as if there was a correct version of his life and its aftermath, once distortions had been cast aside. Others argued that older

versions of the Columbus story were simply reflections of who held power at the time they were propagated. Historical truth from this perspective was determined by those who had the authority to make it seem convincing. Emotions ran so high over the issue in Berkeley, California that 12 October 1992 was declared 'Indigenous Peoples' Day' instead of celebrating Columbus. Many argued that historical inquiry must involve the constant re-examination and reassessment of evidence and argument using reason and intelligence, not skin colour and emotion, in coming to terms with controversial themes of the past. These debates suggest how America is still struggling with its own identity and that an important part of its image is constructed through persistent myths that must be examined from a variety of perspectives.

## THE AMERICAN DREAM OF IDENTITY: *THE GREAT GATSBY*

The Columbus myths enabled white Americans to find a beginning, to declare a courageous opening to their 'story'. It was part of the influential dream myth of origin so prevalent in America. 'America, said the founding documents, was the living incarnation of the search for a common humanity . . . America declared itself as a dream . . . the microcosm, or prefiguration of humanity' (Calhoun 1994: 159). F. Scott Fitzgerald's *The Great Gatsby* (1926) is aware both of the power of American dreams and the problems of seeking them out in lived experience. The ideals of endless progress, self-creation, achievement and success – the mythicised dream incorporated in the spirit of Columbus – are played out in the figure of Jay Gatsby as seen through the eyes of Nick Carraway. The novel concerns itself with issues of identity and in particular with the temptation to believe in a 'dream' which is manifested in Gatsby's yearning for Daisy Buchanan, a woman he almost married in the past, who encompasses 'the endless desire to return to "lost origins", to be one again with the mother, to go back to the beginning' (Rutherford 1990: 236), and yet proves to be beyond his reach and unattainable as all such dreams are.

> 'You can't repeat the past.'
> 'Can't repeat the past?' he cried incredulously. 'Why of course you can!'
>
> (Fitzgerald 1974: 117)

In Nick Carraway's story of Jay Gatsby one can uncover much about the contradictions of identity and how these are central to any conception of 'America'. In the same way that Nick constructs a history of Gatsby through the telling of his narrative, so too has America been invented and reinvented by each generation. On one level, Nick's story

amplifies one of the founding myths of American culture, the belief in the fresh start, the new beginning. In the case of Gatsby, Nick tells us, he 'sprang from his Platonic conception of himself' (ibid.: 105), that is a self-making process in which 'he invented just the sort of Jay Gatsby a seventeen-year-old boy would be likely to invent' (ibid.), full of hope and 'romantic readiness' (ibid.: 8). In 1980, Ronald Reagan spoke too of how 'we built a new breed of human called an American' (quoted in Bercovitch and Jehlen 1986: 26), as if to invoke the idea of self-creation as a core myth of American identity. Gatsby comes to embody similar American ideological principles for Nick and through him he records his own 'history' of America. It is a story, however, marked by its contradictions, its ambiguities and its complexities. As we read Nick's story, what emerges are some of the necessary doubts and queries we bring to any consideration of America and American identity.

At the close of the narrative, Nick returns to Gatsby's empty house refusing to listen to the taxi-driver's 'story' of his friend and erasing an obscene word scratched on the steps by a boy, as if to remind us that it is only Nick's story we will hear. The exclusion of other voices at the end of the novel perpetuates the control that Nick has exercised for all the story. This history, this Gatsby, is one funnelled through Nick's eyes, tempered by a total belief in Gatsby and what Nick wants to see in him – the Dream. In the moonlight, a characteristic time of romance and uncertain vision, Nick returns in his mind to another age when the houses of West Egg are replaced by a fresh vision of possibility, 'the old island that flowered once for Dutch sailors' eyes – a fresh, green breast of the new world' when 'the last and greatest of all human dreams' still seemed feasible (Fitzgerald 1974: 187). This dream, for Nick, links Gatsby with adventurers like Columbus and represents the 'last time in history' when mankind faced 'something commensurate to his capacity for wonder'; the moment in which mankind physically arrived at a place big enough to hold its dreams and allow it to invent new selves and new beginnings.[2] For Nick – and this was also Gatsby's quest – there was a belief that all things were possible still and that the sense of the past was not lost but could be repeated and recovered. And yet, at the very moment that Nick reveals this equation to us, it is brought into question because the dream as a tangible achievement 'was already behind him' (ibid.: 188). What remains is the spirit of the quest, the indefatigable urge to go on looking and searching, 'boats against the current', for something in the future that is only held in the memory of the past.

The 'past' is the last word of *The Great Gatsby* and serves to remind us of the ambivalence of the novel's sense of time and history. Nick preserves a story of Gatsby by controlling what we are allowed to know about him, and yet there is still a sense of 'the foul dust' that surrounds

his dream in the sub-texts of his business contacts and acquaintances. Nick admits at one point that Gatsby

> must have felt that he had lost the old warm world, paid a high price for living too long with a single dream.... A new world, material without being real, where poor ghosts, breathing dreams like air, drifted fortuitously about.
>
> (ibid.: 168)

Here, the New World is a different vision, still of dreams, but trapped in a hopeless, lost cycle of despair symbolised throughout the novel by the wasteland of the 'valley of ashes'. Even Nick sees himself as 'within and without, simultaneously enchanted and repelled by the inexhaustible variety of life' (ibid.: 42). All people desire to invent and reinvent themselves, Fitzgerald suggests, and none more so than Americans, many of whom travelled to the land itself with that aim and belief. But there are complex reasons why they are denied those dreams in a culture not structured on simple myths, but on ideologies of power, class, race and gender.

The Great Gatsby's fascination with the multiple identities of America, embodied in the figure of Gatsby himself, are played out around the idea of the dream and the new beginning. Again and again in American culture, there has been a belief in the possibility of renewal set alongside doubts and questionings about the reality of such a concept. This has often been interpreted as a naïve, superficial dream associated with the mythic portrayals of America as the promised land and a new Eden. This 'new' continent seemed to offer the last great hope for mankind to begin again and put right all the wrongs of the Old World. The truth of such claims was quickly dispelled and yet it survived as a structural myth in American culture.

The very 'Americanness' of Fitzgerald's novel has much to do with its internal conflicts and contradictions, as if within itself a whole drama of American uncertainty and division is played out. Rather like Marshall Berman's definition of modernity, The Great Gatsby presents a world 'that promises ... and at the same time, ... threatens to destroy everything we have, everything we know, everything we are'. It is a world of 'disintegration and renewal, of struggle and contradiction, of ambiguity and anguish' (Berman 1983: 15). Experiencing the narrative's dark moments and its radiant dreams is to fall into these contradictions embodied in Gatsby himself, 'the poet of openness, the future, the green light'. And 'On the other hand, his most profound profession of faith is that the past can "of course" be repeated; he is a prophet of stasis' (Holquist 1991: 180). This tension between stasis and the future is part of the web of contradictions and conflicts that fill the novel and suggest an American

identity wrestling with diversity and unity, assimilation and separation, individualism and community, roots and routes, just as the self-made man 'Gatsby' himself is simultaneously of the West *and* the East, Old World *and* New.

## MAYBE THIS IS HEAVEN: *FIELD OF DREAMS* (1989)

Fitzgerald's examination of America's dreamscape and its sense of identity born out of newness and beginning has become a major theme in American cultural expression. Individual courage, persistence and determination focused on idealism and 'dream' have become a strong, resilient strand in expressions of 'Americanness'. Phil Alden Robinson's film *Field of Dreams* (1989) dwells on possibility, rekindling a sense of wonder that the Reagan presidency had promised, but failed to deliver. In part, the film responds ambivalently to the so-called 'culture wars' debates of the 1980s–1990s in which issues of identity politics, multiculturalism and the representation of US history came to the fore, often embedded in the looser exchanges and controversies over so-called political correctness. Lynne Cheney, E.D. Hirsch, Allan Bloom and others, began to attack new forms of history teaching for betraying particular established knowledges about America and its past. As Cheney wrote in 1988, history textbooks needed to be like those of the 'early decades of the century ... filled with stories – the magic of myths, fables, and tales of heroes', providing 'symbols to share ... help[ing] us all, no matter how diverse our backgrounds, feel part of a common undertaking' (in Lipsitz 1990: 24–5). Cheney's belief that national identity was best served by the articulation of history as 'heroic' and unidirectional was at odds with the growing emphasis upon multicultural representations insisting upon 'the complex realities of American history itself' (ibid.: 27). Although broadly liberal, the film shares something of Cheney's conservatism in its celebration of fundamental ideological units, the individual and the family following their 'heroic' dream. It belongs to a particular tradition in American thought, derived from strands of Puritan and republican traditions, 'a discourse of moral virtue and responsibility' stemming from 'a belief in chosenness and an original unity of communal virtue in a "city set upon a hill" or a "virtuous republic" of yeomen farmers' (King 1993: 364). Appropriately, it involves the land and an Iowa farmer Ray Kinsella (Kevin Costner) who hears voices from the fields telling him that 'if you build it, he will come'. Ploughing up his crops, and so rejecting economic security, he builds a baseball field in the belief that it will connect him with some lost sense of life that is unclear until the end of the film. The clue is the role of his own father:

> I never forgave him for getting old. . . . He must've had dreams but he never did anything about them . . . he could have heard voices but he sure didn't listen to them. . . . He never did one spontaneous thing in all the years I knew him. I'm afraid of that happening to me.

Ray says, 'I'm scared to death of turning into my father' because the father is the Past, but not one to be restored or repeated as in the mythic return so prevalent in the American Dream. Rather, the father is a signifier of waste, of the failure of the dream rather than its fulfilment. Other characters gather around Ray and the film draws together the threads of their disparate dreams, as if all of them need to reconcile themselves with some aspect of their past. Just as Ray will ultimately be reconciled with his father who returns as a ghost from the past, so the film reminds us of the values that the 1980s have destroyed: family, friendship, individualism, radicalism (the 1960s are a constant point of reference) and dreams.

> People will come . . . as innocent as children, longing for the past . . . it's money they have and it's peace they like . . . they'll watch the game and it'll be like they dipped themselves in magic waters, the memories will be so thick they'll have to brush them away from their faces.
>
> This field, this game is part of our past . . . it reminds us of all that was once good and could be good again.

There is, of course, a link back to Gatsby here, for Shoeless Joe Jackson, who returns to the baseball field, was cast out from the game by the 1919 World Series fixing scandal. In Fitzgerald's novel, it is Gatsby's friend, Meyer Wolfshiem, who is said to have fixed the series and represents the dark individualism, the dream's inversion, corrupt and yet entrepreneurial, for as Gatsby says, 'he just saw the opportunity' (Fitzgerald 1974: 80). It is Wolfshiem's greed and power that *Field of Dreams* opposes with its renewal of past values, both of the 1960s' counter-culture and the original 'capacity for wonder' that Nick Carraway longs for. The film criticises the book-burners of the Moral Majority, as well as the bankers foreclosing on Ray's farm, and thus connects to a wider liberal agenda that again underlines the ways stories can be appropriated by both right and left. But it is *the* American game, baseball, that has been corrupted, and the film uses it symbolically to represent all that has to be renewed, as Robinson said himself, 'it's symbolic of the better things about America that have been lost' (Robinson 1986: 6).

In all its powerful, emotive force, the film reiterates populist, mythic and traditional values – the pull of the land and the Puritan dream of the city on the hill (Ray's white house is prominent throughout) – as signifiers of goodness and vision. The community in which Ray lives mocks him, but in the end they will come to his vision, built from the individual power of his dream. Its values are those of the family, the home, the land, hard work and strong belief, but it also re-casts the 1960s as a time of possibility, talks of reconciliation and moves towards some shared, multi-cultural vision of the future at odds with the conservative opinions voiced in the 'culture wars' debates. The final visual image of the film, as the camera moves heavenward, is of the baseball field at night with the lights of a thousand cars moving towards it across the mid-West. The field is the heart in the heart of America, a replenished 'homeland', and the people are its renewing blood surging to their dreams, unifying black and white, old and young, urban and rural in a new liberal consensus.

## 'THE SURFACE OF AN IDENTITY': THE PAST AS PRESIDENTIAL DISCOURSE

The powerful emotional and mythic images employed in *Field of Dreams* speak of renewal and reconciliation of the homeland, popular themes in American political rhetoric. D.H. Lawrence celebrated a 'new voice' in American literature, 'a shifting over from the old psyche to something new', but this 'displacement . . . hurt' (Lawrence 1977: 7). It was about 'cutting away the old emotions and consciousness' (ibid.: 8) leading 'us back, through pang after pang of disintegrative sensation, back towards the end of all things, where the beginning is: just as the year begins where the year is utterly dead' (Lawrence 1962: 117). This poetic language suggests something of the impulse to reinvention and renewal that has characterised many of the myths of America, but whereas Lawrence's words are full of complexity and unspoken meanings, by the time the language has been selected and re-used in the political sphere, it has become curtailed and simplified. It is no surprise perhaps to find the Inaugural Address of President Bill Clinton in 1993 employing similar seasonal imagery to describe his version of America's new hope. After the Republican presidencies of Bush Senior and Reagan, Clinton, a Democrat, called for 'the mystery of American renewal', 'a new season of renewal' to once again alter the country and replenish the nation/land through the fundamental core myths of American culture. First there is the belief in the capacity 'to reinvent America'; second, to 'define what it means to be an American'; and third, to 'begin anew with energy and hope, with faith and discipline' (Maidment and Dawson 1994: 197–200).

The implications of this speech reinforce key ideas and assumptions about American identity that connect it with a 'mystery', an invocation of the divine and Manifest Destiny of the nation as some final expression of the promised land where all Americans participate in its 'divine' mission, this dream. Individuals, wrapped in the nation, choose to define themselves, to invent their own identity and place within the idealised new 'spring reborn'. Nature itself is a part of the divine mystery of America's renewal, its capacity for change and for opportunity, and it is the heritage of this generation to 'rededicate' itself to the dream, 'the very idea of America' (ibid.: 200).

Clinton's speech implies American identity is free from ideology when he says, 'we march to the music of our time, [but] our mission is timeless' (ibid.: 197), as if history has been by-passed in the creation of the values and goals he talks of. He is, however, reinvoking the core myths, an essence, around which America has structured its dominant ideological meanings, myths whose 'meaning is *already* complete . . . a kind of knowledge, a past, a memory, a comparative order of facts, ideas, decisions' (Barthes 1976: 117). Clinton's speech, his story of America, 'thickens, becomes vitrified, freezes into an eternal reference meant to *establish* [American identity]' (ibid.: 125) by repeating the past, or the language of the past, and seeking to apply it to the present. 'Myth is speech *stolen* [from the past] and *restored* [to the present]' (ibid.) and the images it restores transform historical processes into apparently natural occurrences so that we fail to read them as a motive, only as a reason (see ibid.: 129).

These myths form a complex ideological system that appears simple and uncomplicated for it functions by assumption, and we *assume* its values for they seem to be natural, to belong, to fit the place they have been given in the order of things. Of course, we must suspect such a discourse and interrogate its operation, ideologies, assumptions and exclusions. For this mythic framework excludes by constructing a single narrative of America, fixing certain dominant meanings: of individuality, the nation, Nature, rootedness, divinity, discipline and work, that cannot apply to all Americans, nor should they. The umbrella of myth tries to incorporate and *speak for* all whilst at the same time claiming that Americans can 'define what it means to be an American'. Here is the contradiction of myth/ideology, for it glosses over or elides difference, contingency and diversity in favour of clarity which 'goes-without-saying'; it functions to reassure (as Presidential speeches must) and 'organizes a world without contradictions' (ibid.: 143). The Inaugural Address speaks to the American people as if they were 'one', seeking to reassure them of presidential new beginnings, of commitment to great visions and old traditions, and as such functions less at a level of

policy-making than as a rallying cry for the continuity of the new presidential term of office. It serves to remind Americans of 'their' individual and collective dreams.

The presidential discourse of America is a tried and tested mythological system that attempts to speak of renewal and invoke new beginnings as an appeal that '*harmonizes* with the world, not as it is, but as it wants to create itself' (ibid.: 156). Thus, Clinton, a Democrat, employs similar rhetoric to Reagan whose Inaugural Address of 1981 had also claimed the old territory of Dream, Frontier and renewal: 'let us review our determination, our courage, and our strength. And let us renew our faith and our hope. We have every right to dream heroic dreams. . . . Their values sustain our national life' (Maidment and Dawson 1994: 194). The broad, sweeping, general appeal is to 'eternal' values that nobody can disagree with, often cynically referred to as 'Mom and apple pie' – and its function is to evaporate history from the content of the discourse and remove 'all soiling trace of origin or choice' (Barthes 1976: 151).

For President George W. Bush, the rhetoric is similarly organic, emphasising America's role at home and in the world, but mixing it with a familiar mythic religiosity and dreamscape:

> The story of America is the story of expanding liberty: an ever-widening circle, constantly growing to reach further and include more. . . . In our world, and here at home, we will extend the frontiers of freedom. . . . Like generations before us, we have a calling from beyond the stars to stand for freedom. This is the everlasting dream of America and tonight, in this place, that dream is renewed.
> (Bush 2004)

Whereas the rhetoric remains in this mythic speech, any genuine call to the past as a truly destructive, or deconstructive, process has gone and been replaced by the actionless imagery of renewal. Thus, following 9/11, Bush spoke again of 'a new spirit in America . . . a renewed spirit of patriotism . . . one nation under God . . . the land that we all love', turning familiar rhetoric to new purposes around a repeated notion of 'we' (Bush 2001). Barthes argues that criticism involves 'the essential destruction of the past' (Barthes 1976: 158) and not simply a 'restoring' and evocation of its images, for any harmonised narrative, any rendering of cultural wholeness is an improbable deception, a trick of mythology. Nick Carraway *wants* to believe in Gatsby's restorative dream, his wholeness of vision, but Fitzgerald's text encourages the reader to see beyond his 'single window' and 'partial view' to recognise that 'the rock of the world was founded securely on a fairy's wing' (Fitzgerald 1974: 10–11, 106). That novel's subtle contradictions, its doubts and

tensions, remind us of America's diversity and the impossibility of any single, authoritative, totalising point of view. The mythic spin of presidential discourse, of the ideological past restored like Gatsby's mausoleum-like mansion, is finally empty and exists only 'at the surface of an identity' excluding the multifaceted details of cultural difference and the ambiguous nature of that 'past' (Barthes 1976: 101). America has to be 'read' as a polysemy, that is, a space of many signs, a rich text, 'a complex signifier, a contested textual construct that bears the name "America"' (Mathy 1993: 3).

Any 'partial view' that seeks to label America in a single manner misses the vast 'teeming nation of nations' that Walt Whitman recognised as its source of democratic hope. However, it is not enough to assert, as presidents do, that America is 'one nation', since it is clearly constructed from competing discourses, and presidential speeches simply tap into the deep tradition of myths of new beginnings and the dream, and ignore those counter- or border-discourses that are also 'America', but which exist on the edge of the frame fighting to be heard and to become more influential.

## COUNTER-CULTURAL DREAMS

The radical criticism of the mainstream by the counter-cultures of the 1950s and 1960s is an interesting example of how the embodiment of possibility in America lived on as part of a counter-hegemonic alternative voice. Counter-cultural critics felt that the dream imagery had been hijacked by the corporate 'organisation man' and the values of the new beginning turned into the slogans of the consumer culture and presidential politics. In the works of many Beat writers, who emerged as rebellious figures willing to criticise and attack mainstream society, there is a determined effort to reclaim the identity of America as a statement of possibility rather than production. Allen Ginsberg wrote of

> an America gone mad with materialism ... prepared to battle the world in defense of a false image of its Authority. Not the wild and beautiful America of the comrades of Whitman ... where the spiritual independence of each individual was an America.
>
> (Allen 1960: 333)

This lost America has to be rediscovered, or reinvented, as a protest against the narrowing vision of 'Authority' – Ginsberg's expression for the dominant hegemonic power which dictates the terms of existence, spells out the dream through a 'fixed and universal monopoly on reality' (Allen and Tallman 1973: 243). 'America will be discovered' (Allen 1960: 321) and for Ginsberg and other artists, it was through a renewal of

form, a challenge to the stasis that seemed only to serve the status quo of hegemony. As Michael McClure wrote, 'we wanted to make it new and we wanted to invent it . . . we wanted voice and we wanted vision' (McClure 1982: 12–13). The language recalls the mythic notion of new beginnings and celebrates the idealism of America, not as an imperial power, a conqueror of native lands or an oppressor of minorities, but as a place capable of change – make it new, he cries. For these critics there was something worth saving, something that was not mere rhetoric.

The counter-culture sought both the renewal of 'wonder' and the politics of opposition, both vision and action; and in this regard it was very much in an American tradition. The poet, Lawrence Ferlinghetti, called for 'a rebirth of wonder' and 'for someone to really discover America' (Ferlinghetti 1968: 49), emphasising both the loss of spirit and the failure in American life to realise the true potential of the place. What had to be discovered was that which had been obscured by dominant, but limited definitions of American identity, that excluded or marginalised vital groups with much to contribute. It is significant that alongside and within the counter-culture emerged other alternative, previously marginalised voices (African Americans, Native Americans, women, gays, etc.) offering different expressions and definitions of identities.

In the Port Huron Statement (1962), 'the most authentically American expression of a new radicalism' (Sayres *et al.* 1984: 250), the counter-culture, voiced familiar calls for 'American values', which had been lost as a generation was 'maturing in complacency' (Maidment and Dawson 1994: 237), and demanded change. It repeated the plea to go 'beneath' 'the temporary equilibriums [or consensus] of our society', 'the stagnation of those who have closed their minds to the future' and to reject the feeling of 'the exhaustion not only of Utopias, but of any new departures as well' (ibid.: 238). The hegemonic, dominant culture promised stability and prosperity, but also perpetuated norms which excluded and limited the capacity for human potential. American identity has always involved tensions between the individual and the collective identity, for as the Port Huron Statement concludes, 'the object is not to have one's way so much as it is to have a way that is one's own' (ibid.: 241).

Thus in *Easy Rider* (1968), a key film often read as a counter-cultural text, one of the characters, Hanson (Jack Nicholson), says, 'This used to be a helluva country. I can't understand what's going on', and throughout the film we are presented with images of nostalgia for some half-remembered golden age, signified most often as an eternal, mythical West as opposed to the intolerance and corruptions of a modern world. The film's value system is contradictory throughout, but it does valorise certain traditional images such as the land and the family, very much in the way *Field of Dreams* did in the late 1980s. Sitting down to

eat with a mixed American–Mexican family (another image of recon-
ciliation and hope?), Wyatt comments on the righteousness of 'living
from the land' as if to celebrate a vision of timelessness and wholeness
outside the mania of the city they have left behind. The drug culture,
as portrayed in the early parts of the film, supports the view that alter-
native perceptions were part of the process of re-visioning America
and questioning its values, but this is also shown through the film's
western landscapes and use of sacred Native-American culture. Much
of the journey is through Native-American lands of Utah and New
Mexico, with sequences in Monument Valley and Taos Pueblo, with
references to the 'people' buried in the sacred land itself, as if to artic-
ulate the film's tentative portrayal of new identities and its challenges
to the accepted culture of the times. Indeed, the film plays with alter-
natives to the dominant culture (such as the commune), but none are
satisfactory and any sense of resistance is ultimately contained in the
individual figures of Wyatt and Billy who are destroyed and erased at
the end of the movie. Change seems impossible, as the camera lifts
above the final fiery destruction, in a shot reminiscent of the conclud-
ing shot of *Field of Dreams*, but unlike that film's sense of regeneration
and possibility, *Easy Rider* ends in horror, death and the denial of
alternatives.

The 1960s opened a dialogue with the stale imagery of the American
Dream and sought to reinvent it with hope and to enlarge it through
inclusiveness, by 'stressing the *utopian* aspects . . . as distinguished from
its *economic* aspects' (Sayres *et al.* 1984: 249). As Fredric Jameson argues,
the 1960s in America were part of a wider global reaction to colonialism
involving 'those inner colonized of the first world – "minorities",
marginals, and women – who became integral to a "coming to self-
consciousness of subject peoples"' (ibid.: 181). Groups excluded from
early visions of the 'dream' and silenced by the processes of history,
sought to play some role in the renewal of ideas of identity and nation.
As the radical Chicana feminist Gloria Anzaldúa has written, 'We have
come to realise that we are not alone in our struggles nor separate nor
autonomous but that we – white black straight queer female male – are
connected and interdependent' (Moraga and Anzaldúa 1983: Foreword).
This recognition of a diverse but connected struggle for renewal can
still be expressed in the mythic language of America: '*Women, let's not
let the danger of the journey and the vastness of the territory scare us – let's
look forward and open paths in these woods*' (ibid. – italics in the original).
In 'unlearning to not speak', as the poet and novelist Marge Piercy
puts it, women and other excluded groups have explored and reinvented
identities, not to reduce them down to a formulaic myth of consensus
and unity, but to provide true scope for expansiveness and diversity
(see Chapter 7).

## MULTIPLICITY, DIFFERENCE AND RE-VISION

As we have seen in this chapter and in the introduction, identity is a constant shifting territory in America, with renewal as a significant element in the recognition of difference and diversity, rather than fixity and stasis. American identity is characterised by re-vision as a process of renewal: 'Re-vision – the act of looking back, of seeing with fresh eyes, of entering an old text from a new critical direction' (Rich 1993: 167). The voices of people of colour, feminists and radicals coming from the margins of American culture and beyond the USA altogether, have caused the 'assumptions' to which Adrienne Rich refers, to be examined and reviewed, but this is a process inherent in a radical interpretation of the myth of new beginnings. The French critic Gilles Deleuze argues, like D.H. Lawrence and others, that America is concerned with 'deterritorialisation' or the movement across lines and boundaries, unafraid to flee to new lands or leave old ones behind. He writes of the American passion for 'departure, becoming, passage' in its creation of 'a New Earth' (Deleuze and Parnet 1987: 36).

The very act of movement is akin to the desire for renewal, for 'becoming' American. The constant 'passages' suggest that identity cannot in this scheme of things become fixed, nor arrive at some final point in which the authentic American is defined as an eternal essence. Deleuze touches upon the fact of American restlessness, its mobilities, or what we earlier termed the 'routes' of identity, as a sign of its 'multiplicity' – 'a set of lines or dimensions which are irreducible to one another' and in which 'what counts are not the terms or the elements, but what there is "between" ... *a set of relations which are not separable from each other'* (ibid.: vi, vii – our italics).

This is crucial, for it suggests something of the nature of American identities as plural and irreducible to a single fixed idea of 'Americanness', but also, in contrast, dynamic, best recognised – to repeat – as 'a set of relations which are not separable from each other'. The implications of connection and dialogue come through here, and the idea of an American cultural identity derived through multiplicities rather than conformity and closure is in keeping with attitudes to cultural difference. 'The time for "assimilating" minorities to holistic and organic notions of cultural value has passed' (Rutherford 1990: 219) and what must be set alongside is a new definition of cultural identity, which is not based on any true Americanness, any 'oneness' of agreed values and history, but the recognition of difference. 'We cannot speak for very long, with any exactness, about "one experience, one identity", without acknowledging its other side – the ruptures and discontinuities which constitute ... [American] "uniqueness"' (ibid.: 225). These renegotiations are integral to discussions of identity in a contemporary culture where

the fixities of big concepts like 'nation', 'identity' and 'culture' must be continually re-examined and challenged. Definitions are only provisional and 'subject to new analyses, new questions and new understandings if we are to unlock some of the narrow terms of the discourses in which we are inscribed' (Boyce-Davies 1994: 5).

The American sense of new beginnings, once demythicised, can still have a genuine and important meaning in the exploration of cultural practices and identity, for it is part of the endless efforts to trace the self, to follow the many lines that make up the 'teeming nation of nations' and to keep revisiting and redefining them from new perspectives for 'a new interrogation of meaning' (ibid.). In part, what is needed is Cornel West's 'new cultural politics of difference' which

> affirms the perennial quest for precious ideals of individuality and democracy by digging deep in the depths of human particularities and social specificities in order to construct new kinds of connections, affinities and communities across empire, nation, region, gender, age and sexual orientation.
>
> (West 1993: 29)

## NEW INTERROGATIONS: GLORIA ANZALDÚA, BARRY LOPEZ AND TRINH T. MINH-HA

Barry Lopez and Gloria Anzaldúa combine a number of the perspectives that we have put forward in this chapter in an effort to both realise the complex nature of American identities and to suggest a constructive and realistic way ahead. They are both concerned with what James Clifford calls 'presents-becoming-futures' involving the recognition of both 'utopian, persistent hope for the reinvention of difference' and the realisation of the potential for the 'destructive, homogenizing effects of global economic and cultural centralization' (Clifford 1988: 15). They are interdisciplinary writers and activists, concerned with environmental issues, radical politics and cultural criticism, who have expressed their views in many voices: fiction, essays, travel writing, and meditative poetic pieces. Their works attempt to redefine American identities to some extent by 're-mapping' and decentring certain assumptions about the self and its relationships to place and others. Their work is hybrid (see Chapter 2) in that it merges with other cultural forms such as oral traditions, myths, trickster stories, and it unfixes itself from any obvious, stable tradition that one might too neatly term 'American'. They are border-writers, endlessly crossing boundaries between different cultural practices – becoming, challenging, redefining what it is to live in America and to think beyond simplistic national narratives towards the trans- or post-national perspectives discussed earlier. Between culture and nature,

man and animal, life and death, space and place, wilderness and civil-
isation, new stories are told that remind us of William Carlos Williams's
statement: 'History, history! We fools, what do we know or care? History
begins for us with murder and enslavement, not with discovery'
(Williams 1971: 55).

For Barry Lopez, whose work is broadly seen as environmental liter-
ature, America is a conquered land, colonised by Spaniards and other
Europeans, and he writes of the horrors of conquest and imperial hege-
mony demanding that we 'rediscover the original wisdom' derived
from pre-conquest cultures and their relationships 'with the nonhuman
world'. To 'reclaim that metaphysics' is tied to the 'practical need' to
see beyond the terrible history and seek an imaginative new beginning
that refigures the relationship of humanity to place (Lopez 1988: 198).
In *The Rediscovery of North America* (1990) Lopez brings together these
ideas, tracing a 'tone' back to the conquest of America and agreeing with
Tzvetan Todorov's claim that it 'heralds and establishes . . . [America's]
present identity' (Todorov 1987: 5). Since colonisation, argues Lopez, 'we
have imposed, not proposed. . . . We said what we thought, and bent to
our will whatever resisted' (Lopez 1990: 18). In the New World 'we came
to talk, not to listen (ibid.: 19), thus establishing a monologue in which
other voices were ignored, destroyed or marginalised. The first 'new
beginning' ignored what the New World had to say and closed its mind
to the wisdom of the place and its particular energies, preferring instead
to view the land as 'empty' and awaiting the arrival of the European
mind to 'write' itself onto the continent. Identity as such was formed
around exclusions and denials, especially of Native cultures and existing
traditions, rather than openness and possibility.

However, even in Lopez's dark remembrances there is still belief: 'It
is still in some real sense the New World' (ibid.: 29), because the idea
of American identity remains fluid. For him, this means a chance for
new beginnings in which 'proposals' are made, a dialogue – 'opening
an intelligent conversation' (ibid.: 36) – with the environment created,
which would permit a new 'moral universe' where the land was included
in 'the meaning of the word community' (ibid.: 34). He continues: 'In
these ways we begin, I think, to find a home, to sense how to fit a place'
(ibid.: 37), and it is this concept of home that is so important to Lopez,
for it indicates 'a place where we take on the responsibilities of adults
to the human community' (ibid.: 48). Unlike current appropriations of
the term 'homeland' in terms of security and the policing of borders,
Lopez sees home as expansive and open, a new beginning, and rejects
any static 'dream' of some lost time.

Lopez recognises the New World not as a place to 'recover' but to
'rediscover', that is to see it differently, unlike before. There is no whole
sense of America that can be recovered, so 'we need to sojourn in it

again, to discover the lineaments of cooperation with it' – 'we have a
monumental adjustment to make, and only our companions on the ship
to look to. We must turn to each other, and sense that this is possible'
(Lopez 1990: 49, 58). This renewal of hope, based on the need to change
and to look again at the way people live, carries with it the contempo-
rary concern for ecology, the wisdom of ancient tribes, nature and the
actual knowledge of modernity, working together and 'rethinking our
relationships' (Lopez 1988: 198). As he wrote in *Arctic Dreams* (1986),
there is a need for

> [an] altered perspective to imagine afresh the way to a lasting secu-
> rity of the soul and heart, and toward an accommodation in the flow
> of time we call history, ours and the world's. That dream . . . is the
> dream of great and common people alike.
>
> (Lopez 1987: 12)

And, in a more recent work, he states 'other voices were as indispens-
able to our survival as variation in our DNA' (1999: 13).

Lopez's qualified optimism for a new 'dream' full of 'other voices' is
echoed in the work of critic and film-maker Trinh T. Minh-ha, who has
written that 'identity is a way of re-departing . . . to start again with re-
departures, different pauses, different arrivals' (Trinh 1990: 328). Here
the American sense of new beginning is empowering, learning from the
past with the belief that one can begin again without repeating all the
mistakes of the past. It becomes 'everything monologism has repressed.
. . . Here again and anew, gender and sexuality and other struggles
of borders. . . . The challenge is thus: how can one re-create without
re-circulating domination?' (ibid.: 329). As in Barry Lopez's work, Trinh
T. Minh-ha appropriates images of renewal and infuses them with new
purposes to indicate the possibility of inclusion and expansion within
America without stating the older definitions of totality. In her book
*Woman Native Other*, Trinh states that what is desirable is a community
'built on differences . . . [that] . . . subverts every notion of completeness
and its frame remains a non-totalizable one', articulated through a story
that 'circulates like a gift' but which cannot be possessed by any one
person or group, 'a gift built on multiplicity . . . inexhaustible within its
own limits' (Trinh 1989: 2). In her vision, 'Life is a perpetual to and fro,
a dis/continuous releasing and absorbing of the self' (ibid.: 128) where
'plurality adds up to no total' (ibid.: 330), but offers a source of renewal
with its many voices, 'companions on the ship', to use Lopez's phrase,
working towards different destinations and with different priorities. This
suggests a sensitive and human response to the complexities of contem-
porary culture, which presents a possible way forward to make it over
'a-new a-gain', as she puts it (ibid.: 128).

Gloria Anzaldúa, writing as a Chicana lesbian feminist, sees herself as existing in the multiple 'borderlands' of American culture: 'that liminal landscape of changing meanings on which distinct human cultures encounter one another's "otherness" and appropriate, accommodate, or domesticate it through language' (Kolodny 1992: 9). Just as Lopez and Trinh are fascinated by the possibilities of the border, so too is Anzaldúa, recognising in it an 'inherently unstable locus . . . of environmental transitions and cultural interpenetrations' (ibid.: 10) which 'destabilizes easy assumptions about centers and margins' (ibid.: 12). The border, for Anzaldúa, is resistant to unitary explanations and neat stories; it is a place where 'different cultures, identities, sexualities, classes, geographies, races, genders and so on collide or interchange' (Boyce-Davies 1994: 16).

In many respects, as we discussed in the Introduction, this is a description of American culture itself as a multiple and dynamic 'contact zone' giving rise to Anzaldúa's new, hybrid subjectivity – the mestiza – constituted by the acts of crossing and recrossing the border until 'a new life begins' (Anzaldúa 1987: 49). For her, the old ideas of being assimilated or 'rooted' as an 'American' are meaningless, for 'she learns to juggle cultures. She has a plural personality. . . . Not only does she sustain contradictions, she turns the ambivalence into something else' (ibid.: 79). It is a 'new birth' or beginning, what she terms a 'new consciousness' (ibid.: 80), but it is no easy, harmonious position, rather, one full of turmoil and pain, involving the 'uprooting of dualistic thinking' (ibid.) that constantly divides and sets one against the other. This 'third perspective' (ibid.: 46) offers a new subjectivity 'routed' beyond the norms and expectations of a narrowly defined 'American identity', seen as 'universal' (but in fact white, male, heterosexual, etc.). It is a visionary new beginning cast from the realities of a postmodern culture of difference and multiplicity with a sense of self that is open, plural, 'a space through which to negotiate ambivalence and heteroglossia' (Smith 1993: 175). Evoking once again Bakhtin's cultural ideal, Anzaldúa posits a new America where 'many languages intermingle with one another, in a state of nonhierarchical multiplicity, creating a hybrid language' (ibid.: 176).

The utopianism of these positions, despite their realistic acceptance of struggle and contest, asserts the persistence of the ideas of reinvention and new beginnings in American culture but refigured through the new positions of marginality, difference and otherness. It is not necessarily an end to the 'broad-based democratic cultural discourse that implies more than a collection of marginalized groups' (King 1993: 378), but, rather, a reconstruction of American cultural identities in which new groups find a voice and new subjectivities emerge. As Trinh T. Minh-ha has said:

the self ... is not so much a core as a process, one finds oneself in the context of cultural hybridity, always pushing one's questioning of oneself to the limit of what one is and what one is not. . . . Fragmentation is therefore a way of living at the borders.

(Wheale 1995: 252)[3]

Such a positive use of her multiple identities, as Vietnamese–African–French–American, is a recognition of how such unfixing of cultural identity can 'displace certainties in order to gain new ground' (ibid.). To borrow one of the titles from her films, one might term this new ground of identity as a 'reassemblage' acknowledging 'there is no real me to return to, no whole self ... there are instead, diverse recognitions of self through difference, and unfinished, contingent, arbitrary closures that make possible both politics and identity' (ibid.: 255). Perhaps here in the postmodern shifting of identity, within the universal pressures of globalisation, diversity and difference is the appropriate platform for a democratic America which recognises its own multiplicities and relates to wider, extra-national cultural connections to do with language, gender, race, ethnicity, religion and sexuality. In this re-vision there exists the timeless idea of the American dream, recast, but still vibrant in its signification of creative regeneration and the quest for new beginnings, perhaps showing that 'the imagination is today a staging ground for action, and not only for escape' (Appadurai 2000: 7).

## CONCLUSION: DIGGING DEEP – *LONE STAR* (1996)

John Sayles's film *Lone Star* begins literally in the American land, on the Mexican border, with the discovery of a skeleton, a Mason's ring, and a sheriff's badge buried in the desert. References to the 'Coronado Expedition', quickly locate the significance of colonial history to this film and suggest its continued relevance to the present day lives of this border community, Frontera (border). 'This country's seen a good few disagreements over the years', we are told, but if 'You live in a place, you should learn something about it'. In this archaeological resurrection of the 'buried' and 'forgotten' pasts the film's interest in sites of memory and their relationships to official history is established, as well as its critique and expansion through 'learning' about place through uncovered memories and stories. *Lone Star*'s stories – Hispanic, African American, Anglo, and women's – contribute to a multicultural layering of alternative, buried voices and versions of the past providing a framework for Sayles's reconsideration of relations of memory and history within his 'new cultural politics of difference'. Indeed, *Lone Star* was referred to as a 'prophetic allegory' by Mary Helen Washington in her Presidential

Address to the American Studies Association in 1997, offering a new approach to studying America in which the 'differences of language, politics, historical vision' were not allowed 'to dissolve in a soothing movement toward consensus', but instead 'presents the multicultural moment as one of tension, struggle, discomfort and disagreement' (Washington 1998: 16). The following year Janice Radway re-iterated the film's significance by using it too as a locus for her questioning of the meaning of 'American' within American Studies and the possibility of an interdisciplinary practice of 'intricate interdependencies' reflected in the 'cultural menudo' of Sayles' frontier community (Radway 1999: 6).

In this way, *Lone Star* examines multiple borders, from the ever-present geopolitical southwest border, to those drawn through the diverse lives that intersect within the community viewed not as unitary, but rather a complex contact zone. Through the film's central narrative Sam Deeds uncovers his own family history by demythicising his father's 'legend' and his secret relations with a Mexican woman – Mercedes Cruz. The final revelations of incest provide a metaphor for Sayles's inter-connected community where blood and history are mixed and complex rather than separate and simple. The scene takes place in a disused drive-in movie theatre where Pilar, Sam's lover (and half-sister), calls for a clean break, a new beginning: 'We'll start from scratch. ... All that other stuff, all that history, to Hell with it right? Forget the Alamo'. Looking up at the blank screen ravaged by time passing, Pilar and Sam are ready to 'project' their new vision upon it, ready to take over the role of the movie as the traditional 'escape' from the everyday borders and restrictions of their lives in the creative imagining of alternative identities. As the film *Lone Star* ends, Sayles suggests that the latent possibility inherent in the experience of movies can be carried forward into life itself – that is, into the imaginative reconstruction of identity, community and nation.

As Sayles has said, 'American culture is not monolingual or monoracial. It's always been a mix' and in this moment of decision Sam and Pilar 'choose to cross that border of moral opinion' and assert this new 'family' (Carson 1999: 213, 216). Their incipient migratory movement and willingness to break the 'rule' and social taboo are signs of a wider recognition of the necessity for that very dialogical, hybrid mix that Sayles sees as fundamentally American. As if to directly respond to the kind of one-dimensional notions of identity and nation associated with conservative historians and theorists, Sayles allows Sam and Pilar a 'second life' as an anti-essentialist identity forged from movements and migrations rather than formed by a single and rooted attachment to one place.

In this Sayles echoes Gloria Anzaldúa's optimism for the future based on a similar belief that 'There will be a hybridity of equal parts instead of a graft and a major tree', and that identity

is an arrangement or series of clusters, a kind of stacking or layering of selves, horizontal and vertical layers, the geography of selves made up of different communities you inhabit. . . . Where these spaces overlap is nepantla, the Borderlands. Identity is process-in-the-making . . . you shift, cross the border from one to the other.

(Anzaldúa 2000: 278, 238–9)

Anzaldúa's 'nepantla' is an 'in-between' space that facilitates transformation since within it, as in *Lone Star*, traditionally assumed and fixed borders break down compelling us to find new ways of defining ourselves and our communities. The forbidden or taboo (like the incest motif and the hidden histories in the film) ruptures the smooth surfaces of the everyday, forming an 'interface' so that 'in the cracks between worlds and realities . . . changes in consciousness can occur. In this shifting space of transitions, we morph, adapt to new cultural realities' (ibid.: 280). Through the retrieval of memory and the reconstruction of Frontera's multiple histories, Sayles's film reaches points of knowledge and reconciliation from which choices can be made about living with the past rather than in its shadow and about identity as a process of 'routes' rather than a fixed and rooted essence.

## NOTES

1   These 'others' speaking from the margins of American mainstream culture will be vital to the re-vision undertaken in this book.
2   Barry Lopez (see the final section of this chapter) has actually used Fitzgerald's phrase in expressing his beliefs 'It's important for me . . . to go into a story with a capacity for wonder' (Aton 1986: 13).
3   The arguments about hybridity and new American identities are taken up and developed in Chapter 2.

## REFERENCES AND FURTHER READING

Allen, D. (1960) *The New American Poetry*, New York: Grove Press.
Allen, D. and Tallman, W. (eds) (1973) *The Poetics of the New American Poetry*, New York: Grove Press.
Anzaldúa, G. (1987) *Borderlands/La Frontera*, New York: Aunt Lute Books.
—— (2000) *Interviews/Entrevistas*, London: Routledge.
Appadurai, A. (2000) *Modernity At Large*, Minneapolis: University of Minnesota Press.
Aton, J. (1986) 'An Interview with Barry Lopez', *Western American Literature*, vol. 21, no. 1, pp. 3–17.
Barthes, R. (1976) *Mythologies*, London: Paladin.
Bercovitch, S. and Jehlen, M. (eds) (1986) *Ideology and Classic American Literature*, Cambridge: Cambridge University Press.
Berman, M. (1983) *All That is Solid Melts into Air*, London: Verso.

Boyce-Davies, C. (1994) *Black Women, Writing and Identity*, London: Routledge.

Bush, George W. (2001) 'In Announcement of Lesson of Liberty Initiative, Thomas Wootton High School, Rockville, Maryland, 30 October, 2001', accessed from http://www.whitehouse.gov/kids/connection/20011030–7.html.

—— (2004) 'Republican National Convention Address' accessed via www.americarhetoric.com/speeches/convention2004/georgewbushrnc.htm.

Calhoun, C. (ed.) (1994) *Social Theory and the Politics of Identity*, London: Routledge.

Campbell, N. (2000) *The Cultures of the American New West*, Edinburgh: Edinburgh University Press.

—— (2003) '' Forget the Alamo': History, Legend, and Memory in John Sayles' *Lone Star*' in P. Grainge (ed.) *Memory and Popular Film*, Manchester: Manchester University Press.

Carson, D. (ed.) (1999) *John Sayles Interviews*, Jackson: University of Mississippi Press.

Clifford, J. (1988) *The Predicament of Culture*, Cambridge, MA: Harvard University Press.

Deleuze, G. and Parnet, C. (1987) *Dialogues*, London: The Athlone Press.

Ferlinghetti, L. (1968) *A Coney Island of the Mind*, San Francisco: City Lights.

Fitzgerald, F.S. (1974) (first 1926) *The Great Gatsby*, Harmondsworth: Penguin.

Foucault, M. (1980) *Power/Knowledge: Selected Interviews and Other Writings 1972–77*, London: Harvester Wheatsheaf.

Gidley, M. (ed.) (1993) *Modern American Culture*, London: Longman.

Holquist, M. (1991) *Dialogism: Bakhtin and his World*, London: Routledge.

Humm, M. (1991) *Border Traffic: Strategies of Contemporary Women Writers*, Manchester: Manchester University Press.

King, R. (1993) 'American Cultural Criticism', in M. Gidley (ed.) *Modern American Culture*, London: Longman.

Kolodny, A. (1992) 'Letting Go Our Grand Obsessions: Notes Towards a New Literary History of the American Frontiers', *American Literature*, vol. 64, no. 1, March, pp. 1–18.

Lawrence, D.H. (1962) *The Symbolic Meaning*, London: Centaur Press.

—— (1977) *Studies in Classic American Literature*, Harmondsworth: Penguin.

Lipsitz, G. (1990) *Time Passages*, Minneapolis: University of Minnesota Press.

Lopez, B. (1987) (first 1986) *Arctic Dreams: Imagination and Desire in a Northern Landscape*, New York: Bantam.

—— (1988) *Crossing Open Ground*, London: Macmillan.

—— (1990) *The Rediscovery of North America*, New York: Vintage.

—— (1999) *About this Life*, London: Harvill.

McClure, M. (1982) *Scratching the Beat Surface*, San Francisco: North Point Press.

Maidment, R. and Dawson, M. (eds) (1994) *The United States in the Twentieth Century: Key Documents*, London: Hodder and Stoughton.

Mathy, J.-P. (1993) *Extreme-Occident: French Intellectuals and America*, Chicago: University of Chicago Press.

Moraga, C. and Anzaldúa, G. (eds) (1983) *This Bridge Called My Back*, New York: Kitchen Table Press.

Morley, D. and Robins, K. (1995) *Spaces of Identity*, London: Routledge.

Radway, J. (1999) 'What's in a Name?' Presidential Address to the American Studies Association, 20 November 1998', *American Quarterly*, vol. 51, no. 1, pp. 1–32.

Rich, A. (1993) *Adrienne Rich's Poetry and Prose,* New York: W.W. Norton.

Robinson, P.A. (1986) 'Ball Park Incident', *Films and Filming,* November, p. 6.

Rutherford, J. (ed.) (1990) *Identity: Community, Culture, Difference,* London: Lawrence and Wishart.

Sayres, S. *et al.* (eds) (1984) *The 60s Without Apology,* Minneapolis: University of Minnesota Press.

Smith, S. (1993) *Subjectivity, Identity and the Body,* Bloomington: Indiana University Press.

Soja, E.W. (1989) *Postmodern Geographies: The Reassertion of Space in Critical Social Theory,* London: Verso.

Todorov, T. (1987) *The Conquest of America,* New York: Harper Perennial.

Trinh T. M. (1989) *Woman Native Other,* Bloomington: University of Indiana Press.

—— (1990) 'Cotton and Iron', in R. Ferguson *et al.* (eds) *Out There: Marginalization and Contemporary Cultures,* Cambridge, MA: MIT Press.

Truettner, W. (ed.) (1991) *The West As American: Reinterpreting Images of the Frontier,* Washington, DC: Museum of American Art.

Washington, M.H. (1998) 'Disturbing the Peace: What Happens to American Studies If You Put African Americans at the Center?, Presidential Address to the American Studies Association, 29 October 1997', *American Quarterly,* vol. 50, no. 1, pp. 1–23.

West, C. (1993) *Keeping the Faith,* London: Routledge.

Wheale, N. (ed.) (1995) *Postmodern Arts,* London: Routledge.

Whitman, W. (1971) (first 1855) *Leaves of Grass,* London: Everyman.

Williams, W.C. (1971) *In the American Grain,* Harmondsworth: Peregrine.

## FOLLOW-UP WORK

1   Using W. Truettner (ed.) *The West As America* as a source of images, consider the 'dream' of America conveyed in the Columbus paintings, particularly those by Emanuel Leutze. What sense of the 'New World' is created here and how? Look at the figures in the painting and their relationships – what do they suggest of the connotations of Columbus's role?

2   Using a presidential speech, analyse its use of rhetoric and in particular the different ways it draws upon certain 'mythic' perceptions of America. What images does it use? What references to the dream, to the future, to the people?

*Assignments and areas of study*

3   (a)  Some have argued that hybridity represents the best hope for America as a diverse culture. Discuss the arguments for and against this position, using a range of examples. Use Chapter 2 as well.

   (b)  How has any Hollywood film explored the concept of 'new beginnings' and what ideological implications emerge as a result? (Such diverse films as *Trading Places, Sleepless in Seattle, Grand Canyon,* or *Crash* could be used.)

(c) How does Sayles's film *Lone Star* examine relations between history, power and identity?

(d) Examine how landscape has been used as a powerful aspect of the American 'national narrative' using a range of appropriate sources.

# Ethnicity and immigration
## Between many worlds

## ETHNIC AMERICA: 'A VAST INGATHERING'[1]

The ethnic mix of America is complex, consisting of indigenous peoples as well as voluntary and involuntary immigrants around whom revolve questions of religion, allegiance and national pride.[2] Tension and ambivalence surround the whole idea of ethnicity in America, indeed some would argue that 'our grandparents were ethnic, not us', preferring to believe in the possibility of 'one homogeneous "American" community' (Singh *et al.* 1994: 5). However, the concept of assimilation asserted that all ethnic groups could be incorporated in a new American national identity, with specific shared beliefs and values, and that this would take preference over any previously held system of traditions. Assimilation stressed the denial of ethnic difference and the forgetting of cultural practices in favour of Americanisation which emphasised that one language should dominate as a guard against diverse groups falling outside the social concerns and ideological underpinnings of American society. Native Americans and African Americans, as well as immigrants from Europe and elsewhere, were seen as a threat until they were brought within the acceptable definitions of 'Americanness' or excluded from it entirely. These versions of assimilation focused on conformity and homogeneity as the way of guaranteeing democracy and equality for all in America. In the case of Native Americans, as we shall examine, the differences between tribal and white culture appeared too great for a satisfactory assimilation and the reservation system was employed instead (the case of African Americans is examined in Chapter 3).

Arguments about ethnicity in recent years, influenced by the post-1960s' interest in multiculturalism, have moved away from the pressures to one central, uniform idea of America as the only definition of nationhood and towards cultural pluralism. This still allows for diverse ethnic groups to share common connections as Americans, without losing their links to older allegiances and identities. The civil rights movement helped to cement interests in ethnic pride and cultural diversity

as strengths, asserting the possibility for self-definition and cultural autonomy rather than consensual conformity.[3] The tensions between the call to ethnic assimilation through the abandonment of old values and the pull towards a new sense of plural, multicultural society have, however, remained persistent, and are very much the concerns of the ethnic cultural forms that this chapter will examine (Lowe 1996). In 1988 Peter Marin wrote of 'the generational legacy of every family, a certain residue, a kind of ash, what I would call "ghost-values" . . .', the 'shreds and echoes' of the past (Singh *et al.* 1994: 8). It is, however, these 'ghost-values' that have become of greater and greater significance in the development of ethnic identities in America. No longer viewed as something to be denied, they are instead the sources of cultural strength and assertion. Through them many Americans have found a positive and empowering means to achieve a productive plural identity, as ethnic *and* American, allowing them to belong to different sets of values rather than be assimilated into only one. Not subjected to one version of identity, these Americans move between two (or more), with different languages, customs, traditions and values. This hybrid view of ethnicity runs through many of the texts we will examine in this chapter, from Native Americans to Jewish Americans, who have in different ways struggled with their own positions and identities within the nation.

For example, in Philip Roth's novel *The Counterlife* (1986), the central character, Nathan Zuckerman, on a visit to Israel finds himself defending his identity as an American Jew against the claims of an ageing Zionist who insists that there is no country for a Jew but Israel. 'I could not think of any historical society', Zuckerman narrates, 'that had achieved the level of tolerance institutionalised in America or that had placed pluralism smack at the center of its publicly advised dream of itself' (Roth 1987: 58). America was 'a country that did not have at its center the idea of exclusion' (ibid.). Zuckerman's American idealism, however much a performance it may be in the context of the novel, touches a central theme in the debates held about the relationship between ethnic identity and wider national values. From the beginnings of American society, as we discussed in the Introduction, a central question has been whether or not there is a distinctive American identity. Is there such a thing as a national character and how does that character relate to the importance of ethnicity in American culture?

The social historian, Oscar Handlin, in one of the most well-known of all works on American immigration, *The Uprooted,* declared 'Once I thought to write a history of immigrants in America. Then I discovered that the immigrants *were* American history' (Handlin 1951: 3). What he clearly excludes from this 'history' is the importance of Native Americans in this process of identity formation since they were not immigrants in Handlin's sense. They exist only, it would seem, as Others to be

conquered, destroyed and pitied by the immigrants that Handlin viewed as true Americans.

Earlier, Crevecoeur, in his survey of late eighteenth-century America, *Letters From an American Farmer* (1782), also concentrated on the influx of Europeans as the starting-point for his vision of the New World. He noted its promiscuous social mix where Europeans intermarried in a way that was impossible in any other country. What was more, this process of intermingling made the American into a man who:

> leaving behind him all ancient prejudices and manners, receives new ones from the new mode of life he has embraced, the new government he obeys, and the new rank he holds. . . . In America individuals are melted into a new race of men.
>
> (Crevecoeur 1957: 39)

For Crevecoeur America was the place where migrants would slough off the burdens of their inherited pasts and create themselves anew in the liberating conditions of American life. In the United States rights belonged to the individual rather than to social or ethnic groups; the openness and mobility of American society would encourage personal transformation rather than the reassertion of traditional beliefs and values. Amid all Crevecoeur's optimism he notes that the 'Indian' falls outside this process of 'melting' preferring 'his native woods' over the 'best education', 'bounty' and 'riches' offered by Europeans. He admits an admiration for 'their social bond' over the individualism of Europeans and comments that 'thousands of Europeans are Indians [but] we have no examples of even one of those aborigines having from choice become Europeans!' (ibid.: 42). This suggests the peculiar tensions of ethnic difference and in particular the pull between worlds, traditions and values. In the case of the Native Americans, assimilation, as Crevecoeur testifies, seemed impossible, and with all groups it became a dominant feature of American social development and nation-building. A consideration of ethnicity might, therefore, begin with the particular situation of the Native Americans and their relationship to the wider issues of America as a nation, before moving on to consider other groups and their responses to the centralising demands on identity.

## NATIVE AMERICANS: ASSIMILATION AND RESISTANCE

Turner's 'Frontier thesis' (1893) saw the Native American as a line of 'savagery' against which 'civilisation' had collided, an obstacle in the way of America's 'composite nationality', whose 'primitive Indian life had passed away' in favour of a 'richer tide' (Milner 1989: 16, 8). Assimilation could not, according to this logic, cope with the presence

of the Native Americans whose customs and traditions were too alien, too different to become merged into the new American self. Thus, the struggle against the Native American was a fight over ideological differences based on the idea of 'egocentrism, in the identification of our own values with values in general, of our I with the universe – in the conviction that the world is one' (Todorov 1987: 42–3). Americanisation, in this context, was an imperialist imposition of values, seeking in different ways to assert particular, narrow definitions of what it might mean to be American.

White Americans in positions of cultural power defined Native Americans as racially inferior, savage, child-like, and in need of radical readjustment to the 'better' life of the dominant culture. These stereotypes formed a way of seeing and speaking about Native Americans, a discourse, that contributed greatly to the consensus for their destruction. James Hall wrote in 1834–5 that Native Americans showed 'systematic anarchy' in their tribal organisations, preferring 'a restless wandering' to settlement and government. To combat this 'un-American activity they should be controlled by being rounded up and domesticated, since 'an Indian, like a wolf, is always hungry, and of course always ferocious. In order to tame him, the pressure of hunger must be removed' (Drinnon 1990: 208). Similarly, Elwell S. Otis wrote in 1878 that the Native American lacked 'moral qualities . . . goodness . . . virtues' and shows 'not the slightest conception of definite law as a rule of action. He is guided by his animal desires . . . takes little thought except for the present, knows nothing of property . . . and has not . . . any incentive to labor' (Robertson 1980: 108–9). All these 'lacks' are linked to the 'spirit of communism which is prevalent among all tribes' (ibid.) and so seen as opposite to the traits that Turner saw as being created in the 'new product', the American, on the frontier. Native-American culture represented a challenge to the emergent national identity; it was already 'un-American', believing in communal lands, tribalism, sacredness of the earth, and being suspicious of private property.

The reservation policy aimed to ensure that Native Americans would be systematically educated and 'civilised' into the American way of life. Social planner Francis Amasa Walker equated the Native American with the madman or the criminal and imagined the reservation as a kind of asylum or prison. Secluded and separated from the mainstream they could be watched over, ordered and trained into habits of respectability, ownership, self-reliance and other similarly authorised values. The reservation was to be 'a rigid reformatory discipline' (Takaki 1979: 186) in which an ideological homogeneity could be instilled in the wayward Indian, just like upon the insane in Foucault's discussion of the asylum where 'a system of responsibilities' (Foucault 1977: 247) became the norm, involving work and education. On the reservation, as in the asylum, the

inmates are 'transformed into minors ... a new system of education must be applied, a new direction given to their ideas; they must first be subjugated, then encouraged, then applied to work' (ibid.: 252). 'Ethical uniformity' (ibid.: 257) was the underlying intention of the reservation system and the establishment of Indian schools, like the Carlisle School started in 1879 with a philosophy of 'Kill the Indian and save the man'. Both worked towards de-Indianisation and the ideology 'one country, one language, and one flag' (Adams 1991: 39).

With the massacre of the Lakota Sioux at Wounded Knee in 1890 the 'primary resistance' of 'literally fighting against outside intrusion' (Said 1994: 252), came to a close. However, the Native-American 'ideological resistance' aimed at reconstituting 'a shattered community, to save and restore the sense and fact of community against all the pressures of the colonial system' (ibid.: 252–3) has never ceased its actions. Louis Owens has written of the 'recovering or rearticulation of an identity, a process dependent upon a rediscovered sense of place as well as community' (Owens 1992: 5), through Native-American narrative in the twentieth and twenty-first century. The attack on tribalism was an assault upon the culture and tradition of the Native Americans, and as such at its history and its beliefs. The need to rediscover self-belief, or what in the 1960s was known as 'Red Power', has been crucial to the growing authority of the Native American. As Said has written:

> To achieve recognition is to chart and then to occupy the place in imperial cultural forms reserved for subordination, to occupy it self-consciously, fighting for it on the very same territory once ruled by a consciousness that assumed the subordination of a designated inferior Other.
>
> (Said 1994: 253)

The Native Americans, like other ethnic groups in America, had to decolonise language for their own uses, through what Said calls 'reinscription'. The task for writers was to 'reclaim, rename, and reinhabit the land' (ibid.: 273) both literally and metaphorically.

## REINSCRIBING THE TRIBE: WRITING ETHNICITY

One of the functions of stories in the Native-American tradition has always been to unify the tribe and endow it with a communality and continuity. For so long these were attributes diminished by the Indian policies of the successive administrations. Leslie Marmon Silko, a Native-American storyteller, explains that telling stories is an essential component of her life since 'one story is only the beginning of many stories, and the sense that stories never truly end' (Mariani 1991: 84) is a reminder

of the survivalist character of the people. For her, 'storytelling continues from generation to generation' and 'cannot be separated from ... [the] geographical' because in them the present and living are connected to the past and the dead. For in the telling of the story, in its coherence, 'we are still all in this place, and language ... is our way of passing through or being with them, of being together again' (ibid.: 84, 92). In the 1890s the Ghost Dance Religion was an attempt to reconnect the living with a vision of the next world in which the whites would disappear and all the dead Native Americans would rise up, with the buffalo, to live again in a Utopia. Stories perform a similar function, a circulation of the tribal life-blood through the act of telling and an assertion of visibility against the dominant culture's denial of native life, against its creation of absence, and much Native-American narrative works against these 'narratives of absence and victimry' (Vizenor 1998: 23).

By the 1960s 'those inner colonized of the First World – "minorities", marginals, women' all began to find 'the right to speak in a new collective voice' and the 'hierarchical positions of Self and Other, Center and Margin [were] forcibly reversed' (Jameson 1984: 181, 188). Alongside the struggle of African Americans within the dominant white culture during the 1960s, there was also a resurgence in many ethnic literatures – Native-American and Chicano in particular. The 'Declaration of Indian Purpose' (1961) spoke of being 'absorbed' by American society and called for 'a better life educationally, economically, and spiritually' (Josephy 1985: 37) through self-determination, the protection of existing lands, and continued federal aid. Activism in the 1960s, including the National Indian Youth Council (NIYC) and the American Indian Movement (AIM), challenged further diminution of Indian rights. President of NIYC, Melvin Thorn, said in 1964: 'We do not want to be pushed into the mainstream of American life.... Any real help for Indian people must take cultural values into consideration' (ibid.: 55–6).

By 1969 'the normal expectation on the reservation is that the Indians may not do anything unless it is specifically permitted by the government' (ibid.: 99). Increasingly direct actions, such as 'fish-ins' protesting against the loss of land rights, the occupation of Alcatraz in 1969 to reclaim land, and the confrontations at Wounded Knee in 1973 and Oglala in 1975 showed the growing resistance and anger amongst the Native Americans. Above all, these protests asserted that 'Indian voices are not lost' in the 'bureaucratic and political maze in which Indians [were] trapped' (ibid.: 135). Alongside political resistance, both passive and active, there grew an ever-more persistent assertion of 'Indian voices' through imaginative and polemical literature. Gerald Vizenor argues that these are 'postindian warriors' in that they have come through the 'Indian' phase of being spoken for and controlled by others, and now

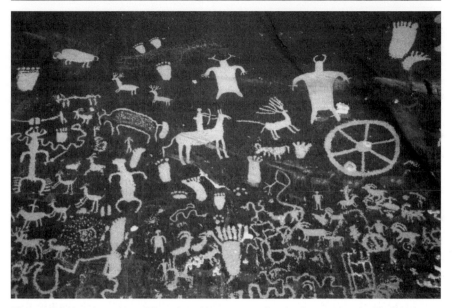

*Plate 1* Native American Histories: Newspaper Rock, Canyonlands National Park, Utah

*Source*: Neil Campbell, 1995

'encounter their enemies with the same courage in literature as their ancestors once evinced on horses, and they create their stories with a new sense of survivance and counter the manifest manners of domination' (Vizenor 1994: 4). Vizenor's work weaves a linguistic spell 'to create a new tribal presence in stories', 'surmount the scriptures of manifest manners . . . [and] counter the surveillance and literature of dominance' (ibid.: 5, 12). His ethnic stories counter those perpetuated by others like Ronald Reagan, whom Vizenor calls the 'master of . . . manifest manners' (Kroeber 1994: 232), who spoke in 1988 of how 'we', that is the dominant white culture, had 'humored' the Indian who 'want[ed] to stay in that primitive life style', but should have been encouraged to 'be citizens along with the rest of us' (Drinnon 1990: xiii). Vizenor writes of 'tragic wisdom' born out of tribal power, as 'a pronative voice of liberation and survivance, a condition in native stories and literature that denies victimization' (Vizenor 1994: 6).

Leslie Marmon Silko's novel *Ceremony* (1977) epitomises such wisdom, beginning with the reminder that stories 'are all we have' and that to 'destroy the stories' is to make Native Americans 'defenseless' (Silko 1977, n.p.). Yet as long as the stories survive and are passed on, the native peoples retain their traditions, history and identity, reminding them of their roots in the land, which in turn constitutes their sense of

self. Tayo, the central character, broken by war and 'trained' in the Indian school to take on the white ways, journeys to a new point of recognition about his construction in the white world so that he might be healed. He remembers his school where science books explained the world to him and contradicted the stories of the tribe and yet 'he still felt it was true, despite all they had taught him in school' since, 'everywhere he looked, he saw a world made of stories, the long ago, time immemorial stories, as old Grandma called them' (ibid.: 95). Tayo must re-learn and be healed in the tribe, and be able to see 'beyond the lie' of a 'nation built on stolen land' (ibid.: 191).

Similarly, in Louise Erdrich's *Tracks* (1988), we find the 'tribe unravelled like a coarse rope' (Erdrich 1988: 2), losing its land to corporate America and government taxes, and consequently losing its traditions and its grip on history. 'Land is the only thing that lasts life to life. Money burns like tinder, flows off like water. And as for government promises, the wind is steadier' (ibid.: 33). Dollar bills cause the memory to vanish (ibid.: 174), Nanapush, one of the narrators, says at one point. Erdrich's concern is that the collective, cultural memory survives, for it provides the strength of what Vizenor calls survivance and tragic wisdom. Echoing a phrase in *Ceremony* – 'vitality locked deep in blood memory' (Silko 1977: 220) – Erdrich writes that 'Power travels in the bloodlines, handed out before birth. . . . The blood draws us back, as if it runs through a vein of earth' (Erdrich 1988: 31). The task of Nanapush's story-telling is to instruct his granddaughter, Lulu, in the history of her family, the tribe and the land. She has been educated off the reservation in the government school and must be re-educated, like Tayo, by the stories. Nanapush says he has 'so many stories. . . . They're all attached, and once I start there is no end to telling' (ibid.: 46). This is not an unqualified positive novel, but it presents a strong image, like Silko's *Ceremony*, of solidarity and ethnic survival through the persistence of tradition, the 'blood memory' of history, and the power of a forward-looking community.

The film *Smoke Signals* (1998, directed by Chris Eyre, scripted by Sherman Alexie from his 'novel' *The Lone Ranger and Tonto Fist-fight in Heaven*) is a 'post-Western', produced entirely by Native Americans and deliberately feeding off Hollywood's stereotype of the 'Celluloid Indian' in order to challenge it through irony and humour (see Churchill 1998). It resists and plays with the bank of knowledge about how Indians have been portrayed and have been complicit in their own representation – 'Indians watching Indians on TV'. In this way it is 'post', that is, *beyond* the Western – but nonetheless 'needs' the Western to exist. There are references within it to *Dances with Wolves*, John Wayne, and the Lone Ranger, as the film charts the journey of two young men, Thomas Builds-the-Fire and Victor, towards friendship and reconciliation with

family and community. Reservation life is revealed as harsh, troubled (by alcohol and violence), but also warm and engaging, as the film is reluctant to represent any simplistic one-dimensional view; indeed, as Susan Kollin has written, it re-thinks and revises the audience's concept of 'what Indians are and what they do and believe . . . creating an insurgent Native American counter-cinema' (Kollin 2000: 142). The film uses the idea of paternal disappearance and loss as a framing device, through the fire that kills Thomas's father, him being saved by Arnold (Victor's father), who in turn runs away from his family and dies in Phoenix. The road movie that ensues enacts an ironic redemption, returning Arnold to the salmon river of his ancestors from the trailer park in Phoenix and drawing the rebellious Victor towards some sense of his 'native' self. Its use of humour, irony, parody, self-deprecation all function to play with the stereotypes of the 'noble' stoic Indian – the romance of tribal memory is attacked on both sides and yet there are still elements of 'tragic wisdom' (Vizenor 1994: 12) evident in the film – stories told, magic sensed, the past's presence in the present, and the need for community and 'survivance'.

In these different patterns of denial and resistance we can learn much about the experience of ethnic Americans who, in different ways, have had to confront the pressures to assimilate and diminish their former traditions. Native Americans faced near genocide in the process of 'nation-building', but have survived to rearticulate and promote their cultures within the United States. Although always an uneasy and ambivalent position, their ethnic identity has not been made invisible and their culture and history still inform each generation. As Vizenor has written, 'Natives create their identities in "dialogical relations" with many others, with nature, and with those who must bear the *indian* simulations of dominance' (Vizenor 1998: 22).

## IMMIGRATION AND AMERICANISATION

The experience of Native Americans demonstrates the extreme workings of assimilation theory, or the 'melting pot', and how in many cases it meant 'renouncing – often in clearly public ways – one's subjectivity, who one literally was: in name, in culture, and, as far as possible, in color' (Goldberg 1995: 5). It also shows how ethnic identity can be preserved as an active coexistent element even within the larger 'nation'. Native Americans were seen as beyond assimilation because their ethnicity was too dissimilar to the traditions of Northern European American culture. It was, therefore, to the immigrants that attention turned and the efforts to integrate them into the existent culture of America.

The assimilationist metaphor of melting down emerged in a play entitled *The Melting Pot* by an English Jew, Israel Zangwill in 1908.

The play celebrates the possibility of different backgrounds and religions being united in the 'American crucible'. The original set contained a view of Lower Manhattan and the Statue of Liberty outlined against a setting sun, literally an image of the golden land:

> DAVID (*Prophetically exalted by the spectacle.*): It is the fires of God around His Crucible. (*He drops her hand and points downward.*) There she lies, the great Melting Pot – listen! Can't you hear the roaring and the bubbling? There she gapes her mouth (*He points east.*) – the harbour where a thousand mammoth feeders come from the ends of the world to put in their human freight. Ah, what a stirring and a seething! Celt and Latin, Slav and Teuton, Greek and Syrian – black and yellow –
>
> VERA (*Softly nestling to him.*): Jew and Gentile –
>
> DAVID: . . . Here shall they all unite to build the Republic of Man and the Kingdom of God . . . what is the glory of Rome and Jerusalem . . . compared with glory of America, where all races come to labour and look forward!
>
> (Zangwill 1908: 184–5)

Zangwill's play was first produced in Washington, DC in 1908 at a critical moment in the history of American immigration. The period since the 1880s had witnessed both a massive expansion in the numbers of those leaving Europe and other parts of the world for the United States and as a shift in their countries of origin. The net migration to the USA between 1881 and 1890 was 4.966 million, between 1891 and 1900 it rose to 3.711 million, and between 1901 and 1910 to 6.294 million. Increasingly migrants from such well-established regions as the United Kingdom, Germany and Scandinavia were being joined by citizens from the many different provinces of the Austro-Hungarian Empire, Italy and Russia. The apparent change in the nature of migrants pouring into the country gave rise to a major debate about the the effect they would have on American society and values. Some argued that these 'new' immigrants brought with them cultural, social and political practices which made them far more difficult to assimilate into American life than immigrants of the old-stock who largely came from Northern and Western Europe. This concept of the threat of the 'new' was documented in the forty-one volume Dillingham Commission Report (1911) which investigated the impact of unrestricted immigration on the United States. The report claimed that the 'old' immigrant values and institutions went back to the origins of the Republic, whilst the 'new' brought with them what appeared to be a challenge to the dominant Anglo-Saxon tradition. Increasingly, the case for restriction took on an explicitly racialist tone. It was not just that new immigrants, in the words of the poet Thomas

Bailey Aldrich writing in 1892, were 'a wild and motley throng' carry-
ing to America 'unknown Gods and rites ... tiger passions ... strange
tongues' and 'accounts of menace alien to our air', but also that they
seemed to threaten American racial homogeneity. 'O liberty, white
Goddess!' asked Aldrich, 'Is it well to leave the gates unguarded?' (Fuchs
1990: 57). His question was increasingly argued in the negative in the
period between the end of the nineteenth century and the early 1920s.
Many felt that America's racial as well as cultural identity was threat-
ened by unrestricted immigration and 'mongrelisation' just as it had
been by Native-American tribes. Such a hierarchical view of white Anglo-
Saxon racial superiority ran counter to Zangwill's assumptions that 'all
nations and races' were welcome in 'the glory of America', but in the
end it prevailed, encouraged by fears of business and labour leaders that
unrestricted immigration threatened economic stability, and further
enhanced by the debate over national identity which broke out with
American involvement in the First World War in 1917. The results were
the Immigration Restriction Act of 1921 and the National Quota Act of
1924, which explicitly sought to protect the Anglo-Saxon element in the
American population against further encroachment by undesirable
groups from Southern and Eastern Europe and Asia. The Immigration
Acts of the 1920s contained within them, therefore, assumptions about
the desirable national racial mix, and the terms on which immigrants,
both past and present, would be expected to adapt to the majority
culture.

'Americanisation' and the forging of a 'true' American identity
demanded strict adherence to the values of the cultural majority in
such key areas as language, religion and manners. The New York
Kindergarten Association in a 1919 survey of educational provision in
Manhattan, found that, in one small area, 309 out of 310 children were
of foreign parentage and English was rarely to be heard. What could
there be of 'an American atmosphere in such homes? What did such
children know about the Fourth of July or the Spirit of 76 or Washington
or Lincoln?' Taking such children away from the potentially harmful
influences of immigrant families and friends and placing them in
more secure and controlled environments would 'make Americans of
them'. Kindergartens, for instance, could provide in their games, 'whole-
some lessons in Americanism' by encouraging immigrant children 'to
feel that there is such a country as America and that they are part of
it'. There is a curious similarity between this logic and that which created
reservations to re-educate and Americanise Native Americans.

The model of the melting pot assumed that everyone could better
themselves in American society, despite any ethnic distinctiveness,
and improve their position through economic opportunity. There might
have been disagreements about how best to maximise that opportunity,

*version of American dream.*

but whether it was realised through free-market forces or through federal intervention and social reform, the result would be the same: old ethnic loyalties would diminish in the face of an inexorable process which emphasised those values that Americans held in common rather than those which kept them apart.

One prominent area which has aroused considerable disagreement has been the issue of language. In the period immediately before the Immigration Acts of the 1920s, it was generally assumed that while linguistic diversity might continue at a local level, English would be maintained as the language of the public culture. In the nineteenth century across the country a number of states, counties and local school districts allowed at least some educational provision in languages other than English, but this tended to die out as the campaign for immigration restriction developed in the early twentieth century. In its place came a much greater insistence that English was the necessary basis of a unified culture. This was regularly enforced by both private industry and city and state governments, in a way which reveals the close links between language and expected patterns of social and political behaviour. The International Harvester Corporation, for instance, promulgated English 'Lesson One' for its largely Polish workforce as follows:

> I hear the whistle. I must hurry . . .
> It is time to go into the shop . . .
> I change my clothes and get ready to work.
> The starting whistle blows.
> I eat my lunch.
> It is forbidden to eat until then . . .
> I wait until the whistle blows to quit.
> I leave my place nice and clean.
> I put all my clothes in the locker.
> I must go home.
>                     (Gutman 1977: 6)

In a similar vein, the Detroit Board of Education, in 1915, launched a cooperative programme with local industry to transform Detroit from a place in which about three-quarters of the population was foreign-born, of foreign parentage and largely foreign-speaking, into an English-speaking city within two years. Adopted policies included making night school attendance for non-English-speaking workers a condition of employment; preferential employment strategies in which workers who were trying to learn English would be the first to be promoted, the last to be laid off, and the first to be taken back; and incentive schemes whereby non-English-speakers who attended night school would receive a bonus in their wages. State governments in the same period emphasised the role of the public school system in the safe-

guarding of a distinct national linguistic identity. The Americanisation
Department of Connecticut, for instance, argued in 1919 that 'America
was in danger of being not a unified America, but a polyglot boarding
house'. One solution was to promote

> the school [as] the melting pot of the nation, where Americanism is
> molded and formed, the great factor of our national life. Our whole
> fabric and national ideal is here inculcated in the heart and mind of
> young America, its history, customs, its laws and language.
>
> (Circular Letter No. 5, October 1918)

By the 1970s, however, it was clear that the battle for an unquestioned
national linguistic identity was far from over. Encouraged by the attempts
of African Americans to first recover and then reassert the importance
of a black culture, other minority groups sought to articulate their own
sense of marginalisation in an English-speaking world by emphasising
the continuing vitality of their linguistic inheritance. This process has
been affected by further changes in the main sources of immigration to
the United States. Since the Second World War, and more particularly
since the Immigration Act of 1965, Europe's role as the main supplier
of migrants has been taken over by the Americas and Asia. By the 1980s,
over three-quarters of American immigrants were of Latin-American or
Asian origin. By 1990, about 20 million people of Latin-American back-
ground lived in the United States, 7 million of whom had come to
America between 1980 and 1990. Many government agencies, both at a
national and a local level, now existed to help immigrants adjust to
American society and were more sympathetic to ethnic ties in aiding the
process of adjustment. Becoming American, it was officially argued, need
not be at the expense of older ethnic cultural traditions. But, just as this
new sensitivity to minority concerns was encouraged by the emergence
of the civil rights movement in the 1960s, so the ebbing of enthus-
iasm for civil rights in the 1970s and 1980s often brought with it hostility
to such programmes. In 1981, for instance, Senator Alan Simpson of
Wyoming articulated his own fears about the massive rise in the Hispanic
population in words which were strongly reminiscent of the language
used by campaigners in the early twentieth century: 'A substantial
proportion of these new persons and their descendants do not assimi-
late into our society. . . . If language and cultural separation rise above
a certain level, the unity and political stability of our nation will – in
time – be seriously eroded' (Dinnerstein and Reimers 1982: 273).
Simpson's concerns were reflected in the attempts of a number of states
to declare English their official language, an issue which became most
significant in 1986 in California where voters decided to adopt such a
measure, much to the dismay of the large numbers of Asian and Mexican

inhabitants. What this meant in practice was less clear, particularly in places like Los Angeles, where education officials had to manage a school population of over 600,000 of whom perhaps as many as 170,000 had, at best, only a limited grasp of English. What the continuing controversy over language emphasised, however, was that recurring tension between the acknowledgement of diversity and concerns for unified national identity which had so marked earlier debates over the role of ethnicity in American life.

## THE CRUCIBLE OF DIFFERENCE

Ethnicity in contemporary America is a 'pluralist, multidimensional, or multifaceted concept of self' in which 'one can be many different things, and this personal sense can be a crucible for a wider social ethos of pluralism' (Fischer 1986: 196). Fischer's language harks back to the earlier idea of the 'crucible' in which Americans were forged, melted down from their various ethnicities into a new nation, but alters it with his sense of a crucible for difference and pluralism in which class, race, religion and gender are all inter-connected with ethnicity. At a base level, 'ethnicity is a process of inter-reference between two or more cultural traditions' and it is this rich 'reservoir that sustains and renews humane attitudes' (ibid.: 201, 230). Cohering with Werner Sollors's famous comment that ethnic literature is 'prototypically American literature' (Sollors 1986: 8), Fischer goes on to declare the potentiality for 'reinvigoration and reinspiration' at work in the mingling of different ethnicities, with their own traditions, cultural practices and expressions. Rather than a retreat into the past or a separatist mentality, he sees the 'textured sense of being American' as the process through which 'a dialogue generating new perspectives for the present and future' is created (Fischer 1986: 230, 231). For example, the works of Jewish Americans like Roth, Bellow and Malamud act as an 'interference' between the Jewish and the American, preserving, reworking and creating through their language some new considerations, and at the same time, they are 'inter-referencing' between different cultural traditions, mingling and connecting, questioning and accepting. The point here is that ethnic literatures are dynamic and mobile, born out of the traditions of immigration and migration, and they are also the products of tradition and continuity. This duality is productive and enables a richness and diversity in their interactions within American life. As Bodnar has written:

> The point is that instead of linear progression, immigrants faced a continual dynamic between economy and society, between class and culture. It was in the swirl of this interaction and competition that ordinary individuals had to sort out options, listen to all the

prophets, and arrive at decisions of their own. . . . Inevitably the results were mixed.

(Bodnar 1985: xx)

Such an atmosphere is apparent in the stories of immigrants, both first-hand and fictional, and in the work of subsequent generations still haunted by these tensions. As Madan Sarup has put it, 'When migrants cross a boundary line there is hostility *and* welcome. [They] are included and excluded in different ways' (Sarup 1994: 95). These are recurrent and potent themes in immigrant and ethnic literature, raising thoughts of home, belonging, memory and forgetting, old and new traditions; and every crossed borderline, real or imagined, brings these questions to mind. Like the migrant person, 'the borderline is always ambivalent' (ibid.: 99), marking the transformative movement between worlds of desire and trepidation, hope and fear. 'In the transformation every step forward can also be a step back: the migrant is here and there' and it is for these reasons of ambivalence that to understand America, in par-ticular, one must wrestle with the migrant experience, for it asserts above all that 'identity is not to do with being but with becoming' (ibid.: 98).

Traditional imaginings of America were of the promised land where the newcomer could undo the sufferings of the Old World. Louis Adamic expressed this as: 'it was a grand, amazing, somewhat fantastic place – the Golden Country – a sort of Paradise – the Land of promise in more ways than one – huge beyond conception . . . untellingly exciting, explo-sive, quite incomparable' (King *et al.* 1995: 164). Immigrant stories, both 'old' and 'new', respond to and engage with the tensions that arise from such myths in order to demonstrate how ethnic Americans cope with something 'beyond conception'. Myths are present in Jewish-American texts, as we shall see, and equally in the work of Chinese Americans, like Maxine Hong Kingston, whose characters leave China in search of 'Gold Mountain' (Kingston 1981: 45) which they 'invented and discov-ered' on every journey (ibid.).

## IMMIGRANT STORIES: JEWISH AMERICANS

You are the promise of the centuries to come. You are the heart, the creative pulse of America to be.

(Yezierska 1987: 137)

A prominent group within patterns of American immigration have been the Jews, who arrived in the country from Eastern Europe as a result of the prejudicial laws and pogroms after 1880. Imagining America as a place where they might be free from persecution and able to practise their religion unhindered, the New World echoed Jewish beliefs about

a promised land and seemed to fulfil their greatest dreams. For this reason, much Jewish writing articulates mythic notions of America, typified by stories of hard work, suffering, promise and achievement. Early immigrant accounts and autobiographies like Mary Antin's book *The Promised Land* (1912) typify a celebratory representation of America:

> So there was our promised land, and many faces were turned towards the West. And if the waters of the Atlantic did not part for them, the wanderers rode its bitter flood by a miracle as great as any the rod of Moses ever wrought.
>
> (Antin 1912: 364)

She links the religious dreams of redemption and hope with the possibilities of America as a 'second birth' allowing her a creative mixture of two worlds: 'Mine is the whole majestic past, and mine is the shining future' (ibid.). For her, tensions between the old and new, past and future were interpreted as an advantage and a source of possibility, whereas for others, it became the emblem of immigrant dilemmas. How was one to be an American while tied to the Old World through customs, religion and family? Unlike Antin, who found education and the process of 'Americanisation' a source of reinvigoration, many found America a destabilising place without the security of the village and their ancestral past. Handlin calls the village and land the 'pivot of a complex circle of relationships, the primary index of . . . status' (Handlin 1951: 20). Losing this secure base in America and taking up a new life in the city, 'was like a man without legs who crawls about and cannot get anywhere' (ibid.). For some, the rootedness of ancient community was threatened by the wrench into the New World and the mixing with others from outside the village. Anzia Yezierska describes it as like 'getting ready to tear my life from my body' (Yezierska 1987: 124). However disorientating this experience was for some, for others it marked their freedom and was viewed as a liberating possibility for building a new identity in America. Outside the controls of the village were different challenges which became synonymous with the American Dream of achievement through struggle and industriousness: 'Though a man's life may be sown with labor, with hardship, with blood, a crop will come of it, a harvest be reaped' (Handlin 1951: 102). The immigrant experience thus confirmed and reinforced certain dominant stories of America, an argument asserted in Handlin's grandiloquence: 'The new was not the old. Yet the new and the old are related . . . by the death of the old which was necessary for the birth of the new' (ibid.: 101–2).

For Handlin, America is a place 'in motion', constructed by 'the values of flight' and rooted in the 'experience of being rootless, adrift' (ibid.:

307), and this is vital to the belief, now current in critical thinking, that identity is neither fixed, nor unitary, but fluid and multiple, conditioned and constructed in a variety of changing situations. Thus Carole Boyce-Davies argues that she, as a 'migratory subjectivity', has learned that 'the renegotiating of identities is fundamental to migration. . . . It is the convergence of multiple places and cultures' (Boyce-Davies 1994: 3). Immigrant stories of Jews and others do not together create a harmonised, orchestrated version of America as 'one voice', but instead stress dissonance and variation: a 'dissensus' (Ferraro 1993: 6). In early immigrant voices, with their tense negotiations over old and new, self and other, past and future, America debated its identities and established the cultural contest over the centre and the margin that has characterised so much of its later history. The centre here is the pull to assimilation and acculturation, that is, the Antin school of immigrant culture that veers towards the embrace of an acceptance of Americanisation above the pull back to traditions from the Old World. At the margins are the less settled, migratory forces that feel uneasy in accepting such a positioning and would rather continue to question and contest the cultural meanings provided from the centre. Amid such collisions, 'The migrant voice tells us what it is like to feel a stranger and yet at home, to live simultaneously inside and outside one's immediate situation' (King *et al.* 1995: xv).

One can see many of these tensions, negotiations and meanings played out in the films of Woody Allen. In particular, *Radio Days* (1986) articulates the immigrant community as settled and yet still in turmoil, working through its inter-generational desires for different and better lives in America. The family are introduced to the audience through the narrative voice of the main character, remembering his boyhood in Rockaway. He is shown torn between the pull of the radio with its unifying 'American' adventure stories of the 'Masked Avenger' who can magically restore order and put the world to rights, and the 'real' issues presented through Hebrew School and the rabbi as he is encouraged to collect for 'the Jewish homeland in Palestine'. To the boy this means nothing except 'some place near Egypt' and he would rather use the collection to buy the 'Masked Avenger secret compartment ring' – his own object of desire. When found out, the boy is brought before the rabbi in a scene that suggests comically the confusions of the two worlds: the dark, forbidding world of the rabbi in contrast to the brash excitements of the radio adventure; the call for 'discipline' in contrast to the apparent laxity of mainstream America. The boy is literally caught between the parental punishment and that of the rabbi, whom the boy has unknowingly insulted by calling him his 'trusty Indian companion' (in a reference to the Lone Ranger). The rich comic effects do, however,

leave us with a sense of cultural tension, especially for the boy for whom America signifies not the disciplined faith, nor the dreamy hopes of his parents, but a radio adventure and the romance of New York.

The tensions of immigrant experience are expressed well in the work of Anzia Yezierska, who portrays a woman's struggle between the dreams of 'the new golden country' (Yezierska 1975: 9) and the 'shut-in-ness' (Yezierska 1987: 170) of the ghetto. In her work the Old World is related to the further restrictions of gender and thus is associated with the twin powers of father and Torah (Jewish religious law). For her, the escape to America is also the possibility of escaping these limitations on her self-definition. In some respects, her largely autobiographical stories embrace America through linking themes such as education (as Mary Antin had too), marriage (into non-Jewish life) and success, but not without careful interrogations of the idealisations of America through immigrant eyes. As a later writer, Bernard Malamud, has Bober say in *The Assistant* (1957), 'Without education you are lost' (Malamud 1975: 77). Education is represented as a key to the creation of a new life. In one of Yezierska's stories she quotes Waldo Frank: 'We go forth all to seek America. And in the seeking we create her. In the quality of our search shall be the nature of the America that we create' (Yezierska 1987: 297). This suggests the twin factors of search and creation that figure in her stories of immigrant life, with her characters longing for America initially through dreams and then tempered by lived experience. It is a 'hunger' to possess the dream, to be taken up by America – often imaged as a lover – and yet Yezierska's stories are not lost in sentiment, for they also reflect the processes of immigrant struggle and de-idealisation. As if deliberately countering Emma Lazarus's words on the Statue of Liberty to 'Give me your tired, your poor, your huddled masses yearning to breathe free', Yezierska's immigrants are trapped in the ghettos of the New World, choking and restricted, struggling to better themselves through education and hard work. However, Yezierska suggests that America can be re-made constantly through the additions and mixtures provided by new groups. Rather than the 'dead grooves' (ibid.: 140) of homogeneity, she proposes the 'power to fly' (ibid.: 137), to resist incorp-oration into a ready-made America and make it yourself; for as Frank wrote, it is in the seeking that we make her. The 'unused gifts' (ibid.: 283) of ethnic Americans had to be realised in order for the whole nation to benefit, argues Yezierska, and yet the prejudices constantly keep the worlds apart. In one of her best stories, 'Soap and Water', she identifies mainstream American society as the 'laundered world' that she keeps clean as a worker in the laundry itself: 'I, the unclean one, am actually fashioning the pedestal of their cleanliness' (ibid.: 167). Again trapped by economics, class and a lack of power, her character seems hopeless,

but education offers her a way out. It is the 'voice', 'the birth of a new religion in my soul' (ibid.: 168), that education might provide that could enable and empower her to resist those 'agents of clean society' who withheld positions and judged her from the outside only. Unwilling to remain strangled and 'unlived' (ibid.: 173), Yezierska links personal fulfilment and education with the wider possibilities of social change. The individual, improved by work and education, can, in her vision of America, alter the public sphere; as she puts it, 'I was changed and the world was changed' (ibid.: 177).

Such belief in the vitality of ethnic Americans was echoed in the work of Randolph Bourne, whose essay 'Trans-National America' (1916) was published before Yezierska's work, but was connected to her through his mentor John Dewey, who had a brief relationship with Yezierska. Bourne's essay questions the 'melting pot' theory of immigration and the process of assimilation that it presumed, and like Yezierska felt 'that America shall be what the immigrant will have a hand in making it, and not what a ruling class ... decide that America shall be made' (Lauter *et al.* 1994: 1733). Bourne argues that Americanisation must not mean that 'these distinctive qualities should be washed out into a tasteless, colorless fluid of uniformity' (ibid.: 1736), for such a loss would weaken and deprive the nation as a whole. Assimilation that was akin to uniformity produced an 'elementary grasping animal' without connection to a strong tradition and was rather part of the 'cultural wreckage of our time' (ibid.: 1736–7). For Bourne, America is summed up in his slogan: 'They merge but they do not fuse' (ibid.). Americans must, he argued, re-write 'the weary old nationalism' (ibid.) that was tearing Europe apart in 1916, reject the uniform ideology of the 'melting-pot' and reach towards 'a new key' (ibid.: 1738) to unlock the future – a future in which 'America is coming to be, not a nationality but a trans-nationality, a weaving back and forth, with the other lands, of many threads of all sizes and colors' (ibid.: 1742). The effect of such an approach for Bourne was to enliven America, rather than flatten it into uniformity through melting down existing differences, and so 'liberate and harmonize the creative power of all these peoples and give them the new spiritual citizenship' (ibid.) and a real investment in 'the Beloved Community' (ibid.: 1743).

Bourne's American 'Beloved Community' enriched by ethnicity and Yezierska's belief in personal achievement as an emblem of collective social betterment were not persuasive visions for all immigrants, many of whom questioned the possibility of changing anything, especially as individuals. The mistrust of immigrants was a reason for this doubt and especially in the strong nativist feelings expressed by the likes of Madison Grant in the same year as Bourne's essay. He wrote of the

'mongrelisation' of America in his *The Passing of the Great Race* (1916), and claimed that immigrants 'adopt the language of the native American [that is the white American], they wear his clothes, they steal his name and they are beginning to take his women, but they seldom adopt his religion or his ideals' (Horowitz *et al.* 1990: 11). This kind of racism had been used against the Native Americans too and one of the great perpetuators of this pseudo-science was Theodore Roosevelt who worried about the 'deterioration in the English-speaking peoples' (ibid.). To counter such views and gain some power, many immigrants became involved in political activism and union movements in attempts to secure collective, organised social change. For example, rather than follow the beliefs of their immigrant parents, awaiting the Messiah, many Jews sought a political 'messiah' in Communism and Socialism condemning the capitalist system that created exploitation and poverty and rewarding the struggling working people. Writer-activists like Michael Gold who edited the radical paper *The Liberator* in the 1920s and helped to found 'The New Masses' which specifically published left-wing writers, spoke from a Jewish immigrant background, but with the purpose of precise social protest. Gold's major work, *Jews Without Money* (1930), is a hard-hitting description of ghetto life and suffering, and a vehement attack on capitalism as a root cause of the difference in class and status. It is full of questions, anger and exclamatory prose and in Gold's novel, the promised land is 'O golden dyspeptic God of America' (Lauter *et al.* 1994: 1759), a place of destruction that has 'taught the sons of tubercular Jewish tailors how to kill' (Gold 1965: 23). In one scene, Gold emphasises the clash of old and new cultures as the Father extols the importance of the Talmud to Jewish faith and life and the son is asked to recite his hymn to Americanisation learned in the public school: 'I love the name of Washington/I love my country too,/I love the flag, the dear old flag,/The red, white and blue' (ibid.: 80). Gold wants to surmount these simple myths of belief and strike out for political change, from a learning rooted not in dreams, but the harsh experience of ghetto life. As the autobiographical novel says, 'It is all useless. A curse on Columbus! A Curse on America, the thief! It is a land where the lice make fortunes, and the good men starve!' (ibid.: 79).

Philip Roth's early work represents a more cynical view of ethnic life in America and his own position is more fluid and less fixed on the issues of ethnicity and community. Using an essay by the critic Philip Rahv, which had discussed America as a nation divided between 'Redskins' and 'Palefaces', and hence split along lines of ethnic ancestry and beliefs, Roth argued that he felt himself to be a 'redface' who 'sympathises equally with both parties in their disdain for the other' (Roth 1977: 76–7). His work explores this position and the confusions of ethnic identities in contemporary America:

All this talk about 'identities' – your 'identity' is just where you decide to stop thinking, as far as I can see. I think all these ethnic groups ... simply make life more difficult in a society where we're trying to just live amicably.

(Roth 1987: 305)

This suggests some of the problems in over-emphasising ethnic differences at the cost of living amicably in a community. His work often presents ongoing ethnic divisions and is well demonstrated in a novella that, in part, echoes Michael Gold's curse on Columbus, in its title *Goodbye, Columbus* (1959). His young Jewish protagonist's name, Klugman, means both 'clever' and 'curse' as if to signal again the kind of in-betweenness that interests Roth. He is between two cultures, the old Newark Jews of his childhood and the upwardly mobile Jews of Short Hills. The use of place in the novella articulates the kind of communal tensions over identity and belonging that are explored in the work as a whole. Neil Klugman, existential migrant, crosses a borderline within the Jewish community, proving, as Roth is keen to do, that difference marks all people and there is no identifiable, single Jewish American. 'It was, in fact, as though the hundred and eighty feet that the suburbs rose in altitude above Newark brought one closer to heaven, for the sun itself became bigger, lower, and rounder' (Roth 1964: 14). This environment, with 'regulated ... moisture' from garden hoses, 'planned ... destinies of the sons of its citizens' and streets with the names of eastern colleges contrasts with the old community down below 'in the cindery darkness of the alley' and the sweet 'promise of afterlife' (ibid.). Klugman belongs in neither and his life is defined only by 'edginess' because that is where he is positioned, on the edge, between the offered communities. Roth links Klugman to a black child who visits the library where he works and becomes enthralled by the worlds projected in the paintings of Gauguin. It is as if both ethnic Americans long for something other than the lives they have, but their dreams are as unreal as the Polynesian images in the paintings, distant and out of reach. Roth is also reminding us of the immense difference within ethnic groups and how there can be no single community or determined sense of identity, all is flux and division. Even the assimilation of the Short Hills' Jews does not mean uniformity, but only more division. As Mrs Patimkin asks Klugman, 'are you orthodox or conservative?' to which he naively replies, 'I'm just Jewish' (ibid.: 87). Roth's comic but sensitive awareness of the mixture of American identities reminds us of the current debates about identity as problematic because of the multicultural, hybridised nature of contemporary America. At the end of *Goodbye, Columbus*, Klugman, troubled by his own sense of self and identity, gazes at himself in the library window. What is reflected back is not a single, neat

vision of a whole individualised self, but 'a broken wall of books, imperfectedly shelved' (ibid.: 131), suggesting the multi-faceted imperfections of the postmodern American identity constituted not by simple ethnic regulations but by difference and contest. He is a reflection of the multiple stories contained in those haphazard books, and not a single self. In this he is like America, constructed of many dissimilar, ill-fitting pieces all of which can co-exist and can function together. This moment brings to mind a comment from a character in a later Roth book who asks, 'What's so intolerable about tolerating a few differences?' (Roth 1987: 305).

## THE FUTURE BELONGS TO THE MIXTURE:[4] MELTING POT, MOSAIC OR HYBRID?

Stuart Hall has written of the fact that 'we all speak from a particular place, out of a particular history, out of a particular experience, a particular culture, without being contained by that position' and goes on to stress that 'our ethnic identities are crucial to our subjective sense of who we are'. Yet such a location is not necessarily based upon exclusivity or 'marginalizing, dispossessing, displacing and forgetting other ethnicities', as older imperialisms had been. Instead, argues Hall, we can achieve a 'politics of ethnicity predicated on difference and diversity', re-thinking identity and culture as a series of overlapping routes that accepts 'diasporic' movement as part of the process (Morley and Chen 1996: 447; Massey and Jess 1995). This is a cultural approach that has emerged as a result of multiculturalism and 'ethnocriticism' (Krupat 1992) in which immigrant and ethnic voices are central, contributing hugely to the 'polyvocality' (many-voicedness) that describes a cosmopolitan, multicultural America. Thus culture is seen like language, hybrid, an encounter that can be both familiar and new, different and the same within itself. This possibility recognised in language has a useful parallel in the study of ethnic America, which, as we have suggested, is a culture of encounter and contact, of boundary crossings, and so a place of merging, of tension and contest, in which differences co-exist. Bakhtin, exploring novelistic language, wrote of the 'dialogic ... [where] two points of view are not mixed, but set against each other dialogically' (Bakhtin 1990: 360). This resembles America, where the impetus to forge a single, American self, a national identity, out of difference, has always existed in special tension with a counter-impetus towards separation, distinct communities of interest, religion, race and ethnicity. Bakhtin, however, argues that a certain type of hybridity 'sets different points of view against each other in a conflictual structure, which retains "a certain elemental, organic energy and openendedness"' (Young, quoting Bakhtin, 1995: 22). Thus in Bakhtin's use, hybridity

connotes 'an antithetical movement of *coalescence and antagonism* ... that both brings together, fuses, but also maintains separation' (ibid.: our emphasis). Ethnicity in America is precisely this blend of antagonism and coalescence, a mix of different voices struggling to be heard, some restricted and silenced, whilst others dominate, and yet always with the possibility of finding expression and authority.

Homi Bhabha has taken these linguistic ideas and extended them to examine relations of power within the colonial situation, and his conclusions too are relevant to the American experience. He argues that hybridity allows the voice of the other, the marginalised, and the dominated to exist within the language of the dominant group, whose voice is never totally in control. As Young puts it:

> hybridity begins to become the form of cultural difference itself, the jarrings of a differentiated culture whose 'hybrid counter-energies' in Said's phrase, challenge the centred, dominant cultural norms with their unsettling perplexities generated out of their 'disjunctive, liminal space'.
>
> (Young 1995: 23)

This is an interesting way of seeing America; hybrid in the sense of permitting challenge, 'counter-energies' and 'unsettling perplexities' to exist in constant dialogue with the dominant norms of established mainstream culture. Hybridity is once again viewed as merger *and* 'a dialectical articulation' (ibid.), characteristic of post-colonial, syncretic cultures which are blends and co-minglings of different voices and traditions; for example, Native-American with the mainstream. In this respect, America can be seen as 'post-colonial', with its range of other voices, the 'inner colonized', interrogating the dominant discourses of power with gestures of fusing and of countering – always the double action of hybridity (see Singh and Schmidt 2000).

> Hybridization as creolization involves fusion, the creation of a new form, which can then be set against the old form, of which it is partly made up ... as 'raceless chaos' by contrast, [it] produces no stable new form but rather something closer to Bhabha's restless, uneasy, interstitial hybridity: a radical heterogeneity, discontinuity, the permanent revolution of forms.
>
> (Young 1995: 25)

If the old metaphors for American ethnicity no longer ring true; 'melting pot', 'mosaic', 'salad bowl', then a more fluid representative accumulation of tensions may be found in the ideas of hybridity, which are ambiguous, contrary and processive. Hybridity pulls towards sameness

and fusion whilst also allowing for the importance of difference as a creative, new energy brought to the mix.

What hybridity cannot do is to resolve the differences and tensions between groups or ideologies, but instead it establishes a problematic in which 'other "denied" knowledges enter upon the dominant discourse and estrange the basis of its authority' (ibid.: 114). The emergent histories of ethnic groups within American culture serve to articulate and rearticulate hidden pasts and excluded voices that provide a heterogeneous, multiplicitous re-mapping of American culture and identity. As a place of encounter, migration, mixing, settlement, colonialism, exploitation, resistance, dream and other forces, America cannot be viewed as a closed culture with a single tradition, but as 'diasporic' because, as Hall puts it, summarising Gilroy and Clifford's work, 'the connections are not linear but circular. We should think of culture as moving, not in a line but through different circuits' with an emphasis on the different routes that have been travelled to form its complex, unstable ensemble (Hall in Massey and Jess 1995: 207–9).

In re-viewing America from its ethnic 'borderlands', one can see the value of such ideas (see Saldivar 1997) as in the 'circuits' undertaken by Mexican-Americans as they move across to work in the USA and return to villages in the south (see Martinez 2001, Boyle 1995). Gloria Anzaldúa, Chicana, lesbian, living on the borderlines, in every sense of the phrase, sees America as 'a place of contradictions' with herself 'at the juncture of cultures' which is 'not a comfortable place to be'. Yet it is still a place of possibility, where 'languages cross-pollinate and are re-vitalized; they die and are born' (Anzaldúa 1987: Preface). Like America itself, the borderlands, unfixed and fluid, permit 'one's shifting and multiple identity and integrity . . . to swim in a new element' (ibid.). Here exists a hybrid place, for the 'new mestiza', as she terms it, where multiplicity is encouraged, rather than curtailed, in the creation of a collage-like new subjectivity.

The possibilities of a hybrid America may, however, only be another version of the old migrant dream. The journalist and poet Ruben Martinez writes of his hope that 'the many selves can find some kind of form together without annihilating one another' and that the warring selves within himself might 'sign treaties' (Martinez 1992: 2). And yet, he recognises that the reality of contemporary America resists such a coming together, replacing it with something 'like a crucifixion – each encounter signifies a contradiction, a cross: the contrary signs battle each other without end' (ibid.). This is 'anything but a multicultural paradise' (ibid.) with cultures in cities like Los Angeles in violent struggle, but he still longs for some sense of 'new subjectivity', like Anzaldúa. For him, it is signified in the search for 'the home' and for 'a one that is much

more than two . . . North and South in the North and in the South' (ibid.: 2–3). Ultimately, as his later work *Crossing Over: A Mexican Family on the Migrant Trail* testifies, in a diasporic American life there can be no idealised, fixed, promised land, but instead an ambivalent 'jumble of objects is as close as I get to "home"' (ibid.: 166).

## CONCLUSION: THE NEW AMERICANS?

'Where do you come from?'
' What's the difference, I'm here now.'

(woman in Louis Malle's *And the Pursuit
of Happiness*, 1986)

Louis Malle, the French film director, made a fictional film in 1985, *Alamo Bay*, about a Galveston Bay fishing community beset by migrant Vietnamese who had fled their war-ravaged country to live in the USA.[5] The film dramatises the problems of new ethnic groups in America and brings out many of the nativist fears that have recurred throughout the nation's history. The white community feel threatened by the competition of Vietnamese fishermen and by the new faces and practices entering their neighbourhood, heightened by the confused aftermath of the Vietnam War. The involvement of the Ku Klux Klan further connects these contemporary events with earlier ethnic and racial conflicts in America and suggests the persistence of deep-seated fears of the outsider and the alien in American life. A year later, Malle made a complementary documentary about new immigration to America called *And the Pursuit of Happiness* in which he emphasised the persistence of the immigrant dream. The film ranges across myriad ethnic groups who straddle various cultures and demonstrates through interviews and reportage their aspirations and their doubts about the country. In one scene, Malle, himself a migrant, meets a group of mixed immigrants who have established their own company in Dallas, Texas. Appropriately the firm is the 'Liberty Cab Company', with drivers from Kurdistan and Ethiopia, and a manager from Ghana, who had established a democratic cooperative with share-ownership amongst the 130 drivers. Contained in this scene are the persistent signs of the immigrant dream of America as a place of possibility, a vision, it would appear, undeterred by the experiences of others before them who may not have succeeded. Although Malle's film is far from celebratory, it does, however, suggest the resilience of the beliefs that pulled people to America from its very beginnings. In an equally revealing moment in the film, an Asian family are shown with a Hindu temple and a barbecue pit alongside each other in their home, as if to present visually what the father explains on camera,

that they 'have two cultures and . . . can choose the best from it' in order to create their new and better lives. Another Asian American, the writer Bharati Mukherjee has made a similar point, arguing that America is a place where she could choose 'to discard that part of my history that I want, and invent a whole new history for myself' (Lauter *et al.* 1994: 3103).

In 2004 Ruben Martinez published *The New Americans* to accompany a television documentary about immigrants in the USA from all over the world (Palestine, Nigeria, India, Mexico) and begins by reviewing how the 'outsider' might be seen differently after 9/11 and the subsequent 'war on terror'. Despite the increased nativism and the effects of the so-called Patriot Act, Martinez recognised the continued 'pull' of the USA and that 'who and what is an American, has never been resolved', since it is an 'ongoing process' of 'acculturation – an adaptation, not a whole-scale transformation . . . somewhere in-between Old and New worlds, in between languages, mores, and tastes. . . . The in-between space is dynamic and shifting' (Martinez 2004: 24, 208). These comments echo the theoretical ideas of Bhabha, Hall, Gilroy and Clifford discussed throughout this section, and without being over-romanticised suggest the possibility of 'new ethnicities' emerging from the complex processes of cultural hybridity. However, Martinez is quick to recognise the conflict, inequality, racism, and division that remains within this process and in migrants: he writes, there is a 'mirror in which we see the best and worst of ourselves, our past and our future. They remind us over and again that there is nothing stable in our world . . . migrants tell us that we are, all of us, always on the move' (ibid.: 225). In this tension, between dynamism and division, is the challenge for America's future:

> A newly emergent American identity must acknowledge and empower difference without breaking under its weight. In rethinking our complex multicultural past, we need to address issues of distortion and erasure, of shared myths and attitudes, even as they are interrogated, separately and together, by race, immigration, and ethnicity.
>
> (Singh *et al.* 1994: 25)

Ruben Martinez, following Mexicans on the migrant trail in his *Crossing Over* recognised that 'they can partake in – indeed, be protagonists of – transnational or "global" culture even as they nurture the vestiges of their roots. In this context, the regional is global and vice-versa' (Martinez 2001: 132). Here he sees a form of 'newly emergent American identity' where 'The kids will be neither Mexican nor gringo but both, and more than both, they will be the New Americans, imbibing cultures from all over the globe' (ibid.: 191).

## NOTES

1  From J.P. Shenton, 'Ethnicity and Immigration', in Foner (1990: 251).
2  Issues which are raised in this chapter are also relevant to our discussions of ethnic relations in Chapter 3 on African Americans.
3  It has been suggested that ethnic Americans can be seen as belonging to one of four groups:

(a) 'total identifers' to an ethnic group;
(b) partial identifiers who select their connections to the ethnic group;
(c) 'disaffiliates' who have broken away from their ethnic roots; or
(d) 'hybrids' who are mixed or blended between worlds.

(Mann 1992: 89–90)

Although these categories are limited, they do show the importance of the position of immigrant groups within larger arguments about the nature and construction of American identity.
4  This phrase is taken from Sollors (1989: xvii) in a discussion of the work of Virgil Elizondo.
5  The increasing number of Vietnamese entered America under the Orderly Departure Program, a 1979 agreement between the USA and Vietnam, which allowed 20,000 family members to enter annually. See T. Dublin (1993) *Immigrant Voices*, Chapter 10 for a Vietnamese immigrant story.

## REFERENCES AND FURTHER READING

Adams, D.W. (1991) 'Schooling the Hopi: Federal Indian Policy Writ Small, 1887–1917', in L. Dinnerstein and K.T. Jackson (eds) *American Vistas: 1877 to the Present*, New York: Oxford University Press.

Alba, R. and Nee, V. (2003) *Remaking the American Mainstream: Assimilation and Contemporary Immigration*, Cambridge, MA: Harvard University Press.

Altsehuler, G. (1982) *Race, Ethnicity and Class in American Social Thought, 1865–1919*, Arlington Heights: Davidson.

Antin, M. (1912) *The Promised Land*, Boston: Houghton Mifflin.

Anzaldúa, G. (1987) *Borderlands/La Frontera*, San Francisco: Aunt Lute Books.

Archdeacon, T. (1983) *Becoming American: An Ethnic History*, London: Collier Macmillan.

Bakhtin, M. (1984) *Rabelais and His World*, Bloomington: Indiana University Press.
—— (1990) *The Dialogic Imagination*, Austin: University of Texas Press.

Bammer, A. (ed.) (1994) *Displacements: Cultural Identities in Question*, Bloomington: Indiana University Press.

Bhabha, H.K. (1994) *The Location of Culture*, London: Routledge.

Bodnar, J. (1985) *The Transplanted: A History of Immigrants in Urban America*, Bloomington: Indiana University Press.

Boyce-Davies, C. (1994) *Black Women, Writing and Identity*, London: Routledge.

Boyle, T.C. (1995) *Tortilla Curtain*, London: Bloomsbury.

Capra, F. and Curran, T. (eds) (1976) *The Immigrant Experience in America*, Boston: Twayne.

Churchill, W. (1998) *Fantasies of the Master Race: Literature, Cinema, and the Colonization of American Indians*, San Francisco: City Lights.

Clifford, J. (1988) *The Predicament of Culture*, Cambridge, MA: Harvard University Press.

—— (1997) *Routes: Travel and Translation in the Twentieth Century*, Cambridge, MA: Harvard University Press.

Crevecoeur, H. St J. de (1957) (first 1782) *Letters From an American Farmer*, New York: E.P. Dutton.

Deloria, P. and Salisbury, N. (eds) *Companion to Native American History*, Oxford: Blackwell.

Dinnerstein, L., Nichols, R.L. and Reimers, D.M. (eds) (1990) *Natives and Strangers, Ethnic Groups and the Building of America*, New York: Oxford University Press.

Dinnerstein, L. and Reimers, D.M. (1982) *Ethnic Americans: A History of Immigration and Assimilation*, New York: Harper.

Drinnon, R. (1990) *Facing West: The Metaphysics of Indian Hating and Empire Building*, New York: Schocken Books.

Dublin, T. (ed.) (1993) *Immigrant Voices: New Lives in America, 1773–1986*, Chicago: University of Illinois Press.

Erdrich, L. (1988) *Tracks*, New York: Harper Perennial.

Ewen, E. (1985) *Immigrant Women in the Land of Dollars: Life and Culture on the Lower East Side, 1890–1925*, New York: Monthly Review Press.

Ferraro, T.J. (1993) *Ethnic Passages: Literary Immigrants in Twentieth-Century America*, Chicago: University of Chicago Press.

Fischer, M.M.J. (1986) 'Ethnicity and the Post-Modern Arts of Memory', in J. Clifford and G. Marcus (eds) *Writing Culture*, Berkeley, CA: University of California Press.

Foner, E. (ed.) (1990) *The New American History*, Philadelphia: Temple University Press.

Foucault, M. (1977) *Discipline and Punish: The Birth of the Prison*, Harmondsworth: Penguin.

Fuchs, L. (1990) *The American Kaleidoscope, Race, Ethnicity and the Civic Culture*, Hanover: Wesleyan University Press.

Gilroy, P. (1993) *The Black Atlantic*, London: Verso.

Gold, M. (1965) (first 1930) *Jews Without Money*, New York: Avon Books.

Goldberg, D.T. (ed.) (1995) *Multiculturalism: A Critical Reader*, Oxford: Blackwell.

Gunn Allen, P. (1992) *The Sacred Hoop*, Boston: Beacon.

Gutman, H. (1977) *Work, Culture and Society in Industrialising America*, Oxford: Blackwell.

Hall, S. (1995) 'New Cultures for Old', in D. Massey and P. Jess (eds), *A Place in the World?*, Oxford: Oxford University Press.

—— (1996) 'New Ethnicities', in D. Morley and K.-H. Chen (eds) *Stuart Hall: Critical Dialogues in Cultural Studies*, London: Routledge.

Handlin O. (1951) *The Uprooted*, New York: Grosset and Dunlap.

—— (1959) *Immigration as a Factor in American History*, Englewood Cliffs, NJ: Prentice Hall.

Hansen, M. (1964) *The Immigrant in American History*, New York: Harper and Row.

Higham J. (ed.) (1978) *Ethnic Leadership in America*, Baltimore: Johns Hopkins University Press.

—— (1981) *Strangers in the Land: Patterns of American Nativism, 1860–1925*, New York: Atheneum.

—— (1989) *Send These to Me: Immigrants in Urban America*, New York: Harper and Row.

Horowitz, D.A., Carroll, P.N. and Lee, D.D. (1990) *On The Edge: A New History of Twentieth Century America*, New York: West Publishing.

Jacobson, D. (ed.) (1998) *The Immigration Reader*, Oxford: Blackwell.

Jacoby, T. (2004) *Reinventing the Melting Pot*, New York: Basic Books.

Jameson, F. (1984) 'Periodizing the Sixties', in S. Sayres *et al.*, *The 60s Without Apology*, Minneapolis: University of Minnesota Press.

Jones, M. (1992) *American Immigration*, Chicago: University of Chicago Press.

Jones, P. and Holli, M. (1981) *Ethnic Chicago*, Grand Rapids: W.B. Eerdmans.

Jordan, G. and Weedon, C. (1995) *Cultural Politics*, Oxford: Blackwell.

Josephy, A.M. (1985) *Red Power: The American Indians' Fight For Freedom*, Lincoln: University of Nebraska Press.

Kidwell, C.S. and Velie, A. (2005) *Native American Studies*, Edinburgh: Edinburgh University Press.

King, R., Connell, J. and White, P. (eds) (1995) *Writing Across Worlds*, London: Routledge.

Kingston, M.H. (1981) *Woman Warrior*, London: Picador.

Klein, M. (1981) *Foreigners: The Making of American Literature, 1900–1940*, Chicago: University of Chicago Press.

Kollin, S. (2000) 'Dead Man, Dead West', *Arizona Quarterly* 56, Autumn, pp. 125–54.

Kraut, A. (1982) *The Huddled Masses: The Immigrant in American Society*, Arlington Heights: Harlan Davidson.

Kroeber, K. (ed.) (1994) *American Indian Persistence and Resurgence*, Durham: Duke University Press.

Krupat, A. (1992) *Ethnocriticism: Ethnography, History, Literature*, Berkeley, CA: University of California Press.

Lauter, P. *et al.* (1994) *The Heath Anthology of American Literature* vol. 2, Lexington: D.C. Heath.

Lowe, L. (1996) *Immigrant Acts: On Asian American Cultural Politics*, Durham: Duke University Press.

Luedtke, L. (ed.) (1992) *Making America*, Chapel Hill: University of North Carolina Press.

Malamud, B. (1975) (first 1957) *The Assistant*, Harmondsworth: Penguin.

Mann, A. (1979) 'The Melting Pot', in R. Bushman *et al.* (eds) *Uprooted Americans: Essays to Honour Oscar Handlin*, Boston: Little Brown.

—— (1992) 'From Immigration to Acculturation', in L. Luedtke (ed.) *Making America*, Chapel Hill: University of North Carolina Press.

Mariani, P (ed.) (1991) *Critical Fictions*, Seattle: Bay Press.

Martinez, R. (1992) *The Other Side: Fault Lines, Guerrilla Saints and the True Heart of Rock and Roll*, London: Verso.

—— (2001) *Crossing Over: A Mexican Family on the Migrant Trail*, New York: Picador.

—— (2004) *The New Americans*, New York: The New Press.

Massey, D. and Jess, P. (eds) (1995) *A Place in the World?*, Oxford: Oxford University Press.

Milner, C.A. (ed.) (1989) *Major Problems in the History of the American West*, Lexington: D.C. Heath.

Morley, D. and Chen, K.-H. (eds) (1996) *Stuart Hall: Critical Dialogues in Cultural Studies*, London: Routledge.

Naficy, H. (1999) *Home, Exile, Homeland*, London: Routledge.

Owens, L. (1992) *Other Destinies: Understanding the American Indian Novel,* Norman: University of Oklahoma Press.

Parrillo, V. (1980) *Strangers to These Shores: Race and Ethnic Relations in the United States,* Boston: Houghton Mifflin.

Robertson, G. *et al.* (eds) (1994) *Travellers' Tales: Narratives of Home and Displacement,* London: Routledge.

Robertson, J.O. (1980) *American Myth, American Reality,* New York: Hill and Wang.

Roth, P. (1964) (first 1959) *Goodbye, Columbus,* London: Corgi.

—— (1977) *Reading Myself and Others,* London: Corgi.

—— (1987) (first 1986) *The Counterlife,* London: Jonathan Cape.

Said, E. (1994) (first 1993) *Culture and Imperialism,* London: Vintage.

Saldivar, J.D. (1997) *Border Matters: Remapping American Cultural Studies,* Berkeley: University of California Press.

Sarup, M. (1994) 'Home and Identity, in G. Robertson *et al.* (eds) *Travellers' Tales,* London: Routledge.

Sayres, S. *et al.* (eds) (1984) *The 60s Without Apology,* Minneapolis: University of Minnesota Press.

Seller, M. (1977) To *Seek America: A History of Ethnic Life in the United States,* Englewood Cliffs, NJ: J.S. Ozer.

Shenton, J.P. (1990) 'Ethnicity and Immigration', in E. Foner (ed.) *The New American History,* Philadelphia: Temple University Press.

Silko, L.M. (1977) *Ceremony,* New York: Penguin.

—— (1981) *Storyteller,* New York: Arcade.

Singh, A., Skerrett, J.T. and Hogan, R.E. (eds) (1994) *Memory, Narrative and Identity: New Essays in Ethnic American Literatures,* Boston: Northeastern University Press.

Singh, A. and Schmidt, P. (eds) (2000) *Postcolonial Theory and the United States: Race, Ethnicity and Literature,* Jackson: University of Mississippi Press.

Sollors, W. (1986) *Beyond Ethnicity: Consent and Descent in American Literature,* New York: Oxford University Press.

Sollors, W. (ed.) (1989) *The Invention of Ethnicity,* New York: Oxford University Press.

Stam, R. and Shohat, E. (1994) *Unthinking Eurocentrism,* London: Routledge.

Steiner, D. (1987) *Of Thee We Sing: Immigrants and American History,* San Diego: Harcourt Brace Jovanovich.

Takaki, R. (1979) *Iron Cages: Race and Culture in Nineteenth Century America,* London: Athlone.

—— (1994) *From Different Shores: Perspectives on Race and Ethnicity,* New York: Oxford University Press.

Taylor, P. (1960) *The Distant Magnet: European Immigration to the United States,* London: Eyre and Spottiswoode.

Thernstrom, S. (ed.) (1980) *The Harvard Encyclopedia of American Ethnic Groups,* Cambridge, MA: Harvard University Press.

Todorov, T. (1987) *The Conquest of America,* translated by R. Howard, New York: Harper Perennial.

Vizenor, G. (ed.) (1993) *Narrative Chance: Postmodern Discourse on Native-American Indian Literatures,* Norman and London: University of Oklahoma Press.

—— (1994) *Manifest Manners: Postindian Warriors of Survivance,* Hanover and London: Wesleyan University Press.

—— (1998) *Fugitive Poses,* Lincoln: University of Nebraska Press.

Wilkinson, R. (1992) *The American Social Character*, New York: HarperCollins.
Yans-McLaughlin, V. (ed.) (1990) *Immigration Reconsidered: History, Sociology, Politics*, New York: Oxford University Press.
Yezierska, A. (1975) *Bread Givers*, New York: Persea Books.
—— (1987) (first 1920) *Hungry Hearts and Other Stories*, London: Virago.
Young, R.J.C. (1995) *Colonial Desire: Hybridity in Theory, Culture and Race*, London: Routledge.
Zangwill, I. (1908) *The Melting Pot*, New York: Macmillan.

## FOLLOW-UP WORK

1  Examine how the work of Sherman Alexie – as novelist and script-writer – has challenged stereotypes with humour and irony, and presented native American life as complex and ambiguous.

2  Consider the work of the film-maker Joan Micklin Silver. *Hester Street* and *Crossing Delancey* are both different types of film that address issues and tensions involved in the historical and contemporary processes of assimilation. Discuss the ways in which the films concentrate on the old and the new, ideas about 'American' values, marriage and gender.

3  Mexican-Americans are a major immigrant group in the USA, examine how the experience of border crossing and migrant life is dealt with in Ruben Martinez's *Crossing Over*, Luis-Alberto Urrea's *The Devil's Highway*, or the films *El Norte* and *Alumbrista*.

*Assignments and areas of study*

4  (a) How helpful is the distinction between 'old' and 'new' immigrants in explaining the history of American immigration?

   (b) Examine, through the use of different Native-American texts, how the importance of story-telling is related to ethnic identity and continuity.

   (c) Examine the distinctive features of community life in the Jewish ghettos of American cities in the early twentieth century. (You may, if you wish, substitute another immigrant group for the Jews, for example, Mexican-Americans.)

   (d) Examine the origins, aims and policies of the Americanisation movement in twentieth-century America.

   (e) Examine the experience of any one significant group of contemporary immigrants in the US as represented in first-hand accounts and how these have been represented in film. See T. Dublin (1993) as a source, alongside films such as *Alamo Bay*, *Avalon*, *East L.A.*, *Mississippi Masala*, *Star Maps*, *House of Sand and Fog*.

# Chapter 3

# African Americans
## 'I don't sing other people's voices'
## (Skip James)

## OUT OF SLAVERY

This chapter discusses the issues surrounding African Americans and their struggle for self-definition within the United States of America, through an exploration of various assertive modes of expression. In a culture whose dominant historical voice has been white, there is a vital need for African Americans to present their lives, past and future, as of equal importance in the 'American story'. As Werner Sollors writes, 'For this reason, what is called "memory" . . . may become a form of counter-history that challenges the false generalizations in exclusionary "History"' (Sollors 1994: 8). African-American 'voices' actively express 'memory', as Sollors refers to it, present 'counterhistories' to resist the tendency to exclude, and articulate African-American identities to break the imposed 'silence'[1] inherited from slavery and perpetuated in the written history and social frameworks of the USA. This chapter will emphasise the dynamic quality of the contest between 'silence' and 'voice' in African-American culture and how this process has been integral to a wider struggle for political power and authority in the United States. This concept of expressive 'voices' takes a variety of forms: slave songs, autobiography, fiction, political speech, rap music and film, but together they create an alternative mode of communication through which the African Americans both state their own culture and assert their difference, whilst positioning themselves alongside the often more dominant voices of white mainstream culture. These 'repositories of individual memories, taken together, create a collective communal memory' (Fabre and O'Meally 1994: 9) that represent a black counter-historical identity.

This 'collective construction' of identity includes the vital oral culture from Africa sustained and developed through many expressive modes such as song and story. This was, according to Ralph Ellison, 'what we had in place of freedom' (Ellison 1972: 255), because 'since we were excluded from the cultural mainstream', it was 'only performative

spaces we had left' (Hall 1992: 27). In the very first black newspaper, published in 1827, its editor John B. Russwurm wrote that for 'too long others have spoken for us' (Ripley 1993: 11) and so put into words the primary concern of African Americans, to speak for themselves and dispel the 'implication . . . that only certain Americans can define what it means to be American – and the rest must simply fit in (West 1993a: 256–7).

To resist definition and speak for oneself is fundamental to the assertion of identity, as bell hooks puts it:

> Moving from silence into speech is for the oppressed, the colonized, the exploited, and those who stand and struggle side by side, a gesture of defiance that heals, that makes new life, and new growth possible. It is that act of speech, of 'talking back' that is no mere gesture of empty words, that is the expression of moving from object to subject, that is the liberated voice.
>
> (Mariani 1991: 340)

In order to examine the idea of expression, of 'voice' and 'talking back', we will begin with the heritage of slavery in African-American culture and its impact on the positioning of people of colour within a framework of values dominated by the mainstream culture of whites who tended to assume the slave was 'a kind of *tabula rasa* upon which the white man could write what he chose' (Levine 1977: 52). The 'master-culture', like the master of the plantation who sought to rule the lives of the slaves, tried to impose its norms and values on the minority group who were derided because of their colour and because of an inherited European view of the African as barbaric, heathen and inferior.

> The African was . . . defined as an inferior human being. The representation of the African as Other signified phenotypical and cultural characteristics as evidence of this inferiority and the attributed condition of Africans therefore constituted a measure of European progress and civilization.
>
> (Miles 1989: 30)

Defining the African within these limits of representation meant the power and status of the master were increased since, as the quotation suggests, the slave was an Other or a mirror against which the whites measured themselves and their value systems, and to assume the inferiority of the African thus bolstered the power of the whites. The master/slave system was grounded in denials: of black history, identity, humanity, community, knowledge and language. These were all seen

as means through which slaves might assert themselves and ultimately question their condition in relation to the dominant group. To deny or erase these was, therefore, a method of control, a device to deny the slaves' identity and history and enforce an impression of being adrift, worthless and devoid of ancestry.

In 1965, during the struggles for civil rights, James Baldwin echoed many of these ideas when he wrote:

> It comes as a great shock to discover that the country which is your birthplace and to which you owe your life and identity has not, in its whole system of reality, evolved any place for you.... I was taught in American history books that Africa had no history and neither did I. I was a savage about whom the least said the better. ... You belonged where white people put you.
>
> (Baldwin 1985: 404)

Baldwin's own writings sought to construct a place in America for the black man and to defy being positioned by 'challenging the white world's assumptions' (Baldwin 1963: 31):

> the truth about a black man, as a historical entity and as a human being, has been hidden from him, deliberately and cruelly; the power of the white world is threatened whenever a black man refuses to accept the white world's definitions.
>
> (ibid.: 62)

The increased political demands for Black Power in the 1960s also followed this argument, claiming that any movement 'must speak in the tone of that community ... [so that] black people are going to use the words they want to use – not just the words whites want to hear' (Carmichael 1967: 5).

## NEW BLACK HISTORIES

As a consequence of the civil rights movement and the kind of 'refusal' that Baldwin and Carmichael refer to, African-American and white American historians working on slave culture began to question official versions of history by arguing that the denials, brutality and restraints of slavery did not crush the persistent desire in the slave community to maintain their own identities and their own sense of culture. The work of John W. Blassingame (1972), for example, demonstrates how through various cultural forms, such as songs, stories, dance and religion,

the rigors of bondage did not crush the slave's creative energies [and] through these means the slave could view himself as an object, hold on to fantasies about his status, engender hope and patience, and at least use rebellious language when contemplating his life.

(Blassingame 1972: 59)

The tentative assertions made here by Blassingame hint at the controversial nature of these claims, but later in the book his point is made even more clearly when he states that such slave expression encouraged 'group identification' and therefore argued 'that slaves were not solely dependent on the white man's cultural frames of reference for their ideas and values' (ibid.: 75–6).

Lawrence Levine develops these arguments, claiming that slaves 'were able to create an independent art form and a distinctive voice' (Levine 1977: 30) through vital channels of expression outside the control of the 'master-culture'. The importance of language and of preserving a 'voice' is a recurrent idea in these new histories of slavery and its culture. They indicate an important stream of resistance which was conveyed through the arts of expression, especially song and story-telling. For through these, the communities of Africans could articulate and understand their place in the world outside of the immediate horrors and restrictions of slavery. The past was not dead in these oral arts, but very much present and real in the authority of the singer/teller or 'griot'. As Africans in America, they had 'alternatives open to them – alternatives that they themselves fashioned out of the fusion of their African heritage and their new religion' (ibid.: 35). Levine's emphasis falls importantly on the phrase 'that they themselves fashioned' because it underscores the essential quality of self-definition associated with these creative acts. In them and through them, the self is asserted in a world of constant denial in which the 'definitions belong to the definers, not the defined' (Morrison 1987a: 190).

Levine's idea of 'fusion' establishes a sense of new identity for African Americans who as slaves still maintained an effective and life-affirming set of values through the power of the voice and its willingness to enter into a dialogue with the dominant culture's own expressions. Levine is clearly seeing in these early examples a pattern in history towards integration wherein the black and white culture could find some point of harmonious contact. In this respect Levine's history is in keeping with a particular set of arguments and interpretations of African-American life associated with the stance of Martin Luther King in the civil rights movement. The liberal position suggested by Levine is of a distinct and valid 'black culture and consciousness' which 'interacted with a larger society that deeply affected it but to which it did not completely succumb' (Levine 1977: 297).

In contrast to the white historian's liberal perspective offered by Levine, Sterling Stuckey's work argues that the roots of black 'nationalist consciousness' (Stuckey 1987: 30) can be found in the slave culture because it was there that different tribes were forced together in slavery into shared experiences and 'the principal forms of cultural expression [were] essentially the same' and helped to mould a 'oneness of black culture' (ibid.: 82, 83).

In all these versions of slavery, the idea of a resistance and defiance of the master-culture is paramount and is always connected to the ability of the slaves to hold on to the ancestral past through the internal rituals, songs and stories of the group. Recent scholarship has suggested even more complex and ambiguous relationships between the slave and the master in which the master encouraged slave performance as an 'exotic presence' (Abrahams 1992: xvii), but the slave used this as a means of maintaining community and ancient beliefs. Abrahams argues for 'dynamic, expressive interrelations of the two cultures living side by side' (ibid.), acknowledging the persistence of African culture in the expressive, but subversive, lives of slaves. This passing on is expressed well in two brief fictional examples. In Ellison's *Invisible Man* (1952) Brother Tarp passes on a link from a slave's leg chain, saying 'it's got a heap of signifying wrapped up in it and it might help you to remember what we're really fighting against' (Ellison 1952: 313). An object can voice history and memory, tell a vital story as part of the struggle. Second, in Alice Walker's *Meridian*, the story of Louvinie, the story-teller, is used as a reminder of both the importance of passing on the memories, and also of the risk it poses to white society who fear the re-writing of 'their' versions of history. Her tongue 'was clipped out at the root' (Walker 1976: 33) as a punishment for telling her tales, thus imposing silence and obedience once again.

Levine tells of a way the slaves continued these rituals of telling and passing on despite the ever-watchful eyes of the overseers, and captures the two sides of the 'fearful paradox' (Baldwin 1963: 71). He describes how slaves would contain the sounds of their shouts, songs and rituals by various means, for example, by chanting into a large kettle which muffled their voices so they would not be found out. He comments, 'they could shout and sing all they wanted to and the noise would not go outside' (Levine 1977: 42). The paradox is surely in the slaves' desire to express themselves and yet at the same time being unable to move 'outside', into a genuine, public point of contact with the world beyond the plantation. This encapsulates an important aspect of the struggle for voice and expression in black life. How could the creative spirit, the assertion of a valid, black history, be extended rather than continually stifled by the presence of a more dominant and powerful voice of the white master-culture?

One answer to this had to be the increasing presence of African Americans in the public sphere, particularly during the civil rights movement, as a determined effort to take their 'voice' outside, and engage directly with the authorised and official culture. Indeed, the very writing of new black histories demonstrates post-civil-rights confidence in their use of slave testimony and narratives, and shows the pattern of resistance and the need to hold on to an identity despite the slave system's brutal attempts to erase it as crucially linked to the struggle of the 1950s and 1960s. One slave narrative above all serves to illustrate the need 'to voice or speak the African into existence in Western letters' (Gates 1985: 403) and that is Frederick Douglass's. Unlike Levine's story of the muffling of the voice, Douglass had to find ways out of this imposed silence of slavery in order to tell the world 'outside' of its horrors. In this respect it is a kind of prototype for so many African-American literary forms. *The Narrative of the Life of Frederick Douglass, An American Slave* (1845) charts the journey from slavery by linking it with the assertion and command of language. For Douglass the process of liberation is intimately connected with the ability to express and define oneself in society. Consider, for example, how the narrative begins:

> I have no accurate knowledge of my age, never having seen any authentic record containing it. . . . slaves know as little of their age as horses know of theirs, and it is the wish of most masters . . . to keep their slaves thus ignorant.
>
> (Douglass 1982: 47)

What does this suggest of Douglass's condition under slavery? He goes on in the next few lines to answer this question using negatives such as 'I could not tell . . . deprived . . . not allowed . . . I know nothing; the means of knowing was withheld from me' (ibid.: 47–8). The 'want of information' (ibid.: 47) oppresses him, dehumanises him to the level below a horse by depriving him of basic human facts of identity. He is denied an immediate history, but recognises the importance of finding a means of articulating as a source of self-assertion.[2] It is through songs that Douglass is first stirred:

> They told a tale of woe which was then altogether beyond my feeble comprehension . . . they breathed the complaint of souls boiling with the bitterest anguish. . . . The songs of the slave represent the sorrows of his heart; and he is relieved by them, only as an aching heart is relieved by its tears.
>
> (ibid.: 57–8)

Years later the African-American intellectual W.E.B. Du Bois wrote of also being 'stirred' (Du Bois 1965: 378) by the 'sorrow songs' because

they were 'full of the voices of the past' and 'the singular spiritual heritage' (ibid.) which together formed 'unvoiced longing toward a truer world of misty wanderings and hidden ways' (ibid.: 380). Writing in 1903, Du Bois saw the 'negro' as part of a world that yielded him 'no self-consciousness, but only lets him see himself through the revelation of the other world' (ibid.: 214–15). This became Du Bois's famous definition of 'double-consciousness' for the African American, 'always looking at the world through the eyes of others, of measuring one's soul by the tape of a world that looks on in amused contempt and pity' (ibid.: 215). Du Bois wrote of the 'twoness – an American, a Negro; two souls, two thoughts, two unreconciled strivings; two warring ideals in one dark body, whose dogged strength alone keeps it from being torn asunder' (ibid.).

Prompted by the slave songs, Douglass and later Du Bois felt the call to resist the *prescribed* world of the master-culture, by which we mean a world already set out, as if literally 'written' for the African American, with its denials, its imposed public silences and its cruel disciplinary system. As Douglass writes, 'To all these complaints, no matter how unjust, the slave must answer never a word. . . . When [the master] spoke, a slave must stand, listen, and tremble' (Douglass 1982: 61).

In another slave narrative, *Incidents in the Life of a Slave Girl* (1861) the female slave-author, Harriet Jacobs, uses almost identical words to identify her master's control over speech and movement: 'I was obliged to stand and listen to such language as he saw fit to address to me' (Gates 1987: 364). Echoing Levine's stifling of voice story, Douglass writes that there evolved a 'maxim' for slaves defined by these boundaries: 'a still tongue makes a wise head. They suppress the truth rather than take the consequences of telling it, and in so doing prove themselves members of the human family' (Douglass 1982: 62). It was as if the only way to be connected to the 'human family' was to 'suppress' speech and expression and follow the lead of the master who dictated and 'authored' the terms of life in a system of 'no answering back' (ibid.: 65). Douglass states clearly the relationship of expression to freedom: 'What he most dreaded, I most desired. . . . That which to him was a great evil, to be carefully shunned, was to me a great good, to be diligently sought' (ibid.: 79). To have knowledge, to read, write and express oneself was to step outside the master's boundaries and away from the dictated and defined world he established and controlled for the slave. Indeed, any effort to 'talk back' was a blow against a system that denied the African American 'the full, complex ambiguity of the human' and preferred to present the image of the 'oversimplified clown, a beast, or an angel' (Ellison 1972: 26). W.E.B. Du Bois saw the journey to knowledge and expression as essential for the development of a strong culture.

In those somber forests of his striving his own soul rose before him, and he saw himself – darkly as through a veil; and yet he saw in himself some faint revelation of his power, of his mission. He began to have a dim feeling that, to attain his place in the world, he must be himself, and not another. For the first time he sought to analyze the burden he bore upon his back.

(Du Bois 1965: 218)

Du Bois's sense of the veil that must be seen through is a valuable image, for it suggests the difficulty of asserting a self in a world that continually seeks to place and determine what you are and can be by prescribing your history and denying you any opportunity to express your thoughts or feelings. Later, James Baldwin wrote, 'The details and symbols of your life have been deliberately constructed to make you believe what white people say about you. ... Please try to be clear, ... about the reality which lies behind the words' (Baldwin 1963: 16).

In a similar vein, Houston Baker has written that 'blacks lay veiled in a shroud of silence, invisible not because they had no face, but rather because they had no voice. Voice, after all, presupposes face. ... Without a voice, the African is absent, or defaced, from history' (Baker 1987: 104). The slave narrative was an essential expressive effort to break this silence, for as Baker adds, 'slaves could inscribe their selves only in language' (ibid.: 105). Expression, through speech, song and later writing was a means of resistance, an 'act of creating a public, historical self' (ibid.: 108) and to enable the radical shift of the African American from prescription to inscription and from clownish representation and over-simplification to complex, human ambiguity. The terms are important for they suggest the very politics of the process towards authority in African-American culture as prefigured in the author-ing of their own life stories and history. This struggle for voice and identity within African-American life can be linked to the post-colonial movements of Africa where similar arguments have been made about the need to maintain and develop the languages of resistance. As Ngugi wa Thiong'o has written, 'Values are the basis of a people's identity, their sense of particularity as members of the human race. All this is carried by language. Language as culture is the collective memory bank of a people's experience in history' (Williams and Chrisman 1994: 441). Ralph Ellison, whose novel *Invisible Man* (1952) is concerned with the need to break the silence and invisibility that surrounded black life, expressed this idea with characteristic sharpness.

For history records the pattern of men's lives, they say. ... All things ... are duly recorded – all things of importance that is. But not quite, for actually it is only the known, the seen, the heard and only those

> events that the recorder regards as important that are put down,
> those lies his keepers keep their power by.
>
> (Ellison 1952: 353)

Slave narratives, like those of Douglass and Jacobs, and later 'autobiographical criticism', as bell hooks has termed it, are concerned with 'sharing the contradictions of our lives, [to] help each other learn how to grapple with contradictions as part of the process of becoming a critical thinker, a radical subject' (hooks 1994a: 186). These forms of expression characteristically are about the transformation of the self from the object of someone else's control and authority, to the possibility of self-definition and being one's own subject. As hooks writes, quoting Michelle Cliff, it is the 'work against the odds to claim the I' (ibid.: 177) from those who would contain, define and limit black experience and continue to deny them the full opportunity within the USA.

## IMAGINATIVE CULTURAL RETRIEVAL

African-American expression provides a means of 'claiming the I' through telling personal and cultural histories that together form a vital strand of black experience not given space in traditional white history books. As Malcolm X writes in his *Autobiography*, at school when they came to the section on Negro history, 'it was exactly one paragraph long' and told how the 'slaves . . . were lazy and dumb and shiftless' (Malcolm X 1985: 110). Instead of the dominant culture's control of language, African-American culture took up the call to re-establish its own history as a means of political and social assertion, through a diverse 'telling', using a variety of avenues through which to express its own vision and to tell its own story rather than the 'whitened' version that Malcolm X knew. As one person said, 'while you whites have schools and books for teaching your children, we tell stories, for stories are our books' (Levine 1977: 90). The use of memory has become central to this process for it allows the inclusion of stories excluded or denigrated or erased from the versions of white history. African myths, folklore, the communal stories and tales of slavery and freedom could be passed on orally, as they always had been, through alternative channels of communication within the black community. If the books, media and other techniques of the mainstream dominant culture denied space and access to these stories then other ways had to be found to express the continuities of black life.

The post-colonial critic Edward Said argues that, 'The power to narrate, or to block other narratives from forming and emerging, is very important to culture and imperialism, and constitutes one of the main connections between them' (Said 1994: xiii). In a world where such power

dictates, authorises and controls what can be said, done and thought, there is a need to intervene in the process and 'un-block' the imperialist grip on a single version, and to 'progress beyond a number of assumptions that have been accepted uncritically for too long' (Levine 1977: 444). For bell hooks this means habits of being that were a part of traditional black folk experience that we can re-enact, rituals of belonging . . . [the] sharing of stories that taught history, family genealogy, and the facts about the African-American past (hooks 1991: 39). In this type of alternative education 'memory [is] . . . a way of knowing and learning from the past' (ibid.: 40) so that one might be able 'to accept one's past – one's history – [and] learn . . . how to use it' (Baldwin 1963: 71) in a positive, assertive way.

George Lipsitz calls this 'counter-memory' which he explains as 'not just a rejection of history, but a reconstitution of it' (Lipsitz 1990: 227),

> a way of remembering and forgetting that starts with the local, the immediate, and the personal. Unlike historical narratives that begin with the totality of human existence and then locate specific actions and events within that totality, counter-memory starts with the particular and then builds . . . [it] looks to the past for hidden histories excluded from dominant narratives . . . [and] forces revision . . . by supplying new perspectives.
>
> (ibid.: 213)

In writing, it is like 'literary archaeology' visiting the 'site to see what remains were left behind and to reconstruct the world that these remains imply' (Morrison 1987b: 112) in order to provide a sense of racial continuity in a culture structured on its denial.

A very similar and related project is Julie Dash's *Daughters of the Dust* (1991), a film set at the turn of the century in the South Carolina islands dealing with a Gullah family of slave descendants who have retained their ancestral connections to Africa and yet are being pulled into the world of the 'mainland' with all its new pressures and demands. The film is about story-telling and the importance of passing on the memories of the people as a mode of cultural anchorage. To this end, Dash is concerned with the role of the 'griot' or story-teller who 'will recount the family's history, with the stories going off at a tangent, weaving in and out' (Dash 1993: Argus/BFI video sleeve).[3] This is how she structures her film too, with many voices in the text, from the past, the future and the present, echoing the work of Walker and Morrison, to whom Dash has paid homage as her inspiration; 'they made me whole' (ibid.) she says, and their technique was transposed into her own film-making. At a key point in the film, the sense of struggle and the threat of the loss of the past and its traditions are emphasised through the ideas of

'recollection', stories and their importance. Nana, the great-grandmother, tells the leaving Eli Peazant: 'It's up to the living to keep in touch with the dead. . . . Respect your elders, respect your family, respect your ancestors. . . . Call on your ancestors Eli, let them guide. . . . Never forget who we is and how far we done come this far.' It is the duty of each generation to connect with its past, to remember the 'wisdom', for it provides a framework of belief and history that is not that imposed by the white culture. 'There's a time, a recollection, something somebody remembers, we carry these memories inside of we. . . . I'm trying to give you something to take along with you, along with all your great big dreams.' Dash's film dramatises the process of recovery and invites us to 'undergo a triple process of recollecting the disremembered past, recognizing and reappraising cultural icons and codes, and recentering and revalidating the self' so that African Americans 'consider our positions and our power in the USA' (Bambara 1993: 125).

Dash, therefore, has continued and up-dated the work of Blassingame, Stuckey, Genovese and others who have reclaimed invaluable aspects of previously buried histories for black culture and expression, and parallelled imaginative writing's efforts to go further. The novels of Toni Morrison, in particular, demonstrate the imaginative reconstruction of black history, using fiction to tell 'a whole unrecorded history' (Ellison 1952: 379). As Michelle Wallace has written:

> we must choose to recount and recollect the negativity, the discount, the loss. In the process, we may, ultimately make a new kind of history that first recalls how its own disciplinary discourse was made in brutality and exclusion, and second, a history that seeks as its starting point the heterogeneity of the present.
>
> (Mariani 1991: 139)

Toni Morrison's fiction, like Dash's film, aims 'to bear witness to a history that is unrecorded, untaught, in mainstream education, and to enlighten our people' (Wisker 1993: 80) through the telling of stories often ignored in conventional sources. Echoing Du Bois, she longs 'to rip that veil drawn over proceedings too terrible to relate' (Morrison 1987b: 109–10). She wishes 'to implement the stories that I heard' so as to 'fill in the blanks that the slave narratives left' and to re-position the African American into 'the discourse that proceeded without us' (Morrison 1987b: 111–12). Like Wallace, she writes of a 'reconstruction of a world . . . [and] exploration of an interior life that was not written and to the revelation of a kind of truth' (ibid.: 115). Through her form of counter-memory, Morrison's fiction aims to re-position African Americans in American life by reexamining their history. In her novel *The Bluest Eye* (1970), she writes:

Being a minority in both caste and class, we moved about anyway on the hem of life, struggling to consolidate our weaknesses and hang on, or creep singly up to the major folds of the garment. Our peripheral existence, however, was something we learned to deal with.

(Morrison 1970: 11)

Morrison combats marginalisation through the reconstructive process of telling African-American history to remind her audience, both black and white, of the restrictions imposed on the opportunities of young blacks, as in this section from *The Bluest Eye:*

They go to land-grant colleges, normal schools, and learn the white man's work with refinement: home economics to prepare his food; teacher education to instruct black children in obedience; music to soothe the weary master and entertain his blunted soul. Here they learn ... how to behave. ... In short, how to get rid of funkiness. The dreadful funkiness of passion, the funkiness of nature, the funkiness of the wide range of human emotions.

(ibid.: 64)

Reminiscent of Jacobs and Douglass, this passage posits 'funkiness' as a version of self-expression that needs to find an outlet, for 'Funk is really nothing more than the intrusion of the past in the present' (Gates 1984: 280). What Morrison calls eruptions of funk are the threads of an alternative narrative of African-American life that refuse to be veiled behind the master narrative. Indeed, this is the premise of the novel *Beloved,* wherein the past returns to the present in the form of a family ghost in order to bring others to certain recognitions about their past lives and their racial history.

The community of women is central to this vision of a 'new history', for they pass it on to their children. As bell hooks writes,

We could not learn to love or respect ourselves in the culture of white supremacy, on the outside; it was there on the inside, in that 'homeplace', most often created and kept by black women, that we had the opportunity to grow and develop, to nurture our spirits.

(hooks 1991: 42)

The 'ghost' of the past, Beloved, enters into one such 'homeplace' in Morrison's novel of the same name, and forces the group of women to uncover and discuss their lives. This force of counter-memory surges into the lives of Sethe and Denver to strengthen them against the repressive, dominant power of 'schoolteacher', the overseer on the plantation. He literally 'writes' the existence of the slaves by charting and recording

them in his 'book', with their 'characteristics' divided into 'animal' and 'human', their bodies measured in pseudo-scientific ways, aimed at dehumanisation as a means of social control. Under the gaze of the master who writes only his version of the narrative into his 'notebook' and thereby excludes all other stories, Sethe is contained by his words. 'First his shotgun, then his thoughts, for schoolteacher didn't take advice from Negroes. The information they offered he called backtalk and developed a variety of corrections (which he recorded in his notebook) to reeducate them' (Morrison 1987a: 220). What is 'recorded' by schoolteacher is indicative of the single, authorised narrative of black history that must be countered by 'funkiness', the 'homeplace' and the other expressions to which the community has access. It is 'voice', 'backtalk', or 'talking back' that provides the resistance to the schoolteacher's master-culture. In the novel, it is through the stories that Denver is, at first, reluctant to hear from her mother, grandmother, Paul D and Beloved that 'backtalk' emerges as reconstructed history. Only through these is Denver released into the world and able to re-engage with the black community in a way that further aids her healing. The novel suggests that remembering is a way forward for the future (Denver), as Baby Suggs, her grandmother, earlier instructs her to 'Know it, and go on out of the yard. Go on' (ibid.: 244). She must listen to her ancestral voice, not so she can dwell in the past horrors, but so that she can both know who she is and use this to move forward with greater certainty. The growth of Denver from the sheltered and protected daughter of Sethe to her final position in the novel is shown when Paul D says:

> 'Well, if you want my opinion –'
> 'I don't', she said. 'I have my own'.
> 'You grown', he said.
>
> (ibid.: 267)

Denver's assertion of independent thought and opinion shows she has indeed 'grown', both from childhood and also into a new knowledge of her self within a community which comes together at the end of the novel to exorcise the ghost of Beloved, a community described as 'voices of women [that] searched for the right combination, the key, the code, the sound that broke the back of words. Building voice upon voice until they found it' (ibid.: 261).

   Denver's process is echoed in the words at the novel's end; 'she gather them and give them back to me in all the right order' (ibid.: 272–3), for her growth has depended upon the 'pieces I am' being told and brought out into the open, rather than evaded or hidden from view. Out of the pieces of the (hi)story, memory and wisdom, Denver reconstructs a self which is not reliant upon the schoolteacher's 'story', or indeed even

Paul D's, but comes out of her 'familial past' in order to provide her with 'some kind of tomorrow' (ibid.: 273). Denver's going out of the yard is the step into the future based on 'knowing' rather than ignorance, and is her effort to fill 'the space of not knowing' as a positive gesture of resistance and reconstruction of self and community.

## LINKS IN THE CHAIN: MUSIC AND SPEECH

If contemporary fiction could play a part in the process of self-definition and the growing confidence of African Americans in the public sphere, then as important, if not more so, has been the role of music. We have already seen that songs played an important part in the preservation of African culture for slaves, and that tradition, like so many others, was passed on as musical forms developed. As Lawrence Levine has written:

> Black secular song, along with other forms of oral tradition, allowed them to express themselves communally and individually, to derive pleasure, to perpetuate traditions, to keep values from eroding, and to begin to create new expressive moods . . . which continued a rich internal life.
>
> (Levine 1977: 297)

The potential of music and language to challenge white power is characterised by this section from Ishmael Reed's *Mumbo Jumbo.*

> Son, these niggers writing. Profaning our sacred words. Taking them from us and beating them on the anvil of Boogie-Woogie, putting their black hands on them so that they shine like burnished amulets. Taking our words, son, these filthy niggers and using them.
>
> (Reed 1972: 130)

To acquire a language seen only as 'white' and seek to 'use' it, and indeed prove that it can be used with power and authority, was a threat to the established order of things. Music had long provided a source of just such powerful expression within the black community.

One can see this in Ralph Ellison's description of jazz musicians' 'delicate balance . . . between strong individual personality and the group' which, he goes on to write, had as its goal

> the desire to express an affirmative way of life through its musical tradition and that this tradition insisted that each artist achieve his creativity within its frame. He must learn the best of the past, and add to it his personal vision.
>
> (Ellison 1972: 189)

Jazz, for Ellison, was 'a definition of ... identity: as individual, as member of the collectivity and as a link in the chain of tradition' (ibid.: 234) because it permits full creative expression of the self, in combination with others responding to their energy, but both relating to a long, varied tradition of other forms of articulation. In *Invisible Man* Louis Armstrong's jazz reveals 'unheard sounds ... and each melodic line existed of itself, stood out clearly from all the rest, said its piece, and waited patiently for the other voices to speak' (ibid.: 11). And these voices open a journey into an often hidden African-American past, with

> an old woman singing a spiritual ... a beautiful girl ... pleading in a voice like my mother's as she stood before a group of slave owners who bid for her naked body ... I heard someone shout: 'Brothers and sisters, my text for this morning is the "Blackness of Blackness".
>
> (ibid.: 13)

In this, Ellison suggests the capacity of music to carry 'a whole unrecorded history' (ibid.: 379) and to offer the listener and the performer access to emotions and ideas little expressed in the mainstream dominant culture.

August Wilson's play *Ma Rainey's Black Bottom* (1985) makes a similar claim about the blues in a speech given by Ma Rainey, a real-life blues singer from the 1920s.

> White folks don't understand about the blues. They hear it come out, but they don't know how it got there. They don't understand that's life's way of talking. You don't sing to feel better. You sing 'cause that's a way of understanding life. . . . This be an empty world without the blues. I take that emptiness and try to fill it up with something.
>
> (Wilson 1985: 194–5)

Black music, in various forms, is about 'talking', 'understanding' and 'filling up' life, for it channels emotions and responses into an accepted mode of expression. Blues was 'a way of solidifying community and commenting on the social fabric of Black life in America' (Hill Collins 1990: 99). If other routes of communication are not available, then the African American has learned to use those that are – the song, the pulpit, the written word – as methods of resistance and self-definition.

The African American traditions of song, story-telling and preaching found a precise outlet in the politics of the civil rights movement and beyond. With the increased importance of the mass meeting, often directed from local churches, expression was a vital component of the political process. The meetings were 'events/places where participants

could express fear as well as resolution, anger as well as understanding, make plans and formulate strategies ... expression became a way of channelling fear and anger into effective collective action' (King 1988: 10). On such occasions expression found a variety of avenues, as it always had in black life: preaching, testifying, passing on stories of the movement and through the 'freedom songs', which had taken on a precise relationship to the push for civil rights. Richard King calls these expressions 'the new language of public action' (ibid.: 11), and it can be seen in the oratory of Martin Luther King who built his speeches upon a diverse background of biblical, folk and slave stories to weave a persuasive, rhythmic song-like pattern which asserted the individual power of the voice, but included the audience in the spectacle and the occasion. It is, as Levine wrote of slave songs and Ellison of jazz, both personal and political, individual and collective. Instead of 'a junkheap of isolated voices, unrelated experiences, and forgettable characters', preachers formed a chain of connections, creating a 'choir of voices', the many in one (Miller 1992: 131, 144). In King's speeches there is a strong attention to 'voice merging', or the bringing together of diverse moments into a harmonious whole, parallelling his style with the politics of integration for which he stood. Drawing upon concepts which were as much a part of white American mythology as black, such as the American Dream, he merged them with a rich tradition integrating the hopes of one section of the community with the aspirations of another in the civil rights movement. His most famous speech, 'I Have a Dream' (1963), creates just such a new, inclusive voice for America that unites around Abraham Lincoln – under whose memorial the speech was given – the biblical prophecies of Isaiah and Amos, 'justice rolls down like waters ...', and the Negro spiritual, 'Free at last'.

This powerful voice became vital to the movement in the 1950s and 1960s where public speeches, rallies and marches were an essential method of protest, but also of communication within the African-American community. The new confidence and visibility of King can be compared to the growing black music business, and in particular the Tamla Motown label established by Berry Gordy in 1960. Although not overtly political, the fact of a successful black enterprise and the impact of black performers echoed the slow changes being made politically. Within the wider context of the civil rights movement and dramatic social change, Martha Reeves's song 'Dancing in the Street' is a call to emancipation: 'Calling out around the world, are you ready for a brand new beat'. Motown's merging of gospel traditions such as tambourines, clapping, call and response and advisory lyrics, with the interest in a greater freedom of expression, provided a base for Motown and other soul singers to contribute to the voicing of black culture. As James Brown sang, 'Say it Loud (I'm Black and I'm Proud)'.

Politics continued to discover the power of language in other ways. For example, Malcolm X, during his time in prison, saw the relationship between self-expression and liberation, beginning with reading and moving on to the power of speech: '[I]n the prison, speaking to a crowd, was as exhilarating to me as the discovery of knowledge through reading had been' (Malcolm X 1968: 280). Malcolm X's use of language could be more direct than the 'voice-merging' style of King, and used none of the preaching techniques that King had learned in the seminary. Malcolm's voice comes out of the poverty of the ghetto where he 'learned early that crying out in protest could accomplish things' (ibid.: 86) and he speaks in a direct and forceful manner; more James Brown than Motown:

> I'm speaking as a victim of this American system. . . . I don't see any American dream; I see an American nightmare. These 22 million victims are waking up. Their eyes are coming open. They're beginning to see what they used to only look at.
> (Malcolm X in Lauter *et al.* 1994: 2497)

The tone and choice of words show clearly the different message and yet the vital importance of the voice as the means of communication within the community. For Malcolm X, the voice must carry the 'raw, naked truth . . . to clear the air of the racial mirages, cliches and lies' (Malcolm X 1968: 379). He goes on in the same speech to call for 'a new interpretation' of the civil rights movement, for 'black nationalism' to 'enable us to come into it, take part in it', rather than wait for others to give you 'what's already yours' (Lauter *et al.* 1994: 2500–1). As Eldridge Cleaver later wrote, Malcolm X 'articulated . . . aspirations better than any other man of our time . . . he had continued to give voice to the mute ambitions in the black man's soul' (Cleaver 1968: 47). Malcolm X's autobiography explains his own, personal journey towards self-determination, but like so much black autobiography, it also relates to the wider condition of the community's movement to political status. The individual voice must be found so that it can speak out with confidence and self-respect to the group, to 'build up the black race's ability to do for itself' (Malcolm X 1968: 382), within a context provided by the stories and heritage of a meaningful past. In this way the individual life can become a 'testimony of some social value' (ibid.: 497) for it becomes a thread within the larger fabric of black life.

Thus, the push for self-definition, 'the claiming of the I', was only a stage in the political process, which aimed at transforming the 'I' to a 'We': 'We must move past always focusing on the "personal self" because there's a larger self. There's a "self" of black people' (Tate 1983: 134). Alice Walker, who was active in the civil rights movement, captures

these sentiments in her novel *Meridian* (1976) which shows the struggle of Meridian Hill for self-definition, both as woman and African American, in a white, male-dominated society, but also shows her growing awareness of the importance of community to the wider struggle. Walker echoes the words of Stokely Carmichael, the Black Power leader, who wrote of the need to 'create in the community an aroused and continuing black consciousness that will provide the basis for political strength' (Carmichael 1967: 6). Walker suggests this in a scene at the end of the novel when Meridian goes to church to hear a politicised preacher, 'deliberately imitating King ... consciously keeping the voice alive ... not his own voice at all, but rather the voice of millions who could no longer speak' (Walker 1976: 200). Walker sees the strands of tradition come together: the oral inspiration, the re-telling of black history and the empowerment of the group through vital expressivity: 'Focussing on connection rather than separation, transforming silence into speech, giving back power to the culturally disenfranchised, black women writers affirm the wholeness and endurance of a vision that, once articulated, can be shared' (Pryse and Spillers 1985: 5). This 'sharing' is demonstrated in the communality of the gathering at the end of the novel:

> [L]et us weave your story and your son's life and death into what we already know – into songs, the sermons, the 'brother and sister' – ... 'the church' (and Meridian knew they did not just mean simply 'church' as in Baptist, Methodist or whatnot, but rather communal spirit, togetherness, righteous convergence) ... 'the kind of ritual you share with us, these are the ways to transformation that we know'. ... For she understood, finally, that the respect she owed her life was to continue, against whatever obstacles, to live it. ... And that this existence extended beyond herself to those around her because, in fact, the years in America had created them One Life.
>
> (Walker 1976: 204)

Meridian's revelation connects so many of the strands of black resistance, and emphasises the power of the voice, what she calls the 'song of the people, transformed by the experience of each generation' as the means 'that holds them together' (ibid.: 205) as part of a broad unified view of black life within America, rather than separate from it. Her politics are closer to those of Martin Luther King and the integrationists than to the more extreme views of the Black Muslims who called for separation, or the Black Power movement who felt the civil rights movement's 'tone of voice was adapted to an audience of liberal whites' (Carmichael 1967: 5).

However, in the later stage of the career of Malcolm X, for so long a voice associated with black nationalism and the Muslims, one sees emerging a position quite close to that expressed in Walker's novel. It is a new universalism, 'committed to survival and wholeness of entire people, male and female' (Walker 1984: n.p.), a call for human rights, not dissimilar from that expressed by Black Power leader Stokely Carmichael who wrote in 1966, 'We are just going to work, in the way we see fit, and on our goals we define, not for civil rights but for all human rights' (Carmichael 1967: 8). Malcolm X states his goal as, 'truth, no matter who tells it. I'm for justice, no matter who it's for or against. I'm a human being first and foremost, and as such I'm for whoever and whatever benefits humanity as a *whole*' (Malcolm X 1985: 483). There is less talk of separatism and more about joint responsibility between races since 'with equal rights there had to be a bearing of equal responsibilities' (ibid.: 494). By the end of his autobiography, Malcolm X, echoing King, expresses his hopes in terms of the specific contribution he had made to the struggle for human rights in America.

> Sometimes, I have dared to dream to myself that one day, history may even say that my voice – which disturbed the white man's smugness, and his arrogance, and his complacency – that my voice helped to save America from a grave, possibly even a fatal catastrophe.
>
> (ibid.: 496)

Malcolm X's tone, as ever, is far more direct and assertive in its condemnation of white culture than is King's, but his use of the 'dream' and his recognition that it is his 'voice' that carries his authority place the two together in the struggle for 'what America must become' (Baldwin 1963: 17). It also recognises the inter-relatedness of the two cultures, black and white, and echoes Paul Gilroy's work examining how 'double consciousness' involves precisely this inter-relationship between black and white cultures within and without America, creating a hybrid sense of identity. The Afrocentric 'roots' were necessarily crossed by the many 'routes' traveled by Africans in their diasporic relations with the world (Gilroy 1993).

## NEW BLACK VOICES

In contemporary American culture, it is hip hop, in its diverse forms, that best exemplifies the continuing importance of the necessity of expression in African-American life. Despite the struggles of those figures and movements discussed in this chapter, there is a constant need for African Americans to assert their rights within a hegemonic white

society, and one means, as we have shown, is through popular cultural expression. Rap music, in particular, articulates a youthful, vital voice, at once rooted in the everyday traditions and sources that have been discussed throughout, but also creating a new mode of expression. As always, the 'voice' has found a new form, often mixing and 'sampling' from others, through which to convey its messages and resist the dominant culture. As rapper Melle Mel has said, 'Rap music makes up for its lack of melody with its sense of reminder. It's linked somewhere into a legacy that has been overlooked, forgotten, or just pushed to the side amongst the glut of everything else' ('Looking for the Perfect Beat', *The South Bank Show* 1993).

In an interview in 1989 Cornel West (1992: 222) commented that 'music and preaching' are central to African-American communication and that 'rap is unique because it combines the black preacher and the black music tradition ... pulling from the past and present, innovatively producing a heterogeneous product' that links the 'oral, the literate, and the musical' (ibid.). The essence of what Melle Mel calls the 'reminder' in rap music is a call to an African-American history, which for so long has been hidden or erased by a dominant white culture in the USA. Like the preacher calling to his congregation, or indeed King or Malcolm X from their platforms, the rapper exhorts his audience to listen and to learn from the words he weaves into narratives of experience and the rhythms of black life. But as West suggests, the form of the rap intertwines different modes, extending, sampling, playing with sound and language in an effort to create something new and communicative. It is the new '"testimony" for the underclass' providing young blacks with a 'critical voice ... a "common literacy" ... explaining, demanding, urging' (hooks 1994b: 424). Rapper Chuck D calls rap 'media piracy ... to get a big text to people ... an information network of sorts ... to fuel the mind and the body' (*The South Bank Show* 1993). Rap 'is black America's TV station ... and black life doesn't get the total spectrum of information through anything else' (Ross and Rose 1994: 103).

Tricia Rose terms this characteristic 'polyvocal conversations' (Rose 1994: 2) through which raps become elaborate stories 'to articulate the shifting terms of black marginality in contemporary American culture' (ibid.: 3). As the sounds are 'mixed' in the textures of the 'sonic force' of the music, so too does the vocal 'cut and mix' different threads of stories and snippets of noise from the variety of street life experienced by the African American. Chuck D of 'Public Enemy' explains the effects of this on his work: 'I'm trying to alert as many people as possible and that's why on my records I like to put noise in them. I consider them an alarm for Black-Americans' (BBC2, *Rap Rap Rapido*, broadcast March 1992). 'Noise', like shouting at a congregation or haranguing a

crowd, can be a useful tool for the orator and works together with the educational passing on of communal stories. As Rose writes, like ' "noise" on the one hand and communal countermemory on the other, rap music conjures and razes in one stroke' (Rose 1994: 65), constructing 'oppositional transcripts' as cultural responses to oppression and the stories told from within the closed circle of a preferred, official discourse. Rap provides resistance to 'dominant public transcripts' (ibid.: 100), offering the oppressed a public arena through which to air their 'hidden transcript' and so to give voice to a history not often told: 'a contemporary stage for the theater of the powerless' (ibid.: 101). Hence, a rap like Public Enemy's 'Fight the Power' attacks both lyrically and musically the bastions of the mainstream. Elvis Presley, 'a hero to most' means nothing to the young, urban black man who sees him as a 'racist . . . simple and plain' in a culture that pretends that 'we are the same', when there are vast differences in wealth and power. The rap calls for forthrightness: 'What we need is awareness, we can't get careless' and to question such bases of power. A more extreme rap, developed as part of the Los Angeles 'gangsta' rap scene, is that of Ice T's 'Freedom of Speech' of 1990 which challenges those who would censor rap lyrics: 'We should be able to say anything/Our lungs were meant to shout . . . Say what we feel, yell out what's real'. Expression, of various kinds, is still a marker of freedom, 'a form of testimony . . . of social protest' (ibid.: 144–5) that rap has taken forward by embracing technology to construct a musical style that pushes African-American story-telling into the future. Rap refuses to languish in the past, but instead has found a method of speaking to the future.

> Rappers . . . are the miners, they are the cultivators of communal artifacts, refining and developing the framework of alternative identities that draw on Afrodiasporic approaches to sound organization, rhythm, pleasure, style, and community. . . . Rap is a technologically sophisticated project in African-American recuperation and revision . . . yet another way to unnerve and simultaneously revitalize American culture.
>
> (ibid.: 185)

Like Morrison's literary archaeology and project to re-write history, rap is engaged in 'massive archiving', 'gather[ing] . . . a reservoir of threads' (Baker 1993b: 89) drawn from a range of sources into a new, vital hybrid form. Of course, within this 'archive' are rappers, like Snoop Dogg or 50 Cent, whose expression is as much about performing an identity, as 'gangsta', articulating a different version of self-definition (however ironic and playful) aligned to empowerment through wealth, 'respect',

territorialism, and sexuality. But despite the showmanship and technology, Baker argues it is, in the end, 'the voice' that 'catches the consciousness' (ibid.: 91), the voice that refutes homogeneity in favour of the critical mix of the 'sonic soul force', the dialogics of 'edutainment' as KRS-1 termed it: education and entertainment speaking together as the 'updated song of explanation' (Baker 1993a: 46).

## *BOYZ N THE HOOD* (1991)

> ... it's you young ones what has to remember and take the lead.
>
> (Ellison 1952: 207)

John Singleton's *Boyz n the Hood* is a rites of passage story dramatising the triangular relationship between the sports star (Ricky), the 'gangsta' (Doughboy) and the boy 'in between' (Tre), all struggling to come to terms with the ghetto life of containment, control, surveillance, and oppression. Singleton wanted to give black youth stories an audience in a way that rap had done in music, bringing to the fore familiar themes of self-definition, violence and masculinity with some of the forms of the autobiographical tradition in black writing. As he put it:

> Everything in the culture tells him to 'be a man'. Everything has something to do with a dysfunctional rite of passage: You have to be a killer to be a man. And who are they talking about killing? Each other. There are all these insults to a person's manhood. So these guys are growing up in basically a 'baby boy' situation, where they're raised by their [single] mothers and are always trying to define – then defend – their manhood.
>
> (Singleton 1995)

Singleton's film offers various narratives of masculinity, from excessive gang violence and misogyny to patriarchal guidance for wayward sons, but its overarching theme is education, from the 'street' and school, as well as from Tre's black nationalist father, Furious Styles, and his successful, but estranged, mother. The drama is then about whether Tre will learn to take responsibility for himself and his community and be empowered to escape the ghetto. Ultimately, despite the perpetual waste and death around him, he does, going on to college and a more balanced life with his girlfriend Brandi. In this, the film points towards a vision of African-American life that understands the value of knowledge, self awareness, and community – the lessons given by Furious – but refuses to be bound only by those ties at the expense of equality and opportunity that may indeed exist beyond or alongside these perspectives.

## CONCLUSION: A STORY TO PASS ON

Manning Marable has written that:

> African-American identity is much more than race. It is also the traditions, rituals, values, and belief systems of African-American people ... our culture, history, art and literature ... our sense of ethnic consciousness and pride in our heritage of resistance against racism.
>
> (Dent 1992: 295)

And this 'collectively constructed' identity is an essential part of the freedom struggle to go alongside the more specific dismantling of the economic, legal and social aspects of racism, for it empowers the black community through expressions of human dignity which assert 'a sense of "being-for-ourselves", and not for others' (ibid.: 302). It has been the struggle to 'position' oneself rather than be positioned by others that we have followed in African-American life, but as many critics have commented, these processes are unfinished and cannot be ignored in the contemporary world.

One description of the future, provided by Cornel West, is of the 'new cultural politics of difference' in which differences are not elided, but accepted as healthy expressions of individual and communal energies. Rather than an 'a homogenizing impulse' which suggests that all black people are the same, West calls for 'responses that articulate the complexity and diversity of Black practices' and that engage with the 'mainstream' and the 'nourishing subcultures', so that they 'cultivate critical sensibilities and personal accountability – without inhibiting individual expressions, curiosities and idiosyncrasies' (West 1993b: 17, 14). Rather like the conclusion to *Boyz n the Hood*, West's vision is 'to look beyond the same elites and voices that recycle the older frameworks' to 'a new language of empathy and compassion' (West 1993a: 260). Perhaps, to pursue the idea of 'voice', the African-American community's struggle to find its own voice within America has, at least, provided the opportunity to be heard in the public arena. This recalls the scene in *Invisible Man* when the narrator delivers a speech inadvertently referring to 'social equality' only to be greeted with 'the sudden stillness ... sounds of displeasure ... [and] hostile phrases', and the swift reminder 'you've got to know your place at all times' (Ellison 1952: 30). In contrast, Alice Walker, describing a voter registration episode in *Meridian*, states, 'It may be useless. Or maybe it can be the beginning of the use of your voice. You have to get used to using your voice, you know. You start on simple things and move on' (Walker 1976: 210). Between the 1940s and the 1960s, clearly things have changed, but the

need to 'move on' is essential, so as to have both a voiced identity rooted in a strong sense of the past, and to use it in the context of the world in which there are still many changes to be made. As Catherine Clinton has written, 'the power of memory must draw us out of the novel [and other cultural forms] and into the archives. Erasure and silence will not defeat us if we remember – this is a story to pass on' (Fabre and O'Meally 1994: 216).

## NOTES

1   Silence is a concept often used, as here, to suggest the cultural impositions and denials of slavery, but as we shall argue, despite these conditions there was always a powerful 'voice' of resistance within the black community. In part, the silence of slavery was a colonial myth reinforcing positions of control and power (see Bhabha 1994).
2   This is also reflected in *The Autobiography of Malcolm* X (1985: 256).
3   Julie Dash's structure is reminiscent of quilt-making in that it weaves and connects fragments, or scraps of recollections and stories, into a complex and multi-faceted text. In this she links with an important African-American craft tradition that has become highly significant in the work of Afri-feminists like Morrison and Walker. See in particular Walker's *In Search of Our Mothers' Gardens* (1984).

## REFERENCES AND FURTHER READING

Abrahams, R.D. (1992) *Singing the Master: The Emergence of African-American Culture in the Plantation*, New York: Pantheon.
Angelou, M. (1984) (first 1969) *I Know Why the Caged Bird Sings*, London: Virago.
—— (1986) *All God's Children Need Travelling Shoes*, London: Virago.
Aronowitz, S. (1994) *Dead Artists, Live Theories*, London: Routledge.
Baker, H. (1972) *Long Black Song*, Chapel Hill: University of North Carolina.
—— (1987) *Modernism and the Harlem Renaissance*, Chicago: University of Chicago Press.
—— (1993a) 'Scene . . . Not Heard', in R. Gooding-Williams (ed.) (1993) *Reading Rodney King, Reading Urban Uprising*, London: Routledge.
—— (1993b) *Black Studies, Rap and the Academy*, Chicago: University of Chicago Press.
Baldwin, J. (1963) *The Fire Next Time*, Harmondsworth: Penguin.
—— (1972) *No Name in the Street*, London: Michael Joseph.
—— (1985) *The Price of the Ticket: Collected Essays 1948–85*, London: Michael Joseph.
Bambara, T.C. (1993) 'Reading the Signs, Empowering the Eye: Daughters of the Dust and the Black Independent Cinema Movement', in M. Diawara (ed.) *Black American Cinema*, London: Routledge.
Benston, K. (1984) 'I yam what I am: the topos of (un)naming in Afro-American fiction', in H.L. Gates (ed.) *Black Literature and Literary Theory*, London: Routledge.
Bhabha, H.K. (1994) *The Location of Culture*, London: Routledge.

Blassingame, J.W. (1972) *The Slave Community: Plantation Life in the Ante-bellum South*, Oxford: Oxford University Press.

Campbell, N. (1995) 'The Empty Space of Not Knowing: Childhood, Education and Race in African-American Literature', in E. Marum (ed.) *Towards 2000: The Future of Childhood, Literacy and Schooling*, London: Falmer Press.

Carby, H.V. (1987) *Reconstructing Womanhood: The Emergence of the Afro-American Woman Novelist*, Oxford: Oxford University Press.

Carmichael, S. (1967) *Black Power*, Harmondsworth: Penguin.

Clayton, J. (1993) *The Pleasures of Babel: Contemporary American Literature and Theory*, New York; Oxford University Press.

Cleaver, E. (1968) *Soul On Ice*, London: Jonathan Cape.

Couzens Hoy, D. (ed.) (1986) *Foucault: A Critical Reader*, Oxford: Blackwell.

Dent, G. (ed.) (1992) *Black Popular Culture*, Seattle: Bay Press.

Diawara, M. (ed.) (1993) *Black American Cinema*, London: Routledge.

Douglass, F. (1982) (first 1845) *The Narrative of the Life of Frederick Douglass, An American Slave*, Harmondsworth: Penguin.

Du Bois, W.E.B. (1965) (first 1903) *The Souls of Black Folks*, in *Three Negro Classics*, New York: Avon.

—— (1970) *Speeches and Addresses 1920–1963*, London: Pathfinder.

—— (1972) (first 1964) *Shadow and Act*, New York: Vintage Books.

Early, G. (ed.) (1993) *Lure and Loathing: Essays on Race, Identity and the Ambivalence of Assimilation*, London: Allen Lane.

Ellison, R. (1952) *Invisible Man*, Harmondsworth: Penguin.

—— (1972) *Shadow and Act*, New York: Vintage.

Fabre, G. and O'Meally, R. (eds) (1994) *History and Memory in African-American Culture*, New York: Oxford University Press.

Gates, H.L. (ed.) (1984) *Black Literature and Literary Theory*, London: Routledge.

—— (1985) *The Classic Slave Narratives*, New York: Mentor.

—— (1987) *Figures in Black: Words, Signs, and the 'Racial' Self*, Oxford: Oxford University Press.

—— (1990) *Reading Black, Reading Feminist: A Critical Anthology*, New York: Meridian.

Gilroy, P. (2003) *The Black Atlantic: Modernity and Double Consciousness*, London: Verso.

Gooding-Williams, R. (ed.) (1993) *Reading Rodney King, Reading Urban Uprising*, London: Routledge.

Hall, S. (1990) 'Cultural Identity and Diaspora', in J. Rutherford (ed.) *Identity, Community, Culture, Difference*, London: Lawrence and Wishart.

—— (1991) 'Old and New Identities, Old and New Ethnicities', in A.D. King (ed.) *Culture, Globalization and the World System*, London: Macmillan.

—— (1992) 'What is this "Black" in Black Popular Culture?' in G. Dent, (ed.) *Black Popular Culture*, Seattle: Bay Press.

Hill Collins, P. (1990) *Black Feminist Thought*, London: Routledge.

hooks, bell (1990) 'Talking Back', in R. Ferguson *et al.* (eds) *Out There: Marginalization and Contemporary Cultures*, New York: MIT Press.

—— (1991) *Yearning: Race, Gender, and Cultural Politics*, London: Turnaround.

—— (1994a) 'Black Women: Constructing the Revolutionary Subject', in M. Klein (ed.) *An American Half-Century*, London: Pluto Press.

—— (1994b) 'Postmodern Blackness', in P. Williams and L. Chrisman (eds) *Colonial Discourse and Post-Colonial Theory*, London: Harvester Wheatsheaf.

King, A.D. (ed.) (1991) *Culture, Globalization and the World System*, London: Macmillan.

King, R. (1988) 'Citizenship and Self-Respect: The Experience of Politics in the Civil Rights Movement', *Journal of American Studies*, vol. 22, no. 1, pp. 7–24.

Lauret, M. (1994) *Liberating Literature: Feminist Fiction in America*, London: Routledge.

Lauter, P. *et al.* (1994) *The Heath Anthology of American Literature* vol. 1 and 2, Lexington: D.C. Heath.

Levine, L. (1977) *Black Culture and Black Consciousness*, New York: Oxford University Press.

Levine, L.W. (1977) *Black Culture and Black Consciousness: Afro-American Folk Thought from Slavery to Freedom*, New York: Oxford University Press.

Lewis, S. (1990) *African American Art and Artists*, Berkeley, CA: University of California Press.

Lipsitz, G. (1990) *Time Passages*, Minneapolis: University of Minnesota.

Marable, M. (1985) *Black American Politics: From the Washington Marches to Jesse Jackson*, London: Verso.

—— (1992) 'Race, Identity, and Political Culture', in G. Dent (ed.) *Black Popular Culture*, Seattle: Bay Press.

Mariani, P. (ed.) (1991) *Critical Fictions*, Seattle: Bay Press.

Miles, R. (1989) *Racism*, London: Routledge.

Miller, K. (1992) *Voice of Deliverance: The Language of Martin Luther King and Its Sources*, New York: The Free Press.

Morrison, T. (1970) *The Bluest Eye*, London: Chatto and Windus.

—— (1981) 'City Limits, Village Values: Concepts of the Neighbourhood in Black Fiction', in C. Jaye and A.C. Watts (eds) (1981) *Literature and the Urban American Experience*, Manchester: Manchester University Press.

—— (1987a) *Beloved*, London: Picador.

—— (1987b) 'The Site of Memory, in W. Zinsser (ed.) *Inventing the Truth: The Art and Craft of Memoir*, Boston: Houghton Mifflin.

—— (1988) 'Living Memory, *City Limits*, 31 March to 7 April, pp. 10–11.

—— (1989) 'Unspeakable Things Unspoken: The Afro-American Presence in American Literature', *Michigan Quarterly Review*, vol. 28, Winter, pp. 1–34.

Munslow, A. (1992) *Discourse and Culture: The Creation of America 1870–1920*, London: Routledge.

Neal, L. (1989) *Visions of a Liberated Future: Black Arts Movement Writings*, New York: Thindr's Mouth Press.

Pryse, M. and Spillers, H.J. (1985) *Conjuring: Black Women, Fiction and Literary Tradition*, Bloomington: Indiana University Press.

Reed, I. (1972) *Mumbo Jumbo*, New York: Avon.

Ripley, C.P. (ed.) (1993) *Witness For Freedom: African-American Voices on Race, Slavery and Emancipation*, Chapel Hill: University of North Carolina Press.

Rose, T. (1994) *Black Noise: Rap Music and Black Culture in Contemporary America*, Hanover: Wesleyan University Press.

Ross, A. and Rose, T. (eds) (1994) *Microphone Fiends*, London: Routledge.

Said, E. (1978) *Orientalism: Western Conceptions of the Orient*, Harmondsworth: Penguin.

—— (1994) *Culture and Imperialism*, London: Vintage.

Singleton, J. (1995) Interview accessed from www.metrotimes.com/editorial/story.asp?id=1971

Sollors, W. (1994) 'National Identity and Ethnic Diversity: "Of Plymouth Rock and Jamestown and Ellis Island"; or Ethnic Literature and some Redefinitions of American', in G. Fabre and R. O'Meally (eds) *History and Memory in African American Culture*, New York: Oxford University Press.

*South Bank Show, The* (1993) 'Looking For the Perfect Beat', ITV.

Stanley, L.A. (ed.) (1992) *Rap: The Lyrics*, Harmondsworth: Penguin.

Storey, J. (1993) *An Introductory Guide to Cultural Theory and Popular Culture*, London: Harvester Wheatsheaf.

Stuckey, S. (1987) *Slave Culture: Nationalist Theory and the Foundation of Black America*, New York: Oxford University Press.

Tate, C. (ed.) (1983) *Black Women Writers at Work*, Harpenden: Oldcastle.

Walker, A. (1976) *Meridian*, London: Women's Press.

—— (1984) *In Search of Our Mothers' Gardens*, London: Women's Press.

Wallace, M. (1980) *Black Macho and the Myth of the Superwoman*, New York: Warner.

West, C. (1992) 'Interview' in P. Brooker (ed.) *Modernism/Postmodernism*, London: Longman.

—— (1993a) 'Learning to Talk of Race' in R. Gooding-Williams (ed.) *Reading Rodney King, Reading Urban Uprising*, London: Routledge.

—— (1993b) *Keeping Faith: Philosophy and Race in America*, London: Routledge.

Williams, P. and Chrisman, L. (eds) (1994) *Colonial Discourse and Post-Colonial Theory*, London: Harvester Wheatsheaf.

Wilson, A. (1985) *Fences and Ma Rainey's Black Bottom*, Harmondsworth: Penguin.

Wisker, G. (ed.) (1993) *Black Women's Writing*, London: Macmillan.

Wright, R. (1970) (first 1945) *Black Boy*, London: Longman.

X, Malcolm (1985) (first 1965) *The Autobiography of Malcolm X*, Harmondsworth: Penguin.

## FOLLOW-UP WORK

*Film and African-American experience*

1   This chapter has discussed the ways in which different attitudes to integration and separation have been central to post-war African-American culture. A contemporary text that can be very useful as an interdisciplinary focus for a continued debate on this is the film *Do the Right Thing* (Spike Lee, 1988). In particular, examine the self-conscious scenes in which Lee directs the audience to the language of racism and the other divisions of the city: Radio Raheem's 'love and hate' speech; Buggin Out's insistence about having 'brothers' on the wall of the Italian restaurant; Mookie's final confrontation with Sal and Smiley's picture of King and Malcolm X. Lee's form and structure are totally bound up with his content.

This approach can be usefully compared with the feminist work of Julie Dash and again her choice of narrative style: lyrical, mystical and re-articulating the 'griot' story-telling traditions through the new medium of film. Another comparison is to Leslie Harris's film *Just Another Girl on the I.R.T.*

2    African-American art has not been examined here, but many of the ideas put forward could be applied and related to the work of an artist like Romare Bearden (1911–88). In particular his use of collage and photomontage can be related to our interests in story-telling and quilting traditions since as an artist he was fully aware of literary figures as well, and like Dash in film, sought to create visual equivalence to their work.

*Assignments and areas of study*

3    (a)  The issue of stereotyping in African-American culture. The documentary *Color Adjustment* (1992, Marlon Riggs) is an excellent look at the way television has represented African Americans, and can be viewed with other materials such as essays by Michele Wallace, or films like Robert Townsend's *Hollywood Shuffle* or Spike Lee's *Bamboozled*.

(b)  An examination of traditions of 'voice' in African-American culture through an analysis of King's 'I Have A Dream' speech, looking at his combinations of traditions, intertextual references and modes of address. You could also examine a contemporary rap song such as Grandmaster Flash's 'The Message' or a soul song like Aretha Franklin's 'Respect', for the diverse ways in which they project political points of view through form and content.

# Chapter 4

# In God we trust?
## Religion in American life

The role played by religious thought and practice is of immense import-
ance to a full understanding of American life. As Anthony Giddens has
argued, religion is a 'central part of human experience, influencing how
we perceive and react to the environments in which we live' (Giddens
2001: 530). Social surveys suggest how importantly this is reflected in
the contemporary United States. In 2004, 94 per cent of Americans said
they believed in God, 63 per cent said they belonged to a church of some
kind, and 44 per cent attended a weekly church service. Another 59 per
cent believed religion was very important in their lives, and answered
their problems. In 2005 a Gallup poll showed that 81 per cent of
Americans believed in heaven and 70 per cent believed in hell. Most
Americans were pretty sure where they were headed: 77 per cent thought
their chances of getting to heaven were good to excellent, and only 6
per cent felt they were likely to go to hell (Gallup 2004b). By compar-
ison 38 per cent of Germans, 44 per cent of Britons and 54 per cent of
Italians believed in life after death. Half of the population claimed they
prayed at least once a day. In contrast only 10 per cent of Americans in
2004 admitted to no religious preference, or being atheistic or agnostic.
Only 15 per cent felt religion was not very important in their lives (Gallup
2004a). Belief was matched by financial commitment, with contributions
to religion estimated at $57 billion a year in the mid-1990s (Singh 2003:
192–215). 'There is no country in the world where the Christian religion
retains a greater influence over the souls of men than in America', wrote
de Tocqueville in 1835 (1965: 233), but his comment might equally apply
to the contemporary republic. What further complicates the picture
today, of course, is that Christianity has been joined by a number of
other religions to make the American religious mosaic much more varied
than it was in the mid nineteenth century. The great waves of Jewish
immigration in the late nineteenth and early twentieth centuries made
the United States a major centre of Judaism. In the twentieth century a
range of other religions have grown significantly including Islam, and
a host of New Religious Movements, incorporating a wide range of cults,

sects, and other spiritual groups (Giddens 2001: 553). They have also been joined by a host of new ethnic religious groupings stimulated by changing patterns of immigration from Asia and Latin America.

However, to emphasise statistics about church attendance or denominational membership is to paint only part of the picture. Religious traditions in America have always involved visions of America itself. America was where good and evil would struggle in a continuing battle for supremacy in full view of the rest of the world. It may be that America's divine mission would ensure a victory for light over darkness, but the various narratives of that mission have been frequently aware of the dangers of failure. Jonathan Edwards, in the early eighteenth century, on the one hand, located America as the place where God's plans for the world would be realised, where the 'Sun of righteousness' would shine over a paradise set in the wilderness of the West, but at the same time he could issue apocalyptic warnings about the ever-present threat of hell and eternal damnation. The religious dimension to the story of America, where good and evil exist alongside each other, has been a pervasive theme in the country's expressive culture, giving it a powerful resonance beyond the history of specific churches and often endowing its language with special meaning and force. From this perspective, religious imagery and behaviour have had an important part to play in disagreements over how American identity should be defined, and who should be involved in that process. This has been true for much of American history, but it is striking how much religion continues to influence what have been described as the contemporary culture wars.

## CHURCH AND STATE

The importance of religion in American culture may, on the one hand, seem surprising since as part of its historical development the United States relinquished the concept of an established church and instead opted for religious freedom, and a system of churches based on the voluntary principle. The words of Article 6 of the Constitution make the point clearly: 'no religious Test shall ever be required as a Qualification to any Office or public Trust under the United States'. This is reinforced by the declaration in the First Amendment that 'Congress shall make no law respecting an establishment of religion, or prohibiting the free exercise thereof'. For Thomas Jefferson, these provisions were intended, as he suggested to a group of Baptists in 1802, to 'build a wall of separation between church and state' which would prevent mutual interference. The principle of the separation of church and state assumed the secular identity of the state and forbade it from the promotion of specific forms of religious belief and practice. In the contemporary world

it has often been argued that those societies in which religion has continued to survive as a major force have been those where the church has been an arm of the state. Secularisation, in contrast, went hand in hand with modernisation which by its very nature offered a series of irresistible challenges to traditional forms of religious influence. Economic growth, technological sophistication, wider educational provision, and the development of new forms of popular culture, would all weaken the grip of religion on ordinary citizens, and usher in a society where the blinkers of religious belief would be discarded in favour of rational and self-determined choices about how to live the good life. However, in the United States the decision to avoid established religion on the European model clearly has not demonstrated an inexorable link between modernisation and the decline of religious observance. In his discussion of the links between religion and politics in the United States, Kenneth Wald argued that the United States was 'a conspicuous exception to the generalisation that economic development goes hand in hand with a decline in religious sentiment' (Wald 1987: 6).

Elsewhere in the Western world, the development of modern societies has been reflected in patterns of religious decline, but in America this does not appear to have happened in quite the same way. Secularisation, of course, can be measured in other ways than formal church membership. Churchgoing does not necessarily imply profound belief, and positive answers in opinion surveys may disguise a fairly low level of genuine commitment. At the same time, too, assessing the impact of secularisation needs to take into account the extent to which religious organisations are able to exercise an influential public role. High levels of church attendance may still be accompanied by a decline in the political and social influence of church groups. Whatever the answers to these questions, it remains the case, as Robert Handy has succinctly put it, that the provisions of the American constitution 'meant that the churches would increasingly become wholly voluntary institutions, dependent on their ability to reach and persuade free people to join and support them, and that religious pluralism would markedly increase' (Handy 1976: 142). This emphasis on persuasion and competition, what has been described as the 'free market of American popular religion' has characterised American religion ever since the late eighteenth century and appears to have encouraged rather than deterred religious activity (Carpenter 1997: 4). Moreover, religious freedom has not necessarily meant neutrality about the importance of religion in American life. As the social indicators appear to suggest, religion is clearly of central importance in American culture, even though it is not 'established' in any formal sense through a national church. The motto of the country is 'In God we trust'; the federal Congress has chaplains who watch over its business and pray for its successful conclusion;

church properties are able to claim tax exemption; and oath taking in court involves the pledge 'so help me God'. When incoming American Presidents make their Inaugural Address, custom and popular expectations demand some reference to God's purpose for America. 'In this dedication of a Nation we humbly ask the blessing of God', declared Franklin D. Roosevelt in 1933. 'May he protect each and every one of us. May he guide us in the days to come.' Dwight D. Eisenhower in 1957 sought 'before all else . . . upon our common labor as a union, the blessings of Almighty God'. The Roman Catholic John F. Kennedy concluded his remarks in 1961 by asking God's blessing and his help, but knowing that here on earth God's work 'must truly be our own' (Wrage and Baskerville 1962: 161, 313–14, 320). In 1985 Ronald Reagan declared:

> For all our problems, our differences, we are together as of old, as we raise our voices to the God who is the Author of this most tender music. And may He continue to hold us close as we fill the world with our sound – sound in unity, affection, and love – one people under God, dedicated to the dream of freedom that He has placed in the human heart, called upon now to pass that dream on to a waiting and hopeful world.
>
> (Reagan 1985)

'God Bless America,' wrote Irving Berlin in 1939, 'My Home, Sweet Home', a song which has come to serve almost as an alternative national anthem.

It is against this background, that we want, in this chapter, to look at some of the ways in which religion continues to resonate in contemporary American society, and at how the issues it raises influence debates about such topics as the proper division between the sacred and the secular, the private and the public. Our approach is necessarily selective here and does not attempt to provide a survey of American religious practice as a whole.

Rather, we have chosen areas for discussion which seem to us to offer insights into the continuing debates about the importance of religion in the modern United States, and the part it plays in contributing to the formation of a national identity, in a manner which we hope will connect with themes explored in other chapters, notably Chapter 1 and Chapter 2.

## THE EYES OF ALL PEOPLE SHALL BE UPON US

The fate of America has from the very beginning been entwined with notions of religious destiny, which stretch back to John Winthrop's vision, in the early seventeenth century, of Massachusetts as a 'city upon

a hill', with the eyes of the world upon it (see the discussion in Chapter 1). Puritans like Winthrop envisaged a community in which life would be guided by God's will, and there would be close links between civil government and religious authority. Using the biblical precedents of Genesis and Exodus, the Puritans presented themselves as God's Chosen People, searching for the Promised Land. William Bradford, in his journal *Of Plymouth Plantation*, testified at length to the religious significance of the Puritan destiny. Having battled across the Atlantic, the first settlers encountered 'a hideous and desolate wilderness, full of wild beasts and wild men', without 'friends to welcome them nor inns to entertain them or refresh their weather-beaten bodies, [nor] houses or much less towns to repair to, to seek for succour'. All that was left to sustain them was 'the Spirit of God and His Grace' (Miller and Johnson 1963: 100–1). At the beginning of his epic ecclesiastical history of New England, *Magnalia Christi Americana*, first published in 1702, Cotton Mather presented his central theme.

> I write the *Wonders* of the Christian Religion, flying from the Depravations of Europe to the *American Strand*: And, assisted by the Holy Author of that *Religion*, I do with all the conscience of *Truth*, required therein by Him, who is the Truth itself, Report the *Wonderful Displays* of his Infinite Power, Wisdom, Goodness and Faithfulness, wherewith His *Divine Providence* hath *irradiated* an *Indian Wilderness*.
>                                                                                    (ibid.: 163)

Puritanism had begun to lose its energies by the end of the seventeenth century, but it bequeathed to subsequent American culture a sense of the importance of God's purpose for the nation. The Great Awakening of the eighteenth century, which emerged at a time when many colonists had come to believe that religious piety was in decline, provided the opportunity for a fresh reaffirmation of God's role in directing the fortunes of his chosen people. It emphasised the importance of the Millennium, when Christ would return to establish a new kingdom on earth over which he would reign for a thousand years before the Last Judgement. The Millennium, in the words of the evangelist Samuel Hopkins in his *Treatise on the Millennium* published in 1793, would be a time of 'eminent holiness' when there would be 'a great increase of light and knowledge'. It would be a time of universal peace, love and general and cordial friendship, when truth and harmony would prevail over error and conflict. The earth would be marked by 'great enjoyment, happiness and universal joy. . . . All outward worldly circumstances would then be agreeable and prosperous.' Here religious prophecy merged with republican optimism to describe a coming golden age of benevolence, prosperity and righteousness' (Wood 1990: 45–53). The Revolution, while

it reinforced the special destiny of the United States in political terms, acted as something of a solvent on traditional forms of religion, by cutting churches loose from government, and by encouraging rationalism and concepts of individual liberty. In the 1790s formal church membership for white adults may have dropped to as low as 10 per cent of the population. However, as in the early eighteenth century, concern over the decline of religious belief was in turn followed by a fresh wave of revivalism known as the Second Great Awakening, which had a profound impact both on the scale of church membership, and on the range of American sectarianism. In the nineteenth century, despite the republican commitment to freedom of religion, Americans themselves as well as external commentators frequently remarked on how important broad religious values were for some sense of national identity.

The most important of European writers on America, Comte Alexis de Tocqueville, wrote in 1835, in his classic text, *Democracy in America*, that America's westward progress was providential in that it was 'like some flood of humanity, rising constantly and driven on by the hand of God'. The phrase 'manifest destiny', coined in 1839 by John L. O'Sullivan, a New York editor, expressed similar attitudes and encouraged the expansion of American borders, and the spreading of American influence. Henry F. May has discussed how these kinds of attitudes in the early nineteenth century meshed with evangelicalism and revivalism to form what has been described as the religion of the Republic, a national religion which in his words was 'Progressive, Patriotic and Protestant' (May 1983: 179). It was progressive in the sense that it incorporated the belief inherited from the eighteenth-century Enlightenment that mankind had within it the capability to improve its position through the application of reason and science. At the same time it drew on the pervasive popular hope in mainstream evangelicalism about the advent of the millennium and the establishment of God's kingdom on this earth. As part of this process the world would be converted to Christianity and democracy in a manner which connected America's historic destiny to the full implications of the Protestant Reformation, particularly its belief that salvation would be obtained by faith, and that all believers were members of the priesthood, concepts which May argues worked as well for the secular as for the sacred sphere. This Protestant worldview also emphasised the importance of personal morality both for individuals and for the success of the national project. All of this would be achieved within America, to which God had given a special purpose in the world. May argues that this discourse prospered during the nineteenth century reaching something of a peak in the late nineteenth and early twentieth centuries, where it was reflected not only in a range of religious activists like Henry Ward Beecher and Washington Gladden but also in political leaders like Theodore Roosevelt, and above all

Woodrow Wilson, whose views about America's role in the wider world contained many of these assumptions. What damaged this vision was the disillusionment which followed the end of the First World War. In 1919 a range of American churches launched the Interchurch World Movement which aimed to convert the whole world to evangelical Christianity through a mighty crusade that would be the 'greatest programme undertaken by Christians since the days of the Apostles'. The movement collapsed, however, without achieving any of its aims, and this, for May, marked at least the end of the hegemony of the progressive, Protestant strand in American religious discourse, though it remained a significant force in the way many Americans thought about their country and its place in the world (May 1983: 163–83). By that stage, of course, American religion had become much more varied in its make-up. The great waves of immigration of the nineteenth and early twentieth century brought with them a massive influx of fresh Christian and non-Christian beliefs which served to dilute the Protestant domination of American religious culture. By the early twentieth century, for instance, Catholicism had become a major force in American religious life, sustained by a highly organised parochial system, and with strong links to the international Catholic Church. At the same time Judaism had become well established, particularly in the major cities of the East Coast, where large numbers of Jewish migrants from Eastern Europe settled in the late nineteenth and early twentieth centuries. Many Protestants were alarmed at the threat these developments posed to 'the American tradition', and threw their support behind such movements as the campaign to end unrestricted immigration, in part because it promised to prevent further erosion of the religious beliefs which had guided the Republic through the first hundred years of its history. By the 1920s, however, it was too late, and much more extensive patterns of religious diversity had become firmly entrenched on American soil.

## CHANGING PATTERNS IN AMERICAN RELIGIOUS LIFE

### Variety and secularisation

This emphasis on the variety of its religious life continued to characterise the American experience after the Second World War. Against this backdrop, however, a number of important themes emerged. First was the resurgence of religious involvement in the late 1940s and 1950s. At the same time, however, the expansion and diversification of the economy encouraged a continuing shift towards secularisation in terms of the patterns of daily life. Major religious groups gradually found themselves adjusting to the demands of modern culture, in ways which perhaps began the process of diluting their distinctiveness from each

other. This was a process that operated at different speeds and at different times across the country, but it was nevertheless far-reaching. The traditional Sunday, for instance, in which patterns of life were lived according to a routine of expected church attendance, and there was little opportunity for any other kind of activity outside of the home, came under considerable pressure. Community custom, sometimes reinforced by 'Blue' laws, had ensured that Sunday was very different from other days of the week. Since the Second World War, however, the whole concept of Sunday as a special day set aside for prayer and rest came under attack from a host of rival attractions such as restaurants, shopping malls, supermarkets and cinemas. Norman Mailer put the charge succinctly in *Advertisements for Myself.* 'American Protestantism has become oriented to the machine, and lukewarm in its enthusiasm for such notions as heaven, hell and the soul' (Mailer 1968: 348). To this extent, then, secularisation appears to have had an effect on the way people lived their religious lives on a daily basis. The statistics cited at the start of this chapter may appear to contradict this argument, but seen from this angle they represent the popularity of a diluted, generalised form of religion in which the importance attached to sharply defined matters of theology or dogma has given way to a broader acceptance of what Will Herberg called 'the American Way of Life' (Herberg 1955: 86–94).

## Weakening of denominational loyalty

As part of this process, it has been argued, major religious groups began to lose the qualities which marked them out from each other, and, as a result, their traditional hold on their members began to slip. One conventional attribute of religious behaviour in the United States had been the importance of denominational loyalty. Throughout the nineteenth and early twentieth centuries American denominations frequently asserted the supremacy of their own missions as against the errors and apostasies of their rivals. The division was perhaps clearest in the split between Catholics and Protestants, and American history is littered with outbreaks of conflict between the two. As late as the 1950s a leading Catholic churchman, Cardinal Francis Spellman, Archbishop of New York, could refer to Protestants as unhooded Klansmen. Tensions were also frequently apparent within Protestantism, and encouraged that tendency towards sectarianism which has been such a marked feature of American society. However, in the period since the Second World War, in particular, significant changes began to dilute the firmness of the attachment Americans had to a specific denomination. As late as 1955, a vast majority of church members remained loyal to the denomination of their childhood. By 2000, however, something like a third of

adults had switched from the denomination in which they had been reared. In some of the older denominations this trend has been particularly striking. Presbyterians, Methodists and Episcopalians all have recently witnessed significant loss of members to other denominations of the order of around 40 per cent. Even Catholics, Baptists and Jews have shown significant losses of around 25 per cent. What this trend appeared to show, in part, was an increasing tendency for American worshippers to experiment with attending services across traditional boundaries. Almost two-thirds of Americans in the 1980s attended the church services of at least three different denominations, a trend which appears to be encouraged by educational background and inter-marriage. At those services, too, they could expect to receive an increasingly warm welcome, as denominations themselves relaxed rules on participation. Surveys in the 1970s and 1980s suggested that most Protestants were in favour of more cooperation between local churches and generally sympathetic to the beliefs and practices of Protestants in other denominations. This shift has not only been apparent within the Protestant Churches but also between Catholics and Protestants. The successful participation of Catholics in American political life at the highest level was crowned by John F. Kennedy's election in 1960 as President. Marriages between Catholics and Protestants had become far less controversial by the early twenty-first century than they had been in the 1950s. As ecumenism spread throughout considerable sections of the Christian world, Catholics and Protestants frequently cooperated at a local level in a way which would have been unthinkable fifty years before.

**Orthodox versus progressives**

On the other hand, this weakening of denominational loyalties did not lead to a broad cross-religious consensus on public issues, in opposition to a secular perspective, as the discussion of fundamentalism (see p. 119) makes clear. Instead a sweeping ideological realignment took place across denominational boundaries. In place of the traditional division between Catholics and Protestants, for instance, what emerged was a growing affinity between orthodox and progressive groups within different religious groups. By the 1980s, surveys increasingly found that those who held orthodox views on the theology of their faith, whatever the denomination, often had more in common on a range of public issues with orthodox members of other denominations than with progressive members of their own faith. The obverse was also the case, as progressives of one faith frequently made common cause with progressives of another. Generally orthodox opinion was sympathetic to what might be described as a right-wing set of political and cultural attitudes, while

progressives were more likely to veer towards liberalism. If one takes the example of America's role in the world, for instance, a major 1987 survey found that a considerable majority of the orthodox within Protestantism, Catholicism, and Judaism believed that America was a 'force for good' in the world, while a slight majority of progressives believed that her influence was either 'neutral' or a 'force for ill'. The orthodox were far more likely to be suspicious of government pro-grammes like social welfare, while progressives were much more likely to be sympathetic to federal reform programmes. These divisions between orthodox and progressive within denominations were reflected in an increasing number of alliances across what were often in the past unbreachable barriers, as like-minded believers came together to make common cause on the cultural issues that concerned them. Though one way of categorising these alliances was to see them along a conservative–liberal political spectrum, they also reflected a much deeper disagreement over the sources of moral authority. For the orthodox, moral authority came from God's will for the world; for progressives moral authority was to be found in rational attempts to come to terms with the world, without relying on external authority. Two recent commentators conclude that it was

> these opposing conceptions of moral authority [which] are at the heart of most of the political and ideological disagreements in American public discourse – including the debates over abortion, legitimate sexuality, the nature of the family, the moral content of education, Church/State law, and the meaning of First Amendment free speech liberties.
>
> (Hunter and Rice 1991: 331)

## CONTEMPORARY EVANGELICALISM

The weakening of older denominational loyalties has been accompanied by the continuing vitality of evangelical Christianity as a major charac-teristic of American religion, sometimes, but by no means always, associated with fundamentalist traits. Evangelicalism is a flexible term but generally includes an emphasis on the significance of the conversion experience (being 'born again'), the authority and accuracy of the Bible (but not necessarily its literal truth), and a commitment to religious activism (or evangelism). Probably about 35 per cent of the total popu-lation, amounting to as much as 100 million people, were defined as evangelicals at the beginning of the twenty-first century. Evangelicalism is sometimes described as a style of religious practice, which could be found across the religious spectrum, and marked even parts of the Roman Catholic Church, but it was most clearly evident in the popularity

of fundamentalists (defined as those who believe in the literal truth of the bible), Charismatics and Pentecostals. Its most controversial and sensational popular representation could be found in the growth of television preachers since the 1960s, who were able to reach massive new audiences through their exploitation of the electronic media, but despite their undoubted success and the attention which has been paid to them, they were not fully representative of the sheer variety of evangelicalism, particularly at a grass-roots level.

## Coming to terms with modernity

Evangelicalism in practice is an extremely varied form of religious expression, which goes beyond the temptation in the media to equate it either with fundamentalism, or with political conservatism. We shall be exploring below the links between evangelicalism and the political Right in the period after 1970, but throughout the post-war era there have been other successful evangelical movements which have sought to try to adapt evangelicalism more effectively to mainstream American life, rather than simply call for the restoration of the old ways. One representative figure of this strain in modern evangelicalism has been Billy Graham, who was educated at the stronghold of conservative fundamentalism, Bob Jones University in Greenville, South Carolina, but whose crusades since the 1950s have sought to appeal to many ordinary Americans in a manner that was self-consciously inclusive. At the height of the Cold War he could certainly be described as anti-communist, but also often showed some sympathy for liberal issues. In the late 1960s, he was sometimes criticised by more politically right-wing evangelicals who felt that his willingness to admit that racism and poverty were pressing problems in contemporary America was betraying the cause. This is a reminder that religious conservatism did not always imply political conservatism. Most black evangelicals, as we shall see below, hardly fitted into that equation, and even one of the fastest growing of all evangelical groupings, the Southern Baptists, contained a significant liberal wing. A number of prominent evangelicals have also been sympathetic to domestic liberal causes, most notably Jimmy Carter, the former Governor of Georgia, who was elected as President in 1976. Carter talked openly during his campaign about being 'born again', about how the experience of conversion had transformed his life, and encouraged a commitment to social justice at home and human rights abroad.

Another feature of post-war evangelicalism has been the attempt to use its influence to try to restore some sense of community in a society which it sees as threatened by increasing divisions between individuals and groups. In a considerable number of American cities the size of many evangelical congregations has encouraged their emergence as

alternative communities which offer shops, schools, and a whole array of social and cultural institutions alongside their staple religious services. Willow Creek Community Church in South Barrington, in the north-western suburbs of Chicago, has a regular weekend congregation of 20,000 and its physical appearance is something of a cross between a giant corporate headquarters and a shopping mall. Its services are carefully crafted and choreographed, more like variety shows, with a sophisticated packaging aimed at its mainly white middle-class audience. The church is equipped with extensive lighting and sound systems, and video recording systems which capture on tape every detail of the weekly meetings. Its services and values are based on market research carried out in the 1970s, which discovered that one way to recapture suburban support was to adapt to its surrounding culture. It has a Board of Directors, and uses the language of business administration to convey its message. Willow Creek is unashamedly based on the premise that religious truth can be packaged and sold in much the same way as any other product. Its supporters insist that this truth is unchanging but its presentation in a form which is congenial to its suburban audience allows it to be communicated in a manner which would otherwise be impossible. Adherence to the literal truth of the Bible and the experience of being born again are presented in the carefully crafted language and form of mainstream popular entertainment. There is also a strong emphasis on the church as a source of community in a world where other social institutions are seen as weak or inadequate. Willow Creek, according to its own prospectus, is a centre of activity, fellowship and learning for the hundreds of sports teams, youth groups and children's ministries that meet regularly, a community where families and friends can meet to talk, eat and share each other's lives as they sit in the 750-seat Atrium/Food Court. It also provides a range of support services for its members, which cover such areas as recovery from addiction, financial advice, and family counselling, as well as practical workshops teaching basic skills like car maintenance and do-it-yourself (Willow Creek Community Church 2005). Willow Creek's success has made it a model for many other similar community churches across the country, which have also sought to make contemporary evangelicalism much more palatable and accessible. (Shibley 1996). As in the 1920s, when attempts to modernise church services aroused criticism from more orthodox sources, the community church has its critics, who have generally argued that it has given in rather too easily to contemporary culture. Market research and adaptation to the demands of modern consumerism are an insufficient guide to what form religious belief and practice should take. To rely on them overmuch is to abdicate the Church's traditional responsibility to give people what faith and doctrine say they need, rather than what people themselves say they want.

Another example of the scope and energy of modern evangelicalism can be found in its cultural activity, as it entered into the popular American mainstream. An early example was the success of *The Late Great Planet Earth*, by Hal Lindsey, which became the best-selling non-fiction book of the 1970s, with its prophecy that the end of the world would come in 1988. By 2000, Christian music was the fifth largest genre in the country with gains of 11.5 per cent in album sales compared to 6.2 per cent for the music industry as a whole. Even more striking was the growth of popular fiction. The Reverend Tim LaHaye and Jerry Jenkins, authors of the 'Left Behind' series, have reached a huge readership with their ongoing novels about the 'rapture', when, at the end of the world, those who have been born again will disappear and rise up into heaven. The series is estimated to have sold *c.* 40 million copies since its first publication in 1995, making the pair amongst the best-selling novelists in the US in 2005. Together with children's versions, and audio and comic formats, the series earns $100 million annually. Using a fast-paced thriller structure, the books portray the struggle between good and evil in the seven-year period from the beginning of the rapture to the Second Coming. The aim of the series clearly is to evangelise as much as it is to entertain. 'I think if you cut us, Jerry and I would bleed red, white and blue', says LaHaye. 'We believe that God has raised up America to be a tool in these last days, to get the Gospel to the innermost parts of the earth' (Safer 2004). At the same time, too, the novels explain the world, by providing a series of answers to perplexing problems both at home and abroad. They also provide an endlessly replayed vision of a happy ending, though one that avoids the trap of specificity in terms of time. The concept of the 'last days' proves sufficiently indeterminate to allow the series to be extended into a number of 'prequels' which have the effect of postponing Armageddon just a little further. The end of the world will certainly come, but just not yet.

## Fundamentalism

Fundamentalism is often loosely used as an alternative to evangelical-ism, but it is perhaps more accurate to see it as a strand within the wider movement. Fundamentalists may be described as evangelicals, but not all evangelicals are fundamentalists. Part of the problem, as Joel Carpenter has argued, is that it has 'become a word of wide usage and immense symbolic power ... that represent(s) deep and long-standing cultural conflicts in modern America'. As a result it has often been used in a generic way to describe American religious conservatism, at the expense of obscuring the unique identities of specific American religious groupings (Carpenter 1997: 4–6). This temptation to describe funda-mentalism in generalised terms, has also been encouraged by the

movement's ongoing temptation to get involved in American cultural politics, as spokespersons for the 'true' American way. Fundamentalism had its roots in a strand of Protestant evangelicalism, which emphasised the saving of the individual soul as against some form of accommodation with the modern world. Hopes for a progressive transformation of society were doomed. In the words of one of its most influential spokesmen, Dwight L. Moody, 'The Earth is going to grow worse and worse' and the distinction between sinners and those who had been saved would become ever clearer. Men needed to be saved from the world rather than needing to work to change it. In contrast to the post-millennial beliefs of many late eighteenth- and early nineteenth-century preachers, this tradition, sometimes described as pre-millennial, argued that conditions on earth would inexorably worsen until Jesus returned to establish his Kingdom at the battle of Armageddon. Until then true believers should concentrate on saving their own souls, for only they would not have to suffer the tribulations accompanying the final struggles between Christ and Antichrist. Instead, they would rise into the air to meet Christ in the 'secret rapture' (as described in Tim LaHaye's novels discussed above), and thus escape the terrors of the end of the world. The point of religion was to prepare yourself for the rapture. This trend was reinforced by the crusades of the late nineteenth century against vice and alcohol, and the revivalist attempts by figures like Moody to resist the modernising and liberalising forces at work in early twentieth-century America. It was suspicious of the liberal sympathies of the Social Gospel, and of the spread both of other religions, often associated with the immigrant churches, and a renewed rationalism, which sought to come to terms with science and other features of modern society. Between 1900 and 1915, it acquired a newly self-conscious tone with the emergence of 'fundamentalism', a term coined to represent efforts to reawaken evangelicalism to the fundamentals of faith. At the heart of fundamentalism lay a belief in the literal truth of the Bible, and what made it immediately effective was the link between the conviction of its own cause, and the effectiveness with which it spread its message. In a precursor of the direct mailing tactics used so effectively by the religious Right since the 1970s, books and pamphlets containing the fundamentals of faith were distributed widely across the country.

By the 1920s a recognisable coalition of conservative Christian groups had emerged, opposed to the teaching of evolution in the public school system and the influence of Catholicism, as well as older targets like alcohol. During the 1930s and the Second World War, however, religious conservatism moved away from the kind of assertive confrontation with the demons of modern, urban America, which had been reflected in the cultural struggles of the 1910s and 1920s over such issues as prohibition and the public school curriculum. Instead it regrouped, preferring to

focus on promoting its activities at a local and regional level. However, after the Second World War, it once again emerged into the national arena from its bases in the South and the West as it profited from the religious revival of the late 1940s and 1950s, when it gained a strongly patriotic and anticommunist gloss. An important feature of its success was its capacity to organise effectively. Bodies such as Carl Mcintyre's American Council of Christian Churches, and Billy James Hargis's Christian Crusade provided successful examples of leadership and coordination for the Christian Right to use in the 1970s and 1980s. By the 1940s a rising generation of fundamentalist leaders had gravitated toward radio broadcasting and new, electronically inspired entertainment (Carpenter 1997: 236). This highlights a paradox in the re-emergence of fundamentalism as an efficient and effective exponent of the use of modern technology. Many fundamentalists inveigh against the innovations of contemporary society and the way they ensnare the unsuspecting into a trap of consumerism and fulfilment of the self. On the other hand, their message frequently is conveyed through sophisticated use of modern media forms and a willingness to confront what they see as the godless manipulators of popular culture on their own ground.

This was revealed in the way fundamentalism's continued success in the late twentieth century was advanced by torch-bearers like Jerry Falwell, pastor at the Thomas Road Baptist Church Lynchburg, Virginia, and founder of Liberty Baptist College, whose task was to train a new generation of fundamentalist ministers to save America. Falwell had risen to national prominence through the success of his Old Time Gospel Hour which was distributed widely across the country every Sunday morning. Though in the early 1960s Falwell had firmly asserted that churchmen should concentrate on individual transformation rather than social reformation, by 1980 he had changed his mind, and had emerged as the leader of what he called the 'Moral Majority', a movement aimed at pushing back the tide of 'secular humanism' which apparently threatened the stability of American life. It was opposed, amongst many other causes, to the right to abortion, to the Equal Rights Amendment for women, to legal and social equality for homosexuals, and argued strongly for the protection of the traditional family, and for the spread of religious values into areas of American life from which they had been excluded by the doctrine of the separation of church and state. Particularly important here was the issue of prayer in the public school system, which had been barred by the Supreme Court, but which became an important symbol of the renewed fundamentalist commitment to political action. By 1980 the Moral Majority and other conservative religious groupings had attached themselves firmly to the coat-tails of Ronald Reagan's presidential candidacy, in which issues like anti-

abortion and anti-feminism became linked to Reagan's emphasis on the need to revive the free enterprise economy and American military capability

Whatever the importance of the role played by the Moral Majority in helping Ronald Reagan to gain the presidency, in office he proved to be something of a disappointment, failing to deliver on many of the key fundamentalist issues like abortion and school prayer. It was not surprising then that in 1988 televangelist Pat Robertson decided that if politicians were unreliable it might be more effective for religious leaders to run for office themselves. His bid for the 1988 presidential nomination faltered, but it only reinforced the conviction that if the fundamentalist cause was to prevail it had to enter fully into the political mainstream, and, more specifically, play a central role in the organisation and ideological development of the Republican Party (see below).

Another sign of fundamentalism's influence on other evangelicals, and indeed on society more generally, has been its persistence in advocating creationism in opposition to Darwin's theory of evolution. The Scopes trial of 1925 in Tennessee first dramatised this battle on the national stage. Though John Scopes was found guilty of breaking a state law, which banned the teaching of Darwinian biology, the anti-evolution forces were much mocked for their scientific ignorance, and for a while the movement for anti-evolution teaching broke up. Perhaps re-grouped however, would be a more accurate term, for it re-emerged just as strongly at the century's end. This time it took the form of 'intelligent design' (a belief that evolution is not proven and nature is so complicated that it must have been designed by God) as well as biblical literalism. In 2005, 64 per cent of Americans (many of whom normally would not describe themselves as fundamentalists) said they would be open to the idea of creationism being taught in public schools, and 38 per cent said they would like it to replace Darwinian evolution altogether (*Guardian* 2005). Another poll in 2005 indicated that 55 per cent of Americans believed that God created humans in their present form, and another 27 per cent that he guided the process of human evolution (CBS 2004). George W. Bush in the run up to the 2000 election, said that he favoured the teaching of 'different schools of thought', particularly since 'religion had been around a lot longer than Darwin' (Kettle 2005).

Much of this political and social activism points to an ambiguity in fundamentalist attitudes between a pessimistic doctrine of God-willed world decline and the optimistic advocacy of political action (O'Leary 1998: 173). A central strand in fundamentalist theology had been premillennial, emphasising, as we have seen, efforts to save men's souls. The activism of the Moral Majority and the Christian Coalition, however,

indicated a move towards the post-millennial position on the Second Coming. It might be possible to avert the worst aspects of Armageddon, by preparing the way for Jesus's return. Christian action now could help in the transition to the establishment of the Kingdom on this earth. For many Christian activists in the 1980s and 1990s, saving your own soul remained important, but personal salvation must be accompanied by work to establish a truly Christian society. The traditional division between church and state set up by the Founding Fathers had only allowed the spread of humanism and secularism, and therefore disdain for Christian moral values. 'The moral order at the heart of the universe is broken daily in blasphemy, adulterous sex, in lying, disrespect for parents, and coveting', argued Pat Robertson in his tract, *The New World Order*, published in 1992. 'Society encourages, where possible, every imaginable conduct to violate the true moral law' (Breidlid *et al.* 1996: 260). Faced with such a situation, post-millennialism demanded that Christians no longer refrain from political involvement, but commit themselves fully to the task of establishing God's Kingdom. 'It's important for us not to be afraid of political power', declared an Iowa housewife in 1994. 'We have to assume it as it is given to us and God prepares us to take it. Inch by inch, line by line, we move the way God directs us, reviving America to return to her roots.' As these comments suggest, however, this version of post-millennialism looked to the past rather than the future. Preparation for the millennium could be achieved by restoring that older America before a purer past had been sullied by the perils of modern life. As Falwell put it, before his apparent disillusionment with political activism, his aim was a crusade to 'lead the nation back to the moral stance that made America great . . . to bring America back . . . to the way we were' (Combs 1993: 126). In this respect as Carpenter has suggested

> for millions of ordinary Americans, this movement has been an adaptive way of living with modernity. Fundamentalism has offered ordinary people of conservative instincts an alternative to liberal faith in human progress, a way of making sense out of the world, exerting some control over their lives, and creating a way of life they can believe in.
>
> (Carpenter 1997: 9)

## RELIGION AND POLITICS

As the activities of Falwell and Robertson suggest, fundamentalism has played a more overtly political role in American culture since the 1970s, but it is also the case that religion more generally, particularly

evangelicalism, has become increasingly prominent in what have been described as the culture wars of recent American politics. During the cultural turbulence of the 1960s, there was a tendency to underestimate its significance, in part because of the attention paid in the national media to voices of dissent on the left, but this apparent silence was misleading. The unravelling of political liberalism and the collapse of left-wing radicalism at the end of the decade provided a space into which religious conservatism could move, as a self-proclaimed alternative to the supposed collapse of moral values. Moreover, as Steve Bruce has argued, the nature of the American political system allowed considerable social, political and legislative opportunities for religious pressure groups to promote their causes (Bruce 1998: 159).

What has given conservative political influence an extra dimension has been its sophisticated use of the mass media, in particular television, as well as its increasing effectiveness in terms of organisation and communication. As Michael Lienesch has suggested, one important characteristic of the religious Right in action has been the way in which popular preachers have been adept at using the mass media to promote their causes (Lienesch 1993). A great deal of publicity has been given to the electronic church since the 1980s but the kinds of techniques it uses built on the use of radio by such figures as Gerald L.K. Smith in the 1930s, Reverend Carl Mcintyre in the 1940s and 1950s, and Billy James Hargis in the 1950s and early 1960s. All three showed how it was possible to use the media to promote conservative messages beyond the confines of the traditional pulpit. By 2005 the National Religious Broadcasters Association was able to claim a membership of over 1,600 broadcasting organisations, dedicated to communicating 'the Gospel of Jesus Christ to a lost and dying world' (National Religious Broadcasters Association 2005). At the same time, in the 1980s, activists like Richard Viguerie and Paul Weyrich pioneered the use of computer technology to develop more sophisticated methods of contacting potential supporters.

There has been considerable debate about how much impact this activity has actually had, both in terms of electoral success, or actual legislation. Bruce's careful analysis of a range of specific campaigns at state and federal levels in the 1980s and 1990s shows that many of the political aspirations of religious activists remained unrealised (Bruce 1998: 143–89). In the case of George W. Bush the evidence is mixed. In some ways, Bush is difficult to pin down in terms of his religious beliefs. He openly committed to the evangelical cause in the run-up to the 2000 Presidential election, but has never claimed to be 'born again' as did Jimmy Carter. He has often spoken about the significance of his faith as an aid to decision-making and the conduct of policy. He revealed the transformation in his life to a gathering of religious leaders:

I had a drinking problem. Right now I should be in a bar in Texas, not the Oval Office. There is only one reason that I am in the Oval Office and not in a bar. I found faith. I found God. I am here because of the power of prayer.

(Frum 2003: 283)

Though not a fundamentalist, Bush put forward his view of religion as a means to understand the world at a Presidential Prayer Breakfast in 2003. What faith shows us, he declared, is 'the reality of good and the reality of evil. Some acts and choices in this world have eternal consequences', he continued. 'It is always, and everywhere, wrong to target and kill the innocent. It is always, and everywhere, wrong to be cruel and hateful, to enslave and oppress. It is always, and everywhere, right to be kind and just, to protect the lives of others, and to lay down your life for a friend'. Many of Bush's critics inside and outside America mock these kinds of sentiments, but Bush's religious mix appears to conform to the mainstream evangelical *mélange*, rather than any secretive fundamentalist agenda. This was confirmed at his re-election in 2004, when he received 78 per cent of the white evangelical Protestant vote, and clearly profited from the cultural conflicts that had surfaced during the campaign over issues like gay marriage. On the other hand, in terms of legislative achievements, the Christian Right's record remained as limited after Bush's first term as it had been after Ronald Reagan's period in office. This appears to be due both to the centripetal nature of the American political system, which makes it difficult for sectional interests to get their policies realised, as well as to what Bruce describes as 'the general reluctance of Americans to support theocracy' (Bruce 2003: 423).

## AFRICAN-AMERICAN RELIGION

As we have seen elsewhere in this book, one of the central themes in American history has been the interaction between white and black culture, whether in the nineteenth-century South, or across the nation in the twentieth century. Of no area has this been truer than religion. African-American religion has been extremely important both for American religious culture as a whole, and for the black community itself. Malcolm X used regularly to argue that in America 'the black man ha[d] been robbed by the white man of his culture, of his identity, of his soul, of his self'. Slavery in particular had provided the opportunity for the colonisation of the black mind, through the imposition of white values and beliefs, especially Christianity. Any sense of an autonomous African religion had been destroyed by the horrors of the Middle Passage, and the oppressiveness of the plantation system. We will be

returning to the Nation of Islam later in this discussion, but at this stage it is important to note that there is an alternative vision of the part played by the Christian religion in black culture, which has emphasised its significance in encouraging the emergence of black identity and self-worth. This may be traced back to the period of slavery before the Civil War. Under the restrictions of slave society, masters generally assumed control of their slaves' religious behaviour. Christianity was widespread on the plantation, both because many masters encouraged missionary activity and because slaves often converted voluntarily. Slaves generally were expected to worship under white supervision in services held by white ministers, and in the same churches as their masters, though seating arrangements generally were segregated. Nevertheless, despite this emphasis on supervision and control, one of the most striking themes in the slave experience was the way in which the slaves themselves succeeded in developing their own distinctive religious beliefs and practices, in a manner which enabled them to withstand the travails of bondage. What was crucial here was the autonomy they managed to find in the practice of their faith. The evidence culled from their religious behaviour shows that slaves were not simply acted upon, the passive and downtrodden recipients of whatever their master chose to give them but, rather, acted for themselves in a way that was extremely important in encouraging a sense of identity and purpose in their lives. As John Blassingame has put it, 'In religion, slave(s) exercised their own independence of conscience' (Blassingame 1972: viii). Under slavery, African Americans developed many of the features that were to mark black Christianity in the future. Of particular interest here was the way in which slaves meshed African inheritances with the evangelical practices they took from white society.

After emancipation, the freedmen withdrew from the white-dominated churches in which they had been forced to worship before the Civil War, and set up their own religious institutions. For many of them the freedom to leave behind white preachers and their messages of obedience and restraint and to practise their faith in the way that they chose for themselves was an act of immense importance. 'Praise God for this day of liberty to worship God!' declared one ex-slave (Litwack 1980: 465). As a result of this process the new black churches assumed a central position in the lives of African Americans; they quickly became the main social and cultural institutions which blacks made and operated for themselves, and therefore were indispensable in promoting a sense of communal purpose. Black churches provided the organisational framework for most activities of the community: economic, political and educational as well as religious. At the same time, they provided an opportunity for the expression of individual faith in a manner which encouraged a sense of identity, and confirmed God's role in their lives.

In deciding to 'make Jesus their choice', as Cornel West has put it, 'and to share with one another their common Christian sense of purpose and Christian understanding of their circumstances', they created a situation in which their faith enabled them to hope for eventual triumph, however much they were 'seemingly forever on the cross, perennially crucified, continuously abused and incessantly devaluated' (West 1993: 117–18). Within the black churches, their ministers assumed a particular significance, not just as preachers of gospel but also as educators, community organisers and political leaders. W.E.B. Du Bois at the turn of the century would call the preacher 'the most unique personality developed by the Negro on American soil' (Branch 1988: 3).

If one turns against this backdrop to the black experience in post-Second World War America, and in particular to the civil rights movement, then the enduring importance of the black church is readily apparent. As civil rights activity developed at a local level across the South in the 1940s and early 1950s, and then assumed national prominence with the Montgomery Bus Boycott, which began in 1955, religion played a crucial role. It provided, amongst other things, an organisational structure with deep roots in the black community which could mobilise human and financial support in a manner which was largely independent of white society. It also, in the black ministry, provided a ready pool of potential leaders, many of them college-educated, who could draw on a long tradition of testifying on behalf of their congregations. Black preachers brought to the movement a language which allowed them to link contemporary political struggles to the age-old efforts to escape from captivity and reach the promised land.

All of this was reflected in the career of Martin Luther King who, as figure-head of the civil rights movement from 1955 until his assassination in 1968, became the most significant spokesman of his generation for the importance of religion in national public life. This was never an easy task. King faced many critics, both within his own black community, and from the white churches, who argued that his social activism threatened public order, and ran the risk of damaging the spiritual role of the church by dragging it into politics. While it was true, as suggested above, that the black church was an indispensable institutional foundation for the civil rights movement, there were nevertheless many individual black ministers who were fearful of challenging the racial status quo for fear of awakening white reprisals, and this was reflected in the caution of established church groups like the National Baptist Convention. King found here that it was more effective to use new organisations like the Southern Christian Leadership Conference, which he helped to set up in 1957, to stimulate the black churches into social action. By moving outside the established centres of authority in the black religious community, King encouraged a grass-roots revival which would play

an essential role in transforming the face of the South in the 1960s. At the same time, he spoke out against those in the white religious community who argued that episodes like the Montgomery Bus Boycott or the Birmingham Campaign of 1963 brought religion too much into politics. It was the responsibility of politicians to effect political change, not churchmen.

King in his *Letter from Birmingham Jail* argued that such a distinction made no sense when men were confronted with evil. It was vital for the sacred to inform the secular if God's will was to be realised. No society could ever fully meet the exacting aims laid down in the Bible, but it was always important that committed Christians struggle to achieve them. Put another way, civil law had to be judged by higher principles than those of the state. King argued:

> A just law is a man-made code that squares with the moral law or the law of God. An unjust law is a code that is out of harmony with the moral law. . . . Any law that uplifts human personality is just. Any law that degrades human personality is unjust.
>
> (King 1964: 84)

The Jim Crow statutes of the South were unjust because segregation distorted the soul and damaged the personality. Drawing on the German theologian Paul Tillich's argument that sin was separation, King indicted segregation because it exemplified man's 'awful estrangement, his terrible sinfulness' (ibid.: 85). Faced with such evidence of sin, the contemporary church had spoken too often in 'a weak, ineffectual voice, with an uncertain sound'. Organised religion had become too wedded to the preservation of the status quo, when it should be a 'headlight leading men to higher levels of justice'. Faced with compromise and complacency, civil disobedience would reawaken the national conscience, and carry it back to 'the sacred heritage of our nation and the eternal will of God', to all/the best in the American dream'.

As the example of King's career makes clear, Christianity has been central to the African-American experience, but it has been challenged over the last forty years by the rise of Islam as an alternative form of religious behaviour. Islam has owed its growing popularity in America to a number of factors, but particularly influential has been the argument that it was the original religion of those Africans who were captured and brought across the Atlantic as slaves. Whereas the black Christian tradition has emphasised the role it played in giving African Americans a sense of identity and purpose, the Muslim claim that theirs was the true faith has fitted well into the search for African roots in other areas of black life. This argument was given its most forceful and effective statement by Malcolm X, who became the leading American

spokesman for Islam in the early 1960s. He was a member of the Nation of Islam which, despite its name, is scorned by orthodox Muslims, because of its reluctance to believe that Muhammad himself was the last prophet. The Nation of Islam gives that honour to Elijah Muhammad, the former Elijah Poole, who was instrumental in building up the nation in the post-war era. Still, for Malcolm, Islam provided a means for the recovery of an identity which had been stripped from him by white Americans. In America, argued Malcolm,

> the black man has been colonised mentally, his mind has been destroyed, his identity has been destroyed, he has been made to hate his black skin, he has been made to hate the texture of his hair, he has been made to hate the features that God gave him.
>
> (Malcolm X 1980: 263)

The chief weapon of colonisation had been Christianity, which had been imposed on black slaves to make them pliant and obedient. If African Americans were to restore any feelings of self-worth, then they had to reject the religion of slavery and segregation, no matter how pervasive it was in the black community. In its most radical form, Islam assumed a black nationalist tone in the 1960s, specifically rejecting the integrationist approach of King to America's racial problems, and calling for a separatist solution to the country's racial problems. In the last years of his life Malcolm increasingly became drawn to mainstream Islam outside of the United States, and under its influence began to admit that some form of cooperation between the oppressed of both the white and the black race might be possible, but his early death in 1965 left the implications of this move unfulfilled. Malcolm's journey through the particular stages of his life was vividly described in his *Autobiography*, which though it consistently denounces the links between Christianity and racism, itself belongs to a confessional tradition in which the sinner repents of his sins, and through the process of conversion becomes a preacher for his newly found faith. After breaking with the Nation of Islam, Malcolm eventually found some sense of resolution on a visit to Mecca where he joined his fellow pilgrims 'drinking without hesitation from the same glass as others . . . washing from the same little pitcher of water; and sleeping with eight or ten others on a mat in the open' (ibid.: 343–4).

The most recent manifestation of Islam in the United States has been the rise of Louis Farrakhan, like Malcolm also a member of the Nation of Islam. Farrakhan has become a figure of controversy because of the way in which his fervent black nationalism has spilled over into messages of open hostility to white society, and because of his often virulent attacks on American Jews for their historical role as slave traders, ghetto

employers and landlords. Farrakhan's fierce invective, however, cannot hide the continuing success of the Nation of Islam. By 1995 the sect had mosques in about 120 American cities, as well as a range of other social and cultural institutions, which increasingly helped to make it a viable alternative to the Christian Church. An important aspect of the sect is its emphasis on community work of various kinds. It organises its own schools, which are run according to a strict regimen, which emphasises discipline and the virtues of a traditional curriculum. It also operates a range of other community ventures including supermarkets, restaurants, bakeries and bookstores. Recruits have to undergo 'manhood training classes' which underline the importance of good behaviour, a sober dress code, and rigorous self-discipline. Within the black community it runs a range of rehabilitation programmes for drug addicts, alcoholics, ex-prisoners and gang members, emphasising self-help and the need for the community to take more responsibility for its own conduct. As some of this suggests, the Nation of Islam is undoubtedly male in its orien-tation. Women within the organisation are assigned traditional roles, which emphasise housework, child-rearing and clothing regulations that call for them to be covered. Farrakhan, too, shares white conservative concerns that welfare subsidises single women to have babies out of wedlock. Many of these attitudes were reflected in the Million Man March of 1995, when several hundred thousand black men met in the Mall in Washington, DC under the auspices of the Nation of Islam. The success of the march was a clue to the Nation's increasing appeal. To many African-Americans, Muslims are attractive because of the consist-ency between their message and the way they live their lives. Black Christianity, from this perspective, cannot help but be weakened by the compromises it has had to make with white society, partly because of a shared commitment to similar religious beliefs and practices. The reason so many white Americans outside the South were sympathetic to Martin Luther King – members of the Nation of Islam have argued – was that his approach did not directly confront their own involvement in an oppressive system. Farrakhan, in contrast, continually underlines two of the most unpalatable facts about contemporary American life. Many African Americans are full of anger at the oppressive nature of white society, and many white Americans are frightened of their black counterparts.

## CONCLUSION

Ronald Reagan in his 1983 address to the National Association of Evangelicals talked about a 'great spiritual awakening in America, a renewal of the traditional values that have been the bedrock of America's goodness and greatness'. Americans were far more religious than people

of other nations, with 'a deep reverence for the importance of family ties and religious belief'. Americans lived in an imperfect world in which sin and evil existed, but their glory lay in their 'capacity for transcending the moral evils of [the] past'. They would never abandon their belief in God, because it ensured that the source of their strength in the quest for human freedom was not material but spiritual (Erickson 1985: 155–66). Reagan's words, and the support they aroused, testified to the continuing importance of religion in American life, but they also perhaps disguised some of the underlying patterns in religious behaviour which made his picture of a great 'spiritual awakening' in America more complicated than it might at first seem. The evidence of the last half of the twentieth century might suggest that American religion was still thriving, but at the same time it was also changing. Religious behaviour and practice had been forced to adapt to the changing conditions of the late twentieth- and early twenty-first-century world and even where there were apparent strongholds of resistance to modernity, as in funda-mental evangelicalism, these were themselves often created with the weapons and techniques of modern society.

## REFERENCES AND FURTHER READING

Ahlstrom, S. (1974) *A Religious History of the American People*, New Haven, CT: Yale University Press.
Bellah, R. (1988) *Habits of the Heart: Individualism and Commitment in American Life*, London: Hutchinson.
Blassingame, J. (1972) *The Slave Community*, Oxford: Oxford University Press.
Branch, T. (1988) *Parting the Waters: America in the King Years*, New York: Simon and Schuster.
Breidlid, A. *et al.* (eds) (1996) *American Culture: An Anthology of Civilisation Texts*, London: Routledge.
Bruce, S. (1988) *The Rise and Fall of the New Christian Right*, Oxford: Clarendon.
—— (1990) *Pray T.V.: Televangelism in America*, London: Routledge.
—— (2003) 'Religion' in Singh, R. (ed.) *Governing America: The Politics of a Divided Democracy*, Oxford: Oxford University Press.
Carpenter, J. (1997) *Revive us Again: The Re-Awakening of American Fundamentalism*, Oxford: Oxford University Press.
CBS (2004) 'Poll: Creationism Trumps Evolution' at http://www.cbsnews.com/stories/2004/11/22/opinion/polls/main657083.shtml
Combs, J. (1993) *The Reagan Range: The Nostalgic Myth in American Politics*, Bowling Green: Bowling Green State University Popular Press.
de Tocqueville, A. (1965) *Democracy in America*, London: Oxford University Press.
Erickson, P. (1985) *Reagan Speaks: The Making of an American Myth*, New York: New York University Press.
Fitzgerald, F. (1987) *Cities on a Hill: A Journey Through Contemporary American Cultures*, London: Picador.
Frum, D. (2003) *The Right Man*, London: Weidenfeld & Nicolson.

Gallup Poll Tuesday Briefing (2004a) 'A Look at Americans and Religion Today' 23 March, pp. 1–7.
Gallup Poll Tuesday Briefing (2004b) 'Eternal Destinations: Americans Believe in Heaven, Hell' 25 May, pp. 1–4.
Gallup Poll Tuesday Briefing (2005) 'Religiosity Measure Shows Stalled Recovery' 11 January, pp. 1–2.
Garrow, B. (1986) *Bearing the Cross: Martin Luther King and the Southern Christian Leadership Conference*, New York: Random House.
Giddens, A. (2001) *Sociology*, Cambridge: Polity Press.
*Guardian* (2005) 'On the seventh day, America went to court', 2 October.
Handy, R. (1976) *A History of the Churches in the United States and Canada*, Oxford: Oxford University Press.
Herberg, W. (1955) *Protestant–Catholic–Jew*, New York: Doubleday.
Hunter, J. (1991) *The Culture Wars: The Struggle to Define America*, New York: Basic Books.
Hunter, J. and Rice, J. (1991) 'Unlikely Alliances: The Changing Contours of American Religious Faith', in A. Wolfe (ed.) *America at Century's End*, Berkeley, CA: University of California Press.
Keen, J. (2003) 'Strain of Iraq War Showing on Bush, Those who Know him Say' *USA Today*, 2 April.
Kettle, M. (2005) 'Between Science and God', Guardian Weekly, 2 December, at http://www.guardian.co.uk/guardianweekly/story/0,,1654094,00.html
King, M.L. (1964) *Why We Can't Wait*, New York: Mentor.
Levine, L. (1977) *Black Culture and Black Consciousness*, New York: Oxford University Press.
Lienesch, M. (1993) *Redeeming America: Piety and Politics in the New Christian Right*, Chapel Hill: University of North Carolina.
Litwack, L. (1980) *Been in the Storm So Long: the Aftermath of Slavery*, New York: Vintage.
Mailer, N. (1968) *Advertisements for Myself*, London: Panther.
May, H. (1983) *Ideas, Faith and Feelings: Essays in American Intellectual and Religious History*, Oxford: Oxford University Press.
Miller, K. (1992) *Voice of Deliverance: The Language of Martin Luther King and Its Sources*, New York: The Free Press.
Miller, P. and Johnson, T. (eds) (1963) *The Puritans*, New York: Harper and Row.
National Religious Broadcasters Association (2005) at http://www.nrb.org (accessed 23/11/2005).
O'Leary, S. (1998) *Arguing the Apocalypse: A Theory of Millennial Rhetoric*, Oxford: Oxford University Press.
Promise Keepers (2005) at http://www.promisekeepers.org/
Reagan, R. (1985) '2nd Inaugural Address' at, http://www.yale.edu/lawweb/Avalon/presiden/inaug/reagan2.htm
Roth, P. (1988) *The Counterlife*, London: Penguin.
Safer, M. (2004) 'Rise of the Righteous Army', *60 Minutes*, at http://www.cbsnews.com/stories/2004/02/05/60minutes/main598218.shtml (accessed 17/11/2005).
Shafer, B. (1991) *Is America Different? A New Look at American Exceptionalism*, Oxford: Clarendon.
Shibley, M. (1996) *Resurgent Evangelicalism in the United States: Mapping Cultural Change Since 1970*, Columbia: University of South Carolina Press.
Singh, R. (2003) *American Government and Politics*, London: Sage.

Wald, K. (1987) *Religion and Politics in the United States*, New York: St Martin's Press.

West, C. (1993) 'The Religious Foundation of the Thought of Martin Luther King', in P. Albert and R. Hoffman (eds) *Martin Luther King and the Black Freedom Struggle*, New York: Da Capo.

Willow Creek Community Church (2005) at http://www.willowcreek.org/welcome.asp (accessed 24/11/05).

Wood, G. (ed.) (1990) *The Rising Glory of America*, Boston: North Eastern University Press.

Wrage, E. and Baskerville, B. (eds) (1962) *Contemporary Forum: American Speeches on Twentieth Century Issues*, Seattle: University of Washington Press.

Wuthnow, R. (1988) *The Restructuring of American Religion*, Princeton, NJ: Princeton University Press.

X, Malcolm (1980) (first 1965) *The Autobiography of Malcolm X*, London: Penguin.

## FOLLOW-UP WORK

1   How has religion been represented in American cinema? Movies for individual consideration here might include those which treat specific moments/themes in American religious culture, like *Inherit the Wind* which deals with the Scopes trial of 1924 when fundamentalists challenged the teaching of Darwinian biology in the public school system or *Elmer Gantry* which looks at evangelism. Another approach is to look at how religion has influenced the work of specific directors, for instance, Frank Capra or Martin Scorsese. To what extent do films like *It's a Wonderful Life* or *Mean Streets* use religious themes and motifs?

2   The relationship between religion and ethnicity may be fruitfully explored through the work of specific writers like Philip Roth, both in early work like the range of stories collected in *Goodbye, Columbus* (1964) and more self-reflective later novels like *The Counterlife* (1988).

3   The place of religion in popular culture may be explored through its influence on both black and white musical forms. The development of black consciousness and its expression in a range of musical forms, from slave spirituals, through the blues and gospel, to soul raise all kinds of questions about cultural identity. Lawrence Levine's (1977) classic study, *Black Culture and Black Consciousness*, is a helpful starting-point here. Similarly, the importance of religious themes in the country music of the South again raises questions about the construction of cultural identity.

*Assignments and areas for further study*

4   (a) Has the wide range of religious choice in America meant that all religions have equal status? What implications has

America's traditional commitment to religious freedom had for non-Christian religions? How have non-Christian religions such as Judaism and Islam fitted into a society which has tended to assume that America is, above all, a Christian nation? What has religious freedom meant for the different denominations of the Christian church or for non-believers?

(b) How has religious liberty accorded with concepts of secularisation? The principle of the separation of church and state assumes the secular identity of the state, but how far has this been reflected in practice?

(c) What has been the relationship between religious diversity and civic values? If America has never had an established church, has it nevertheless had what has been described as a 'civil religion', in which a number of key shared concepts are articulated in ways that share some of the characteristics of an established religion on the European model? What kind of role have civic traditions and values had in American history where established or national institutions have been relatively weak?

# Chapter 5

# Approaches to regionalism
## The West and the South

Michel Foucault has argued that history has excluded too readily 'particular, local, regional knowledge ... incapable of unanimity', in favour of 'systematising thought', or the official version (Foucault 1980: 82). He calls for the 'subjugated knowledges' 'buried' below to be rediscovered and injected into our perceptions of culture. He calls for a 'genealogy' – a 'painstaking rediscovery of struggles together with the rude memory of their conflicts' – which would combine erudite knowledge and 'local memories' (ibid.: 83) in the understanding of the cultural process. Rather than assume a 'unitary' version of American regions like the West or South, this method insists upon the inclusion of multiple stories of local and regional significance and relates them to a wider inter- or transnational perspective. Such a method takes note of the struggles for power that have marked the burial of certain stories and the elevation of others, and builds them into the analysis. It questions the notion that a particular place or region has a unique or settled set of qualities, and instead argues that stories which have been written about such places have often been written from a perspective that is partial and selective and may even downgrade or omit groups or interests whose experiences or values do not fit with the received version. This is a reminder that we need to take care when we examine the way in which the supposed identity of a place interacts with its history. Generalisations about the character of the South or West may depend upon assumptions about their 'past', which themselves contain untested judgements. This section argues, therefore, for a form of *Critical Regionalism*, a term evolved from the architectural work of Lefaivre and Tzonis and Kenneth Frampton, suggesting a sense of regionalism 'infused with ... relativity', critical of both imposed universalism and naïve localism, and in a 'constant process of negotiation between local and global' (Lefaivre and Tzonis 2003: 34). The recognition of alternative stories in the form of regional variety and difference asserts diversity and pluralism against any totalising impulse, showing an awareness of complex issues of race, gender and ethnicity, balking against assumptions of some common identity, and preferring

instead the assertion of difference. In this spirit, we would concur with Stephanie Foote's comment:

> The local knowledges that regionalism first helped publicize fracture any monolithic narrative of American literature and ... identity. Because it held open the meaning of America and Americanness, regional writing helped to create a way to understand and value social differences, and helped to establish a way of imagining communities that interrupted even as they sustained a national culture.
>
> (in Crow 2003: 40)

Rooted in the actual varied landscapes of America, regionalism exists as a series of critical dialogues with the centre's official histories and definitions and with the world beyond, whilst still celebrating local multiplicity and national diversity.

## CASE STUDY 1: REVISING THE AMERICAN WEST

> All America lies at the end of the wilderness road, and our past is not dead past but still lives in us.... Our forefathers had civilization inside themselves, the wild outside. We live in the civilization they created, but within us the wilderness still lingers. What they dreamed, we live; and what they lived, we dream. That is why our western story still holds us, however ineptly told.
>
> (Whipple 1943: 65)

This quotation begins Larry McMurtry's epic novel of the West, *Lonesome Dove* (1985), and closes the television documentary *The Wild West* (1995).[1] It is both suggestive and ambiguous about the relationship of the 'historic' West to contemporary America's sense of itself. After the transmission of Ric Burns's documentary, one reviewer wrote that, 'Anyone who seeks to understand the United States has first to understand this story, for the West ... "was the place where we became mythic in our own minds"' (*The Observer* 21 May 1995: 21). Like Whipple's statement, this suggests that the development of American culture and identity and how it has seen and defined itself are linked to the West; and second, it indicates the intertwined relationships between the 'mythic' and the historical, that is, between actual events and how they have been told and retold over time. It reminds us that the West is a 'story' over which there has been an endless contest for 'understanding', and lastly, it suggests there might, in fact be, a final understanding, a 'knowing' of the story, which raises the issue of how the 'story' of the West has been produced and received over the last century.

This section will examine how the West, as a region, has been dominant in the way America has imagined itself as a nation. Through representations in different texts we will witness 'a pendulum between a diversity of sectional voices and an ever-new project of unity' (Fisher 1991: xii). By adopting revisionist approaches, we will show the region as dynamic and unsettled instead of one through which a coherent, single American identity emerges.[2] By studying the narratives of place as responses to the West, one acknowledges previously ignored or silenced voices asserting their presence in 'history', just as they have in the culture as a whole. In so doing, they have enriched the whole picture and forced many reassessments of long-held beliefs and assumptions about the formation of the American nation (see the Introduction and Chapter 1). In pursuing these threads, we will also show that the construction of the idea of the West reveals certain ideologies that are central to any consideration of American cultural values: exceptionalism, destiny, power, race, ecology, gender and identity. Through examining aspects of this region, one is able to see universal concerns played out in its local and specific representations, tracing the continued significance of the West in the American imagination.

## IMAGINED WESTS

In Michael Crichton's film *Westworld* (1973) an organised theme park becomes out of control when illusions take on a frightening and brutal reality. At the heart of the pleasure park is the most popular resort, 'Westworld', in which rich, white middle-class, urban, male Americans take on the personae of Wild West gunfighters, with the guarantee that their fantasies will be played out under a safe and structured set of rules. This is a simulation of a particular version of the West, with all the outcomes pre-arranged and ordered, and a script ready to be followed. When the robot gunfighter (Yul Brynner) breaks out of the neatness of the script, the version of the West is radically altered. Blood, death and fear enter the previously safe and constructed world of 'history'.

In many respects, the film articulates the nature of the American West's relationship to the American cultural memory. The West has too often become a neat script, mixing mythic notions of heroism with stories of the formation of the 'true' character and institutions of the nation forged in its confrontation with 'wilderness'. This orderly vision, as we shall see, has been disrupted in recent years by a 'New Western History' [3] which has sought to revise these 'scripts' of the region and unsettle and challenge the myths that have persisted for so long as central tenets of Americanism. The comforts of such old histories have been disturbed by the intrusive new force, like Yul Brynner's robot, bringing in its wake a new consciousness about the West's past and future. As in the film,

once the challenge is made to the bastion of 'reality' that determines the 'world of the West', this new history is a site of struggle and resistance, conquest and death, and contention and confusion rather than neat, orderly patterns of existence. *Westworld* is akin to myth because

> Myth functions to control history, to shape it in text or image as an ordained sequence of events. The world is rendered pure in the process; complexity and contradictions give way to order, clarity, and direction. Myth, then, can be understood as an abstract shelter restricting debate.
>
> (Truettner 1991: 40)

In a similar way, Disneyland's 'Frontierland' puts the West at the centre of American history and character as a 'tribute to those hardy pioneers . . . [and] frontier way of life . . . symbolized by the coonskin cap and the cowboy hat, the calico sunbonnet and the plantation straw' (Fjellman 1992: 73). The assumptions are part of a ' "Disney realism", sort of Utopian in nature [which] . . . program[s] out all the negative, unwanted elements and program[s] in the positive elements' (Zukin 1991: 222). In E.L. Doctorow's radical novel, *The Book of Daniel* (1971), Disneyland's 'monorail' directs, not just people, but their views, 'like a birth canal', permitting them to participate in 'mythic rituals of the culture', where 'historical reality' becomes a 'sentimental compression . . . [a] radical process of reduction', and what remains is 'a substitute for education and, eventually a substitute for experience'. Just as Disneyland reduces history to a simple tale, 'totalitarian in nature', and excludes all elements that do not fit its pattern, it also excludes marginalised people, according to Doctorow, who do not conform to the park's idea of America: 'There is an absence altogether of long-haired youth, heads, hippies, girls in miniskirts, gypsies. . . . Disneyland turns away people it doesn' t like the looks of (Doctorow 1994: 292, 294–6). Both Disneyland's representation of the West and its dramatisation in the theme park of Westworld exemplify the dominance of the region in the nation's efforts to define its identity.

An earlier attempt to centralise the importance of the West in the history of the nation was Frederick Jackson Turner's 'The Significance of the Frontier in American History', given as a lecture at the Columbian Exposition in 1893. He argued that on the frontier, a 'line' between savagery and civilisation, American 'traits' and institutions were forged in contact with a variety of forces, of which three were 'free land', nature and the Indian. Turner's 'thesis' attempts to *explain* American progress across the West, as if the complex histories of the region could be organised, like Disneyland, into an identifiable, single shape. 'Turner, in 1893, seemed to have the field of Western American History fully corralled,

unified under the concept "frontier". . . . In fact, the apparently unifying concept of the frontier had arbitrary limits that excluded more than they contained' (Limerick 1987: 21). Turner's 'corral'[4] was constructed to exclude certain views of America and exclude a number of other voices and interpretations which did not fit the particular story he wanted to tell. As Turner had written in 1889, four years before delivering his thesis, 'American history needs a connected and unified account of the progress of civilisation across the continent' (Trachtenberg 1982: 13), and the notion of a 'frontier' provided the opportunity for him to produce a 'coherent, integrated story' (ibid.: 13), a creation story for America. However, Turner's 'corral' defines America by exclusion, measuring its resilient 'character' against Native Americans, the land and by little or no reference to women or other ethnic groups. It creates a 'cultural myth' (ibid.: 17), controlled like Disneyland: tidy, simple and apparently natural, that is, in a manner which makes its contents appear to be acceptable and 'taken-for-granted'. Turner's language reveals precise ideological readings of the West as a vacant place available, because of its primitive state, to the 'advance' of the urban, sophisticated developments that appeared inevitable and natural. It was a 'wildernesss' to be won by creating 'progress out of the primitive' (Milner 1989: 2) in a movement as 'natural' as glaciation, but predicated upon the diminishment of the Native American, the silencing of women and the 'masterful grasp of material things' (ibid.: 21) implied in a phrase like, 'in spite of environment' (ibid.). Revisionism and the reassertion of marginalised voices in the West have permitted a critical reassessment of Turner's grand narrative. To borrow from Limerick, 'Exclude women [*Native-Americans and their relationship to land*] from Western history, and unreality sets in. Restore them, and the Western drama gains a fully human cast of characters' (Limerick 1987: 52 – our additions in italics). Revisionism can enlarge what the thesis had reduced and show the West not as a 'corral', but an open range of contesting forces, a 'liminal landscape of changing meanings' (Kolodny 1992: 9) in which ethnic, racial, linguistic, gender and geographical diversities have entered the critical arena (see Comer 1999, Robinson 1998).

## LAND AND THE WEST

The examination of regions is, as we have seen, only partly about geography, but always about place and space. The responses to and representations of the Western landscape have been central to the diverse human interactions within the region, and to study them reveals much about the ecological attitudes prevalent over time in region and nation. One of Kolodny's 'changing meanings' is clearly that of land, and to

trace some of these changes is to see how the West's ecology has been interpreted differently by those who lived within it.

For Native Americans, the land is sacred, bound up in an intricate web of meaning with all living things, including humankind. The land cannot become property because 'We are the land, and the land is mother to us all' and 'the land is not really a place, separate from ourselves' (Gunn Allen 1992: 119). The abundant wholeness at the centre of this ritual imagery is contained in the metaphorical 'sacred hoop' or circle of being, which is 'dynamic and encompassing' (ibid.: 56):

> In American Indian thought, God is known as the All Spirit, and other beings are also spirit. . . . The natural state of existence is whole. Thus healing chants and ceremonies emphasize restoration of wholeness, for division is a condition of division and separation from the harmony of the whole.
>
> (ibid.: 60)

In contrast, many Anglo-Americans came to the land 'as possessive individuals pursuing private dreams, trying to fence in their portion of the whole' and 'thought about the land as they thought about each other, in simplifying, fragmenting terms' (Worster 1994: 14–15). As Sitting Bull said, 'healthy feet can hear the very heart of Holy Earth', but the white invaders of his nation's lands had 'a love of possession [which] is a disease with them' and sought to 'claim this mother of ours, the earth, for their own and fence their neighbors away . . . [and] deface her with their buildings and their refuse' (Turner 1977: 255). Thus ecological imperialism was part of the process by which existing Indian attitudes to the land were altered by the arrival of the settlers.

In the West the capitalist ideology of ownership found a perfect manifestation; it was a 'cultural imperative' (Limerick 1987: 53) to see the land as something to divide, distribute and register. As we have seen, the Turner thesis was based upon the premise that there was 'free land' into which the white settlers came 'winning a wilderness' (Milner 1989: 2). If it was 'free', it was also 'vacant' and 'virgin' to the white settlers, with strong connotations of the promised land, imbued with a mystical sense in early painted images. This linked it with biblical stories of a new Canaan, suggesting the 'fecundity and promise of the New World and the untold riches that lay in its dark and unexplored corridors' (Greenblatt 1991: 85). Herein lies a constant theme in the history of the West – the conflict between the longed-for possibility of spiritual renewal (fecundity) and the pull to the materiality of wealth (riches). The blurring of distinctions between wealth and spirit is typical of the representation of the West in the minds of many nineteenth-century white Americans.

The Gold Rush of 1849 encouraged the development of new settlements and railroads, but quickly replaced the romantic image of the lone prospector with the large corporations who introduced hydraulic mining, often diverting precious water to blast the ore. As Trachtenberg writes, 'in the path of America's future seemed to lie a natural history' (Trachtenberg 1982: 18) rapidly interpreted as 'natural wealth' to be consumed and used. The Homestead Act (1862) parcelled the land into 160-acre plots to be sold for the nominal amount of $10, and meanwhile the railroad companies were being awarded huge land grants to enable the continued expansion of the railroads across the Plains. Native lands were being divided, buffalo ranges bisected and the once-uncharted wilderness was being surveyed by large corporate interests: railroads, mining and timber companies, driven by profit and loss.

This westward push was imperialist; 'Time's noblest offspring is the last' as George Berkeley wrote in *Verses on the Prospect of Planting Arts and Learning in America* (1726). America was the final act of Time, following its Manifest Destiny which God ordained, to be the domain of the white settler whose duty it was to 'overspread the continent allotted by Providence' (John L. O'Sullivan quoted in Milner *et al.* 1994: 166), move west, occupy and possess the lands there. The journalist, William Gilpin, wrote in 1846 that 'the untransacted destiny of the American people is to subdue the continent – to rush over this vast field to the Pacific Ocean – [. . .] to teach old nations a new civilization – to confirm the destiny of the human race' (Truettner 1991: 101). Paintings such as Leutze's 'Westward the Course of Empire Takes Its Way' (1861) or John Gast's 'American Progress' (1872) dramatise these urges perfectly (see Plate 2).

Images of sexual violence and conquest have often been used to describe the possession of the West, and have been taken as a starting point for the kind of feminist revisions which explore the 'psychosexual dynamic' of the West 'where the material and the erotic were to be harmoniously intermingled' in male language (Kolodny 1984: 3, 4). The land-as-feminine provided a repetitive image of the West as a place of male protection, possession and assault, in which the woman was passively held as fantasy or ideal. A cluster of images emerged that have maintained their power within American culture to the extent that Chicana feminist Gloria Anzaldúa described the situation in the following way:

> The Gringo, locked into the fiction of white superiority, seized complete political power, stripping Indians and Mexicans of their land while their feet were still rooted in it . . . we were jerked out by the roots, truncated, dispossessed, and separated from our identity and our history.
>
> (Anzaldúa 1987: 8)

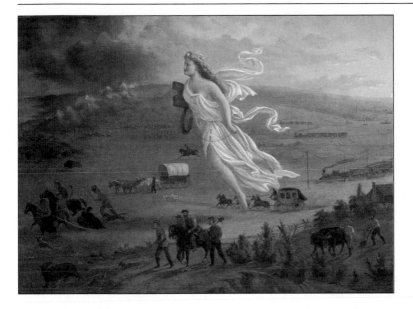

*Plate 2* John Gast *American Progress*, 1872
*Source*: Museum of the American West collection. Autry National Center, Los Angeles

The excluded are linked here through the metaphors of violation: women, 'Indians and Mexicans' and the land are all tied to an identity and history that revisionism has sought to reassert.

## MASCULINITY AND THE LAND

The dominant image of the land in white American culture is of being associated with masculinity. From the earliest western novels, like Owen Wister's *The Virginian* (1902), the West is represented as the testing ground for manhood. The film *Pale Rider* (1985) contains a key scene showing the process of hydraulic mining as a hellish, phallic vision of the land's destruction. In *Shane*, which *Pale Rider* echoes in many ways, the final resistance of the land is signified by the tree stump which is collectively removed by Joe and Shane's 'manpower' (Schaefer 1989: 37). In *Pale Rider*, the manpower, now embodied in the machine, is detached and brutal in its destructiveness, but the scene goes further, in juxtaposing the violation of the land with the attempted rape of a young girl. The environmental 'raping' of the land is parallelled to the male sub-ordination and violation of the girl. The scene is crude and problematical, especially as it ultimately becomes a vehicle for the 'saviour-hero' to rescue the girl and the land from their fates, but, however one responds

to the film's ideology, this scene does show that even Hollywood mainstream cinema has been touched by revisionism, and has attempted to inter-link contemporary concerns about masculinity and its relationship to the feminine and to the environment. This is even more apparent in *Unforgiven* (1992), *The Ballad of Little Jo* (1993) (see Campbell 2000), and more recently in films like *Open Range* (2003) and *The Missing* (2003).

The opening sequences of many classic Western films begin with the hero emerging from the land, as if he is part of its hardness, its severity: 'it says . . . you will become like this – hard, austere, sublime . . . you will have to do without here' (Tompkins 1992: 71). The land is immense, powerful and. dominating, but man aspires to its supremacy and so 'men imitate the land in Westerns . . . which means to be hard, to be tough, to be unforgiving' (ibid.: 72–3). This is the chosen landscape of hills and desert, excluding as myths do so well, the other formations of land that promise 'fertility, abundance, softness, fluidity, manylayeredness' (ibid.: 74) for these may be confused with other, feminine qualities. The apparent blankness presents the male hero with a 'tabula rasa on which man can write, as if for the first time, the story he wants to live' (ibid.). However 'fictional' these images are, they demonstrate the dominant attitude to the land as testing ground for masculine expression, for simple, unsocial, premodern rituals to take place. In *Shane* (1949), for example, the hero enters 'from the open plain beyond' (Schaefer 1989: 5), his clothes with 'the dust of distance . . . beaten into them', his body with 'the endurance in the lines of that dark figure and the quiet power in its effortless, unthinking adjustment' and his face 'lean and hard and burned' (ibid.: 6). The young observer, Bob, sees in Shane the lone rider, born from the land, that Tompkins writes about, and learns from him a version of masculinity: 'Everything about him showed the effects of long use and hard use, but showed too the strength of quality and competence' (ibid.: 9). But for all his fascination, Shane, like the land he comes from, is no longer suited to the progress represented in the novel by the Starrett family. The 'open range can't last forever', for the future lies with the homesteader and with settlement and, 'the thing to do is pick your spot, get your land, your own land' (ibid.: 13). But Shane, like Ethan Edwards in *The Searchers* (1956),[5] cannot settle or own the land because it is in him and defines his being. Both men need the openness and freedom of the range and cannot exist within a social domain of the feminine, the domestic or the settled. They carry back to the land the central myth of a masculine West.

This myth is examined in Cormac McCarthy's revisionist novel *Blood Meridian, or the Evening Redness in the West* (1985), arguably the first part of his tetralogy of novels (*All the Pretty Horses, The Crossing, Cities of the Plain*), where the West is a place of imperialism and Manifest Destiny, not a sacred quest, but a brutal and terrifying assault. At the heart of

*Blood Meridian* is Judge Holden, who exemplifies the mythic relationship to the land in *extremis,* wishing to possess the land totally. McCarthy dramatises what Slotkin recognised about the West.

> Its ideological underpinnings are those same 'laws' of capitalist competition, of supply and demand, of Social Darwinism's 'survival of the fittest' as a rationale for social order, and 'Manifest Destiny' that have been the building blocks of our domestic historiographical tradition and political ideology.
>
> (Slotkin 1985: 15)

Holden desires to be 'suzerain of the earth' (McCarthy 1990: 198), a Godlike omnipotent force who acquires all the knowledge contained in nature and stores it in a ledger for himself. At one point, he is seen breaking fossils and minerals from the land because 'he purported to read news of the earth's origins' in them (ibid.: 116), but this is not knowledge to be shared, only to add to his power. The natural objects are 'his [God's] words', since 'He speaks in stones and trees, the bones of things' (ibid.) and Holden is Faust, Ahab, Lear – a terrible vision of mankind's quest for power and control, here played out in the West, the *'terra damnata'* of conquest and imperialism. He must kill to possess, destroy to steal the knowledge and claim it for himself. As D.H. Lawrence wrote,

> To *know* a living thing is to kill it. You have to kill a thing to know it satisfactorily. For this reason, the desirous consciousness, the SPIRIT, is a vampire . . . to *know* any thing is to try to suck the life out of that being.
>
> (Lawrence 1977: 75)

The land is being sucked of all its value for 'man does . . . want to master the secret of life and of individuality' (ibid.: 76). Holden is a dark, rapacious portrayal of the ideology of possession, even to the extent of refuting 'Manifest Destiny' as such and seeking to claim control of it himself: 'Only nature can enslave man and only when the existence of each last entity is routed out and made to stand naked before him will he be properly suzerain of the earth' (McCarthy 1990: 198). Holden's 'claim' is not a patch of land, but the earth itself and all its 'secrets' so that he will have 'taken charge of the world . . . [and] effect a way to dictate the terms of his own fate' (ibid.: 199). He personifies destructive, imperial values where 'the act of destruction itself somehow makes us believe in our manhood and godhood, our Ahab's power to dominate life and to perpetuate and extend ourselves and our power' (Slotkin 1973: 563). Holden is totalitarianism writ large, with his wilful desire for immortality parallelled with the westward quest, which sought to

possess the land, destroy the Native American and exclude anything that had no role in this grand design. The West's 'blank page', as Turner called it, offered the opportunity for self-assertion on a massive and terrifying scale. He wrote, 'the individual has been given an open field, unchecked by restraints of an old social order, or of scientific administration of government [and] the self-made man was the Western man's ideal' (Turner 1962: 213).

This rampant, unrestrained individualism epitomises the West as a place of brutal competition, death and horror, where, as William Burroughs wrote, 'all the filth and horror, fear, hate, disease and death of human history flows between you and the Western lands' (Burroughs 1988: 257). How far all this is from the prevalent myths of the golden land and from the 'sacred hoop' of Native-American culture. In the extreme revisionism of McCarthy, we are forced to see the repressed of the Western story as he 'rehistoricizes the mythic subject' (Slotkin 1985: 45), not by claiming to give us actual truths about the West, but by creating an imaginative representation that jars the reader into rethinking the old stories and the hollowed-out myths.

## WOMEN AND THE WEST

One of the most important revisions of the American West has been undertaken by feminist critics, who have challenged the conventional histories and representations of the region. Susan Armitage puts it clearly: 'most histories of the American West are heroic tales: stories of adventure, exploration and conflict . . . their coherence is achieved by a narrowing of focus' (Armitage and Jameson 1987: 10). As Tompkins has argued, such narratives of the West developed as an 'answer' (1992: 39) to the prevalence of domestic, sentimental, female books popular in the East which 'Culturally and politically . . . establish women at the center of the world's most important work [saving souls] and . . . assert that in the end spiritual power is always superior to worldly might' (ibid.: 38).

For Tompkins, the Western is 'secular, materialist, and antifeminist; it focuses on conflict in the public space, is obsessed by death, and worships the phallus' (ibid.: 28). Its masculine representations refer directly to the feminine realms of power: the home, the Church, the family, and seek, as textual re-workings of actuality, to keep the domains apart and allow men the space in which to *imagine* an order in which they can be tested. Thus the Western genre developed a whole set of 'counterrituals and beliefs' (ibid.: 35) to portray masculinity and exclude or marginalise women. The cultural order from which Turner emerged in 1893 permitted him to write of a 'masterful grasp . . . restless, nervous energy . . . dominant individualism' (Milner 1989: 21), always gendered

as 'he', and reacting to 'the cult of domesticity' that had dominated American Victorian society.

Even a sensitive, radical poet like Walt Whitman in his 'Pioneers, O Pioneers' (1865) demonstrates through its language and imagery the prevailing idea of the West as the domain of men:

> full of manly pride and friendship . . .
> Conquering, holding, daring, venturing as we go the
> unknown ways . . .
> We the primeval forests felling.
> We the rivers stemming, vexing we and piercing deep the
>     mines within,
> We the surface broad surveying, we the virgin soil upheaving.
>
> (Whitman 1971: 194)

It is a male fantasy of control and domination over both the land and the feminine which comes through this poem, that in so many other ways celebrates the expansionist policies of westward movement. In relationships with women and land, man had to be assertive, to prove himself as superior, to 'tame' them in different ways, and literature offered one method, becoming 'psychosexual dramas of men intent on possessing a virgin continent' (Kolodny 1984: xiii). 'New histories' of the West show the significant roles of women in the region, not just in the permitted, stereotyped roles of 'help-mate', civiliser, whore and mother, but by providing new female viewpoints. One method is to re-value the individual stories of women's lives, their domestic rituals and everyday habits, in contrast to the search for the grand narratives of the West, which sought to identify large trends and 'waves' of settlement.

A 'classic' Western novel and later a film, *Shane*, which has many merits, portrays Marian Starrett in the stereotyped mould of the Madonna of the Prairie, the civilising force for which men struggle. The first words that define her in the text are 'mother's kitchen garden' (Schaefer 1989: 7), and we are soon told: 'She was proud of her cooking. . . . As long as she could still prepare a proper dinner, she would tell father when things were not going right, she knew she was still civilized and there was hope of getting ahead' (ibid.: 11). She is domestic, civilised and yet strangely, as the novel suggests, capable of being stirred by the sexual threat of the wild Shane. As a woman in the West, she has to be contained by the role, by the house and by the garden, all of which demonstrate the limits of her permitted territory. She may be in the wilderness, but it cannot be in her. It must be repressed and channelled into the healthy domestication that the novel delineates. It was for women, for civilisation, such texts suggest, that men strove to tame

the land, remove the wild Indian and drive away the outlaw. In John Ford's classic Western film *My Darling Clementine* (1946), women are firmly rooted in the stereotypes of whore-half-breed Chihuahua and schoolteacher-virgin Clementine, and 'women, the family and the bonds of community can thrive, it seems, only when the West has been tamed. They are the motive that invests the history of western violence with virtue' (Milner *et al.* 1994: 316). In the film, Wyatt Earp is shown to be gradually 'civilised' and in one scene is washed, dressed and perfumed at the barber shop before escorting Clementine to the new town church dance where he is eased into the Fordian ritual of community, the dance. Here, Earp removes his hat and joins the ritual that bonds him, in part, to the new West of town and community, and signals the ultimate settlement and organisation that his violence has enabled. Although finally he cannot settle, the process has been established in the film, as in so many Westerns, and women and the feminine are at its heart, remaining behind in the new order, which has begun to reconcile 'the premodern West and the new, civilized West' (White 1991: 628). The film echoes the ending of *Shane* in which the reassuring voice of Marian asserts that Shane has not gone but remains 'here, in this place, *in this place he gave us.* He's around us and in us, and he always will be' (Schaefer 1989: 157 – our emphasis). The civilised, tamed West is the domain of Marian, Clementine and of all the other Madonna-women that masculine mythology created to explain the violence of the country. One image perfectly captures this filmic sentimental ideology in the form of George Caleb Bingham's painting 'Daniel Boone Escorting Settlers through the Cumberland Gap' (1851–2). It portrays a Madonna figure being led on a white horse into the Western light by the strong, rugged, begunned Turneresque Boone. The hierarchy of power is apparent in the composition, and the definitions of what women could be in the West are emphasised (see Plate 3).

The ideological elements of these myths serve at least two purposes: first, to gender the West and set definite roles for women and men, and second, to link this with the wider process of westward expansion as if the two were totally normal and ordained, 'a quality of absolute legitimacy, as if what is being described is natural and unquestionable and therefore a fully sanctioned enterprise' (Truettner 1991: 40). Fortunately, these ideologies can be revealed 'when viewed through a new perspective' and be seen to 'yield [an] agenda' (ibid.), which at the time of their making was masked by their social acceptance and the apparent harmlessness of their intention. Such a 'new perspective' can be seen in the fictional work of Willa Cather, who was prepared to challenge the gendered representations of the West.

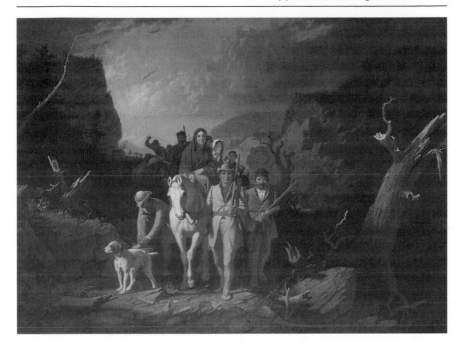

*Plate 3* George Caleb Bingham, *Daniel Boone Escorting Settlers through the Cumberland Gap*, 1851–52

*Source*: Oil on canvas, 36½ × 50½. Mildred Lane Kemper Art Museum, Washington University in St. Louis. Gift of Nathaniel Phillips, 1890.

## A DIVERSE WEST: WILLA CATHER AND BEYOND

In Willa Cather's *O Pioneers* (1913), the traditional, constrained view of the Madonna of the Prairie is countered by answering Whitman's poem, from which she borrows her title, in its portrayal of a capable woman with vision and power, who develops a creative, mutual relationship with the land. Cather's Alexandra Bergson comes from a family whose father saw the land as something to 'tame' (Cather 1913: 20) because 'its Genius was unfriendly to man' (ibid.), an 'enigma . . . like a horse that no one knows how to break to harness' (ibid.: 22). She learns from her father's persistence and industriousness, her mother's sense of heritage and preservation (we see her endlessly preserving fruit in the novel) and above all from the proto-environmentalist Ivar, who lives in harmony with the land. Rather than 'break' the land, Alex learns to live 'without defiling the face of nature any more than the coyote that had lived there before' (ibid.: 36). She has a 'new relation' to the land in which her 'house is the big out-of-doors, and . . . it is in the soil that she

expresses herself best' (ibid.: 71, 84). For Cather, the public space is available to women, and they can operate within it without simply imitating men and their mistakes. The Western land is not to be subdued, but to be nurtured and lived with, becoming like an extension of her own body: 'she was close to the flat, fallow world about her, and felt, as it were, in her own body the joyous germination in the soil' (ibid.: 204). Cather proposes a mutual relationship to the land, closer to the Native-American view: 'we come and go, but the land is always here' (ibid.: 308). Indeed, in one of the final speeches in the novel, Alex, talking to her future husband Carl, discusses the future of the West and claims 'it is we who write it, with the best we have' (ibid.: 307). The emphasis here is on the 'we', the male and female 'writing' of Western history and the 'writing' of the landscape itself. Elinore Pruitt Stewart, who read and admired Willa Cather, actually lived the frontier life and wrote about it in her letters, seeing homesteading for women as a means of expression and liberation from the ordeals and limitations of the urban East:

> any woman who can stand her own company . . . see the beauty of the sunset, loves growing things, and is willing to put in much time at the careful labor as she does over the washtub, will certainly succeed; will have independence, plenty to eat all the time, and a home of her own in the end.
>
> (Milner 1989: 408)

This 'new perspective' of women's histories is one of the tools by which 'conventional' history can be interrogated and the 'dominant discourse' of white male history be shown to 'close down [effect a closure] on those readings they wish not to run' (Jenkins 1991: 67). As Anzaldúa writes, 'Culture forms our beliefs. . . . Culture is made by those in power – men' (Anzaldúa 1987: 16), but she, like many other women, has begun to question this discourse. Diverse voices have now been empowered by this rethinking of Western history: Chicana, Native-American, Anglo, Asian American women have expressed their stories alongside the more conventionally accepted and official versions in a new multiculturalism in the West[6] (see Comer 1999, Campbell 2000). One example here is the work of E. Annie Proulx whose Wyoming Stories in *Close Range* (1999) and *Bad Dirt* (2004) and in the novel *That Old Ace in the Hole* (2002) explore versions of the West that deliberately revise conventional stereotypes and modern images of the New West, best introduced by the epigraph to *Close Range*, 'Reality's never been of much use out here'. Her work uses quirky, broken lives, oddball characters, and sardonic humour to examine the continued dreams, hardship, disappointment and corporatisation of the region, and in so doing challenges readers' expectations and assumptions. This is most evident

in 'Brokeback Mountain' a daring, elegiac story of a homosexual rela-
tionship between two cowboys – Ennis Del Mar and Jack Twist – lasting
twenty years and cutting through many of the traditional images and
codes of what she calls the West's normative 'stoic life' – family, work,
and prescribed masculinity (Proulx 1999: 284). In this mythic West
'turned upside down' Proulx explores the 'slow corrosion' of lives in a
region whose strict boundaries have been breached so that, as she says,
'everything seemed mixed' (ibid.: 302, 292) and suddenly problematic,
no longer under the spell of mythologies and fixed rules. In the story's
moving climax Ennis visits the room of his secret lover Jack after his
death to find their work shirts hanging inside one another in the
closet: 'the pair like two skins, one inside the other, two in one' (ibid.:
316). In many ways this hidden, *closeted* story reminds us of Foucault's
call for subjugated knowledges to be heard, and of their necessary inter-
connection, multiple stories relating to the non-unanimous whole, 'one
inside the other', forming the complex, diverse fabric – the 'imagined
power' of the West (ibid.).

## CONCLUSION: THE CONTESTED LANDSCAPES OF THE CONTEMPORARY WEST

These revisions have made accessible more stories about the West than
just the official history or the myths transmitted through popular
discourse, and they have demonstrated the intricate relationship between
the 'real' and the 'imagined'. Slotkin's 'productive revision of myth' will
'open the system and permit it to adjust its beliefs [and the fictions
that carry them] to changing realities' because, if not, the alternative is
'the rigid defense of existing systems, the refusal of change, which bind
us to dead or destructive patterns of action and belief that are out of
phase with social and environmental reality' (Slotkin 1992: 654–5).
Reappraisals 'destabilise the past and fracture it, so that, in the cracks
opened up, new histories can be made' reminding us 'that interpreta-
tions ... are aligned to the dominant discursive practices' (Jenkins
1991: 66). Bret Easton Ellis's novel *Less Than Zero* (1985) is a form of this
'new history' whose epigraph is: 'There's a feeling I get when I look to
the West', and represents an excessive, metropolitan region without any
concern for the past. In a series of stunning motifs that conclude the
novel, Ellis writes of 'ghosts; apparitions of the Wild West' that haunt
the wealthy suburbs, with Indians intruding, like the return of the
repressed, into the self-obsessed lives of these 'new frontiersmen' (Ellis
1985: 206). No one wants to think about the past, about the ravaging of
the land and the Native population that has enabled the vast wealth of
his young characters, but it refuses to go away. It remains, a reminder
of other lives and other values.

Other images follow. First, a poster of California 'old and torn down the middle and tilted and hanging unevenly', juxtaposed with 'an old deserted carnival' and a coyote howling (ibid.: 207). This curious, powerful montage spells out the contemporary West, part carnival, part degraded lopsided illusion, part ghostly, natural past. At this moment, Clay, the novel's central character knows 'it was time to go back' (ibid.), by which he means to the East, to his own personal past, and also into the forgotten past of the West, to understand how his world 'so violent and malicious' (ibid.: 208) was formed. The inner collapse in Ellis's West is reflected in the landscape that intrudes into the human environment like a sinister reminder of the past. The 'houses falling, slipping down the hills in the middle of the night' (ibid.: 114), the earthquakes and the storms suggest the fragility of human existence in the West and remind us of the ever present environment. As Worster wrote, 'the western lands were not a blank slate on which any identity, old or new, could be arbitrarily written' (Worster 1994: 6).

Mike Davis, who has contributed in recent years to the necessary 'anti-mythography' of the New West, has developed a specific critique of Western urbanism and environmental abuse. He shows how the West has become a series of over-developed cities, like Los Angeles and Las Vegas, with surveillance, gated communities, racism, and decreased public space. He has drawn attention to the West as a dump for the weapons industry and nuclear waste, and uses the photographs of Richard Misrach as documents of this environmental damage[7] (see Davis 1990, 2002). These photographs are a 'frontal attack on the hegemony of Ansel Adams' whose awesome photographs of nature in the West have been seen as a final statement of environmental well-being. Misrach and others have 'rudely deconstructed this myth of the virginal, if imperilled nature' and present an 'alternative iconography' (ibid.: 57–8) of Western waste and debris in order to instigate a photographic equivalent to the work of historians, writers and film-makers discussed earlier. They are 'resurveying' the West, just as it had been originally in the 1870s, in part to demonstrate change and destruction and more generally, as with all revisioning, to alert people to what lies behind the official versions of events. In the words of Mark Klett, one of the 'rephotographers' of the West, the aim was 'to raise questions we might never have thought to ask' (Bruce 1990: 81) about the West as a zone of engagement where different peoples and geographies collide. It is, however, clear that the Turner 'corral' has been opened forever to new and exciting versions of the West, but as Richard White comments, 'this revisioning and reimag-ining of the West is never complete' and must continue to examine critically the region and its multiple relations with both nation and world (White 1991: 629).

## CASE STUDY 2: THE SOUTH – BEYOND COMPREHENSION?

As with the American West, the South has been a region with many competing stories, each making claims upon the region and how it might be a part of or separate from other areas of the nation. At the end of the nineteenth century, for example, Henry Watterson, editor of the *Louisville Courier*, wrote that 'The South is simply a geographic expression' and he, along with a number of other editors and politicians, hoped for the disappearance of what they saw as outmoded Southern values and their replacement by national values which would enable the South to become fully integrated into the rest of the country. By the time of the Second World War, however, it had become clear to some observers, that Watterson's dreams had not yet been realised. 'The South is not quite a nation within a nation, but the next thing to it', asserted W. J. Cash in 1941 (1971: vii). This exchange suggests something of the long-term significance of the debate over the place of the South in the United States, and how closely that debate is connected to arguments about the identity of the region. Discussions about the differences between the South and the rest of the nation have been common among American historians, and this has been reflected in a number of other cultural forms including literature and journalism. In American popular culture too, the question of Southern difference has been a staple topic. Shreve McCannon famously urged Quentin Compson in Faulkner's *Absalom, Absalom,* to 'Tell about the South! What do they do there? Why do they live there? Why do they live at all?', and his injunction has been reflected in the many competing and conflicting attempts to define Southern identity, and come to terms with what to many is an enigma beyond comprehension (Faulkner 1965: 174).

These persistent efforts to understand the South have not only come from within the region, and but also from without. Southern difference, whether expressed in the romance of the Old South, or the violence of racial oppression, has always had an attraction for outsiders. Alison Graham, for instance, has noted the general infatuation of white Americans for the plantation myth, and the way in which its 'dream of racial purity' exerted 'a powerful pull on the American imagination' (Graham 2001: 20). As a result the temptation for external versions of the South to stereotype the region 'through a lexicon of clichés' has often been in conflict with the ways in which Southerners themselves have articulated their own beliefs and values (ibid. 2). William Styron caught something of this tension in the arguments about the meaning of the South in his novel *Sophie's Choice* where one character says:

> at least Southerners have ventured North, have come to see what the North is like, while very few Northerners have ever really troubled themselves to travel to the South . . . I remember you're saying

how smug Northerners appeared to be in their wilful and self-right-
eous arrogance . . . How can I really have hated a place I have never
seen or known?

(Styron 1979: 418–19)

It is therefore revealing to look at the ambiguous ways in which outsiders
have interpreted and responded to the South. There are, for instance,
stories about the South which have held particular power for non-
Southerners, and in turn have become part of the problem of adequately
defining what the South is in any clear-cut way. One of the most
influential of all versions of the South was Harriet Beecher Stowe's *Uncle
Tom's Cabin* (1852), which was largely written in Maine and was based
on very limited direct knowledge of the region. Another northerner,
Stephen Foster, from Pittsburgh, helped to popularise nostalgic views
of plantation society with such songs as 'My Old Kentucky Home' and
'Ole Folks at Home', views echoed in the widely reproduced lithographs
of Currier and Ives. Charles K. Harris, a New York Jew, who wrote,
amongst others, 'Mid the Green Fields of Virginia', had never visited
the state, confessed that his version of the South came entirely from the
imagination and that he had no idea whether corn was grown in Virginia
or whether there were any hills in the Carolinas (Malone 1993: 131).

## A DIVERSE SOUTH

These contradictions suggest the diversity of attempts to define the
South's apparent difference from the rest of the nation and how this has
changed over time. It is a debate which began in the late eighteenth
century, became more intense in the national crisis over slavery in the
nineteenth century and still thrives today. A number of commentators
have argued that these differences have been much exaggerated and that
Southern values and American values have had, and continue to have,
much in common. As one of the leading analysts of Southern difference
once admitted, 'To imagine [the South] existing outside this continent
would be quite impossible' (Cash 1971: viii). Others went further, assert-
ing that many of the distinctive, often negative qualities of the South,
like violence and racism, were only intensified versions of basic American
characteristics. Some have argued that even at the time of the greatest
apparent difference between the North and South during the Civil War
era, Americans had more in common than set them apart.

A variation of this argument has suggested that though a distinctive
Southern identity may once have existed, gradually it has been eroded
by the forces of modernisation that have already come to dominate other
parts of the country. Urbanisation, industrialisation, the rise of mass
communications, an integrated mass transport system, air-conditioning,

have all worked together to break down Southern isolation and to link the region firmly with the national mainstream. There have been a number of moments in post Civil War Southern history when it has been claimed that these kinds of forces significantly changed the 'old' South and made it in some way 'new'. In the 1880s Henry Grady, the publisher of the *Atlanta Constitution,* defined this 'newness': 'We have sowed towns and cities in the place of theories, and put business in the place of politics. ... We have fallen in love with work' (Brinkley 1995: 435). Industrial development and material progress on the northern model would enable the South to resist economic dependency, and regain self-respect after military defeat in the Civil War. In 1895 Booker T. Washington foresaw a 'new heaven and a new earth' in his 'beloved South', as a result of material prosperity and the obliteration of racial animosities. Often these 'new' Souths turned out not to bring a 'new heaven and a new earth', and old patterns of life remained. For many, the New South foreseen in the late nineteenth century did not appear until after the Second World War, when industrial workers for the first time outnumbered farmers, and a majority of the Southern population became urban. Regardless of when the New South became a reality, it is clear that economic indicators suggest the rural, agricultural South has long given way to a social order that shares many of the same conditions as other parts of the country.

In contrast, some observers of Southern society and culture argued for the distinctiveness of the region, and have continued to do so despite the apparent convergence of material conditions between the South and the rest of the country. The South, they argue, is less a collection of material or geographical factors, than a state of mind, a set of psychological tendencies. Thomas Jefferson, in a letter to the French aristocrat the Marquis de Chastellux in 1785, assumed that certain qualities might be linked to climate. The warmth of Virginia, he thought, unnerved both body and mind and its people were fiery, indolent, independent and generous amongst other things, in contrast with the cool North. Jefferson's generalisations are an easy target, but contemporary analysts of region continue to emphasise cultural inheritance. Fischer, for instance, has argued recently for the persistence of cultural 'folkways' which have shaped regional cultures. Cultural systems from this perspective 'have their own imperatives, and are not mere reflexes of material relationships' (Fischer 1989: 10). John Shelton Reed has argued extensively for what he has described as 'the cultural and cognitive reality' of the South, and that it exists as a 'sociological phenomenon' (Reed 1982: 3). The long history of attempts to paint a vanishing South are often linked to arguments about convergence between the Southern way of life and the rest of the nation. Yet a host of factors including culture, religion, social and ethnic traits, myth and folklore, suggest that the South will remain

distinctive for a long while. These cultural differences often have been reinforced at times when the South has been under pressure from the forces of change. A recent study of the University of Mississippi pointed out how supposedly traditional symbols like the carrying of a giant Confederate flag at football games, the singing of Dixie as the school song, and the adoption of Colonel Rebel – a white-goateed Southern gentleman of the old school – as mascot, only dated back to the late 1940s and the challenges to the Southern way of life in the aftermath of the Second World War.

If the debate over the nationalisation of the South remains unresolved, it is also important to be aware of the dangers involved in assuming a monolithic South and underplaying variations within the region. In the past, the American South has often been defined as the eleven former confederate states, along with Kentucky perhaps holding a marginal position, half-in, half-out. But what have these eleven/twelve states had in common in terms of their material experience? There are clearly problems with finding objective characteristics, like the weather, which can be quantitatively assessed in a manner that will tell us where one region begins and another ends. Ulrich B. Phillips, writing in the 1920s, believed the weather was the chief agent making the South distinctive because heat and humidity encouraged the cultivation of specific staple crops like tobacco, rice and cotton, which in turn encouraged plantations and a slave labour force (Phillips 1928). *Absalom, Absalom* echoes this link between land, climate and character:

> This land, this South, for which God has done so much with woods for game and streams for fish and deep rich soil for seed and lush springs to sprout it and long summers to mature it and short mild winters for men and animals.
>
> (Cowley 1977: xxv–vi)

However, on closer analysis, the concept of a 'solid' South tends to fragment when confronted with the internal variety of the region. To discuss the Appalachian mountain regions alongside the Mississippi Delta, or southern Louisiana alongside Virginia, or Florida alongside anywhere, may only expose the fragility of any attempt to provide an objective description of the region as a whole. The South, in geographical terms, has been marked by diverse agricultural patterns, linked to particular types of soil or weather. Recent writers have pointed out the diversity of the Southern economy over place and time, and it is these complexities which exist beneath such broad categories as 'South', 'North' and 'West' that have impressed many commentators. Even during the South's brief existence as an independent nation during the Civil War, there was considerable tension between different parts of the Confederacy over the conduct of political affairs, which, at least in

part, reflected local economic conditions. The Southern up-country, where a majority of white Southerners lived, contained substantial pockets of disaffection with the Confederate cause, and often open and hostile resentment to what many came to see as a rich man's war. Such differences continued to persist in the late nineteenth and twentieth centuries, surfacing with regularity to disrupt the conventional image of the solid white South.

Another set of problems emerge when we link problems of Southern identity to issues of race. Reed has put the question clearly. 'Are Southern blacks "Southerners" in any important sense?' (Reed 1982: 3). Specific versions of Southern myths assume that the South is white. The black response to such versions of the South has been varied, with some like Booker T. Washington, advocating an acceptance of dominant white values at least as a tactic. In the context of the violence and segregation of the late nineteenth-century South, Washington argued that rather than agitating for immediate equality and integration, black Southerners should concentrate on improving their own communities through education and economic development. Once they had something worthy of recognition, then their place in the South would be acknowledged. Others have argued for a re-modelling of the South on inter-racial lines, while retaining a love for the South as a place. The civil rights movement of the 1950s and 1960s was largely made up of local black activists who were seeking to remake the South, rather than simply leave it as many of the previous generations had done in the 1920s and 1940s. This attempt to transform the South into a racial democracy and to integrate blacks into the mainstream of Southern life could have ironic consequences as Martin Luther King noted, writing from Birmingham gaol in the summer of 1963. 'Virtues so long regarded as the exclusive property of the white South – gallantry, loyalty and pride – had passed to the Negro demonstrators in the heat of the summer's battles' (King 1964: 116).

Many blacks rejected the South altogether and simply left it behind, joining the Great Migration to the cities of the North and West in a search for economic opportunities and as an escape from the restrictions of Southern society. Those who stayed found it easier to identify with the changes in the South wrought by the civil rights movement. Another discourse of the South has emphasised black–white interaction and even cooperation. A North Carolina poll of 1971 asked a sample of the adult general population: 'Some people around here think of themselves as Southerners, others don't. How about you – would you say that you are a Southerner or not?' Some 82 per cent of whites answered that they were Southerners, but so did 75 per cent of blacks. As this suggests, 'Southern blacks have on the one hand re-evaluated their white fellow-Southerners and at the same time laid increasing claim themselves to the label "Southerner"' (Reed 1982: 116–19).

In approaching regional identity it is also helpful to note the difference between 'region', and 'regionalism'. The former term defines region in apparently objective terms by analysing, say, its dominant economic and social characteristics. Use of the term 'regionalism', however, goes further and becomes an act of advocacy for a particular set of qualities. 'Regionalism' here owes its origins to the early nineteenth-century romantic association between land and culture. One conventional approach has been that regionalist arguments have often been conservative in approach, looking back to older traditions and patterns of life, which have been threatened or even swamped by the modern world. In the inter-war years, for instance, a group of Southern writers and intellectuals, who came to be described as the 'Agrarians', produced a critique of the urbanising, industrialising forces threatening what they most valued about the South. This 'Southern manifesto' appeared in *I'll Take My Stand: The South and the Agrarian Tradition* (1939) that warned of the threat to individualist and humanist values in a world dominated by the developing power of an economic and political order, which linked centralised government to a productive system based on the machine and the cash nexus. More recently, however, advocates of regionalism have asserted its usefulness as an assertion of difference against the claims of the centralised state dominated by monopolistic economic and cultural institutions. Sometimes these two trends have come together to produce regionalist arguments, which are difficult to classify neatly on a conventional left to right spectrum.

Faced with such difficulties in arriving at any firm physiographic, cultural or social definitions of the South and its relationship to the rest of the nation, it may be more helpful to try to approach the problem of Southern identity through the range of attempts to perceive it. The South, from this perspective, exists because people have seen it as existing, and their efforts to articulate what they have seen, or imagined, carry significance in themselves. As with inhabitants of other cultures, Southerners have developed, within a changing historical context, ways of seeing the world that link with their everyday experience. As Richard Gray has argued 'the South is primarily a concept, a matter of knowing even more than being, and, as such, part of the language of our currency and perception' (Gray 1986: xi–xii). Southerners have been 'busy reimagining and remaking their place in the act of seeing and describing it' (ibid.). The 'stories' created constitute the South and can be examined for 'the often ambiguous ways in which Southerners have interpreted and responded to national developments' (Ownby 1993: 3). This approach puts an emphasis on culture as a process in which people are actively engaged and which they make for themselves even though this frequently involves disagreement and contest since people enjoy unequal access to influential cultural institutions and organisations. Reed attempts to

develop a sociology of regional groups, pointing out how difficult it is to define region in a way that will help to explain regional group behaviour. He suggests starting from the other end by exploring who belongs to regional groups, and then mapping their habitat. For Reed, 'it is less that Southerners are people who come from the South . . . than that the South is where Southerners come from' (Reed 1982: 120). Such an approach puts the emphasis on how group identification is established and how people perceive their identity.

Against this backdrop we want to use examples of how stories have been told about the South and to explore some of the ways cultural evidence can shed light both on what it has meant to be Southern at different stages in Southern history, and how that difference has been articulated by a range of insiders and outsiders. All the while, it is worth noting David Potter's warning about the difficulties facing historians of the South in trying to come to terms with a region 'whose boundaries are indeterminate, whose degree of separateness has fluctuated over time [and] whose distinctiveness may be in some sense fictitious' (Potter 1968: 182).

## DOCUMENTARY REPORTAGE

One attempt to define Southern identity has been to 'document' it in some way and to uncover through observation and investigation a more accurate picture of the region's life. This goes back to Northern and European travellers to the slave South in the years before the Civil War, and has remained a prolific source of material about the region in the twentieth century. The urge to 'document' and just how we should interpret works of documentary remain complex issues. As Paula Rabinowitz has argued, 'documentaries construct not only a vision of truth and identity but an appropriate way of seeing that vision' and so in examining documentary we must interrogate 'what it says, to whom, about whom, and for whom – and how it says it' (Rabinowitz 1994: 7).

In looking at the various forms of documentary which follow it is helpful to bear these considerations in mind. Who has sponsored these specific works? For which kinds of audience are they intended? What kinds of assumptions and expectations would different kinds of audiences have brought to the consumption of these images? How do these assumptions and expectations differ from our own? What kinds of narrative and other formal devices do these works use to gain their effect? These are all awkward questions, but they help to remind us that documentary is a *constructed* form, whose ambiguous meanings need to be as carefully explored as more transparently invented or imagined work. This is crucial when using this material for a history of the South or any other region because documentary work may appear to give us an objective view about different aspects of life in the South, but ultimately they are partial

accounts, ideological texts produced according to certain conventions and rules, to communicate what they see as the 'truth' about the period.

Some of the most powerful images of the South in the twentieth century are provided in the work of photographers in the 1930s, who documented the region in a manner which has exercised a considerable hold on how the decade has been remembered. Much of this work was supported by the federal government, through the activities of a photographic section attached first to the Resettlement Administration and then the Farm Security Administration (FSA). Some FSA work celebrated the 'successes' of agency programmes, but the pictures which had the greatest impact were those documenting the problems associated with rural poverty. FSA photographs were often used in the news media to illustrate the work of the New Deal in rural America, and, more particularly, the South. Photography's apparent transparency represented a South with 'the dignity of fact' (Orvell 1989: 229), which Dorothea Lange summed up by the quotation from Francis Bacon displayed on her darkroom door: 'The contemplation of things as they are, without substitution or imposture, without error or confusion, is in itself a nobler thing than a whole harvest of invention' (ibid.).

However, in examples of FSA work this emphasis on 'fact' and 'things as they are, without substitution or imposture' is problematic since photographic images 'manipulate the subject in front of the camera' (ibid.: 85). Rather than seeing the photograph as an accurate record of the real world, unchanged by artifice or invention, one must ask 'What was a "truthful" picture of reality? Was truth to be found in literal exactitude or in artistic generalisation?' Did it matter if a picture was true or if it was convincing? (ibid.: 8). Thus, a FSA photograph by Arthur Rothstein (Plate 4) depicts a father and his sons caught in a dust storm, which the photographer himself admitted was a 'directed' picture arranged for maximum effect. 'Provided the results are a faithful reproduction of what the photographer believes he saw', Rothstein later argued, 'whatever takes place in the making of a picture is justified' (ibid.: 230). Walker Evans, who also briefly worked for the FSA, felt that in work like this Rothstein had violated the tenets of true documentary: 'that's where the word "documentary" holds', he argued, 'you don't touch a *thing*. You manipulate, if you like, when you frame a picture – one foot one way or one foot another. But you're not putting anything in.' Rothstein, however, was unrepentant. For him, a 'factual and true' picture could be gained by exercising an explicit degree of directorial control over his subject. Evans, in contrast, argued that his ideal was to create a 'stark record'. Alteration or manipulation was out of the question, since it would result in propaganda (all in Orvell 1989: 230–1).

Evans put some of these ideas into practice through his and James Agee's documentary book *Let Us Now Praise Famous Men,* first published

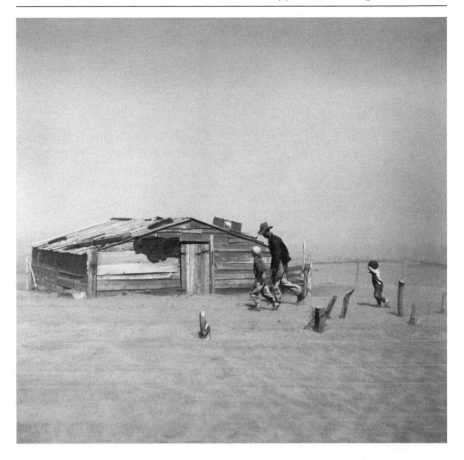

*Plate 4* Arthur Rothstein, *Farmer and his Sons Walking by Shack in a Dust Storm*, 1936
*Source*: CORBIS

in 1941, which combined essays and photographs to record the daily lives of average or representative white Southern tenant farmers. Agee had no formal connections with Southern culture, or with the beliefs and values of established writers in the region, but was a particular advocate of the possibilities of popular culture, especially film and photography, and linked them to a hostility to the kind of social and cultural conservatism he saw in the work of the Southern Agrarians. With Walker Evans as his collaborator, Agee approached Southern identity and how it might be documented, as a radicalised Southerner who had left home and returned to look again at what he had left behind, but more particularly because he raised so explicitly and emphatically the problems associated with the very process of looking. What authority

do we have to record and interpret the lives of others, particularly the poor? For what audiences are our interpretations intended? How can the experiences of our subjects be communicated in a manner that does not demean or marginalise them? In this respect, one critic has suggested that *Let Us Now Praise Famous Men is* not so much a book about share-cropping, but a book about the writing of a book about share-cropping. In so doing, he raised questions about the contradictions the South faced in the late 1930s, between preserving a past associated with suffering and poverty and at the same time containing immense reserves of resilience and cultural depth, and opting for a future that provided material improvement, but at the expense of communal values.

The opening passages of *Let Us Now Praise Famous Men* are concerned with Agee's relentless self-questioning about both the morality of his undertaking, and the technical frailty of the resources at his disposal.

> It seems to me curious, not to say obscene and thoroughly terrifying ... to pry intimately into the lives of an undefended and appallingly damaged group of human beings, an ignorant and helpless rural family, for the purpose of parading the nakedness, disadvantage and humiliation of these lives before another group of human beings, in the name of science, of 'honest journalism' (whatever that paradox may mean), of humanity, of social fearlessness, for money, and for a reputation for crusading and for unbias.
>
> (Agee and Evans 1965: 7)

Agee doubts that language can accurately represent the Southern people and yet he persists in an attempt to capture their spirit. Agee rejects conventional forms of documentary and their concern with 'facts' and objectivity, using different formal devices to overcome concerns about the limitations of the written word. These include extremely detailed accounts of specific topics like work and housing, autobiographical confessions and poetry. Equally important are the 60 uncaptioned photographs by Walker Evans which precede the written text. Standing in juxtaposition to it, they reinforce Agee's concerns with the means of representation. Agee argues that the camera's 'next to unassisted and weaponless consciousness' could overcome the problems he found with words because the camera's ice-cold eye was 'incapable of recording anything but absolute, dry truth (ibid.).

In Evans's photographs his subjects are aware of their part in the making of the photograph and 'are conscious of the camera, of its manipulator, and of the unknowable audience behind it. They are not taken off guard; on the contrary they have been given time to arrange and compose themselves for the picture' (Stott 1973: 268). In fact, in practice, Evans himself resorted to some of the same strategies as Rothstein,

by re-arranging furniture in the share-croppers' houses for aesthetic effect. Nevertheless he tried to give those whom he photographed a degree of self-respect as well as being aware of the sensibilities of the viewer. What Agee and Evans in their different ways consider, there-fore, is what some historians have also identified as a central issue in seeking to understand the lives of ordinary Southerners, particularly the poor, in the 1930s. Progress here was not always an unmixed blessing. It brought with it the benefits of modernisation such as electrification, improved roads, and scientific farming, bringing the South closer to the American mainstream, but it also damaged a way of life, patterns of living, a culture (Daniel 1987, 2000). Agee and Evans, in constantly calling our attention to the beauty of the share-croppers' poverty, in asserting the dignity with which they lived their lives, also remind us 'That the world can be improved and yet must be celebrated as it is are contra-dictions. The beginning of maturity may be the recognition that both are true' (Stott 1973: 289).

## WRITING THE SOUTH

A powerful theme in Southern culture has been the relationship between writers and the region, and this link between writing and place has raised important interpretative issues. Is Southern literature to be valued for the accuracy and depth with which it depicts the geography of the South or, rather, should it be judged as work of the imagination, the authority of which is only diminished by seeking to chain it too closely to some concept of a 'real' world? This tension might be illustrated with reference to the work of a host of Southern writers, but it is most usually found in the work and life of William Faulkner. Faulkner lived most of his life in the small Mississippi town of Oxford, where he created the imagined region he called Yoknapatawpha. This was an invented landscape in which he could confront Southern history and society. But in seeking to come to terms with the burdens of the Southern past, Faulkner treated history not just as a collection of factual events, but as an opportunity for reconstructing the past through the power and scope of his imagina-tion. Southern writers are often concerned with specific themes: family, race, religion, a sense of place and the imperfectibility of man and for Faulkner, and others like Robert Penn Warren, Allen Tate and William Styron, these themes are worked out within the context of Southern history. In contrast, Bobbie Ann Mason's *In Country* (1985) marks a shift from these traditional concerns, presenting a protagonist, Sam Hughes, who inhabits a world where time is measured by the national popular culture, which colours every part of her existence. Television schedules and music concerts provide markers for particular stages in her life, and this apparent lack of rootedness in communal qualities is reinforced by

Sam's restless mobility. In place of Faulkner's contained Yoknapatawpha, we are provided with a South dominated by the road, and by Sam's final trip with her grandmother and her uncle Emmett from Kentucky to the Vietnam memorial in Washington, DC, where she hopes to trace her father's name in the wall. It is not true that Sam is unconcerned with history, but her version of the past comes at the intersection between her personal efforts to make sense of her father's life and the war in Vietnam in which he died, rather than falling under the influence of the older complexities of Southern history. Her past is national rather than regional or local, and her engagement with it is touched by the same popular culture that affects other parts of the country, rather than by any specific Southern values. It is also a short-term past, which only goes back to the early 1960s when the Beatles first came to America, and which makes little attempt to connect the tragedy of Vietnam to deeper themes in the American or the Southern historical experience. C. Vann Woodward once commented that the South, at least up until the Vietnam War, had been un-American in having undergone an experience, which no other part of the country had shared, the lesson of defeat and submission after war. He cherished the hope that this might provide a counter-balance to an unquestioned national faith in political progress and 'the conviction that American ideals, values and principles inevitably prevail in the end' (Woodward 1968: 188–9). He was later forced to qualify his position as Southern politicians, like President Lyndon Johnson and Secretary of State Dean Rusk, played an instrumental role in leading America into Vietnam, but he remained convinced that Americans still had something to learn from the experience of the South with history (ibid.: 233). The main characters in *In Country*, however, are notable for their distrust of history: 'You can't learn from the past', declares Sam's uncle Emmett. 'The main thing you learn from history is that you can't learn from history. That's what history is' (Mason 1987: 226). Mason's South of shopping malls, fast-food restaurants, television series and pop songs, with its concomitant distrust of history and tradition, appears to mark something of a break with the conventions of Southern culture. On the other hand, it may also suggest that *In Country* is different, in that it is about other kinds of Southerners than those who wrote and appeared in earlier Southern fiction. Mason is not writing about the privileged, as older writers had, but about 'the common people' (Hobson 1994: 23). One version of the South may be being discarded here, but another may be appearing in its place.

## SOUTHERN MUSIC

In a visit to Memphis in 1968, the journalist Stanley Booth recorded meeting Dan Penn, an influential producer and song-writer, at the highly

successful American Studios. He spoke of the South as a place where, 'People ... don't let nobody tell them what to do.' 'But how does it happen that they know what to do?', Booth asked, and Penn 'squinted at me across the desk, "I ain't any explanation for it," he said' (Booth 1993: 78). Penn's laconic style catches something of the unpredictable and often innovative way in which Southern music has developed. Popular music has been one of the most significant cultural forms in the lives of many Southerners, and has been one of the most important contributions the South has made to a wider American culture. Southern white and black music, as an expression of the values and beliefs of the common people of the South, has had a particularly important role in the way that ordinary Southerners have thought and felt about the most important themes in their lives such as family, land, work, sacred and profane love.

Such music raises issues about the relationship between popular culture and more traditional notions of Southern culture, linked to the plantation myth and the genteel traditions of the Old South, and emphasises the importance of the relationship between culture and historical change. The spread of Southern music, both across the region, and over the rest of nation, has been closely connected with the modernisation of the South and arguments as to whether that process has diluted distinctively Southern qualities. Because it is so closely identified with the lives of ordinary Southerners, it also inevitably raises the issue of race, and how that has affected the kinds of musical expression that have emerged from the region. Country music has been a particularly important form, and can be examined in a number of ways. One approach is to look at it in the context of the modernisation of Southern culture. As Bill Malone has suggested, 'country entertainers were torn between tradition and modernity' because their music 'had its origins in the folk culture of the South – a diverse culture that drew upon the interrelating resources of Europe and Africa', but it was developed and spread, first throughout the South and then the rest of the nation, by the communications revolution of the inter-war years, symbolised by the growth of radio and the record industry (Malone 1987: 3). This, of course, was precisely the period in which the rural small-town South was being transformed by the experience of agricultural modernisation. Country music, on the one hand, celebrated many of those virtues that 'progress' seemed to be undermining: a sense of place, community, family, church and motherhood, whilst on the other hand, it became increasingly popular directly as a result of modernising forces and technological innovation.

This tension between old and new is apparent in the careers of some of the key performers in early country music. The Carter Family, for instance, came from the Clinch mountains of Virginia and their music generally projected a consistent mood, that of the family home, where

their 'sound remained that of an intimate singing for a small circle of friends where the values of home and family, decency and modesty, were both assumed and shared as living Christian rural fellowship' (ibid.: 65–8). However, one of the important factors in the popularisation of the Carter Family's traditional music was Mexican border radio. Located just across the Rio Grande, and thus outside federal frequency regulations, these stations broadcast to much of the continental United States, as far as the Canadian border. Border radio programming was extremely varied, but it used country music (or hillbilly music as it was still generally called) interspersed with extensive advertising and religious evangelism.

Another significant figure in the development of country music was Jimmy Rodgers, 'The Singing Brakeman', who celebrated a different image of the South from the settled community of the Carters: the attraction of the open road, of individuals who had left home because of opportunity, homelessness, eviction and crime. He became a decisive influence in 'country music's evolution as a star-oriented phenomenon, with traits increasingly national rather than local in scope' (ibid.: 77), even though he himself never performed in the North, spending his short career criss-crossing the South on vaudeville tours and travelling tent shows. More than was the case with the Carter Family, his commercial success on radio and record helped to bring a romantic stereotype of a certain set of Southern attitudes to a regional, national and international audience. Rodgers' songs about leaving were closely connected to changes affecting the South in the 1920s and 1930s as the Depression, drought, agricultural modernisation and government policies forced Southerners to go on the move. As Pete Daniel has noted 'the farther they removed themselves from the country, the more alluring country music became' (Daniel 1987: 102).

During the Second World War country music became increasingly national in its appeal as Southerners continued to migrate in ever-increasing numbers to the West and North, and as the appeal of radio spread still further. This boom lasted into the mid-1950s through the careers of such figures as Hank Williams, and the introduction of country music to television, but in the mid-1950s it was severely challenged by an alternative form of Southern music, rock and roll. Elvis Presley was a Southerner, but his early music, while drawing on traditional white (and black) sources, rapidly changed into something fresh and distinctive. Country music responded in two main ways, either by adapting some of the style and instrumentation of 'pop' music, or by periodically reasserting its traditional roots. Since the late 1950s both of these trends have been in existence, sometimes working together, sometimes in opposition to each other.

Another important theme in Southern popular music has been the interplay between black and white cultures; while there have been, and are, predominantly black idioms, like the blues, or predominantly white idioms, like country music, both are impossible to understand without an appreciation of the bi-racial world from which they emerged. The nature of this 'sharing', however, is a complex question which involves in particular a central issue in Southern popular culture, the relationship between black and white races and their cultural expressions. As Edward Ayers has emphasised, 'the presence of black Southerners shaped the private actions and public culture of the white South' (Ayers 1992: 119). Charles Joyner has argued that 'the central theme of Southern history has been racial integration' and that 'cultural styles have always refused to abide by any colour line, however rigidly it may have been drawn' (Joyner 1993: 3–5). The mixing of cultural traditions has been more important than any other single factor for the extraordinary richness of Southern culture. Even though the South for much of its history has followed a policy of implicit segregation, in terms of popular culture it is evident that both races have been heavily influenced by each other. A number of important white musicians both learned from and cooperated with black musicians and vice versa, to create a 'common legacy of musical performance' (Malone 1993: 151). Elvis Presley drew on the black rhythm and blues of his home town in Memphis, as did Carl Perkins, whose 'Blue Suede Shoes' became the first record to reach the top of the pop, country and rhythm and blues charts. Stanley Booth claims this was more important than the Emancipation Proclamation, which was an edict handed down from above, whereas the success of 'Blue Suede Shoes' among African Americans represented an actual grass-roots acknowledgement of a common heritage, a mutual overcoming of poverty and a kind of redemption (Booth 1993: 14). The Stax label was another cooperative venture that Rodgers Redding, the brother of the leading soul singer Otis Redding, praised in a similar manner: 'What made it work, the key to it all was black and white working together as a team' (Guralnick 1986: 405).

## FILM AND THE SOUTH

Southern identity has also been constructed through film. From its earliest days Hollywood has frequently used the South as subject matter, and in so doing helped to inform the images that Southerners held of their own region, as well as the impressions of non-Southerners, whether in the rest of the country or outside America altogether. Hollywood has often tended to present a range of stereotypical versions of the South, but their resonance and effectiveness have varied according to the era in which they were produced, and the concerns and values

of the audiences who consumed them. One of the most influential of these versions is what a number of critics have labelled the 'Southern', as a counterpart to the more widely recognised genre of the 'Western'. For Leslie Fiedler, writing in 1968, the Southern actively sought 'melodrama, a series of bloody events, sexual by implication at least, played out in the blood-heat of a "long hot summer" against a background of miasmal swamps, live oak, Spanish moss, and the decaying plantation house' (Fiedler 1972: 15–16). The Southern has tended to come in two forms, one relatively nostalgic and benign, the other darker and brooding, and the two themes have often been combined in the same film. Traditional versions of the South have been represented in two of the most influential blockbusters in Hollywood history, *The Birth of a Nation* (D.W. Griffith, 1915) and *Gone with the Wind* (David Selznick, 1939). *The Birth of a Nation* is a difficult film to deal with at the start of the twenty-first century, because its version of Southern history so explicitly endorses white supremacy, and either the child-like or bestial nature of African Americans. Griffith presents a history of the South in which the 'lost cause' of the Confederacy represents all that was best about Southern values and, by implication, those of the rest of the nation. National unity between North and South could only be restored if the virtues of the Southern cause were fully understood and appreciated by 'outsiders'. As one of Griffith's collaborators declared, it was hoped that 'every man who comes out of one of our theaters is a Southern partisan for life' (Kirby 1987: 4).

Scott Simmon has argued that one way to read *The Birth of a Nation* is as part of the sustained Southern argument against Harriet Beecher Stowe's *Uncle Tom's Cabin*. Ever since the novel's original publication in 1852, Southern writers have inveighed against what they saw as Stowe's misrepresentation of the slave South, and the two novels by Thomas Dixon Jr, *The Leopard's Spots* and *The Clansman*, were in part an angry riposte to a popular staging of *Uncle Tom's Cabin* in 1901. Griffith, Simmon argues, used Dixon's material to turn Stowe on her head. 'Whereas Stowe's suffering mothers and violated women served to damn the institution of slavery, the *Birth's* suffering mothers and violated women damned Reconstruction ideals of equality' (Simmon 1993: 125–6). Family and home were revealingly exploited by Griffith as symbols of morality, and women in particular presented as the epitome of purity, whose reputation and safety it was the duty of men to protect. In one of the key scenes of the film, the daughter of the South Carolinian Cameron family throws herself off a cliff to escape the pursuit of Gus, a renegade black soldier. Death for her is far sweeter than dishonour. The rise of the Ku Klux Klan, inspired by her brother, the Little Colonel, would protect Southern womanhood from such threats, and in so doing, regain white supremacy and restore order and harmony in society.

Twenty-four years later, *Gone with the Wind* follows Griffith in repre-senting the plantation South as a kind of Eden, dominated by grace, honour and community but, fitting the Depression years in which it was produced, shows how that idyll was to be destroyed by social collapse and economic disaster. The solution this time is not, however, simply to redeem the South by restoring white rule, though there are affinities between the versions of Reconstruction presented in *The Birth of a Nation* and *Gone with the Wind*, but instead to reassert traditional American beliefs in the virtues of individual effort. Scarlett in the end refuses to stay with Rhett Butler in the privileged and backward-looking seclusion of Charleston and prefers to return to Tara in the hope of restoring both her own and her region's fortunes.

However, to leave the impression that this kind of treatment of the South on film is the only or even the most dominant one would be misleading. Other influential themes have emerged, particularly since the 1940s. One is the treatment of racial issues, often from a critical or liberal perspective. One of the path-breakers here was *Intruder in the Dust* (1949), based on William Faulkner's novel, but it was followed by such films as *The Intruder* (1962) and *To Kill a Mockingbird* (1963). *In the Heat of the Night* (1967), however, did as much as any other movie of this kind to 'break Hollywood's silence about the contemporary South.' by dealing with 'the racism of the Southern legal system' (Graham 2001: 179). By using a plot in which a suspected black criminal, deep in Mississippi, had the false accusations against him cleared after the persis-tent investigations of a black policeman from the North, it appeared to undermine many of Hollywood's earlier evasions about the nature of race relations in the South. However, at another level, its conclusion worked to redeem much of the Southern system. The small-town police chief eventually joins forces with his black counterpart to track down the real villain, who turns out not to be a local land-owner as first suspected, but a feckless redneck. The whiteness of the Southern system is excused by 'projecting the criminality of the race onto its lowest member' (Graham 2003: 181–2). Another more recent trend has been the emergence of films whose protagonists have come from the Southern working-class, often as a conscious alternative to the plantation tradi-tion. Sometimes labeled 'hickflicks', these have taken various forms. One popular plot presents restless white male heroes confronting and sometimes overcoming representatives of state authority, often in the form of the police. Characteristically such narratives have often combined comedy and violence, as in the Burt Reynolds *Smokey and the Bandit* cycle, but they have also on occasion had a more serious purpose, as in a film like *Cool Hand Luke*, where Paul Newman experiences the travails of a Southern chain-gang for a crime which only involved getting drunk

and destroying a parking meter. An alternative version of the poor white South, which has allowed more space for women as representatives of what was most important in the culture of the 'common people', and has often presented men as part of the problem, may be found in the recent series of films dealing with Southern music, and particularly country and western. Films like *A Coalminer's Daughter* (1980) and *Sweet Dreams* (1985) portray the lives of singers Loretta Lynn and Patsy Cline and provide a counter to the plantation myth in which such women appear only on the periphery of the action, and may be seen as part of the same process as the democratisation of Southern literature in the hands of writers like Bobbie Ann Mason. Changing attitudes towards the representation of women in the American South is presented in a still more radical form in *Thelma and Louise* (1991). The South here is not represented by a specific, idealised place like Tara, but instead by many of the same developments that Mason writes about in *In Country*: the open road, cheap motels, popular music. The main protagonists do not look to men for their protection, but instead take their own revenge on an uncaring husband by deserting him, and on would-be rapists by exacting their own, violent, form of revenge. And yet by inverting many of the conventions of the Southern way of life, the film still ties in to many of the debates about Southernness, which gives its often turbulent and violent atmosphere an added resonance.

## CONCLUSION

As the editors of the massive *Encyclopedia of Southern Culture* argue, 'The American South has long generated powerful images and complex emotions' (Wilson and Ferris 1989: viii). In its scale and range the *Encyclopedia* was itself evidence that, despite the nationalising of American culture, the debate over Southern difference is likely to continue for some time yet. In testifying to the vitality of Southern culture in the present as well as in the past, to the host of interpretations of its relationship to the rest of the United States, and to the way in which its cultural products have spread far beyond American borders, it ensures that its significance as a distinctive region within American culture will long deserve further examination. It may be that modernisation has rendered aspects of the Southern world less distinctive and has destroyed that older notion of a 'separate South', set apart from the rest of the country, but somehow Southerners, and Southern identity still persist.

## NOTES

1   *The Wild West* (1995), produced by Ric Burns and Lisa Ades, WGBH Educational Foundation and Steeplechase Films Inc.

2   The approach taken here examines the 'new history' as it relates to the land and women, but it would be possible to consider other re-examinations of Hispanic peoples or Asian Americans in the West.
3   New Western History is best represented in the works of Limerick, Milner, Worster, and White as listed in the bibliography.
4   The idea of the 'corral' is echoed in Doctorow's *The Book of Daniel* (1994: 296) when he describes Disneyland's 'mazes of pens' controlling the crowds.
5   John Ford's *The Searchers* portrays an archetypal gunfighter in Ethan Edwards, who is excluded from the orderly domestic world at the end of the film. He is too chaotic, too violent to have a place in the 'civilised' West.
6   Ana Castillo's novel *So Far From God* (1994a) is concerned, in part, with both the land and the stories told by her community.
7   See Richard Misrach (1990) *Bravo 20*, Albuquerque: University of New Mexico Press.

## REFERENCES AND FURTHER READING

### (a) The West

Allmendinger, B. and Matsumoto, V. (eds) (1999) *Over the Edge: Remapping the American West*, Berkeley: University of California Press.
Anzaldúa, G. (1987) *Borderlands/La Frontera*, San Francisco: Aunt Lute Books.
Appleby, J., Hunt, L. and Jacob, M. (eds) (1994) *Telling the Truth About History*, London: W.W. Norton.
Armitage, S. and Jameson, E. (eds) (1987) *The Women's West*, London: University of Oklahoma Press.
Barthes, R. (1976) *Mythologies*, London: Paladin.
Berkhofer, R.F. (1978) *The White Man's Indian: Images of the American Indian from Columbus to the Present*, New York: Vintage Books.
Bruce, C. (ed.) (1990) *Myth of the West*, New York: Rizzoli.
Burroughs, W. (1988) *The Western Lands*, London: Picador.
Campbell, N. (2000) *The Cultures of the American New West*, Edinburgh: Edinburgh University Press.
Castillo, Ana (1994a) *So Far from God*, London: Women's Press.
—— (1994b) *Massacre of the Dreamers: Essays on Xicanisma*, Albuquerque: University of New Mexico Press.
Cather, W. (1913) *O Pioneers*, London: Heinemann.
Chan, S., Daniels, D.H. *et al.* (eds) (1994) *Peoples of Color in the American West*, Lexington: D.C. Heath.
Comer, K. (1999) *Landscapes of the New West*, Chapel Hill: University of North Carolina Press.
Cronon, W., Miles, G. and Gitlin, J. (1992) *Under An Open Sky: Rethinking America's Western Past*, London: W.W. Norton.
Crow, C. (ed.) (2003) *A Companion to the Regional Literatures of America*, Oxford: Blackwell.
Davis, M. (1990) *City of Quartz: Excavating the Future in Los Angeles*, London: Verso.
—— (1993) 'Dead West: Ecocide in Marlboro Country', *New Left Review* vol. 200, July/August, pp. 49–73.

—— (2002) *Dead Cities and Other Tales*, New York: The New Press.

Deverall, W. (ed.) (2004) *Companion to the American West*, Oxford: Blackwell.

Doctorow, E.L. (1994) (first 1971) *The Book of Daniel*, London: Pan.

Drinnon, R. (1990) *Facing West: The Metaphysics of Indian Hating and Empire Building*, New York: Schocken Books.

Ellis, B. Easton (1985) *Less Than Zero*, London: Picador.

—— (1994) *The Informers*, London: Picador.

Engel, L. (1994) *The Big Empty: Essays on the Land as Narrative*, Albuquerque: University of New Mexico Press.

Fischer, P. (ed.) (1991) *The New American Studies: Essays from Representations*, Berkeley, CA: University of California Press.

Fjellman, S. (1992) *Vinyl Leaves: Walt Disney and America*, Boulder, CO: Westview Press.

Foote, S. (2003) 'The Cultural Work of American Regionalism', in Crow (ed.) *A Companion to the Regional Literatures of America*, Oxford: Blackwell.

Foucault, M. (1977) *Discipline and Punish: The Birth of the Prison*, Harmondsworth: Penguin.

—— (1980) *Power/Knowledge: Selected Interviews and Other Writings 1972–1977*, London: Harvester Wheatsheaf.

Frampton, K. (1983) 'Towards a Critical Regionalism', in H. Foster (ed.) *Postmodern Culture*, London: Pluto Press.

Graulich, M. and Tatum, S. (eds) (2003) *Reading The Virginian in the New West*, Lincoln: University of Nebraska Press.

Greenblatt, S. (1991) *Marvelous Possessions*, London: Routledge.

Gunn Allen, P. (1992) *The Sacred Hoop*, Boston: Beacon.

Jameson, F. (1984) 'Periodizing the Sixties', in S. Sayres *et al.* (eds) *The 60s Without Apology*, Minneapolis: University of Minnesota Press.

Jenkins, K. (1991) *Rethinking History*, London: Routledge.

Kitses, J. (2004) *Horizons West*, London: BFI.

Kolodny, A. (1984) *The Land Before Her: Fantasy and Experience of the American Frontiers, 1630–1860*, Chapel Hill: University of North Carolina.

—— (1992) 'Letting Go Our Grand Obsessions: Notes Towards a New Literary History of the American Frontiers', in *American Literature* vol. 64, no. l, March, pp. 1–18.

Lawrence, D.H. (1977) *Studies in Classic American Literature*, Harmondsworth: Penguin.

Lefaivre, L. and Tzonis, A. (2003) *Critical Regionalism*, Munich: Prestel.

Levi-Strauss, C. (1963) *Structural Anthropology*, New York: Basic Books.

Lewis, N. (2004) *Unsettling the Literary West*, Lincoln: University of Nebraska Press.

Limerick, P.N. (1987) *The Legacy of Conquest: The Unbroken Past of the American West*, New York: W.W. Norton.

Limerick, P.N., Milner, C.A. and Rankin, C.E. (eds) (1991) *Trails: Toward a New Western History*, Lawrence: University of Kansas Press.

McCarthy, C. (1990) (first 1985) *Blood Meridian or the Evening Redness in the West*, London: Picador.

McMurtry, L. (1985) *Lonesome Dove*, New York: Simon and Schuster.

Mariani, P. (ed.) (1991) *Critical Fictions*, Seattle: Bay Press.

Massey, D. (1995) 'Places and their Pasts', *History Workshop Journal*, Spring, vol. 39, pp. 182–92.

Milner, C.A. (1989) *Major Problems in the History of the American West*, Lexington: D.C. Heath.

Milner, C.A., O' Connor, C. and Sandweiss, M.A. (eds) (1994) *The Oxford History of the American West*, London: Oxford University Press.

Misrach, R. (1990) *Bravo 20*, Albuquerque: University of New Mexico Press.

Munslow, A. (1992) *Discourse and Culture: The Creation of America, 1870–1920*, London: Routledge.

Nash Smith, H. (1950) *Virgin Land: The American West as Myth and Symbol*, New York: Vintage.

Proulx, E.A. (1999) *Close Range*, London: Fourth Estate.

—— (2002) *That Old Ace in the Hole*, London: Fourth Estate.

—— (2003) *Bad Dirt*, London: Fourth Estate.

Riley, G. (1992) *A Place to Grow: Women in the American West*, Arlington Heights, IL: Harlan Davidson, Inc.

Robertson, J.O. (1980) *American Myth, American Reality*, New York: Hill and Wang.

Robinson, F. (ed.) (1998) *The New Western History: The Territory Ahead*, Tucson: University of Arizona Press.

Said, E. (1994) *Culture and Imperialism*, London: Vintage.

Sayres, S. *et al.* (eds) (1984) *The 60s Without Apology*, Minneapolis: University of Minnesota Press.

Schaefer, J. (1989) (first 1949) *Shane*, London: Heinemann Educational.

Silko, L.M. (1977) *Ceremony*, New York: Penguin.

—— (1981) *Storyteller*, New York: Arcade.

Slotkin, R. (1973) *Regeneration Through Violence: The Mythology of the American Frontier, 1600–1869*, Middletown: Wesleyan University Press.

—— (1985) *The Fatal Environment: The Myth of the Frontier in the Age of Industrialization, 1800–1890*, New York: Atheneum.

—— (1992) *Gunfighter Nation: The Myth of the Frontier in Twentieth-Century America*, New York: Harper Perennial.

Storey, J. (1993) *An Introductory Guide to Cultural Theory and Popular Culture*, London: Harvester Wheatsheaf.

Tompkins, J. (1992) *West of Everything: The Inner Life of Westerns*, Oxford: Oxford University Press.

Trachtenberg, A. (1982) *The Incorporation of America*, New York: Hill and Wang.

Truettner, W. (ed.) (1991) *The West As America*, Washington, DC: Smithsonian Institute Press.

Turner, F.J. (1962) *The Frontier in American History*, (ed.) R. Billington, New York: Holt, Rinehart and Winston.

Turner, F.W. (ed.) (1977) *The Portable North American Indian*, New York: Penguin/Viking.

Twelve Southerners (1962) (first 1939) *I'll Take My Stand: The South and the Agrarian Tradition*, New York: Harper and Row.

Whipple, T.K. (1943) *Study Out the Land*, Berkeley, CA: University of California Press.

White, R. (1991) *It's Your Misfortune and None of My Own: A New History of the American West*, Norman and London: University of Oklahoma Press.

Whitman, W. (1971) (first 1855) *Leaves of Grass*, London: Everyman.

Worster D. (1992) *Under Western Skies: Nature and History in the American West*, Oxford: Oxford University Press.

—— (1994) *An Unsettled Country: Changing Landscapes of the American West,* Albuquerque: University of New Mexico Press.

Wright, R. (1992) *Stolen Continents: The 'New World' Through Indian Eyes,* Boston: Houghton Mifflin.

Zukin, S. (1991) *Landscapes of Power,* Berkeley, CA: University of California Press.

## (b) The South

Agee, J. and Evans, W. (1965) (first 1941) *Let Us Now Praise Famous Men,* London: Peter Owen.

Ayers, E. (1992) *The Promise of the New South: Life after Reconstruction,* New York: Oxford University Press.

Ayers, E. and Mittendorf, B. (eds) (1997) *The Oxford Book of the American South: Testimony, Memory, and Fiction,* Oxford: Oxford University Press.

Badger, A. (2003) *Race in the American South: from Slavery to Civil Rights,* Edinburgh: Edinburgh University Press.

Baker, H. and Nelson, D. (eds) (2002) *Violence, the Body and the South: A Special Issue of* American Literature, Duke University Press.

Boles, J. (2000) *The South through Time: a History of an American Region,* London and Englewood Cliffs, NJ: Prentice Hall.

Boles, J. (ed.) (2002) *A Companion to the American South,* Oxford: Blackwell.

Booth, S. (1993) *Rythm Oil: A Journey Through the Music of the American South,* London: Vintage.

Brinkley, A. (1995) *American History: A Survey,* New York: McGraw-Hill.

Cash, W.J. (1971) (first 1941) *The Mind of the South,* New York: Vintage.

Cooper, W. and Terrill, T. (1991) *The American South: A History,* New York: McGraw-Hill.

Cowley, M. (ed.) (1977) *The Portable Faulkner,* New York: Viking.

Daniel, P. (1987) *Standing at the Crossroads,* New York: Hill and Wang.

—— (2000) *Lost Revolutions: the South in the 1950s,* Chapel Hill: University of North Carolina Press.

Degler, C. (1977) *Place over Time: The Continuity of Southern Distinctiveness,* Baton Rouge: Louisiana State University Press.

Eagles, C. (ed.) (1992) *The Mind of the South, Fifty Years Later,* London: University of Mississippi Press.

Escott, P. and Goldfield, D. (eds) (1990) *Major Problems in the History of the South,* Lexington: D.C. Heath.

Faulkner, W. (1965) (first 1937) *Absalom, Absalom,* London: Chatto and Windus.

Fiedler, L. (1972) *The Return of the Vanishing American,* London: Paladin.

Fischer, D.H. (1989) *Albion's Seed,* New York: Oxford University Press.

Foner, E. (1989) *Reconstruction: America's Unfinished Revolution,* New York: Harper and Row.

Genovese, E. (1974) *Roll, Jordan, Roll,* New York: Pantheon.

—— (1994) *The Southern Tradition,* London: Harvard University Press.

Gerster, P. and Cords, N. (eds) (1989) *Myth and Southern History,* Urbana: University of Illinois Press.

Goldfield, D. (1987) *Promised Land: The South since 1945,* Arlington Heights: Harlan Davidson.

—— (2002) *Still Fighting the Civil War: the American South and Southern History,* Baton Rouge: Louisiana State University Press.

Graham, A. (2001) *Framing the South: Hollywood, Television, and Race during the Civil Rights Struggle*, Baltimore: Johns Hopkins University Press.

Gray, R. (1986) *Writing the South: Ideas of an American Region*, Cambridge: Cambridge University Press.

—— (2000) *Southern Aberrations: Writers of the American South and the Problems of Regionalism*, Baton Rouge, Louisiana State University Press.

Gregory, J. (2005) *The Southern Diaspora: How the Great Migrations of Black and White Southerners Transformed America*, Chapel Hill: University of North Carolina Press.

Guralnick, P. (1986) *Sweet Soul Music, Rhythm and Blues and the Southern Dream of Freedom*, London: Penguin.

Hobson, F. (1983) *Tell About the South: The Southern Rage to Explain*, Baton Rouge: Louisiana State University Press.

—— (1994) *The Southern Writer in the Post-Modern World*, London: University of Georgia Press.

—— (2002) *South to the Future: an American Region in the Twenty-First Century*, Athens, GA: University of Georgia Press.

Jenkins, M. (1999) *The South in Black and White: Race, Sex, and Literature in the 1940s*, Chapel Hill: University of North Carolina Press.

Joyner, C. (1993) *Black and White Interaction in the Ante-Bellum South*, Jackson: University Press of Mississippi.

King, M.L. (1964) *Why We Can't Wait*, New York: New American Library.

King, R. (1980) *A Southern Renaissance: The Cultural Awakening of the American South*, Oxford: Oxford University Press.

King, R. (ed.) (1995) *Dixie Debates: Perspectives on Southern Cultures*, East Haven: Pluto Press.

—— (1986)*Rural Worlds Lost*, Baton Rouge: Louisiana State University Press.

Kirby, J.T. (1987) (first 1976) *Media Made Dixie*, London: University of Georgia Press.

—— (1995) *The Counter Cultural South*, Athens: University of Georgia Press.

Lee, A.R. (1990) *William Faulkner: The Yoknapatawpha Fiction*, London: Vision Press.

McCardell, J. (1979) *The Idea of a Southern Nation*, New York: W.W. Norton.

McMillen, N. (1997) *Remaking Dixie: the Impact of World War II on the American South*, Jackson, MS: University Press of Mississippi.

Malone, W. (1979) *Southern Music, American Music*, Lexington: University of Kentucky Press.

—— (1987) *Country Music, U.S.A.*, Wellingborough: Equation Press.

—— (1993) *Singing Cowboys and Musical Mountaineers: Southern Culture and the Roots of Country Music*, Athens: University of Georgia Press.

Mason, B.A. (1987) (first 1985) *In Country*, London: Flamingo.

Massey, D. (1995) 'Places and their Pasts', *History Workshop Journal*, Spring, vol. 39, pp. 182–92.

O'Brien, M. (1979) *The Idea of the American South, 1920–1941*, Baltimore: Johns Hopkins University Press.

Orvell, M. (1989) *The Real Thing: Imitation and Authenticity in American Culture, 1880–1940*, Chapel Hill: University of North Carolina Press.

Ownby, T. (ed.) (1993) *Black and White Cultural Interaction in the Ante-Bellum South*, Jackson: University Press of Mississippi.

Phillips, U.B. (1928) 'The Central Theme of Southern History', *American Historical Review* vol. 34, no. 3, pp. 30–43.

Potter, D. (1968) *The South and Sectional Conflict*, Baton Rouge: Louisiana State University Press.

Rabinowitz, P. (1994) *They Must Be Represented: The Politics of Documentary*, London: Verso.

Reed, J.S. (1982) *One South: An Ethnic Approach to Regional Culture*, Baton Rouge: Louisiana State University Press.

—— (1986) *The Enduring South: Subcultural Persistence in Mass Society*, Chapel Hill: University of North Carolina Press.

Simmon, S. (1993) *The Films of D.W. Griffith*, Cambridge: Cambridge University Press.

Stott, W. (1973) *Documentary Expression and Thirties America*, New York: Oxford University Press.

Styron, W. (1979) *Sophie's Choice*, London: Jonathan Cape.

Whisnant, D. (1983) *All That is Native and Fine: The Politics of Culture in an American Region*, Chapel Hill: University of North Carolina Press.

Wilson, C.R. and Ferris, W. (eds) (1989) *The Encyclopedia of Southern Culture*, Chapel Hill: University of North Carolina Press.

Woodward, C.V. (1968) *The Burden of Southern History*, Baton Rouge: Louisiana State University Press.

—— (1971) *The Origins of the New South*, Baton Rouge: Louisiana State University Press.

—— (1983) *American Counterpoint, Slavery and Racism in the North–South Dialogue*, Oxford: Oxford University Press.

Wyatt-Brown, B. (1982) *Southern Honour: Ethics and Behaviour in the Old South*, New York: Oxford University Press.

## FOLLOW-UP WORK

1    Read the essays on Critical Regionalism referenced in this chapter and say to what extent you feel they can be applied to studies of American regions like the South and West.

2    How has the South or the West been represented by non-American writers and film-makers? What versions, for instance, emerge in such films about the regions as *Mississippi Burning* or *The Night of the Hunter* (South) and *Once Upon a Time in the West* and *Paris, Texas* (West)?

3    The television series *Deadwood* has been very successful – in what ways can it be seen as revisionist?

*Assignments and areas for study*

4    (a) Examine the images in this section and discuss what sense of the mythic West they portray. Read Truettner and Barthes (as above) to help you in your analysis.

(b) Recent films, literature and history have become concerned with multicultural contributions and histories of the West. Choose a group and examine its experience and representation in Western history. You might consider Chinese Americans or Hispanic Americans in this study.

(c) What dividends might be gained from a study of contemporary Southern black writers, or black writers about the South, particularly in terms of the debate discussed above about the continuing significance of history for Southern authors?

(d) What kind of versions of the South are represented in rock music in the period since the 1960s? Have Southern rock musicians possessed a distinctive self-consciousness that marks them out from other American performers?

(e) Write a detailed analysis of *either* Annie Proulx's story 'Brokeback Mountain' *or* Ang Lee's film version, demonstrating how it both challenges and confirms certain values and codes of the West.

Chapter 6

# The American city
## 'The old knot of contrariety'

## CAN WE READ THE CITY?

A popular contemporary perception of America is as a vast city recreated from half-remembered fragments of films, television dramas, popular music and a thousand advertising images. Quite simply, American cities appear to be all around us, from the opening sequences of *CSI's* Las Vegas Strip to the futuristic Los Angeles of *Blade Runner*. This is only one aspect of how we imagine America, but it is, for many of us, the most attractive, engaging and threatening aspect of the country. However, despite the constant presence of American cities in our lives, regardless of where we live, they remain mysterious and unknowable, like a familiar text that we seem to possess but whose final meaning evades us as we attempt to read it.

This idea may sound rather odd. After all, how can a city be a text? But a city is a gathering of meanings in which people invest their interpretations and seek to create their own (hi)story, and therefore resembles a text. A city is constructed like a text, it is 'an inscription of man in space' (Barthes 1988: 193), unfolding, challenging, confusing, thrilling and threatening all at the same time. When Joyce Carol Oates asked in 1981, 'If the City is a text, how shall we read it?' (Jaye and Watts 1981: 11), she expressed this fascination with the need to comprehend the very product of our own creation which had somehow become mysterious. It is these different layers of meaning within the city that are hard to fathom, and which vary depending on where you read them from: high and low, skyscraper or street level, uptown or the ghetto, inside or out, feminine or masculine, rich or poor, and so on. These differing points of view explain the endless possibility of the city for artists and the fascination for historians and sociologists studying its meanings.

This chapter will reflect upon various meanings of the city, employing an alternative to a strictly historical or sociological methodology.[1] Such approaches are, of course, an important part of how we under-stand problems of contemporary city life, but it is also revealing and

provocative to explore the multi-faceted nature of the city from different perspectives. James Donald, for instance, has written, 'By calling this diversity "the city", we ascribe to it a coherence or integrity. *The city, is* above all, a representation ... *an imagined environment'* (Bocock and Thompson 1992: 422).

What must concern us then, argues Donald, is how we read the representations of the city and the discourses that express them to us. The idea of discourse is used here to suggest the manner through which the city is represented to us in language and related frames of reference and definition. Discourses (see the Introduction) are 'the conceptual frameworks which allow some modes of thought and deny others ... a body of unwritten rules which *attempt to regulate* what can be written, thought, and acted upon in a particular field' (Storey 1993: 92 – our emphasis). These discourses are not *about* the city, but they *constitute* it for us as 'readers'/viewers. That is, they do not simply describe, but seek to form our concepts about what the city is and how it relates to life in a wider sense. Discourses organize statements, define texts, promote meanings and position subjects, and any study of urban life has to confront these different formations as they compete for our attention. To what extent the individual can choose between these formations is a matter of intense debate which, indeed, emerges as an issue in many urban texts themselves, for example *Sister Carrie,* as we shall see later. This method derives from post-structuralism,[2] which we have discussed elsewhere, and although we do not have the space to explore its many diverse meanings, certain concepts are particularly relevant here. What it offers is one approach and a new way of seeing things that may have been taken for granted before or, indeed, overlooked altogether.

If structuralism looked for the underlying structure upon which rested meaning, then post-structuralism proposes an alternative, in which meaning is always in process and a text is a 'multi-dimensional space in which a variety of writings, none of them original, blend and clash. The 'text is a tissue of quotations drawn from the innumerable centres of culture' (Barthes 1977: 146). This description conveys an image of city-as-text, and like the perceiver of the city, the reader is the only person that can bring some temporary unity to that text, without, however, fixing it permanently or defining the city totally. It represents it for that moment in the process of signification, with the understanding that meaning is deferred because people will bring various perspectives to that moment and so interpret it differently. The city, seen in this way, is a chain of meanings, each of which is in competition with one another, with certain interpretations emerging at specific points in time with more authority and subsequent power than others.

Adopting this approach allows us to interrogate certain established or dominant readings of the city in order to question them and seek

alternative ways of seeing. If there can be no guaranteed or fixed single meaning of the city, it does not just signal the fact that 'anything goes' or that everything is relative, but that certain dominant or prevailing discourses and fixed meanings have emerged in the city through time and that the contexts within which these readings have arisen need to be re-examined in the light of new theoretical understandings.

## COMPETING VERSIONS OF THE CITY

The problem of reading the city can be traced back to the foundation of America. John Winthrop, the first Governor of Massachusetts, gave a sermon on the *Arbella* as it crossed the Atlantic to America in 1630, and spoke of his vision of a new community like 'a City upon a Hill', with 'the eyes of all people . . . upon us'. The ideal of the heavenly city employed here says much about the utopian dreams so often associated with city planning in the future, but it also emphasises the necessity of establishing the city as orderly and godly because the 'eyes' of the world were looking on. He goes on to say 'we shall be *made a story* and a by-word through the world', thereby asserting an early example of the ways in which the city image has been constructed through narrative. The city-story would be watched (and *read*) by the world, noting the good or the bad within it, just as Winthrop, as a Puritan, linked echoes of Sodom and Gomorrah to the possible darker future of the American city, whilst envisioning in it the strongest beliefs and loftiest aspirations of his community. In part this fits with John Bunyan's *Pilgrim's Progress* (1678), in which he describes the road to salvation as passing through Vanity Fair, with its corruptions and disorder, to the Celestial City and its streets paved with gold.

The dark view of cities can be seen in Thomas Jefferson's comment that cities were 'pestilential to the morals, the health and the liberties of men' and that 'those who labor the earth are the chosen people of God . . . [and] the mobs of great cities add just so much to the support of pure government as sores do the strength of the human body' (Bender 1975: 21). The Jeffersonian warning about the dangers of unrestrained urbanism stressed two broad points: that cities threatened personal morality by encouraging vice, sin and indulgence; and that they might ultimately threaten the Republic itself. These arguments reached a climax in the work of the Reverend Josiah Strong, whose *Our Country* (1885) argued that America was to be God's instrument to redeem the world, but the city stood in the way of that mission since it was a 'storm center' full of 'menace'. The following extract suggests his tone:

> The city is the nerve center of our civilization. It is also the storm center. . . . It is the city where wealth is massed; and here are the

tangible evidences of it piled many stories high. Here the sway of Mammon is widest, and his worship the most constant and eager. Here are luxuries gathered – everything that dazzles the eye, or tempts the appetite; here is the most extravagant expenditure. Here also, is the congestion of wealth the severest . . . here in sharp contrast, are the ennui of surfeit and the desperation of starvation. . . . Here is heaped the social dynamite; her roughs, gamblers, thieves, robbers, lawless and desperate men . . . ready . . . to raise riots for the purpose of destruction and plunder; here gather foreigners and wage-workers . . . especially susceptible to socialist arguments. . . . Thus is our civilization multiplying and focalizing the elements of anarchy and destruction.

(in Glaab 1963: 330–6)

This frames the city as a dark and fearful place in the Jeffersonian tradition, with the overriding threats the new urban masses made to social order. At the same time, however, as Strong interpreted cities in these terms, the poet Walt Whitman defined them in more positive ways, as organic bodies, a 'simple, compact, well-join'd scheme' intimately connecting the individual to the whole, and calling for them to

> Thrive, cities – bring your freight, bring your shows, ample and
>     sufficient rivers,
> Expand, being than which none else is more spiritual,
> Keep your places, objects than which none else is more lasting.
> (Whitman, 'Crossing Brooklyn Ferry' 1971: 140)

This essentially positive discourse of the city as vital and dynamic is reflected in William James's appropriation of Strong's 'storm center' image recasting the city as 'the center of the cyclone' producing the 'pulse of the machine,' which he found 'magnificent' along with

> the heaven-scaling audacity of it all, and the lightness withal, as if there were nothing that was not easy, and the great pulses and bounds of progress, so many in directions all simultaneous that the coordination is indefinitely future [and] give a kind of drumming background of life that I have never felt before.
> (James 1920: 67)

James's metaphors, like Whitman's, contributed to an alternative discourse of the city, stressing its dynamic, forward-looking qualities and transformative potential. This kind of discursive conflict is typical of the ways American cities have been read, and is indicative of the city as meaning in process rather than as fixed and static.

This is evident in the ways cities have continued to be represented, for example, in the work of Woody Allen, and particularly the film *Manhattan* (1979), in which the narrator is trying to write the definitive version of the city he loves, but finds the task impossible, reverting instead to a series of complex re-writings, which range wildly from: 'He romanticized it out of all proportion, and to him no matter what the season was, this was still a town that existed in black and white and pulsated to the great tunes of George Gershwin'; to 'He adored New York City, to him it was a metaphor for the decay of contemporary culture . . . how hard it was to exist in a society desensitized by drugs, loud music, television'; to 'He was as tough and romantic as the city he loved, behind his black-rimmed glasses was the coiled sexual power of a jungle cat . . . New York was his town and it always would be.'

At the same time as the voice-over offers us the sense of the city as indefinable, the visual images, in glowing black and white, spread New York's familiar landmarks before us at a distance and with the camera high up in the clouds. This romantic perspective suggests the mystery of the city, without having to confront at 'street level' its awkward and unromantic realities. Because we, as an audience, are at a distance, both physically and formally (Allen uses both black and white photography and a stirring George Gershwin soundtrack), the city shines out as a place of awe and excitement, vitality and wonder. There is little threat in this myth of Manhattan as a gorgeous moment, with all its contradictions reduced into a singular and potent vision. Despite the narrator's comment about it being the 'metaphor for the decay of modern society', the tone and the final swelling music suggest otherwise.

## THEORETICAL CITY: THE DESIRE FOR CONTROL AND ORDER

Thus, from whichever era of American life, the city has always been a focus for human desires and dreams, a place of possibility, success and threat. This is echoed in the way many people, like Whitman, think of the city as alive; writing, for example, about its 'heart' and its 'soul', or like Henry James, in his book *The American Scene* (1907), about 'its sharp free accent . . . [and] its loose limbs' (Marqusee 1988: 160). Viewed as human and organic, the city takes on a moral condition too so that its culture is seen to reflect the values, attitudes and mores of the people who breathe within it. Frederick Howe, a believer in the possibilities of the city, wrote in 1905 of society as 'an organism like the human body, of which the city is the head, heart, and center of the nervous system' (Howe 1905: 10). Above all, the American city is a text created, a story written by people who sought to impose their vision of order, their designs upon the world, and to some extent to control the wilderness

into a contained and disciplined environment. But at the very same time there was a contrary discourse, which sees control as impossible and where social conflict, crime and corruption flourish. Just as the Puritan Winthrop can be seen as constructing a single discourse for his people, of the city as a testament to their grace, there emerged a counter-discourse that defined the city as the place of recklessness and opportunity, a place of desire, offering the freedom from older, more traditional restraints.

Despite the efforts of people to 'plan' the city, there is a resistance to this form of control and containment, as if the dynamism unleashed in its creation is too immense to manipulate and direct into safe, orderly patterns. Architect Rem Koolhaas's *Delirious New York* (1978) claimed 'the Grid's [pattern of city streets] two-dimensional discipline creates undreamt of freedom for three-dimensional anarchy' (Koolhaas 1994: 20). It is a text we cannot read without difficulties, since it always reaches beyond itself, overflows, contradicts and questions what it is and what it can be. This is the 'archetypal ambivalence of the city' with its 'clashing contradictions', and 'perhaps the central fascination of the city, both real and fictional, is that it embodies man's contradictory feelings – pride, love, anxiety and hatred – towards the civilization he has created and the culture to which he belongs' (Pike 1981: 26). The city is not an easy text to read, but one riddled with contradictions and ambiguities, which account for its mysterious fascinations and its 'new inexplicableness . . . and new unintelligibility' (Trachtenberg 1982: 103).

Trachtenberg's city is *the* modern place where the possibilities of technology, planning, industrialisation and commerce come together in a single environment which thrusts together people, ideas and opportunities in a particular mix of productive kinds of strangeness and distance. The great works of modernist art and literature erupted from this creative mix, reflecting the city itself whose very structures were symbolic expressions of this impulse. As Marshall Berman has written:

> To be modern is to live a life of paradox and contradiction . . . in an environment that promises us adventure, power, joy, growth, transformation of ourselves and our world – and, at the same time, threatens to destroy everything we have, everything we know, everything we are.
>
> (Berman 1983: 14–15)

This sense of the city environment as an 'old knot of contrariety', to borrow a phrase from Walt Whitman, echoes the competing discourses we discussed earlier, and is amplified in a helpful essay by the social theorist Michel de Certeau. For him, New York City seen from a skyscraper is a text 'in which extremes coincide – extremes of ambition and

degradation, brutal opposites of races and styles, contrasts between yesterday's buildings, already transformed into trash cans, and today's urban irruptions that block out its space' (de Certeau 1988: 91). It is an ever-changing space/text that 'invents itself from hour to hour' where 'the spectator can read into it a universe that is constantly exploding' and indulge in the 'gigantic rhetoric of excess' that constitutes the urban landscape of America (ibid.). This sense of the whole city spread out like a multi-dimensional text that can be read, 'grasped', even understood, is questioned as it reduces and 'makes the complexity of the city readable, and immobilizes its ... mobility' (ibid.: 92) because one is surveying a 'picture', removed and organised by distance so that all one sees are the grids and the blocks, with all the order and control of the city-planners' blueprints. It is the 'theoretical' city because the life of the city, its 'practices', go on below in the hubbub and chaos of the streets and cannot be seen from the remove of the high vantage points. The 'networks of these moving, intersecting writings compose a manifold story that has neither author nor spectator' (ibid.: 93).

Thus the city's contradictions abound, as Poe charted in 'The Man of the Crowd' (Poe 1975: 169–70) or Paul Auster in *The New York Trilogy* (1987), and are hard to define or fix, despite the constant efforts of planners and designers to create something like the City Beautiful[3] as a model of order and social control. The design of the city has always been at odds with the way people live within it, as if there is a natural resistance in city life to the desired principles of control and order that seem always to be a significant part of their creation. This theoretical argument can be examined in relation to the earlier comments about representation in Woody Allen's *Manhattan* and its tendency to remove us from the city for specific reasons and effects.

The city planners dreamt of a 'benign coercion' 'to eradicate the communal culture of working-class and immigrant streets, to erase that culture's offensive and disturbing foreignness, and replace it with middleclass norms of hearth and tea table'. This was 'the ordering hand of corporate organization, the values of system and hierarchy asserting itself into the lives of the streets and the bustling neighbourhoods' (all Trachtenberg 1982: 111). The potentially unreadable text of the ground-level streets had to be legitimised, ordered and contained within a stable, disciplined text and this can be seen as giving rise to what has been termed a clash between 'civic horizontalism and corporate verticality' (Taylor 1992: 52), where the corporation accesses the tower as a symbol of its power and the rest of the city exists down below in its shadow. An example of this is the skyline of the booming Southern city, Nashville, which has developed rapidly but still bears the traces of the past at lower levels. Plate 5 shows this hierarchical skyline with the foreground of the preserved past, as the city plans into itself a 'historic' simulation of Fort

*Plate 5* A Nashville skyline
*Source*: Neil Campbell, 1994

Nashborough, the original settlement of 1779, overshadowed by the dilapidated warehouses of the old riverfront gradually being reclaimed as leisure and shopping sites. Hovering over both is the symbolic skyscraper of the Bell Corporation, epitomising the new economy of Nashville as the financial and insurance centre of the mid-South.

## THE UNDIVULGED CITY: POE'S 'THE MAN OF THE CROWD'

De Certeau's city of levels and networks, like intermingling stories, is a very exciting way of approaching urban experience and one which can be useful to bear in mind as we begin to examine more specific examples of attempts to read the city. Edgar Allan Poe's 'The Man of the Crowd' (1845) deliberates upon the meaning of the city and suggests that it is like crime itself whose 'essence . . . is undivulged' (Poe 1975: 179).

The story begins with the warning that 'it does not permit itself to be read' (ibid.) and then conveys the condition of the city as seen through the eyes of a questing narrator following 'the man of the crowd'. It is the classic story of the city, in which the narrator, who sees himself as a man of vision, intellect and reason confronts the 'mysteries which will not suffer themselves to be revealed' (ibid.: 179) in the belief that he can unravel them. As in Poe's later Dupin stories,[4] the belief that the city can be understood and solved is central to this piece. Reading his newspaper in the coffeehouse, he surveys the streets outside, as if he could follow the lines and columns of the urban world in the same manner that he 'amuses' himself with the paper's text and in so doing categorises the 'divisions' he witnesses like the sections of the newspaper. This arrogant detachment permits the city scene to become a neat 'scale' into which he fits all the types he sees in the crowd, enabling him to 'frequently *read*, even in that brief interval of a glance, the history of long years' (ibid.: 183 – our emphasis). Poe's narrator echoes the problem described by de Certeau, of the city characterised by those who would try to read its history in a 'glance' and in so doing miss the complex web of relations and practices unfolding there. The urge to define and fix the city as a single thing, like the original and eternal desire to plan and control the life of the city, is suggested here in the actions of the narrator and then rapidly countered by the eruption of 'the man of the crowd' who presents an insoluble dilemma. From the narrator's logical 'analysis of the meaning conveyed', he is altered by the sight of the man, and 'there arose confusedly and paradoxically within [his] mind' a new set of ideas that cannot be so easily reduced to a formula (ibid.). As he follows the man, now engaged himself with the street's 'waver . . . jostle and hum' (ibid.: 184) rather than removed behind the glass, he faces paradoxes and contradictions that defy his 'scale' of meaning and open him up to the street-level city, which 'aroused,

startled, fascinated' (ibid.) in equal measure. He is exposed to the multi-faceted urban environment, one beyond his simplified and limited categories such as 'poverty . . . crime . . . filth . . . desolation' (ibid.: 186–7), to a complex text 'crossed and recrossed' which 'is a grosser book than the *Hortulus Animae* . . . that *es läßst sich nicht lesen*' [it does not permit itself to be read] (ibid.: 179).

The city, embodied in the story, is unreadable and somehow always beyond final comprehension, reinforcing de Certeau's argument that 'Beneath the discourses that ideologise the city, the ruses and combinations of powers that have no readable identity proliferate; without points where one can take hold of them, without rational transparency, they are impossible to administer' (de Certeau 1988: 95). As complex as this seems, it theorises what other texts, like 'The Man of the Crowd', *Manhattan, The Great Gatsby* or *The New York Trilogy*, explore, namely the problematical nature of defining the city and trying to fix its patterns into a single, identifiable shape. Those who try to do this, planners and reformers, are merely seeking to impose on the amorphous plurality of the city a set order and discipline, like the narrator in Poe's story believing such variety can be read and categorised into a neat 'scale'. The lived experience of the 'migrational city' is in flux and process, unlike the orderly interpretative grid of rational definition that some would try to place upon it. Difference, rather than sameness, is essential to this reading of the city.

## THE 'PERSUASIVE LIGHT': COMMERCE AND THE CITY

The tensions inherent within this process can be felt by examining the late 1800s and the specific concerns about the social consequences of the city environment which emerge with rapid urban growth and population increases of extraordinary proportions. In a period between 1870 and 1900, when, for example, Chicago's population multiplied five times and that of New York topped 3.4 million, and when 11 million immigrants arrived in the USA, journalists such as Jacob Riis, with his book *How The Other Half Lives* (1890), and Stephen Crane with his *City Sketches* and *Maggie* (1893) began to question the human costs of such expansion. All these works warrant attention, but we shall examine a novel in which the energies and the consequences of city life are explored in detail and with enormous power. The realist tradition sought to read the city in close-up, paying attention to the street in the hope of exposing its practices and some of the environmental determinants shaping people's lives. Even this project, for all its merits, proved limited as a way of defining the city.

In Theodore Dreiser's *Sister Carrie* (1900), the city has 'cunning wiles' that attract, 'large forces which allure . . . the gleam of a thousand lights

... the persuasive light' (Dreiser 1986: 4). It represents the world of urban capitalism as a beacon, pulling into it moths such as Caroline Meeber. She is 'carried' into the glow of money and the urban dynamo in a way which links her journey with the particular view of the city's rapid expansion as a threat to some older order of things in America, connected to rural, village life and values. Writers like Stephen Crane and Upton Sinclair used realism as a technique to expose the reader to the details of city life and attempted to convince us of the forces that swept their characters into despair and death. Their work, like that of Dreiser, does, however, suggest a discontent with the promise of the city and questions its cultural dominance and its value systems. This attention to the dark side of the city brought into focus doubts about the rapid growth of industrial, commercial centres and the effects on those living within them. For example, Dreiser's innocent Carrie approaches the city with hope, but the narrator qualifies the reader's impressions with doubts about her destination.

> To the child, the genius with imagination, or the wholly untraveled the approach to the city is a wonderful thing. Particularly if it be the evening that mystic period between the glare and the gloom of the world when life is changing from one sphere or condition to another. Ah, the promise of the night.... The street, the lamp, the lighted chamber set for dining are for me. The theatres, the halls, the parties ... these are mine in the night.
>
> (ibid.: 10)

For Dreiser the city lures with the promise and the mystery, but below the gleam is a well of despair where wealth is disguised in the terrible labours of the poor and exploited, and where the dream of a good life is constructed around the needs of the commercial culture of greed.

> It is like a chemical reagent. One day of it, like one drop of the other, will so affect and discolor the views, the aims, the desires of the mind, that it will thereafter remain forever dyed ... like opium to the untried body. A craving is set up ... dreams unfilled – gnawing, luring, idle phantoms which beckon and lead.
>
> (ibid.: 305)

The city is an addictive drug whose commerce is insatiable, a craving that leads us on into an endless cycle of desire and lack. This echoes Henry Adams's famous comment of 1905, that

> The outline of the city became frantic in its effort to explain something that defied meaning. Power seemed to have outgrown its

servitude and to have asserted its freedom. . . . The city had the air of hysteria, and the citizens were crying in every accent of anger and alarm, that the new forces must at any cost be brought under control.

(Adams 1918: 499)

These writings propose an idea of the city out of control, ruled by forces too powerful for the individual to contend with, and so being swept along in its wake. Adams believed these changes required 'a new social mind' and the 'need to jump' (ibid.: 498) into its rapid accelerations in order to keep up at all, but Dreiser feared the capacity of such change to damage and corrupt. Carrie, he writes, 'had little power of initiative, but nevertheless she seemed ever capable of getting herself into the tide of change where she would be easily borne along' (Dreiser 1986: 321).

In this way Carrie becomes like any other object swept along in the urban tide, and she is 'stared at and ogled . . . in fashions throng, on parade in a showplace' (ibid.: 323–4). It is only when she obtains wealth and power that Carrie can move beyond this condition, but only at the expense of others, for then 'She was capital' (ibid.: 447), thus asserting Stephen Crane's sense of the city as a place of hierarchy and status where alienation, superficiality and selfishness are the norm.

## THE SPACES OF THE CITY: ARCHITECTURE, ART AND AMBIVALENCE

However, typical of the ever-contrary nature of the American city, whilst these versions were appearing there emerged further emphasis upon the need to control this burgeoning environment and an attempt to make it work for people rather than against them. This took various forms, political, social, economic and aesthetic. Upton Sinclair, whilst railing against the hierarchy of the city, saw within the idea of the new masses a hope for American socialism as an alternative to the cult of the scientific manager. Here, through collective action instead of alienation, the worker might find a new place in a community of strong, shared values. Other aspects of the 'new social mind' can be seen in the City Parks movement of Frederick Law Olmsted, the growth of interest in public hygiene in the 1890s and the development in architectural design within the 'City Beautiful' group. The notion of a hysterical city, posited by Henry Adams, had to be harnessed and brought to order, and these types of social disciplines were attempts to do just that. Once again, the city could be a tribute to human endeavour rather than a mark of its failures, brought about by the assertion of control. As Burnham and Bennett wrote in their 'Plan of Chicago' (1909), 'the time has come to bring order out

of the chaos incident to rapid growth, and especially to the influx of people of many nationalities without common traditions or habits of life' (Weimar 1962: 86). And yet, as their language indicates, the most well-intentioned planning has within it precise ideological purposes, in this case to control the immigrant masses and prevent disorder on the streets.

So too the growth of the skyscraper suggested a new vision of the city which was exuberant and triumphant, but which created dark canyons below. As Frank Lloyd Wright commented in 1929, it created 'The overpowering sense of the cell. The dreary emphasis of narrowness, slicing, edging, nicking and crowding. Tier above tier the soulless shelf, the empty crevice, the winding ways of the windy unhealthy canyon' (Marqusee 1988: 165). The ironic relation between these two effects once again reinforces the dominant idea of the city as ambiguous and contrary, what, in 1934, Lewis Mumford would term 'negative energy ... suicidal vitality' (ibid.: 160). Louis Sullivan, in his essay 'The Tall Office Building Artistically Considered' (1898) wrote,

> It must be tall, every inch of it tall. The force and power of altitude must be in it, the glory and the pride of exaltation must be in it. It must be every inch a proud and soaring thing, rising in sheer exultation from bottom to top it is a unit without a single dissenting line.
>
> (Taylor 1992: 64)

The language and assumptions here are very revealing about the attitudes embodied in the 'tall building' as a masculine, phallic sign of pride, control, authority and no *dissent*. Here, architecture signifies the desire to order and control the urban space through design, and also registers a variety of ideological meanings about how that might be achieved (see Plate 6).

Edward Hopper (see Plate 7) is an example of an artist whose work was fascinated by the 'raw disorder of New York' (Levin 1980: 22) and its many spaces. This urban space surrounds his subjects, outwardly echoing their inner fears and anxieties, their mix of 'interest, curiosity, fear', which were for Hopper the primary responses to the city (ibid.: 47). In Hopper's art the city takes many forms, moving away from it as a place of elitism and social institutions towards a world of 'mobility and moral relativism replacing the older fixed standards ... with a new amalgam of its own' (Harris: 1990: 25–6). His is a city of streets and everyday practices which we glimpse through the paintings like compelled spectators, before the scene disappears into the rush of the urban whirl. It has a close parallel with the experience of the city recorded in *The Great Gatsby* (1926), written at the time of some of Hopper's finest work:

*Plate 6* Manhattan streets from the Empire State Building
*Source*: Neil Campbell, 2005

there was a *glimpse* of red-belted ocean-going ships ... a cobbled slum lined with the dark, undeserted saloons of the faded-gilt nineteen hundreds. Then the valley of the ashes opened out on both sides of us, and I had a *glimpse of* Mrs Wilson *straining* at the garage pump with *panting vitality* as we went by. . . .

   Over the great bridge, with the sunlight through the girders making *a constant flicker* upon the *moving* cars, with the city *rising up* across the river in white heaps and sugar lumps all built with a wish out of nonolfactory money. The city seen from the Queensboro Bridge is always the city seen for the first time, in its first wild promise of all the mystery and the beauty in the world.

<div align="right">(Fitzgerald 1974: 74–5 – our emphasis)</div>

Fitzgerald's description conveys the frenetic pace and mobility of city life with an edge of sexuality, mystery and a strange mixture of glamour, wealth and fading glory that is always part of the urban milieu. This is the environment of 'sugar lumps' and 'garage pumps', where 'anything can happen ... anything at all'.

   Like Dreiser too, Hopper's attention is given to the sites of popular culture in the city, to the restaurants, movie-houses, theatres, shops and to the everyday world of work. Too often these images in Hopper have

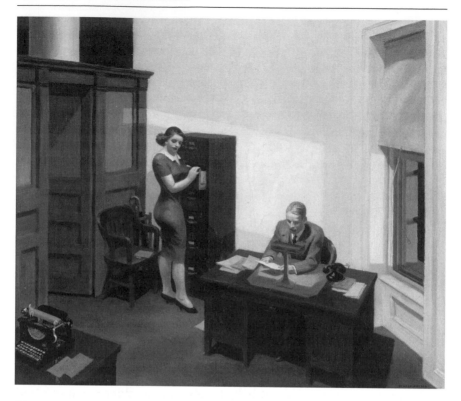

*Plate 7* Edward Hopper *Office at Night*, 1940

Source: Collection of Walker Art Center, Minneapolis, gift of the T.B. Walker Foundation, Gilbert M. Walker Fund, 1948

been explained too neatly as representative of the modern sensibility, of alienation and loneliness in the wastelands of urban America. By a closer consideration of some such paintings, one might see other interpretations, other readings of the cityscape he portrays. We will examine one painting in more depth, 'Office at Night' (1940), in order to suggest this approach. Hopper said this painting was suggested to him

> by many rides on the 'L' train in New York City after dark and glimpses of office interiors that were so fleeting as to leave fresh and vivid impressions on my mind. My aim was to try to give the sense of an isolated and lonely office interior.
>
> (Levin 1980: 58)

Notice the similarity to Fitzgerald's language – 'glimpses/fleeting/impressions' – and the predominant concern with capturing the moment. In doing this, the artist takes us into the world of the office, with its

objects and order, its hierarchy and relationships. Although one might sense a kind of 'estrangement' and 'malaise', words Gail Levin has used about Hopper, and perhaps most strongly suggested by the white space yawning at the centre of the picture, other messages about city life are here too. One significant detail is the repetitive reminder of routine work taking place, through the two figures themselves, but even more so through the pieces of paper positioned around the room. We notice them on the floor, chair, desks, in the man's hand, being filed by the woman; these are signifiers of production, of time filled up, of work completed (there are letters ready to be posted), in an efficient and orderly environment where not even a direct look is permitted. These latter points are suggested by the total arrangement and starkness of the room; for example, the eye is drawn to the umbrella in the corner, the perfectly neat chair and the pure geometry of the man's desk top, all echoed in the rectangles of the screen, walls and window. This echoes the office in Herman Melville's story of Wall Street, 'Bartleby', with its 'desk close up to a small side window [which] commanded at present no view at all, though it gave some light ... from far above, between two lofty buildings' (Melville 1979: 67).

And yet, despite all this work, order and control there is something else carried in the picture's focal point – the woman. Her body's shape under the dress echoes the line in Gatsby about Mrs Wilson's 'straining ... panting vitality', and is in total contrast with the severe, rigid lines of the room, as if her desire for something other than the routinised world of the office is being suggested. Perhaps it is something she links with the man, since Hopper encloses them within the oblong of light cast from the man's desk light, or with the night itself that exists just beyond the boundary of the stark, disciplined office. This may be an image of repressed femininity, caught and held in a masculine world of procedure, paper and routine with a woman powerless to act, 'gaz[ing] speechlessly at nothingness' (Wilson 1991: 82), or it may suggest the tension between the desire to contain the city and the need to express and discover its mysteries, its 'carnival' aspects.[5] As Wilson also reminds us in her feminist study of the city,

> a place of growing threat and paranoia to men, might be a place of liberation for women. The city offers women freedom ... True, on the one hand it makes necessary routinised rituals of transportation and clock watching, factory discipline and timetables, but ... at every turn ... the city dweller is also offered the opposite – pleasure, deviation, disruption ... urban life is actually based on this perpetual struggle between rigid, routinised order and pleasurable anarchy, the male–female dichotomy.
>
> (Wilson 1991: 8)

The 'male–female dichotomy' that Wilson describes can be seen acted out in the shadowy and tense environments of *film noir*, and like Hopper's painting often creates a sense of ambiguity about life in the city. For example, the film *Farewell, My Lovely* (1944) opens with the line, 'There's something about the dead silence of an office building at night. Not quite real'. This sense of the 'not quite real' is ever-present in Hopper and *film noir*, and draws us back to the idea of the city as complex and mysterious.

## COLLAGE CITY

Unlike the ambivalence in Hopper's work and the shadows of *film noir*, the film musical *42nd Street* (1933) culminates in a routine about the street whose lyrics and images record that the city street is 'a crazy quilt' where difference is merged into a harmonious whole, and 'side by side they're glorified, where the underworld can meet the elite, 42nd Street'. This concept of the city as a totality is also registered visually, as we see pedlars close up to play golf and a multi-cultural New York joining together to create the city skyline itself, at whose summit is not the skyscraper, but the lovers themselves. In this discourse of the city, humanity is in control of a benign and unified environment centred on the image of the quilt with all its pieces coherent and patterned towards the whole. This ideological notion of the 1930s, which sought to provide a unitary resolution for the complex, historical problems of the city, was soon countered by the uncertainties of modernism (see Berman 1983), and beyond that by the fragmentations of the postmodern city.

To contrast this effort at portraying the city as a seamless whole, one might look at Hubert Selby Jr's novel *Last Exit to Brooklyn* (1964), which both belongs to the dark, critical tradition of Dreiser, Crane and Sinclair, and also charts new territory as well. This is not 42nd Street or Broadway, but the Housing Projects of post-war Brooklyn, where the brutalities and deprivations of urban life are expressed without unitary resolutions or hopeful escapes. The power and innovation of the novel lie in its prefiguration of postmodern ideas about the collision of voices in the city, captured in Selby's cacophony of capitalised exchanges where noise seems to replace communication and callousness care. Selby's nightmare city fragments like his text and the lives of his sub- jects so that any dream of coherence and possiblity is gone. Here, the city is more of a 'collage', with 'the highly differentiated spaces and mixtures' of the contemporary city (Harvey 1989: 40). Just as De Certeau argued, the city can only be totalised and defined from a distance and at the exclusion of the street life within it, and any effort to provide a grand narrative[6] that encompasses the various movements of the city is

false and artificial. Postmodernism rejects such attempts, preferring 'a multiplicity and mixing of styles and codes, forsaking modernism's attempts to impose a unifying or over-arching (meta-)theory or narrative' (Hall *et al.* 1992: 227).

Thus seeing the city as a collage/montage where texts intersect with other texts and no single reading can ever be final returns us to the idea of the city as a place of competing discourses in eternal contest for power. Donald Barthelme has written that 'New York City is or can be regarded as a collage' and 'the point of collage is that unlike things are stuck together to make, in the best case, a new reality' (Bellamy 1974: 51). In the postmodern urban space 'unlike things' are thrown together, clashing and colliding, rather similar to the ways in which the elements of collage interact, overlap, cover, layer, and so on. No single view is the collage, for it is all the parts at the same time working with and against itself. This creates friction out of the proximity and promiscuity within the space, just as the city does. As Michel Foucault has written, postmodernism 'prefer[s] what is positive and multiple, difference over uniformity, flows over unities, mobile arrangements over systems' (Harvey 1989: 44). It may be that the city has always been this kind of space and that postmodernism has merely offered a new set of terms with which to describe a much more consistent notion of the city in America.

David Harvey refers to the artist Robert Rauschenberg as one of the 'pioneers of the postmodern movement' (ibid.: 55) and this is, in part, explained by his interest in collage or 'combines' where, as John Cage said, 'there is no more subject than there is in a page from a newspaper. Each thing that is there is a subject. It is a situation involving multiplicity' (Cage 1961: 25). This decentred view of art suited Rauschenberg's portrayal of the city wherein he used its detritus to construct a 'fused metaphor' (Rose 1967: 217) for urban life. Later these developed into the 'combine' form, with the artist incorporating three-dimensional objects so that they spill out from the frame and begin to offer back the junk of our world. The artist himself said that 'New York is a maze of unorganized experiences peopled by the unexpected, change is unavoidable' (Conrad 1984: 301).

In 'Estate' (1963) (see Plate 8), a silk-screen painting, Rauschenberg creates the sense of collage, by colliding images and merging and overlaying a series of urban fragments which seem to mix the politics of housing through a kaleidoscope of colour, time, buildings and slums, as well as the signs of the city: the Statue of Liberty ironically lop-sided and the road sign calling us to stop. It employs certain ironies, a characteristic of postmodernism, to contrast inadequate urban housing with the expensive excursion into space, and simple, natural elements

*Plate 8* Robert Rauschenberg, *Estate*, 1963

*Source*: Philadelphia Museum of Art: gift of the Friends of the Philadelphia Museum of Art, 1967 © Robert Rauschenberg/VAGA, New York/DACS, London 2006

such as birds and water, with the chaos of the city that man has created. The painting signifies many things, but always the motion and whirl of the city, captured in the close details, and the larger blocks of colour and shape at a distance, which play with our perceptions and constantly alter our point of view. When Joel Rose's novel *Kill The Poor* (1988) was published in Britain, it used this painting on its cover. The novel, like Rauschenberg's painting, centres on housing problems in New York with a playful sense of the irony and absurdity of the postmodern city. This extract shows how Rose conveys the sense of place through the fragments of the city-collage which surround his narrator.

> My daughter goes to daycare across the street from where I live. The butcher shop around the corner was closed down for selling human meat as barbecue. Paul Newman is filming on the corner. All over the neighborhood, homesteaders are rebuilding shells of buildings that have been abandoned by their landlords. No one likes poor people. On the corner heroin is sold for ten dollars a bag. . . . One day there will be a link between the rich section of town and the poor. My grandmother said they were saying the same thing when she first moved here more than seventy-five years ago. But she doesn't live here now.
>
> (Rose 1990: 18)

Rose's ironic view of his neighbourhood combines the world-weariness of our age with a sharp observant wit and critique of a society where power is in the hands of a few and where image is everything. In some ways like Jay McInerney, he explores the 'ethic of appearances' in the hope of finding the 'ethic of engagement', despite the seeming despondency embodied in the urban space.

Jay McInerney's *Bright Lights, Big City* (1984) is fully conscious of the tradition of urban texts in which it can be placed. He has written introductions for an earlier novel of the city, *Manhattan Transfer* by John Dos Passos (1986 edition), and for the collection *New York: An Illustrated Anthology* (Marqusee 1988), as well as referring to others like *The Great Gatsby* in interviews and indirectly within his own novel (see McInerney 1984: 180, 'the first Dutch settlers'). His first novel, *Bright Lights, Big City*, is an extraordinary urban text that asserts the sense of a postmodern city, a 'republic of voices' (ibid.: 6) echoing 'the idea that all groups have a right to speak for themselves, in their own voice, and have that voice accepted as authentic and legitimate is essential to the pluralistic stance of postmodernism' (Harvey 1989: 48). For McInerney, the city is a dialogue where many voices mix and engage in an endless parade and struggle which resists the single dominant discourse and the fixed

notions of what a city should be, in favour of a more fluid, processive sense.[7] The novel's unnamed protagonist breaks from a job in which he checks and edits language until it is 'verified' and printable, and thus acceptable to the dominant 'voice', and plunges into a journey of education about values and community.

McInerney captures the city's collage-like, ambivalent quality early on: 'a lone hooker totters on heels and tugs at her skirt ... Coming closer, you see that she is a man in drag ... Downriver, the Statue of Liberty shimmers in the haze. Across the water, a huge Colgate sign welcomes you to New Jersey, the Garden State' (McInerney 1984: 10). For the protagonist, the city is unlike the magazine he works for; it cannot be verified, ordered and checked because it is always surprising, as his excursions into the street and subway reveal. One brief example reveals this many-voiced city.

> You step into the train. The car is full of Hasidim from Brooklyn. ... He is reading from his Talmud, running his finger across the page. The strange script is similar to the graffiti signatures all over the surface of the subway car, but the man does not look up at the graffiti, nor does he try to steal a peek at the headlines of your *Post*. This man has God and a History, a Community.... At Fourteenth Street three Rastafarians get on, and soon the car reeks of sweat and reefer. Sometimes you feel like the only man in the city without group affiliation.
>
> (ibid.: 57)

The strange scripts of the city co-mingle, creating a new language in dialogue at all times and curiously unreadable. What McInerney accepts is that the postmodern city is a place of 'competing beliefs, cultures and "stories" ... [and that] this play of unnerving contrasts and extremes is the essence of the "postmodern" experience' (Wilson 1991: 135–6). To accept this flow is not to give in to chaos, but to find a way of living with multiplicity without seeking to distort it into a fixed and single, dominant discourse. One can find 'community' within this flux of voices because it provides the space for self-expression and the possibility for dialogue, bringing it close to Michel Foucault's concept of the *heterotopia*, which when applied to the city suggests a place capable of juxtaposing in a single locale several spaces, several sites that are in themselves incompatible. It is 'disturbing' because in the heterotopia things do not 'hold together' neatly in order, but are spaces of 'contest', of 'a multiplicity of tiny, fragmented regions' where 'no sooner have they been adumbrated than all these groupings dissolve again' because the city is too unstable and changing to sustain them as fixed and final (Foucault 1966: xviii).

## POSTMODERN CITY: LAS VEGAS

Las Vegas, with all its faults, represents a model of the postmodern city, a structure of 'mini-cities' juxtaposing consumption, fantasy and tourism with residential and commercial expansion. Although excessive and larger than life, Las Vegas is a city that refutes any single design principle or meta-narrative, like an urbanised Disneyland, it was first appreciated in Venturi, Scott Brown and Izenour's *Learning from Las Vegas* (1972). They acknowledged its fragmented, commodified surfaces and signs, seeing an urban space that

> *includes*; it includes at all levels, from the mixture of seemingly incongruous land uses to the mixture of seemingly incongruous advertising media ... a variety of changing, juxtaposed orders, like the shifting configurations of a Victor Vasarely painting ... 'Chaos is very near; its nearness, but its avoidance, gives ... force'.
>
> (Venturi *et al.* 1996: 53)

This tension between chaos and order that they found so exciting and postmodern recurs in the current television series *CSI: Crime Scene Investigation*, set in a Las Vegas where the chaos, crime, violence and brutality of the glittery pleasure dome is contrasted with the cool, orderly world of reasoned investigation undertaken by the crime lab at the heart of the show. The forensic fragments of Las Vegas crime scenes are re-ordered, the obscenity of violence is purged and the boiling desert is kept at bay by the actions of the icy Grissom and his fellow officers, and somehow the city itself is placated. *CSI* is a show very much about control, about redeeming a fragile, chaotic world, and reassuring urban audiences that the city can be conquered, or, at least, subdued through the interventions of technology, reason and science.

Las Vegas's simulacrum is like 'a video screen of the national consciousness' (Hess 1993: 123), or more accurately a multiplicity of screens viewed all at once like a frenetic, layered collage, and reminds us again of Foucault's 'heterotopia':

> a kind of effectively enacted utopia in which the real sites that can be found within the culture, are simultaneously represented, contested, and inverted ... capable of juxtaposing in a single real place several spaces, several sites that are in themselves incompatible.
>
> (Foucault 1986: 23, 24, 25)

For Mike Davis, however, Las Vegas is already out of control, almost beyond order, 'a hyperbolic Los Angeles – the Land of Sunshine on fast-forward' repeating LA's mistakes by ignoring water issues, fragmenting

local government in favour of corporate planning, abandoning public space, embracing the automobile and perpetuating social and racial inequality (in Rothman 1998: 59, 60). Its 'hypergrowth and inflexible resource demand' makes the 'need for an alternative settlement model ... doubly urgent' (ibid.: 71), a model involving Green politics, new urban design and a thoughtful, innovative use of planning. Only in this material action, for Davis, rather than the sleek laboratories solving crimes in *CSI* or in abstract postmodern theories, is there real hope for 'an alternative urbanism, sustainable and democratic' (ibid.).

## CONCLUSION, OR NO CONCLUSION POSSIBLE?

Marshall Berman's provocative book *All That Is Solid Melts into Air* (1983) spends a good deal of time discussing the nature of the city experience, and his title, with its insistent irony and ambiguity, stands as a fine expression for the problems of trying to grasp the urban condition in any quantifiable way, for as soon as you have it, it disappears or metamorphoses into something else. In a section of the book he describes an imaginary 'Bronx Mural', which becomes emblematic of the possibility of a city which has learned, however uneasily, to live with itself and with its differences. His description is revealing:

> the driver's view of the Bronx's past life would alternate with sweeping vistas of its present ruin. The mural might depict cross-sections of streets, of houses, even of rooms full of people just as they were before the Expressway cut through them all.
>
> (Berman 1983: 341)

In this representation of the city the mural would tell the story of immigration, transportation, and neighbourhood history in 'radically different styles, so as to express the amazing variety of imaginative visions that spring from these apparently uniform streets' (ibid.: 342). A close reading of this section suggests Berman's sense of loss, but also his hopes for the future in a city that can be many things, and so at the very least, retains its capacity for wonder and its essential transformative powers. If the city is an 'imagined' place that we all create for ourselves in the very acts of existing within it, then it is perhaps this changing nature that is its strength, being what Ihab Hassan called 'variousness itself *inscribed* in steel and stone' (Jaye and Watts 1981: 109 – our emphasis) and which makes its study so endlessly fascinating. His choice of the word 'inscribed' reminds us of where this chapter began, with the idea of the city-text that we try to read, and the signs that surround us in the city that we attempt to navigate. It can be, as Davis asserts, a *noirish* disorder, but as Berman reminds us, there is 'disaster and despair ...

*but there is much more'* (Berman 1983: 343) in an environment where many voices and discourses co-exist in a contest for dominance and authority.

## NOTES

1 The historical approach is still extremely valuable to our understanding of culture, its formations and workings, and informs in a more overt way other chapters in this book. Likewise, in using this definition of the idea of discourse, it does not accept that this is the only way of understanding how we respond to the city. Indeed, we are *shaped* by other forces, and in turn *shape* the city in a variety of other ways. We have chosen, in this chapter, to explore the approach of discourse analysis as a possible method.

2 Nick Peim offers the following definition of post-structuralism:

> Post-structuralism renders it impossible to claim that any signifying events, texts or practices can guarantee or fix their own meanings on their own ... [it] may be used to question all the familiar and habitual assumptions ... everything that has been taken for granted ... problematizing the ready-made assumptions and practices ... [and] likely to be sceptical of the claim of any single system of knowledge ... to comprehensive explanatory power, universal value or truth. Post-structuralism would tend to insist that knowledge and understanding are always *positioned* – and that the identity and meaning of things shifts radically given different perspectives and cultural contexts.
>
> (Peim 1993: 1–2)

3 The City Beautiful Movement flourished in the early 1900s and probably lasted until Burnham and Bennett's Plan of Chicago, 1909.

4 Poe's Dupin stories are 'The Murders in the Rue Morgue', 'The Mystery of Marie Roget' and 'The Purloined Letter'. All, in their own ways, relate crime and mystery to the specific urban locale.

5 The term 'carnival' derives from the work of Mikhail Bakhtin and refers, in part, to the expressions of the underclass, or those usually silenced in society, and can be seen as a form of resistance and as vital step in the dialogical process.

6 The phrase 'grand narrative' is borrowed from the work of Jean-François Lyotard *The Postmodern Condition: A Report on Knowledge* (1984), in which he argues that in the postmodern world there can be no grand, totalising theories which explain and order things for us.

7 Mikhail Bakhtin's theory of dialogics is discussed in the Introduction and Chapter 1.

## REFERENCES AND FURTHER READING

Adams, H. (1918) *The Education of Henry Adams*, New York: Houghton Mifflin.
Auster, P. (1987) *The New York Trilogy*, London: Faber and Faber.
Balshaw, M. and Kennedy, L. (2000) *Urban Space and Representation*, London: Pluto.
Barthes, R. (1977) *Image, Music, Text*, London: Collins.
—— (1988) *The Semiotic Challenge*, Oxford: Blackwell.

Bellamy, J.D. (1974) *The New Fiction: Interviews*, Chicago: University of Illinois.

Bender, T. (1975) *Toward an Urban Vision: Ideas and Institutions in Nineteenth Century America*, Lexington: University of Kentucky Press.

Berman, M. (1983) *All That Is Solid Melts Into Air*, London: Verso.

Bocock, R. and Thompson, K. (eds) (1992) *Social and Cultural Forms of Modernity*, Cambridge: Polity Press.

Brooker, P. (ed.) (1992) *Modernism/Postmodernism*, London: Longman.

Cage, J. (1961) *Silence*, London: Calder and Boyars.

Cisneros, S. (1984) *The House on Mango Street*, New York: Vintage.

Conrad, P. (1984) *The Art of the City*, New York: Oxford University Press.

Davis, M. (1998) 'Las Vegas Versus Nature', in Rothman, H.K. (ed.) *Reopening the American West*, Tucson: University of Arizona Press.

—— (2003) *Dead Cities and Other Tales*, New York: The New Press.

De Certeau, M. (1988) (first 1984) *The Practice of Everyday Life*, Berkeley, CA: University of California Press.

Dos Passos, J. (1986) *Manhattan Transfer*, Harmondsworth: Penguin.

Dreiser, T. (1986) (first 1900) *Sister Carrie*, Harmondsworth: Penguin.

During, S. (ed.) (1993) *The Cultural Studies Reader*, London: Routledge.

Fitzgerald, F.S. (1974) (first 1926) *The Great Gatsby*, Harmondsworth: Penguin.

Foucault, M. (1966) *The Order of Things*, London: Routledge.

—— (1986) 'Of Other Spaces', *Diacritics*, Spring, pp. 2–27.

Glaab, C. (ed.) (1963) *The American City: A Documentary History*, Homewood: Dorsey Press.

Hall, S., Held, D. and McGrew, T. (eds) (1992) *Modernity and its Futures*, Cambridge: Polity Press.

Harris, N. (1990) *Cultural Excursions*, Chicago: University of Chicago Press.

Harvey, D. (1989) *The Condition of Postmodernity*, Oxford: Blackwell.

Hess, A. (1993) *Viva Las Vegas*, San Francisco: Chronicle Books.

Howe, F. (1905) *The City, the Hope of Democracy*, New York: Charles Scribner's Sons.

James, H. (ed.) (1920) *The Letters of William James*, vol. II. Boston: Houghton Mifflin.

Jaye, M.C. and Watts, A.C. (1981) *Literature and the Urban American Experience*, Manchester: Manchester University Press.

Joachimides, C.M. and Rosenthal, N. (1993) *American Art in the Twentieth Century*, London: Royal Academy of Arts.

Koolhaas, R. (1994) (first 1978) *Delirious New York*, New York: The Monacelli Press.

Levin, G. (1980) *Edward Hopper: The Art and the Artist*, New York: Norton.

Lyotard, J.-F. (1984) *The Postmodern Condition: A Report on Knowledge*, Manchester: Manchester University Press.

McInerney, J. (1984) *Bright Lights, Big City*, London: Flamingo.

Marqusee, M. (ed.) (1988) *New York: An Illustrated Anthology*, Introduction by Jay McInerney, London: Conran Octopus.

Melville, H. (1979) *Billy Budd, Sailor and Other Stories*, Harmondsworth: Penguin.

Peim, N. (1993) *Critical Theory and the English Teacher: Transforming the Subject*, London: Routledge.

Petry, A. (1986) (first 1946) *The Street*, London: Virago.

Pike, E. (1981) *The Image of the City in Modern Literature*, Princeton, NJ: Princeton University Press.

Poe, E.A. (1975) *Selected Writings*, Harmondsworth: Penguin.
Rose, B. (1967) *American Art Since 1900: A Critical History*, London: Thames and Hudson.
Rose, J. (1990) (first 1988) *Kill The Poor*, London: Paladin.
Rothman, H.K. (ed.) (1998) *Reopening the American West*, Tucson: University of Arizona Press.
Sanders, J. (2003) *Celluloid Skyline: New York and the Movies*, New York: Alfred Knopf.
Soja, E. (1996) *Thirdspace*, Oxford: Blackwell.
Storey, J. (1993) *An Introductory Guide to Cultural Theory and Popular Culture*, London: Harvester Wheatsheaf.
Taylor, W. (1992) *In Pursuit of Gotham*, New York: Oxford University Press.
Trachtenberg, A. (1982) *The Incorporation of America*, New York: Hill and Wang.
—— (1989) *Reading American Photographs: Images as History*, New York: Hill and Wang.
Venturi, R., Scott Brown, D. and Izenour, S. (1996) (first 1972) *Learning From Las Vegas*, Cambridge: MIT Press.
Weimar, D. (ed.) (1962) *The City and Country in America*, New York: Appletons, Century, Crofts.
Whitman, W. (1971) (first 1855) *Leaves of Grass*, London: Everyman.
Wilson, E. (1991) *The Sphinx in the City*, London: Virago.

## FOLLOW-UP WORK

*Opening sequence exercise – film*

1   View two contrasting films which examine city life in different ways, such as *Taxi Driver* and *Saturday Night Fever*, and think about some or all of the following questions.

(a) How are the central characters introduced to the audience and what kinds of impressions do they create? How is this conveyed to us? Look at body language, relations with others, the way the camera surveys the people.

(b) How do they interconnect with their environment? Do they seem confident, at home, relaxed etc., or is there evidence of other relations – if so, what, and again how is this conveyed to the audience?

(c) Where is the camera, and at what angles does it address its subjects? Does this affect how we respond to them, and how we respond to the city (remind yourself of de Certeau's comments on how we see the city)?

(d) Soundtrack is significant in each sequence, but they can be very different. Describe them both and say how they are related to the mood being established and the way we are responding to place and character.

(e) How is the city being conveyed here, both through the visual messages and through the script and soundtrack?

*Literary analysis*

2   Consider Stephen Crane's *Maggie: A Girl of the Streets* (1893).

(a) Chapter 2. Before Maggie is introduced, Crane conveys a strong sense of environment to us. How does he do this and what impression does it create of the city and its effects? Be specific in your attention to the language Crane uses to describe the place, as his words are chosen very deliberately to create certain precise connotations for the reader.

(b) Chapter 6. How is the bar a representative place in the city? Crane uses repeated patterns of language to establish the impression of the bar as a particular type of place, which in the mode of Naturalism that Crane employs influences and shapes the people who occupy that space. What are these patterns, how do they work and how do they relate to the paragraph that describes the fragments of food etc. all around the room?

*Assignments and areas of study*

3   Consider the following:

(a) How do films such as *Crash* (2005), *LA Story*, *Boyz n the Hood* represent Los Angeles?

(b) Research the Chicago World Fair of 1893, the Columbian Exposition, and comment on their significance for the ways in which cities were seen at the time and into the future. Alan Trachtenberg's *The Incorporation of America*, (1982: Chapter 7) is a good starting point.

(c) Connect this chapter with those on ethnicity and African Americans and discuss the relationship between the city and ethnic experience. You might read about the Harlem Renaissance, the *Autobiography of Malcolm X* (1968), Ann Petry's *The Street* (1986) or Hispanic texts such as Sandra Cisneros's *The House on Mango Street* (1984).

(d) Analyse an episode of *CSI* for what it tells us about the city of Las Vegas, its values and attitudes, and how these contrast with the actions of the investigators.

# Chapter 7

# Gender and sexuality
## 'To break the old circuits'[1]

In his commentary upon the Columbian Exposition of 1893, Alan Trachtenberg describes the special Women's Building as occupying a space between the Court of Honor and the Midway Plaisance, 'at the point of transition from the official view of reality to the world of exotic amusement, of pleasure' (Trachtenberg 1982: 222). This locational irony suggests the position of women in America at the time of the Exposition, since they were, on one hand, revered as the guardians of virtue, the home and the domestic economy, whilst still seen as possessions, apolitical and, at worst, objects for the male gaze – like the 'exotic' women on display on the Midway. Should women have been integrated into the main body of the Exhibition or should they have had a separate building? If they did not have the latter division, would their activities and achievements be smothered by the dominant presence of masculine displays? These discussions from the 1890s reveal significant arguments about gender, power and identity that have persisted throughout the twentieth century. Such interpretations reveal the importance of gender within the politics of culture and begin to show the interrelationships of power, identity, ethnicity and class with issues of gender and sexuality.

The purpose of this chapter is to examine and demonstrate different ways in which 'cultural constructions of sexual difference fundamentally inform history' and how

> the discourses of gender not only regulate the social behaviour of men and women in sexuality, family and work, but they also become ways of ordering politics and of maintaining hierarchies of all kinds ... describ[ing] a fundamental understanding of difference that organizes and produces other relationships of difference – and of power and inequality.
>
> (Melosh 1993: 5)

Gender, that is the feminine or the masculine, is not born into us but, rather, emerges as we develop and experience life. It is a socially constructed definition created through the various networks of forces that intersect around us as we grow. These cultural discourses, 'unities of theme and shared conventions of knowledge' (ibid.: 4), about gender and sexuality, shape and structure us as subjects within the social order. The privileging of certain discourses over others, as always, will determine which group holds greater authority within the culture at that moment. Thus gender and sexuality are part of the elaborate organisation of power within society, something we must examine in order to appreciate its influence upon the structuring of our lives.

This chapter will explore some examples of the processes and effects of this construction within the American cultural order in the twentieth and twenty-first century. It will also discuss how this order has been questioned in different ways by various groups, such as social and radical feminists and male homosexuals. Gender studies has taken its lead from the questionings of feminism which, in its various forms, challenged assumptions of power based upon the positioning of women in a male-dominated and male-defined society. For example, the tendency for there to be an assumed universal and general address seen as a 'norm' which is, however, male, is an indicator of patriarchal authority. If everything proceeds from this norm, then it displaces women from the centre of society and diminishes their worth and status. Thus, given the limits of space here, the majority of this chapter will examine gender in relation to women, but will also try to emphasise the equally important effects of these challenges to masculinity in America, for this too is constructed within the discourses of gender and sexuality at work in the culture. As Sidonie Smith has written:

> While ... gender ideologies rigidly script identities and differences according to apparently 'natural' or 'God-given' distinctions, these cultural scripts of difference remain vulnerable to contradictions from within and contesting social dialects from without that fracture their coherence and dispute their privileges.
>
> (Smith 1993: 21)

This chapter will identify some of these 'cultural scripts' and show how they have become hegemonic, whilst demonstrating, as Smith suggests, the possibility for a renegotiation of their dominance and a fracturing of their authority by various means.

## NINETEENTH-CENTURY ROOTS: CULTURAL POLITICS

As early as 1837, Angelina Grimké (1805–79), an active anti-slavery campaigner, made important connections between slavery and the oppressed

position of women in America. She wrote that 'the mere circumstance of sex does not give to man higher rights and responsibilities than to woman' (Lauter *et al.* 1994: 1866), and so brought into question the assumption that it was 'natural' for women to adopt specific roles in society and for men to assume others.[2] She continued, 'Our duties originate, not from difference of sex, but from the diversity of our relations in life, the various gifts and talents committed to our care, and the different eras in which we live' (ibid.). However, she points out that culture has constructed active 'man',

> whilst woman has been taught to lean upon an arm of flesh, to sit as a doll arrayed in 'gold, and pearls and costly array', to be admired for her personal charms, and caressed and humored like a spoiled child, or converted into a mere drudge to suit the convenience of her lord and master.
>
> (ibid.)

The language employed by Grimké emphasises the relation between power and gender, since the woman is subordinated into a variety of roles – doll/child/pet – over which the man has control as 'master'. Such conditioned social thinking concretises the hierarchy so that the woman is 'robbed ... of essential rights ... to think and speak and act', becoming a silenced 'appendage of his being, an instrument of his convenience and pleasure, the pretty toy ... the pet animal whom he humored into playfulness and submission' (ibid.). This advanced thinking was influential within America and provided the impetus and the language for women such as Elizabeth Cady Stanton and Susan B. Anthony, who organised a woman's convention at Seneca Falls in 1848. Its 'Declaration of Sentiments' echoed the American Declaration of Independence of 1776, emphasising the need for woman's rights and recognition within the democratic framework of the USA which had, it stated, established 'an absolute tyranny' over women (Lauter *et al.* 1994: 1946).

This was a momentous occasion for early American feminism, but within it exist the seeds of a debate, which has raged in different forms within women's groups ever since. That is, whether the demand for equality within the existing system is the correct way forward, or whether the system itself is so strongly biased towards men that it will always favour patriarchy. Patriarchy is a concept at the centre of much theorising and debate within gender studies and is best defined as 'a system of social structures and practices in which men dominate, oppress and exploit women' (Walby 1990: 20). Seneca Falls initiated a number of similar events that became the focus for new forms of collective female activity. As Gerda Lerner has written, 'The emergence of

female consciousness ... rested on the existence and continuity of woman's clubs movements, and female organizations' (Lerner 1977: 392), which included the anti-slavery organisations, The Woman's Christian Temperance Movement (1870s), Female Labor Reform Association (1844) and many others. Through these collectives, women realised organisational skills, reinforced self-confidence, developed female support networks and became actively involved in a range of political tasks, such as fund-raising, information distribution and petitioning. Elizabeth Cady Stanton, speaking at the 1851 Woman's Convention in Akron, Ohio, said that 'self-reliance is educated *out* of the girl' whereas it was seen as central to the power and authority of men in American society. For her, 'experience comes by exposure' and therefore girls should not be sheltered behind the screen of patriarchy.

> Let the girl be thoroughly developed in body and soul, not modeled, like a piece of clay, after some artificial specimen of humanity. . . . Development is one thing, that system of cramping, restraining, torturing, perverting, and mystifying, called education, is quite another.
>
> (Lerner 1977: 416)

Such a radical call for change and the re-education of women grew during the late 1800s and brought into question the assumptions of patriarchy that women were only represented by the 'cardinal virtues' of 'piety, purity, submissiveness and domesticity' (Norton 1989: 122).[3] Cady Stanton linked, as Grimke had, the woman with the slave, for 'all mankind stands on alert to restrain their impulses, check their aspirations, fetter their limbs, lest, in their freedom and strength, in their full development, they should take an even platform with the proud man himself' (Clinton 1984: 70). Confined by gender definitions, women had to question and challenge this fettering process if they were to play a fuller role in American culture.

At the Columbian Exposition the ambiguities of the 'woman question' were being played out on the national stage. This celebration of America's place in the world did acknowledge women in various ways; for example, with the Women's Building, with a female architect, and a Board of Lady Managers. However, these were compromised by the ever-present linking of women with a particularly limiting sphere, namely the home. For example, male critics belittled the work of Sophie Hayden, the architect of Women's Building, describing it as having 'graceful timidity or gentleness . . . [which] differentiates it from its colossal neighbours [*that is, male*], and reveals the sex of its author' (Henry Van Brunt, quoted in Banta 1987: 528 – our emphasis and addition). Even Bertha Palmer, President of the Lady Managers, in her

speech at the opening of the building, refused to 'discuss ... weighty questions' and assured the audience that 'every woman who is presiding over a happy home is fulfilling her highest and truest function' (Muccigrosso 1993: 139). As if to reinforce this, the building contained a model kitchen and was next door to the Children's Building with its nurseries and child-care exhibits.

However, the Exposition did give rise to some more radical voices that spoke out against these narrow definitions of women, echoing the earlier statements of Grimké and Stanton. One speech, 'The Woman's Sphere from a Woman's Standpoint', given in the Congress of Women by Laura DeForce Gordon, decried the 'system of repression, suppression and oppression practiced toward women', suggesting that

> Woman's sphere in life will be defined and determined by herself alone. Her place in nature, no longer fixed by masculine dogmatism, shall be as broad and multifarious in scope as God shall decree her capacity and ability to accomplish.
>
> (Burg 1976: 240–1)

This more radical approach could be seen in the growth of 'social feminism' during the 1890s, which tried to activate the 'scope' that Gordon spoke of through social involvement outside the male-defined terrain of the domestic. Associated with figures such as Jane Addams (born 1860), who founded Hull House in Chicago as a community for reform and aid for women and families, social feminism has been called 'municipal housekeeping' because of its extension of domestic expertise into the wider arena of the public sphere, and so 'melded traditional charity with intellectual challenge ... [permitted] a dominant leadership role ... [and] excluded family demands' (Woloch 1994: 253). New Women of the 1890s, who questioned their roles, like Jane Addams, and became empowered in this way, extended the 'traditional' gender roles of women into the public domain. The philosophy of 'social feminism' could be summed up in the following speech by Marion Talbot in 1911:

> The home does not stop at the street door. It is as wide as the world into which the individual steps forth. The determination of the character of that world and the preservation of those interests which she has safeguarded in the home, constitute the real duty resting upon women.
>
> (ibid.: 270)

However, to step beyond the street door was to enter the domain of men in a public manner that was controversial, but it became an essential element in the process of emancipation. For example, women's

organisations continued to develop throughout this period: the General Federation of Women's Clubs (1890), National American Women's Suffrage Association (1890), National Consumers' League (1899), National Women's Trade Union League (1903) and many others provided 'a living bridge between traditional philanthropy and progressive reform' (ibid.: 299). This accumulation of groups formed a network of women who, together, pushed forward a number of legislative issues, culminating in the 1920 Nineteenth Amendment, which extended suffrage to women.

## NINETEENTH-CENTURY ROOTS: LITERATURE AND THE 'FIRST WAVE' OF FEMINISM

Such concerns were also emerging in the literature of the period and provided another important source of discussion and cultural expression. For example, Kate Chopin (born 1851) wrote a short piece called 'Emancipation' in 1869 beginning with images of confinement, 'confining walls . . . bars of iron . . . a cage', as if to suggest the condition of women caught in the limited, male-defined world of America. The 'animal' that she describes is looked after, but longs for something more, signified by all that exists beyond the cage, and eventually moves out into 'the Unknown'. Now, without the protecting hand of patriarchy, the once-caged animal is awakened to a sensual world: 'seeing, smelling, touching . . . all things', 'seeking, finding, joying and suffering' (Chopin 1984: 177–8). Chopin's sense of activated existence is linked to the freedom from the enclosed world of the cage – patriarchy and domesticity – and although the new life involves suffering, it is preferable to the power-less, protected realm which she clearly associates with the situation of women at the time.

Like so much fiction of the time, Chopin's images of confinement are metaphors for the social controls of patriarchy that separated women into very specific, domestic roles and discouraged other expressions or practices. We see this in Charlotte Perkins Gilman's 'The Yellow Wallpaper' (1892), which like her main work of social theory, *Women and Economics* (1898), is concerned with the power relations between men and women. The latter text argues against women as domestic and dependent on men and articulates the 'sexuo-economic' basis of the relationship that 'locks women into their homes and then identifies the work that is done in them as "natural" work for women. Gilman tears away that facade, exposing the reality of the institution as a limiting space' (Lane 1990: 252).

Gilman was a friend of Jane Addams and spent a good deal of time at Hull House and was 'formed ideologically and politically in the burgeoning reform activities of the 1880s and 1890s' (ibid.: 184). In 'The Yellow Wallpaper', Gilman dramatises aspects of her theory of gender

relations, showing a woman in an actual 'limiting space', (over-)protected by her husband to the point of being, like Chopin's animal, a prisoner. Ironically, the woman (unnamed throughout the story) is imprisoned in a nursery whose 'windows are barred . . . and there are rings and things in the walls' (Gilman 1990: 43). She is made child-like as a mark of her powerlessness and locked into a torture chamber/nursery/bedroom ruled over by her doctor husband. All she has is the paper she writes on and the paper on the walls that she 'reads', gradually seeing there a version of her own life: 'Behind the outside pattern the dim shapes get clearer every day . . . like a woman stooping down and creeping about behind that pattern (ibid.: 49). The outside pattern is that of patriarchy, which has shaped her life and defined her as dependent, weak and silent. But the story interfuses the two patterns until 'she just takes hold of the bars and shakes them hard . . . all the time trying to climb through' (ibid.: 53). It is as if the narrator and the 'creeping woman' have become one in the struggle to free themselves from the pattern and its terrible limiting space. Gilman's ambiguous ending leaves John, the husband, fainted and the woman circling around him rather like an animal freed from its cell but not yet equipped for the wild.

As an imagining of gender power relations the story, like Gilman's theory, is provocative and daring, but it was Kate Chopin who wrote an even more dangerous novel in 1899, *The Awakening*. This shows the 'awakening' of Edna Pontellier from the limiting space of a possessive husband to a new sense of identity and ambiguous freedom. She is 'a valuable piece of personal property' to her husband (Chopin 1984: 44), defined by 'a mother's place' (ibid.: 48) to be a 'mother–woman' only. These social definitions fix her by gender into a certain role with which she increasingly is at odds. She thinks of 'the dual life – that outward existence which conforms, the inward life which questions' (ibid.: 57) and this is connected to the tensions explored by Gilman's metaphor of the 'outside pattern'. For Edna Pontellier, the possibility of a life beyond the cage of rigid social expectations is signified by the sea's fluidity, which is 'seductive; never ceasing, whispering, clamoring, murmuring, inviting the soul to wander for a spell' (ibid.). On or in the sea, she feels liberated, 'borne away from some anchorage which had held her fast, whose chains had been loosening . . . leaving her free to drift whithersoever she chose to set her sails' (ibid.: 81).

Myra Jehlen has written of women existing on a border between states, with 'the female territory . . . envisioned as one long border, and independence for women, not as a separate country, but as open access to the sea' (Showalter 1986: 264). Edna's sensual perception of 'independence' is just such fluidity and something that her husband cannot recognise: 'he could not see she was becoming herself and daily casting aside that fictitious self which we assume like a garment with which to

appear before the world' (ibid.: 108). At the sea, naked, she casts aside the clothing of pretence associated with the 'man-made' world, to borrow from Perkins Gilman, and in her 'suicide' becomes 'like some new-born creature, opening its eyes in a familiar world that it had never known' (ibid.: 175).[4]

Perhaps in the political arena of Woman's Conventions and the Columbian Exposition such radically imagined alternatives to the gender limitations of late nineteenth-century American culture were difficult to articulate formally. As so often, literature could prefigure later, more overt moves towards feminist questioning of the patriarchal norm. Gilman and Chopin's work is close to that of French feminist theorist Hélène Cixous, who wrote in 1976 that 'We must kill the false woman who is preventing the live one from breathing' and so 'emancipat[e] . . . the marvelous text of her self' (Marks and De Courtivron 1981: 250). As in French feminism, writers like Chopin and Gilman knew the import-ance of expression in order to 'break the snare of silence' (ibid.: 251) and to be assertive through the body: 'Women must write through their bodies . . . submerge, cut through, get beyond [patriarchy]' (ibid.: 256). For Cixous, women are akin to birds and thieves (a play on the French word *voler* meaning to fly and to steal), using language stolen from men in order to fly: 'They go by, fly the coop, take pleasure in jumbling the order of space, in disorientating it, in changing around the furniture, dislocating things and values, breaking them all up, emptying structures, and turning propriety upside down' (ibid.: 258).

At the time of Gilman and Chopin's writing, however, America was unwilling to be 'turned upside down', tending to treat these works as 'scandalous' or eccentric, and peripheral to the mainstream or 'male-stream' culture. This is now considered as the 'first wave' of feminism in America, raising important questions about the underlying assump-tions embedded in the idea of 'sex-roles' and 'separate spheres' for men and women. However, it is the patriarchal power of the absent Father in Louisa May Alcott's *Little Women* (1868) that typifies the gender authority that must be overcome. His language, delivered through a letter, imposes control over the female household in which Marmee, the mother, becomes his mouthpiece:

> they will be loving children to you, will do their duty faithfully, fight their bosom enemies bravely, and conquer themselves so beau-tifully, that when I come back to them I may be fonder and prouder than ever of my little women.
>
> (Alcott 1989: 8)

Yet even in such a novel there is the figure of Jo March, who resists the call to duty and repression and seeks, as Cixous says, to 'break the snare

of silence' with her body and her writing. She refuses for as long as possible the social construction of her gender, even though, as the novel suggests, it is an inevitable process. She wants to remain young and outside the gender system that makes her fit the role played out by Marmee and her sisters, but she cannot, and must succumb to marriage and to a role close to that of her dead sister Beth. What the novel shows is the extraordinary power tied to gender and the differences that society imposes upon the male and female. When Laurie, Jo's male friend, speaks of his future, his speech betrays his assertive self and the social acceptability of male freedom: 'After I'd seen as much of the world as I want to, I'd like to . . . choose . . . I'm never to be bothered . . . but just enjoy myself and live for what I like' (ibid.: 142). In contrast, Jo's sense of self and future is tentative, qualified and wrapped in fantasy: 'I'd have a stable full of Arabian steeds . . . I want to do something splendid before I go into my castle – something heroic or wonderful, . . . I don't know what' (ibid.: 143). The 'castle' is a metaphor of confinement, of the domestic world that she knows cannot be avoided, but even before this inevitable gender trap, Jo has less certainty than Laurie, fewer options and little access to the world outside her family. This moment is echoed later in the novel with Laurie trying to persuade Jo to run away with him and 'to break out of bounds in some way; but Jo's construction as a 'girl' has convinced her of 'her place': 'I'm a miserable girl, I must be proper, and stop at home' (ibid.: 213). Again and again Alcott reminds the reader of the gender 'civil war' going on in American society whilst the 'real' battles were being fought elsewhere, and she illuminates the often neglected aspects of power associated with patriarchy and dominance. For example, when Jo sees the fate of Meg marrying John Brooke, she is described as 'enthroned upon his knee, and wearing an expression of abject submission' (ibid.: 232).

During the 1880s and 1890s American women began to organise against such 'abject submission', as we have shown, and their responses were never uniform but formed various strands of feminism, some remaining within the 'family claim' (Rosenberg 1992: 65), while others sought to extend or challenge this notion of the 'woman's sphere' into a wider social dimension. As Rosenberg argues, 'All feminists believed that women should band together to claim personal emancipation, but they disagreed about what emancipation meant and how best to achieve it . . . In these differences of emphasis lay the potential for much future strife' (ibid.: 68). With the granting of suffrage to women in 1920, one aspect of the campaign had been achieved, but what became increasingly clear was that this wave of feminism was more than a 'campaign'. It was 'a dimension which informed and interrogated every facet of personal, social and political life' (Eagleton 1983: 150). It was not just

about equality of power and status with men within an established and structured system, but rather was more concerned with the 'questioning of all such power and status' (ibid.). Matters of gender were now at the heart of American cultural life and would emerge in a variety of forms in the century ahead.

## GENDER AND THE 1950s' 'SECOND WAVE'

After the insecurity of the 1930s and the social disruptions of the Second World War, post-war America looked for a return to security, both in social and political ideologies. Gender offered pre-set compartments into which male and female could be arranged so as to create a sense of 'normalcy' and order that were non-threatening and in keeping with precise, uncomplicated versions of an ideal America developed in these years of consensus. However, this 'consensual hole-in-history', as W.T. Lhamon Jr calls it, was an illusion within which many crucial debates were taking place. Indeed, these were 'crucible years [that] forged the succeeding decades' (Lhamon 1990: 3).

In post-1945 America there was a 'new outburst of domestic ideology, a vigorous revival of traditional ideals of woman's place' (Woloch 1994: 493) and yet, at the same time, there were increased demands for women in the workplace too. This suggests what Nancy Woloch calls the 'split character' of the age (ibid.), with its return to notions of domesticity as the core of women's experience and fulfilment, in conflict with the pull of the labour market. One of the implications of this was a fear among males that their 'masculinity' was under threat. In particular, this definition of masculinity was concerned with employment, 'bread-winning', protection and authority, all of which appeared under fire from the potential encroachments of women into these areas. In wartime this had been acceptable, but during peacetime there had to be a return to 'an ideal script against which [women] measured their performance' (Gatlin 1987: 7). The metaphors used here are revealing, for they signal the growing sense of a 'split', resulting in a 'performance' during which women re-conformed to scripts 'written' by men in earlier generations. If women worked, as many did, it was seen as a temporary measure before settling into marriage and raising a family in the suburbs. When Betty Friedan examined this kind of cultural conditioning, she used the phrase 'the feminine mystique' to suggest the script that women had to learn in order to be acceptable within the new suburban middle class:

> They learned that truly feminine women do not want careers, higher education, political rights – the independence and the opportunities

that the old-fashioned feminists fought for. . . . All they had to do
was devote their lives from earliest girlhood to finding a husband
and bearing children.

(Friedan 1982: 13–14)

A film like *Rebel Without a Cause* (1955) articulates many of these
themes, while ostensibly being a 'youth movie', situating itself in the
suburbs with a mobile family in crisis. The roots of the crisis are to do
with gender, and in particular the roles of the mother and the father.
This was the age in which Dr Benjamin Spock's manual, *Baby and Child
Care* (1944), warned women against the dual dangers of over-protection
and rejection of their children and generally raised the awareness of
models of caring in the public mind. This kind of fascination with raising
children, alongside the growing interest in psychology, can be seen
dramatised in *Rebel Without a Cause*. After all, if things were unstable at
home, if children were wayward and confused, then it must be connected
to the roles within the family. When Jim Stark (James Dean) cries out
'you're tearing me apart', he indicates the film's pursuit of familial confu-
sions as its central theme. Dr Spock advised women to stay at home and
only 'to leave home . . . for a trip to the beauty parlor, to see a movie,
to buy a new hat or dress, or visit a good friend' (Rosenberg 1992: 151),
and to guard against over-protection, for it could lead to 'Momism'. This
meant adversely affecting the (male) child by smothering and domin-
ating them so as to impair their masculine development as individual
beings in a competitive society. 'The ideal mother was ever present never
controlling' (ibid.), and in order for this to occur, it necessitated a strong
husband assuming domestic authority and economic and sexual control
in the home so as not to confuse the child. This was a vision of social
order sited in gender, which scripted distinct roles within the family,
encompassing power and regulation in specific ways. Edmund White
sums up the role of 'manliness' as 'a good business suit, ambition, paying
one's bills on time, enough knowledge of baseball to hand out tips at
the barbershop' (White 1983: 147). In *Rebel Without a Cause*, the father is
weak and 'feminised' – we see him wearing a frilly apron at one point
and Jim mistakes him for his mother – and he is constantly referred to
visually as small, imprisoned or indecisive. All the classical masculine
traits, according to the cultural stereotype of the strong, individual male
figure, are transferred to the mother, who is portrayed as aggressive,
dominant and assertive. In the long opening scene of the film in the
police station, the father arrives with Jim wanting to make him 'king'.
Jim literally enthrones him before our eyes, only to see him 'dethroned'
by the authority of the mother and the grandmother who hover like
fearsome Harpies in the background. Later, Jim asks his father to advise

him, and so take on his ordained position as masculine role model, but when he cannot, the boy is disgusted. At the height of Jim's confusion, just prior to his running away to the mansion, he confronts his parents on the stairs of the family home. It is a wonderful example of director Nicholas Ray's use of the camera, which creates visually a sense of de-stabilisation, with tilted angles and tight close-ups and editing. Jim is imaged as a crucified figure, unable to identify with the weak father who will not stand up for him against his mother. The boy 'longs for unity – with his parents and with his peers – and is repeatedly and frus-tratingly blocked from it' (Byars 1991: 128). The scene ends with Jim kicking a portrait of a matriarchal figure, destroying her whole face before he leaves the room.

In a piece written in 1956 for *Woman's Home Companion* the suburbs were described as being populated with 'women ... like keepers of a prosperous zoo and the men like so many domesticated animals inside of it'. The man, like Jim's father, is 'ill at ease in a world that robs him of his chance at heroism. He wonders, seeing this gap between his dream and his daily life – is he even a man' (Bailey 1989: 103). If masculinity was under threat, then one way of reasserting its traditional 'heroism' was to reinvoke the domestic ideology for women. The 'feminine mystique', the housewife-mother, the suburban goddess, all entwined as a newly written script for post-war women. Appropriately, at the end of *Rebel*, as social order is restored, the father does stand up with Jim ('I'll be as strong as you want me to be') and does silence his wife with a look and a smile before guiding his regenerated family home. Masculinity had to assert itself: 'We must rediscover the art of domin-ating as the lion dominates the lioness – without force usually, without harshness usually, without faltering always' (ibid.: 105). However, a film like *Rebel*, with its 'tenuousness of resolution' (Byars 1991: 130) and its distorted realism indicates the underlying discontent with accepted gender divisions and the fact that despite the smoothing over in its narrative closures, society itself was less easily healed.

These examples show that the pursuit of improvements in the lives of women were now being seen as too extreme, and that the social price of such changes of gender role and power could have specific social problems. Resolutions had to be presented even if social trends were themselves more contradictory. Television in the 1950s seemed to be part of this re-masculinisation of America, with its prime-time serials like *Bonanza, Gunsmoke* and *Daniel Boone* conjuring up heroic, frontier images of rugged individuals who lived their lives successfully without the intrusion of women, as if to answer the situation comedies that made the 'feminised' man, like Jackie Gleason in *The Honeymooners*, the humorous figure of fun. Women had to be contained if men were to rediscover their masculine authority, and from every source messages

came to reinforce the importance of the home, family and marriage. Ironically, it became a 'narrowing of women's sphere' (Harvey 1994: xvi) in which 'their primary focus of interest and activity is the home' (ibid.: 73). After all,

> what profession offers the daily job of turning out a delicious dinner, of converting a few yards of fabric, a pot of paint, and imagination into a new room? Of seeing a tired and unsure man at the end of a working day become a rested lord of his manor?
>
> (ibid.: 73)

This is the 'cultural script' that had to be recognised and challenged by the gender politics of the age. Betty Friedan's idea of the 'truly feminine woman' as scripted in post-war America is echoed by essayist and poet Adrienne Rich, who felt 'that marriage and motherhood ... were supposed to be truly womanly', but which left her 'feeling unfit, disempowered, adrift' (Rich 1993: 244). She saw in her own life and writing the kind of 'split' that Woloch commented on as a characteristic of the age. Rich wrote of 'the split I ... experienced between the girl who wrote poems, who defined herself in writing poems, and the girl who was to define herself by her relationships with men' (ibid.: 171). This conformity to gender expectations and the lines of power channelled through patriarchy forced Rich, like other women of that time, to begin to question this split and the scripts it imposed upon women. Her way forward was to 'use myself as an illustration' (ibid.: 170) and connect her own experiences as a woman in the 1950s with wider 'political' struggles. The two should not be separated, for to do so was to accept the political divisions of gender determined by 'masculine ideologies', which said that women operated in one sphere and that their 'problems [were] trivial, unscholarly, nonexistent' (Rich 1979: 207). This recognition that the 'personal' was the 'political' was central to many of the struggles for 'rights' at this time (see Chapter 3): 'politics was not something "out there" but something "in here" and of the essence of my condition' (Rich 1993: 175).

Thus, out of the 1950s emerged a revived feminism that challenged in different ways the 'script' of domestic ideology being written in the decade: 'Scripts specify, like blueprints the whos, whats, whens, wheres and whys for given types of activity. . . . It is like a blueprint or roadmap or recipe, giving directions' (Weeks 1986: 57). Such impositions of gender 'scripts' had to be interrogated and challenged by activists, writers and, ultimately, in the lives of ordinary people. If these 'blueprints' did not cohere with individual experience, it was because they spoke from a universalised perspective that did not consider the differences inherent within gender. It has, therefore, always been a characteristic of the

excluded and marginalised, like women and homosexuals, that they sought to express their experience in their voice (see Chapter 3). To this end, personal autobiographical or semi-autobiographical works have been central to gender and sexuality studies. If the dominant culture assigned a particular normalised image, then part of the struggle was to present a counter-image through a variety of forms. As we shall show, a characteristic of Gender Studies in America has been the proliferation of diverse personal/political histories, stories and accounts determined to demonstrate that 'a person is not simply the *actor* who follows ideological scripts, but is also an *agent* who reads them in order to insert him/herself into them – or not' (Smith, P. 1988: xxxiv–v). The person that 'speaks' for themselves, in whatever arena or form, has been transformed from object, defined by others, to subject through the process of self-definition.

Women since first wave feminism had begun to connect their personal experience to the wider world of politics, and by the 1960s it had become sloganised as 'the personal is the political'. Using broadly autobiographical experiences, many self-conscious works of subjectivity demonstrated 'new scripts for women's lives ... being written ... as oppositional cultural practices trying to change the cultural meanings of gender' (Lauret 1994: 97, 99). They rejected the 'malestream' stories that had privileged certain views of achievement, history and existence, and pointed out that 'they are neither objective, nor value-free, nor inclusively "human"' (Rich 1979: 207). Women's stories intervene in these assumptions, 'offering explorations of the social and psychic construction of female subjectivity' (Lauret 1994: 99) and presenting women as active, articulate beings in the process of becoming and change, rather than as the products of a patriarchal configuration as mother, lover or wife. Instead of the 'careers of domestic perfection', with women defined by 'the suburbs, technology ... the family' and characterised by 'the sense of drift, of being pulled along on a current' (Rich 1979: 42), women were rediscovering their lives and finding ways to express them.

## OUT OF THE 1950s: SYLVIA PLATH, *THE BELL JAR* (1963)

Published in 1963, the same year as Friedan's *The Feminine Mystique*, Plath's novel is an example of 'self-conscious subjectivity' in which her own life is the raw material through which to explore a 'split' self in a split age. Here the central character, Esther Greenwood, is divided between what she is 'supposed to be' (Plath 1972: 2) according to the gender rules of America in the 1950s, and what she wants to be within herself. Early on in the book, she describes herself 'adrift', like Rich: 'I wasn't steering anything, not even myself ... [I was] like a numb trolley-bus ... still and very empty, the way the eye of a tornado must

feel, moving dully along in the middle of the surrounding hullabaloo' (ibid.: 3). The 'hullabaloo' consists of all the voices and institutions – family, education, work – that seek to define her as 'female' and place her in a specific, preordained category. In particular, Plath uses the world of women's magazines as an example of the formation of such a set of gender guidelines, just as Friedan did in her book and, more recently, Brett Harvey (1994). Esther's self is fixed, with 'the years of my life spaced out along a road in the form of telephone poles, threaded together by wires' (Plath 1972: 129) and all her desires are shrunken and reduced.

One of the prominent metaphors in the novel is that of language and writing, which are traditionally denied to women within the framework of patriarchy. Plath asked in her *Journals,*

> what inner decision, what inner murder or prison break must I commit if I want to speak from my true deep voice in writing ... and not feel this jam-up of feeling behind a glass-dam fancy-facade of numb dumb wordage?
>
> (Yorke 1991: 67)

Marginalised, women do not have access to their own voice and are imprisoned in male language, which 'force[s] us to name our truths in an alien language, to dilute them' (Rich 1979: 207). Toril Moi has termed this 'the ventriloquism of patriarchy' (Moi 1985: 68), with men speaking for women, and Plath uses this precise image of ventriloquism (Plath 1972: 107) in the novel (as does Edmund White later), and in a key section describes how Esther's mother wanted her to learn shorthand, which she resisted because 'I hated the idea of serving men in any way. I wanted to dictate my own thrilling letters' (ibid.: 79). Rather than be 'a slave in some private, totalitarian state' (ibid.: 89), her definition of marriage, she seeks to 'dictate' her own life, write her own script and so reject the limited roles provided by patriarchy:

> The last thing I wanted was infinite security and to be the place an arrow shoots off from. I wanted change and excitement and to shoot off in all directions myself, like the colored arrows from a Fourth of July rocket.
>
> (ibid.: 87)

To reject the fixed script of wife-mother, with its 'infinite security', is to assert the possibility of self-actualisation and alternatives to this 'norm'; to 'write your self', rather than be a 'scrawled over letter' (ibid.: 21), 'reduced to being the servant of the militant male, his shadow' (Marks and De Courtivron 1981: 250). Plath's novel dramatises, as Chopin's *The Awakening* had a century before, the desire to emancipate the self from

the enclosure of patriarchal definition. The transgressive nature of this resistance is articulated using the powerful and violent imagery of suicide, which as Hélène Cixous writes has a precise function: 'we must kill the false woman who is preventing the live one from breathing' (ibid.). In *The Bell Jar*, Esther severs her 'false' self, 'the smudgy photograph of the dead girl' because it represents the terrible uniformity of gendered society, its impositions and restrictions, buried 'deeper, more secret, and a whole lot harder to get at' (Plath 1972: 154, 156).

The radical cutting away of patriarchal power inherent in *The Bell Jar* does not, however, solve Esther's identity quest, but, like Edna Pontellier and the narrator of 'The Yellow Wallpaper', it unchains her from the 'bell jar' of male definition. Indeed, Esther is, at the end of the novel, full of 'question marks' and 'on the threshold', 'pointing to a yet-to-be determined future' rather than any 'fixed and coherent identity' (ibid.: 257). This is an open reading of identity, which counters the traditional, limited definition of 'woman' by men and by liberal feminists, like Friedan,[5] and presents instead an image of 'subjectivity which is always positional, provisional, or ... "subject to change"' (Lauret 1994: 101). Plath replaces fixity with flux, adjusting a patriarchal view of woman with, as Rosi Braidotti puts it, 'a knot of interrelated questions' (ibid.), 'as if the usual order of the world had shifted slightly, and entered a new phase' (Plath 1972: 252).

Plath's work, to some extent, relates to a struggle within feminism in the 1960s, between Friedan's National Organization for Women (NOW), formed in 1966, and Women's Liberation, because the novel is concerned with Esther's discovery of her self outside of the control of men. Her difference is important to the book and cannot be found within the existing male structures of power, which appear as 'totalitarian' and brutalising. She has to free herself from male 'colonialism', wherein her body is their conquest, and assert her own agency, through choice and action, at the novel's end. The precise liberation of the body is crucial since for so long it has been the site of restriction and control. Women's bodies apparently defined their lives because they were capable of childbirth and this, as Perkins Gilman asserts, seemed to confine them to the fragile world of the home and the nursery. Plath's fascination with the body typifies the attention given to it in the 1960s and 1970s by feminists who saw it as the lost territory, colonised by men (doctors, teachers, boyfriends, husbands), that had to be rediscovered and repossessed. Writing was a means to this end, for it gave voice to the female body and freed, as Cixous puts it, 'immense bodily territories which have been kept under seal' (Marks and De Courtivron 1981: 250).

What remains suggestive in Plath's work became vital to the growth of radical feminism in the 1970s, with its call for difference and, in some cases, for separatism. This goes back to first wave feminism's concern

for issues such as whether or not women could be included within a system so heavily biased towards men or whether a separate, woman-identified space was needed. Patriarchal values were so ingrained that women had to exist outside them in order to give full voice to a 'female culture' in its own right. This has been seen in French feminism's call for a distinct women's writing, or *écriture féminine*, in which the female body and female difference are asserted in language.

Such gender-questioning has enabled other factors of difference to be more openly discussed, and in particular, those of class, race and sexuality. Women of colour, often excluded from earlier discussions of gender, could now link their oppressions both to gender and to factors such as racism or poverty. The danger of earlier liberal feminism was its tendency to universalise 'woman', and therefore to see her as white and middle class, like Friedan's women in *The Feminine Mystique*. Thus, the broad politics of the civil rights movement, including African Americans, Native Americans and lesbians, related to this more open attention to difference in ways that hitherto had been impossible. Such diversity meant that middle-class white feminism was no longer the norm, and other voices contributed fruitfully to debates about the inter-relatedness of oppressions across lines of gender, sexuality, class and race. The work of Cherrie Moraga, Gloria Anzaldúa, Maxine Hong Kingston and Alice Walker is of particular importance in challenging the uni-racial model wherein white women appear 'raceless', as though they speak for everyone (Du Bois and Ruiz 1990: xi), rather as patri-archy once did. Similarly, Judith Butler has asserted the importance of 'troubling' accepted categories, refusing to accept any 'single or abiding ground' on which feminism is built (Butler 1990: 33). Instead, she argues, gender is performed as much as constructed, and any 'rigid regulatory frame' needs to be unsettled by questioning forces – 'mobilization, subversive confusion, and proliferation' to undermine any idea of a femi-nist 'we' as anything other than a fantasy (ibid.: 34). This opening-up and 'troubling' of gender studies, within the larger frame of cultural studies, has given rise to what Toni Cade Bambara calls a 'gathering-us-in-ness' (Moraga and Anzaldúa 1983: vi), in which all factors of oppression can be analysed and transformed. One radical group claimed that 'we are actively committed to struggling against racial, sexual, heterosexual, and class oppression and see as our particular task the development of integrated analysis and practice based upon the fact that the major systems of oppression are interlocking' (ibid.: 210).

## SEXUALITY AND GENDER

The introduction of difference into gender studies has opened up the discussion of sexuality as a key factor in the way that identity is

constructed and reconstructed. It is no longer possible to pretend that there is a 'unitary erotics' (Merquior 1985: 133) or a 'normal' sexuality but, rather there exists a diversity of sexualities. These may not represent the views of official reality or be seen as acceptable within the mythical notion of the consensus, but they exist and are part of the cultural order. Plath's Esther Greenwood is circumscribed by gender distinctions, played out in the field of sexuality. For example, masculinity is represented as active and aggressive, like Lenny's place, with its 'great white bearskins ... antlers and buffalo horns ... [and] cowboy boots echoing like pistol shots', while women must be passive, 'the place the arrow shoots from' (Plath 1972: 15, 74). Esther is caught in the sexual 'double standard' of the age in which women were expected to balance sexuality with marriage and children, or risk being ostracised by society. Thus, heterosexuality was part of the 1950s consensus, the uniform response to sexual desire that gave approval to one particular mode of sexual expression and marginalised others. Adrienne Rich calls this 'unexamined heterocentricity' (Rich 1993: 203) and views it as ideological for it limits expression and choice and bolsters a patriarchal system that discourages autonomy and choice. What Rich calls for, like Butler, is a rethinking of such norms, of 'compulsory heterosexuality', so as to permit wider discussion and prevent 'the retreat into sameness ... and a renewed open season on difference' (ibid.: 204; see also Butler 1990).

Homosexual rights groups came to the fore in 1969 following a police raid on the Stonewall Inn in Greenwich Village which turned into a protest riot during which gay men and lesbians made a stand against prejudice and harassment. The Gay Liberation Movement was a product of this event, and began to coordinate protest actions, which ranged from direct action to broader critical discussions of the problems of a centralised blinkered view of sexuality. Lesbianism became a decisive factor in the development of radical feminism, with some believing it was the only true expression of feminism, rejecting the patriarchal conventions of family, marriage and reproduction. Some viewed female biology as 'essential', a determinant of being, and thus it was women who knew women's bodies best, and they were naturally nurturing and non-aggressive. Rich called for a 'lesbian continuum' that is not primarily sexual but to do with 'woman-identified experience' set against 'male tyranny', a 'form of naysaying to patriarchy, an act of resistance' (Rich 1993: 217) based upon the ideal for a truly 'woman-centred' culture.

Although clearly not an issue confined to the 1950s, sexuality was discussed greatly alongside feminism at this time. Indeed, connections were often made between the two, claiming that mothers who were veering away from sexual norms influenced their children in favour of homosexuality or promiscuity (see Friedan 1982: Chapter 11). A film like *Rebel Without a Cause* (1955), which was discussed earlier, also connects

with a prevalent theory of the time namely that 'all parents of homo-
sexuals apparently had severe emotional problems' (Bergman 1991: 190).
This is portrayed by the figure of Plato, who attaches himself to Jim and
is the product of a broken home. It is significant that Plato has to die
at the end of the film, because in one respect he is the dangerous 'rebel'
who threatens the status quo of the family and the masculine bound-
aries of society. Just like women who stand outside the frame of
definitions provided by patriarchy, gays and lesbians have to be excluded
so that 'order' can be resumed. The film's closure, with its salvation of
the family and its prefiguration of the 'new family' of Jim and Judy,
testifies to the social drive, the consensus to marginalise or 'kill off' the
outsider. 'Heterocentricity' is, therefore, reinforced.

Edmund White's trilogy *A Boy's Own Story* (1983), *The Beautiful Room
Is Empty* (1988) and *The Farewell Symphony* (1997), begins in the 1950s
and describes the problems of a boy's collision with this heterocentric
culture, concluding with the coming of AIDS in the 1980s. The link
between White's novels and Plath's is an important one, and there are
many similarities between the two, but in particular, they demonstrate
the pernicious effects of gender and sexual construction upon the indi-
vidual. White's 'boy', who is never named in the novel, is surrounded,
as Esther is, by pressures to conform:

> in the mid-fifties ... there was little consumption of culture and no
> dissent, not in appearance, belief or behaviour.... Everyone ate
> the same food, wore the same clothes.... The three most heinous
> crimes known to man were Communism, heroin addiction and
> homosexuality.
>
> (White 1988: 7)

White's linking of homosexuality with matters of national security was
typical of Cold War paranoia in America, where any threat to the family
and to 'normal' sexual behaviour was viewed as potentially anti-
American. Plath's novel begins in June 1953, on the day the Rosenbergs
were executed for being suspected Soviet spies, and clearly parallels her
own 'shock treatment' with their deaths in the electric chair. Women's
roles and sexuality were policed and controlled to ensure social order
and anyone not conforming was forced into a hidden life. As 'boy'
comments, his life was a 'dumb show in which I played such a decisive
role – it was merely a simulacrum of actual feelings' (White 1983: 70),
causing him to take on a false identity, as Esther had, to be 'the wolf
cub in lamb's skin' (ibid.: 79), divided and silenced.

Like Esther, 'boy' desires expression and to be able to write his own
existence and not have to follow the script of the aforementioned 'dumb
show'. Contained within the discourse of heterosexuality, he sees writing

as a way to 'dictate', to use Plath's word, his own subjectivity, with 'language as a site of resistance to the production of gendered meanings and . . . the perpetuation of heterosexually normative taboos' (Easthope and McGowan 1992: 135). He is still, however, caught between two forms of expression:

> I thought that to write of my own experiences would require a trans-
> lation out of the crude patois of actual slow suffering . . . a way of
> at once elevating and lending momentum to what I felt. At the same
> time I was drawn to. . . . What if I could write about my life exactly
> as it was?
>
> (White 1983: 41)

To do the latter would require breaking through a level of social taboo and role-playing that is similar to that seen in Plath's work and which is called 'the screen of representation' by French theorist Luce Irigaray (Yorke 1991: 88). White, in the spirit of the age, sees 'the hidden designs other people were drawing around [him]' (White 1983: 104), one of which tells him that homosexuality is a sickness that can be cured by educa-tion, psychiatry, religion – all of which become prominent in the novel. But like Esther, he must pass through the 'treatments': confess to his father, betray his teacher and reject the church, before gaining some-thing of his dream of power over the adult world that had circumscribed him. Luce Irigaray has written that women are

> stuck, paralysed by all those images, words, fantasies. Frozen.
> Transfixed . . . dividing me up in their own best interests. So either
> I don't have any 'self', or else I have a multitude of 'selves' appro-
> priated by them, for them, according to their needs or desires.
>
> (Yorke 1991: 88–9)

How similar this is to readers of both gay and feminist literature, for it expresses precisely the tensions that underpin their identities in a world that privileges a patriarchal, heterocentric existence. To be 'beyond . . . the screen of their projections' (ibid.: 88) is to be a danger, an outsider and a threat to social order and normality.

The kind of consciousness-raising work of Edmund White and other gay writers, with its creative exploration of the dilemmas of gender and sexual identity formation, has become intensified by the spread of AIDS in America.[6] The need to speak openly about homosexuality has been an offshoot of the media's representations of AIDS and in particular the association of the disease as a 'gay plague'. Gay lifestyles were thrust into the full light of media attention, to the extent that in 1979 *Time*

magazine's cover would show two males holding hands (and two females) and ask 'How Gay is Gay?'. It became increasingly important that gay people presented their own images to America to counter the scare being conducted in the media. In contrast to the media's single view of marginal, deviant practices that produced the 'plague', many gays wished to present various counter-views, stressing such values as pride, community and identity that surrounded their sexual preferences. Films like *Longtime Companion* (Norman Rene, 1990) depicted gay lives as close, loving and multi-faceted in their dealing with the AIDS crisis, whilst activist movements like ACT-UP (AIDS Coalition To Unleash Power) produced powerful slogans: 'Act-Up! Fight back! Fight AIDS!' and 'Silence = Death'. A writer like Gary Indiana, who represents a more radical gay style, wrote of the 'ideological conformity' and 'large totalitarian capacity' of America and the fact that it necessitated gays be wary of *'how we present ourselves to our executioners'* (Mariani 1991: 23). This debate about self-representation is as alive in the gay community as it has been in feminist movements. In many respects the solution is representational variety and diversity, what Indiana calls 'a plurality of consciousnesses' (ibid.) and what lesbian feminist Audre Lorde expressed as 'the very house of difference rather than the security of any one particular difference' (Lorde 1982: 226).

Perhaps the best example of this kind of 'plurality' is symbolised by the AIDS Quilt, coordinated by the NAMES Project, as a memorial to those – male and female, gay and straight – who have died as a result of the disease (see www.aidsquilt.org). Its slogan is 'Remember. Understand. Share the lesson', and each panel of the quilt emphasises the individuality of the person, in stark contrast to the representations that classify and universalise the sufferers. It does, however, link the individual panels into a whole, to stress unity and diversity whilst creating an AIDS history to set against the myths constructed elsewhere. The quilt becomes a symbolic text, a reading of an invisible history, connecting the condition of AIDS with earlier minority struggles, of women and African Americans in particular:

> he who possesses the rhetoric also possesses the power . . . the Quilt provides an opportunity for People with AIDS (PWA) to repossess the rhetoric and thus inscribe their stories so that they can claim dignity and status for themselves rather than be marginalized into mere victims.
>
> (Elsley 1992: 190)

Tragically, AIDS has provided a rallying point for gay activism, community and for concerns about representation – about how 'straight'

society projected its images of AIDS and gay life into the homes of America. Controversies abounded, like those surrounding AIDS in advertising, and in particular the use of activist David Kirby, dying of AIDS, in the 1992 Benetton advertisement. It offended 'straight' society, not just because it portrayed death, but because it showed a gay man in relations with a family and suggested an almost Christ-like demeanour. By 1994, Jonathan Demme's *Philadelphia* had brought together Hollywood studios, box-office stars like Tom Hanks and Denzil Washington and rock stars like Bruce Springsteen as a way of drama-tising AIDS for the mass market. *Philadelphia* normalised gay life, via Tom Hanks, and perhaps, reduced the complexities surrounding AIDS, but it proved that the issues were at the heart of American life and not confined to the margins of private lives. Philadelphia, the City of Brotherly Love, the cradle of democracy, was the site for a new struggle, one that was no longer simply a gay problem. The AIDS crisis was also dramatised with immense power and controversy in the play and later film of Tony Kushner's *Angels in America* (1993).

By the mid-1990s matters of gender and sexuality were centre-stage, in part because of AIDS, but also as a result of years of discussion arising from feminism. In some respects, Americans learned that they were plural, made up not only of different colours, ethnicities and classes, but of different sexualities and genders also, epitomised perhaps by the publication of Leslie Feinberg's extraordinary novel *Stone Butch Blues* (1993), about 'he–shes' and the world of 'passing' and trans-gendering. The 'centre', with its closed vision of itself as white, heterosexual and male, although still powerful and dominant, had been challenged on a number of fronts; 'the old narratives, stories, scripts, mythologies [have] become transvalued, re-presented in different terms' (Yorke 1991: 1).

## CONCLUSION

You get what you settle for

*(Thelma and Louise,* 1991)

In Betty Friedan's *The Feminine Mystique* one of the women interviewed says, 'I'm desperate. I begin to feel I have no personality. I'm a server of food and a putter-on of pants and a bedmaker, somebody who can be called on when you want something. But who am I?' (Friedan 1982: 19). Although a voice from the 1960s, such a statement could have come from the more recent past, for women still struggle against this kind of desperate limitation of their identities in a domestic, patriarchal world. A popular cultural text such as *Roseanne* shows how this 'despair' and its associated cultural contests can be played out in a different realm of representation with powerful results.

## *Roseanne:* the world blown apart

The popular television programme *Roseanne*, first screened in 1988, is an example of how mainstream culture has integrated aspects of the contests over gender and sexuality into itself. The show adopts the genre made famous in 1950s shows like *Leave it to Beaver* or *The Honeymooners*, but 'is a conscious fracturing of the myth of the happy suburban family', becoming instead, it has been argued, 'a vehicle of resistance' (Dines and Humez 1995: 471) with its deliberate disturbance of gender expectations and sexual norms. *Roseanne* is 'woman-centred', with a 'subversive potential as a source of resistance and inspiration for feminist change' (ibid.: 474), subverting the norms of the sit-com genre which traditionally reduces the influence of the woman along pre-set gender lines. Roseanne has said that humour related to life can have a decisive effect: 'I found a stage, where I began to tell the truth about my life – because I couldn't tell the truth off the stage. And very quickly, the world began to blow apart' (Bonner *et al.* 1992: 286). Like many other texts we have examined in this chapter, *Roseanne* is concerned with 'life-telling' and using these experiences within the 'fiction' of the show. For example, the fictional Roseanne longs to write, just as the 'real' Roseanne did. Writing, as always, signifies the desire for self-expression and authority. However, the show 'blows the world apart' by upsetting the conventions of sit-coms in every way; she is fat, loud, appears disrespectful of her husband, indifferent to her children, and slovenly in her domestic duties. Indeed, 'she built her act and her success on an exposure of the "tropes of femininity" [the ideology of "true womanhood", the perfect wife and mother] by cultivating the opposite [an image of the unruly woman]' (Rowe 1990: 413). The show examines female relationships across generations, races and regions and has chosen to explore varieties of female community or 'woman-space' (Dines and Humez 1995: 473) in different series (the home, the hair salon, 'The Lunch Box', etc.). In a celebratory episode, Roseanne's kitchen is occupied by a group of quintessential middle-class television housewives who stayed at home to rear children, clean their houses and cook, like June Cleaver (*Leave it to Beaver*), Donna Reed (*The Donna Reed Show*) and Norma Arnold (*The Wonder Years*). As if to remind the audience of her subversion of their 'norm', Roseanne educates them in her liberated ways and frees them from the 'script' that they have followed in their fictional incarnations. The show made the point, however, as we have within this chapter, that there has been a script of gender and sexuality established in postwar America that has in recent years come under increased questioning. The self-conscious use of these 1950s 'moms' in a 1990s show makes one conscious of the constructedness of the roles and how they might be interrogated with humour and irony. Roseanne has written that her

mission was 'to break every social norm ... and see that it is laughed at ... because the people I intend to insult offend me horribly' (Rowe 1990: 414).

The show has developed beyond this first-level 'unruliness', with its deconstruction of the 'mom' myth and that of the American sit-com family, to introduce several other issues such as class, race and sexuality into its gender framework. For example, it has two regular, overt gay characters: Nancy (Sandra Bernhard) and Leon (Martin Mull), who are permitted airtime in which to express their sexuality, both visually and verbally. Neither is seen as a 'freak', although, like everyone in the show, they are a source of humour. They are workers, managers, lovers who have power, relationships and emotions, just like all the characters in the comedy. In an infamous episode, Roseanne's overt heterosexuality is challenged by a lesbian relationship, and a screen kiss, with Mariel Hemingway, which deliberately confronted social fears and taboos through the comic medium of the show. Roseanne's control over the show, her 'authority', ensures a diversity in issues and in characterisation that has resisted the conventions and stereotypes of American television and extended debates about family life and 'values'. Her manic laughter, signalled in the opening title sequence of the show, resembles Cixous's Medusa whose subversive power unhinged and disturbed, or Freud's Dora, whose hysteria 'undoes family ties, introduces perturbation into the orderly unfolding of daily life, stirs up magic in apparent reason' (Gallop 1982: 133). What a show like *Roseanne* has enabled is a questioning of definitions of gender and sexuality, in particular around the female image, and offered its audience a series of alternative, competing visions of what have so often appeared as fixed and certain categories within American culture. In the past, the 'unruly' woman could be comically assimilated back into the genre, her outrageousness controlled and tempered by the family group. One thinks of Lucille Ball or *Bewitched*, but in *Roseanne* this is never quite the case. The family is not destroyed by her, but it is questioned and decentred while she remains 'unambiguously non-assimilable' (Gallop 1982: 134) and so is challenging and subversive.

In its own way, the show does assert differences between genders and sexualities, and points towards what we might term postmodern gender and sexuality in the spirit of Judith Butler. This 'rejects all versions of essential femininity or masculinity ... [and] suggests that there is no singular, true [gender definition] ... to reclaim', but instead it is 'fractured, contradictory and produced within social practices' (Jordan and Weedon 1995: 203). The show demonstrates constant negotiations over gender relations, sexualities and power-lines within and outside the family. However, if *Roseanne* has elements of this postmodern sentiment, it is also highly conscious of how these power relations underpin

differences in class, race and gender and how they affect the public validity of the negotiations. The show no longer hides behind the 'screen of projections', but revels in display and spectacle, uses the body as a source of identity and strength and is constantly 'intervening in oppressive identity performances, troubling culturally authorized fictions' (Smith, S. 1993: 162) with its carnival spirit. Gender and sexuality are at centre stage and are part of the show's cacophony of voices, and went onto have a major influence on the kinds of representations that would follow in shows as different as *Ellen*, *Ally McBeal*, *Sex in the City* and *Will and Grace*.

## NOTES

1   Hélène Cixous (Marks and De Courtivron 1981: 261).
2   A continual debate in gender studies has been over 'essentialism', which is the view that 'objects (including people) have an essential, inherent nature which can be discovered' (Burr 1995: 184). In terms of gender this is often connected with the idea that women are 'naturally' or 'essentially' homemakers because of their biological link to birth and nurturing. This is, however, a view contested by all sides of the feminist movement.
3   These pieties and 'virtues' can be seen clearly in the fictions of Louisa May Alcott, as examined later in this chapter.
4   Chopin's exploration of gender and suicide connect her work to that of Sylvia Plath, whose *The Bell Jar is* examined in some detail later in this chapter.
5   Friedan (1982: 233) refers to the 'individual identity' of woman, as though there was a single, fixed 'self' to be found or recovered through feminism. This is a view that has been much discussed and challenged in recent years.
6   There are a growing number of influential gay writers in America whose work is multi-faceted in its attitudes, themes and styles. For example, David Leavitt's *The Lost Language of Cranes*; Gary Indiana's *Horse Crazy* or *Rent Boy*; Dennis Cooper's *Frisk*; or John Rechy's *City of Night*.

## REFERENCES AND FURTHER READING

Alcott, L. (1989) *Little Women*, Harmondsworth: Penguin.
Bailey, B. (1989) *From Front Porch to Back Seat: Courtship in Twentieth Century America*, Baltimore: Johns Hopkins University Press.
Banta, M. (1987) *Imaging American Women: Idea and Ideals in Cultural History*, New York: Columbia University Press.
Barber, S. (1999) *Edmund White: The Burning World*, London: Faber and Faber.
Bergman, D. (1991) *Gaiety Transfigured: Gay Self-Representation in American Literature*, Madison: University of Wisconsin Press.
Bonner, F., Goodwin, L. and Allen, R. (eds) (1992) *Imagining Women: Cultural Representations and Gender*, Cambridge: Polity Press.
Burg, D.F. (1976) *Chicago's White City of 1893*, Lexington: University of Kentucky Press.
Burr, V. (1995) *An Introduction to Social Constructionism*, London: Routledge.

Butler, J. (1990) *Gender Trouble: Feminism and the Subversion of Identity*, London: Routledge.

Byars, J. (1991) *All That Hollywood Allows: Re-reading Gender in 1950s Melodrama*, London: Routledge.

Chafe, W.H. (1974) *The American Woman: Her Changing Social, Economic and Political Roles, 1920–1970*, Oxford: Oxford University Press.

Chopin, K. (1984) (first 1899) *The Awakening and Selected Stories*, Harmondsworth: Penguin.

Clinton, C. (1984) *The Other Civil War: American Women in the Nineteenth Century*, New York: Hill and Wang.

Daniel, R.L. (1989) *American Women in the Twentieth Century*, New York: Harcourt, Brace, Jovanovitch.

Dines, G. and Humez, J. (eds) (1995) *Gender, Race and Class in Media: A Text-reader*, London: Sage.

Du Bois, E.C. and Ruiz, V. (eds) (1990) *Unequal Sisters: A Multicultural Reader in U.S. Women's History*, London: Routledge.

Eagleton, T. (1983) *Literary Theory*, Oxford: Blackwell.

Easthope, A. and McGowan, K. (eds) (1992) *A Critical and Cultural Theory Reader*, Buckingham: Open University Press.

Elsley, J. (1992) 'The Rhetoric of the NAMES Project – AIDS Quilt: Reading the Text(ile)' in E.B. Nelson (ed.) *AIDS: The Literary Response*, New York: Twayne, pp. 186–9.

Friedan, B. (1982) (first 1963) *The Feminine Mystique*, Harmondsworth: Penguin.

Gallop, J. (1982) *Feminism and Psychoanalysis: The Daughter's Seduction*, London: Macmillan.

Gatlin, R. (1987) *American Women Since 1945*, London: Macmillan.

Gilman, C.P. (1990) 'The Yellow Wallpaper', in C. Griffin-Wolff (ed.) *Four Stories By American Women*, Harmondsworth: Penguin.

Harvey, B. (1994) *The Fifties: A Women's Oral History*, New York: Harper Perennial.

Jordan, G. and Weedon, C. (1995) *Cultural Politics: Class, Gender Race and the Postmodern World*, Oxford: Blackwell.

Lane, A.J. (1990) *To Her Land and Beyond: The Life and Works of Charlotte Perkins Gilman*, New York: Pantheon Books.

Lauret, M. (1994) *Liberating Literature: Feminist Fiction in America*, London: Routledge.

Lauter, P. *et al.* (1994) *The Heath Anthology of American Literature*, Lexington: D.C. Heath.

Lerner, G. (ed.) (1977) *The Female Experience: An American Documentary*, Oxford: Oxford University Press.

Lhamon, W.T. Jr (1990) *Deliberate Speed: The Origins of Cultural Style in the American 1950s*, Washington, DC: Smithsonian Institute Press.

Lorde, A. (1982) *Zami: A New Spelling of My Name*, London: Sheba.

Mariani, P. (ed.) (1991) *Critical Fictions*, Seattle: Bay Press.

Marks, E. and De Courtivron, I. (eds) (1981) *New French Feminisms*, London: Harvester Wheatsheaf.

Melosh, B. (ed.) (1993) *Gender and American History since 1890*, London: Routledge.

Merquior, J. (1985) *Foucault*, London: Collins.

Meyerowitz, J. (ed.) (1994) *Not June Cleaver: Women and Gender in Postwar America, 1945–1960*, Philadelphia: Temple University Press.

Moi, T. (1985) *Sexual/Textual Politics: Feminist Literary Theory*, London: Routledge.

Moraga, C. and Anzaldúa, G. (eds) (1983) *This Bridge Called My Back: Writings By Radical Women of Color*, New York: Kitchen Table Press.

Muccigrosso, R. (1993) *Celebrating the New World: Chicago's Columbian Exposition of 1893*, Chicago: Ivan R. Dee.

Mulvey, L. (1991) *Visual and Other Pleasures*, London: Macmillan.

Norton, M.-B. (ed.) (1989) *Major Problems in American Women's History*, Lexington: D.C. Heath.

Plath, S. (1972) (first 1963) *The Bell Jar*, London: Faber and Faber.

Rich, A. (1979) *On Lies, Secrets, and Silence: Selected Prose, 1966–1978*, New York: W.W. Norton.

—— (1993) *Adrienne Rich's Poetry and Prose*, New York: W.W. Norton.

Rosenberg, R. (1992) *Divided Lives: American Women in the Twentieth Century*, New York: Hill and Wang.

Rowe, K.K. (1990) 'Roseanne: Unruly Woman as Domestic Goddess', in *Screen*, vol. 31, no. 4, Winter, pp. 408–19.

Showalter, E. (ed.) (1986) *The New Feminist Criticism*, London: Virago.

—— (1992) *Sexual Anarchy: Gender and Culture at the Fin de Siècle*, London: Virago.

Smith, P. (1988) *Discerning the Subject*, Minneapolis: University of Minnesota.

Smith, S. (1993) *Subjectivity, Identity and the Body in Women's Autobiographical Practices in the Twentieth Century*, Bloomington: Indiana University Press.

Trachtenberg, A. (1982) *The Incorporation of America: Culture and Society in the Gilded Age*, New York: Hill and Wang.

Walby, S. (1990) *Theorizing Patriarchy*, Oxford: Blackwell.

Weeks, J. (1986) *Sexuality*, London: Routledge.

White, E. (1983) *A Boy's Own Story*, London: Picador.

—— (1988) *The Beautiful Room Is Empty*, London: Picador.

Woloch, N. (1994) *Women and the American Experience*, New York: McGraw-Hill.

Yorke, L. (1991) *Impertinent Voices: Subversive Strategies in Contemporary Women's Poetry*, London: Routledge.

## FOLLOW-UP WORK

1   Laura Mulvey's 1975 essay 'Visual Pleasure and Narrative Cinema' (1991) argues that mainstream cinema is structured for the 'male gaze' and excludes the female point of view because the camera assumes a male perspective. Women in the audience have to adjust their view to fit in with the male one presented to them. Some mainstream films in the 1980s, for example, have attempted to challenge this view and the associated limitations on female representation. Consider Susan Seidelman's *Desperately Seeking Susan* (1985), which is concerned with feminine identities, or *Thelma and Louise* (1991), which although directed by a man, Ridley Scott, shows two women breaking away from the definitions of a male world characterised by diner and kitchen. The ambiguous ending of *Thelma and Louise*, like *The Awakening* and *The Bell Jar*, presents the 'reader/viewer' with images of suicide/flight/rebirth, but allows us to decide how we

interpret its meanings. Specific questions these films raise are: have the women moved 'beyond' patriarchy or have they simply given in to its inevitable presence and power? What sense of identity emerges in these films?

*Assignments and areas of study*

2   Consider the following:

(a) Friedan and others discuss the impact of women's magazines on the discourse of femininity. Examine closely a range of American magazines, interpreting both written and visual texts, and analyse the 1990s version of the feminine that emerges. In particular, concentrate on the ideological positions adopted by the magazines, the myths they create and the values they promote. Relate this back to Plath, Friedan and Harvey's view of the 1950s and 1960s.

(b) '*Sex in the City* can be viewed as a "post-feminist" text redefining female identities in complex and varied ways.' Discuss this statement with close reference to the television series.

(c) How is masculinity and femininity examined in a popular action film such as *Die Hard*? To what extent does the film represent the idea of the 'new man' and 'liberated woman' whilst, at the same time, resorting to fairly conventional gender codes?

# Representing youth
## Outside the sunken nursery

Late in Douglas Coupland's *Generation X* (1992), the idea of youth is dwelt upon and a particular metaphor stands out: 'youth really is . . . a sad evocative perfume built of many stray smells' (Coupland 1992: 134). To see youth as something built up, or constructed, of many 'stray smells' is to recognise it as a complex, differentiated 'conjunction point for various discourses' (Acland 1995: 10), all informed by race, class, power, gender and sexuality. Youth is one of the sites where these forces cross, mix and clash: 'at a splendid crossroad where the past meets the future in a jumble of personal anxieties and an urgent need for social self-definition' (Fass 1977: 5). The nature of this collision has given rise to much debate and discussion of youth, its representations and its expressions, and this chapter will examine some of the issues raised by these arguments. What this chapter cannot do is to survey the field and examine youth from all viewpoints, but many of its arguments connect to other chapters in this book. The diversity of youth cultural practices and texts is a testament to the differences within the constructed label 'youth' and this chapter will reflect and explore some of these diverse responses.

If youth is viewed as a 'crossroad', it provides an appropriate spatial metaphor that locates the concerns of this chapter within the extent to which youth challenges social direction, follows the path dictated for it or gravitates across both positions. We will employ spatial images, as youth texts do themselves, as a means of exploring the idea of social boundaries and how these are both transgressed and reinforced by such texts within American culture. As Meyer Spacks has written, youth can be seen 'as violators or precursors of system' (Meyer Spacks 1981: 296), and this chapter will examine the tensions inherent in this duality. These tensions are poetically expressed by the social scientist Edgar Z. Friedenberg's assessment that 'human life is a continuous thread which each of us spins to his own pattern, rich and complex in meaning. There are no natural knots in it. Yet knots form, nearly always in adolescence' (Friedenberg 1963: 3). Youth texts are concerned with the tensions

between the desire for a self-generated 'pattern' – 'to be oneself' – and the 'knots' that fix and bind youth into someone else's definition (see Campbell 2004).

## YOUTH/HISTORY/REPRESENTATION

America's historical formation has always drawn special connections between itself as a nation and the concept of newness and youthfulness (see Chapter 1):

> We are young, vigorous, unique; 'on the cutting edge of history'. Since we are new, what is young, or vigorous, or unique is good to use prima facie. . . . All people, everywhere, value youth . . . but America is the 'fountain of youth'.
>
> (Robertson 1980: 348)

This metaphorical language emphasises a perception of the New World as a place of renewal, literally a rebirth in which the energy of child-hood and of youthfulness represents the chance to begin again and undo the corruptions of the Old World. 'Americans sought their lost innocence increasingly in their children. A psychic primitivism of youth replaced an accompanied geographical and cultural primitivism' (Sanford 1961: 112). The idea of 'psychic primitivism' means that adult-America endowed its children with the hopes of a new future, for they were untarnished and could develop society from the struggles of their parents, who had been touched by the corruptions of the Old World. The investment and the vision were thrust upon the youthful future. This paradigm relates to the view of the Old World as a 'parent culture' that had grown authoritarian in its power, persecuting and alienating certain groups within it and the rebellious 'children' had to oppose them in a classic confrontation between the past and the energetic, new future.

> To follow blindly the footsteps of past masters was to remain forever a child; one should aim to rival and finally to displace them. Inherited wisdom should be assimilated and transformed, not simply revered and repeated.
>
> (Lowenthal 1985: 72)

The past, linked as always with the Old World, 'like a parent' (Lawrence 1977: 10), has to be 'transformed' by the energies imbued by the child of the New World, who is unafraid to rebel, to question and to challenge. Ironically, this rhetoric, which had a genuine purpose in the days of colonial rebellion, later presented problems for the newly forming social system in America because each generation could not be

continually challenged by the next without destabilising the established order. This 'certain tension' (ibid.: 11) in the way youth has been viewed in America is central to this chapter, which will explore the ambiguities and complexities that emerge through the continued obsession with youth in the culture. At once desired as a generalised notion, as a sign of vigour and energy, America had to temper and control youth to avoid clashes with the mature culture being formed.

America saw itself as the 'Good Bad Boy', a phrase coined by Leslie Fiedler, because it signified a youth who was 'authentic . . . crude and unruly in his beginning, but endowed by his creator with an instinctive sense of what is right' (Fiedler 1960: 265). Youth then became a site of 'sanctioned rebellion' (Fetterley 1973) because the original rhetoric of protest, challenge and opposition to the established order was tempered and channelled by the accepted practices of the given social powers. That is, the 'boy' may be 'bad', but only temporarily, before resorting to the 'good', to the socially reinforced and approved, or 'sanctioned'. In this analysis, youth is defused and made safe, representing a natural, but contained outpouring of 'spirit', but one that cannot be permitted to challenge the hegemony of the adult/parent culture. The order remains and the youth is incorporated into the whole society. Many youth texts, that is books, films, television shows, songs, and so on, are microcosmic workings through of this larger cultural picture, demonstrating the necessity for renewed, coherent social/adult order.

A very good example of this in action is the film *The Blackboard Jungle* (Richard Brooks, 1955), which was made at a crucial period in the development of a visible youth culture in America. It was the same year that *Rebel Without a Cause* was released, McDonald's opened, Chuck Berry released 'Maybellene', Little Richard 'Tutti Frutti' and Elvis Presley signed for RCA records. The film chose as its subject the efforts of a city schoolteacher, Mr Dadier (Glenn Ford), to reach a group of disaffected male students. It set the mould for many 'problem youth' films from this period, even being the first film to use a rock 'n' roll soundtrack, Bill Haley's 'Rock Around the Clock'. Yet for all its spectacle of violence, anti-authoritarianism and social divisions, the film ultimately aims to reassure and to reassert the power of righteous adult order. The film, like the later middle-class reconciliation movies of John Hughes, plays out cathartically the terrors of Dadier at the hands of his student-tormentor, the manic West, until the film can resolve and reorganise society around a new 'pact' at the end. Dadier, nicknamed 'Daddyio', re-establishes the law of the father at the end by confronting West and rallying the collective conscience of the class, and in particular the black student Miller (Sidney Poitier). In a wonderfully surreal scene, filmed from a high angle, we see West prowling around the walls of the classroom looking for support to usurp Dadier's power, but visually it

is made clear that he has been contained by the teacher's space and authority and is eventually stopped by the American flag, used to hold him back from attacking the Father-figure. The scene is followed by one of Miller and Dadier leaving the school with their 'pact' established and a new, hopeful order asserted, which is both the rule of the 'parent/teacher' Dadier and a racial bond wrapped up in the Red, White and Blue. By the 1950s youthful exuberance was read as dangerous and as something that had to be curbed and channelled into 'pacts' of this kind or else excluded permanently, like West, so as to prevent social disorder. Images of youth had to be managed just as youth on the streets had to be watched and controlled.

Thirty years later John Hughes's *The Breakfast Club* rekindled a similar set of concerns about youth and education. Some of the differences are, however, instructive and relevant to the way youth has been represented and managed. Hughes's films employ adolescent narrators to suggest they are not adult-driven, but do still assert distinct values, moral lessons and return the audience and the characters to a harmonious sense of order and justice – but not before youth has been paraded as full of possibility and inventiveness, as well as cunning and deviousness. Hughes's films, in their own way, demonstrate reconciliation and the incorporation of youth into the mainstream, but also acknowledge the variety (to an extent), resourcefulness and vitality that have to be admitted into that cultural stream. *The Breakfast Club* begins with five students divided along the lines of class, popularity and gender, arriving for a detention with the task of writing an essay entitled appropriately 'Who do you think you are?' Brian, the narrator, tells us 'You see what you want to see. In the simplest terms, the most convenient definitions' and the film's goal is to alter these simple views. The film's closure is a reconciliation of differences into a workable social mix, an ideological vision of America that harks back to the search for fidelity and sincerity at the heart of so many youth texts, as we shall discuss later. The film suggests you can be anything as long as you are honest, have integrity and don't succumb to those who would 'brainwash' you. The final 'club' is a version of the 'pact' at the closure of *The Blackboard Jungle*, a democratisation of youth that harmonises it with the adult world, in Hughes's work, often represented by the family or school. They are both individuals and a club, united and separate, a classic vision of America as the space for all.

In the nineteenth century, children were often viewed as being 'untainted by social artifice' and possessing innocence and emotional spontaneity 'which seemed increasingly absent from the public realm' (Lears 1981: 146). This emphasis upon nostalgic sincerity endowed youth with regenerative powers capable of replenishing the corrupt 'public realm' through a 'vision of psychic wholeness, a "simple, genuine self"

in a world where selfhood had become problematic and sincerity seemed obsolete' (ibid.: 146). These romantic, Rousseauesque versions of childhood indicate a certain aspect of nineteenth-century attitudes which saw childhood as an expression of values being undermined or lost in the industrial development and urbanisation of America. Childhood could be the receptacle for adult dreams of innocence and hope. Authors such as Alcott and Twain, however, suggested a complex relationship between competing versions of youth which present a more interesting social pattern than the 'sickly-sweet child' (ibid.: 146) often imagined in nineteenth-century representations. Their work, especially *Little Women* and *Tom Sawyer*, explores tensions within the imagined vision of what youth might be and recognises that youth is a border territory where power and authority are contested and space is won and lost.

## BOUNDARIES AND YOUTH SPACES

The concept of youth is 'a term without its own center' (Grossberg 1992: 175), difficult to define, covering many social differences and perceived in a variety of ways depending on the individual's point of view. Youth is part of culture's contested space and any 'unity is an ideological fiction' (Acland 1995: 20). The signifiers that we might try to 'read' in order to define youth are mobile and unfixable, and our attempts to gather them together underline the fact of youth's multi-faceted and complex presence as a concept within American culture.

In *Rebel Without a Cause* (Nicholas Ray, 1955), in which youth is the central focus, Ray makes use of place and space throughout the film to delineate and suggest the 'fields of power relations' (Foucault 1986: 247) within which youth exists. Near the end of the film is a particularly relevant sequence of scenes played out in an abandoned mansion, in which Jim (James Dean), Judy (Natalie Wood) and Plato (Sal Mineo) gather. The film's use of space up until this point is dominated by official, adult, public spaces that seem to constrain and trap the young characters: the school, the home, the police station, the planetarium. Only occasionally does the film permit youth to step beyond these defined and controlled spaces, and the abandoned mansion represents the most powerful example. It is an excessive family home which is empty and absent of family, father and all the immediate connotations of control and surveillance that the film associates with parental/adult culture. At its heart is an image of this vacancy, a vast, deep, empty swimming pool, which Jim refers to as a 'sunken nursery'. The scene dramatises the film's contention that, like *The Blackboard Jungle*, youth is in crisis in the 1950s and that children are better seen but not heard, for to articulate is to possess a voice which might question the emplacement of the child/youth within the space ordained by adult authority. The wild

abandon in the 'abandoned mansion' temporarily carnivalises the adult control and parodies the dominance of the family and its values. Jim and Judy act out roles as a parody family, exaggerating, for comic-ironic effect, the consumerism and narrow-mindedness of the suburban restraint of the family. Judy asks, in her 'role' as Mother, 'what about children?', to which Plato replies 'You see we really don't encourage them, they're so noisy and troublesome'. Indeed, the controlled space of the 'sunken nursery' provides the answer to troublesome youth, for 'if you lock them in you'll never have to see them again, much less talk to them'. Judy answers that 'no one talks to children, no, they just tell them'. In this powerful scene the parody plays out the concerns of the film with youth and permits its young characters to voice their darkest fears through the veil of the 'play'. For our purposes, it demonstrates the way in which space, its control and ordering indicate the social pressure and authority exercised on youth so as to mould and shape them to the will of the adult world.

The film itself reflects many aspects of youth's relation to American mainstream culture, for it fluctuates between representations of resistance and acceptance of parental-authoritarian hegemony. Youth desires its own space outside the adult/public sphere, beyond the surveillance of the authorities and institutions that dominate their lives. This is characteristic of the way youth uses space, as Grossberg writes:

> youth could construct its own places in the space of transition between these institutions: in the street, around the jukebox, at the hop (and later the mall) ... spaces located between the domestic, public and social spaces of the adult world. What the dominant society assumes to be no place at all.
>
> (Grossberg 1992: 179)

Youth texts resonate with these marginal spaces where youth finds domains outside of the 'already defined place within a social narrative that was told before it arrived' (ibid.). A nineteenth-century novel, like *Little Women* (1868), presents Jo March's space as her 'garret' where she writes, keeps pet rats and wears an ink-stained shirt, all of which run contrary to the expectations of the age for both gender and youth. Only here, *within* the house of her powerful, absent father whose 'law', like the law of society, she will finally accept, does she have some temporary control. By the time of *Rebel*, youth cannot bear to remain in the family house and can find no freedom within it. The film is full of dramatic exits by Jim, most memorably when he has his climactic row with his parents and disappears into the night, stopping only to fight with his father and destroy a family matriarchal portrait. Contested space dramatises and represents the tensions over conditioning and socialisation that

occur during childhood and youth and which take a variety of forms, but a predominant example is the domestic control of the house as opposed to Grossberg's notion of the marginal space outside.

## HOUSING THE SELF

The house, as a metaphor for adult-parental space, is often linked to the Father, the representative of the dominant social order, and is a powerful visual image of established, solid, economic territory that surrounds and contains youth, acting as a constant reminder of their subordinate position in the hierarchy of familial and social power. It represents responsibility, order, stability and predictability, the very things that youth is supposed to find itself opposing. In *Shampoo Planet* (1993) Douglas Coupland refers to the joy at finding a space he terms 'the antidote to my father's house' (Coupland 1993: 218). In *Ferris Bueller's Day Off* (John Hughes, 1986), Ferris's rebellion begins and ends in the family home, as if to remind the audience that his adventures are only a rite of passage, literally a 'day off' from the charted life his parents desire for him, rather than acts of total denial and rebellion. At the end of the film he is happy to return and be 're-housed' in the womb-like cosiness of the bed and to receive the approving words and kisses of his parents.

In Joyce Chopra's film *Smooth Talk*, released in the same year as *Ferris* and based on the Joyce Carol Oates story 'Where Are You Going, Where Have You Been?', the house is the central motif in the film, representing the domain of the mother, who spends her life decorating it, and the father, to whom it signifies the pinnacle of his achievements. In a brief scene with his dissatisfied daughter, Connie (Laura Dern), he speaks of the pleasure the house gives him, providing the freedom to sit and smoke 'all night if I want to' on his own 'lawn chair'. Both the mother and the father's attitudes, embodied in the house, are viewed by Connie as sedentary, lifeless and banal, in contrast to her 'trashy day-dreams' of escape, sexual exploration and of the world beyond the boundaries of the house. Again, the visual use of the house makes this set of ideas very clear to the audience. Near the opening of the film, Connie is seen in long shot walking down the hallway of the house, in shadow, leaning against the walls as if they were the bars of a cage. Just before she exits the house and the shot, she glances through an open doorway at her mother who, as always, is seen contemplating the decor of the house, holding up a floral wallpaper onto the very walls that seem to enclose and limit Connie. Boundaries can be real, physical forces but can also be used to represent a wider range of psychological or social determinants that shape and construct youth within the larger cultural framework. In the story, Oates writes that 'Everything about [Connie] had two sides to it,

one for home and one for anywhere that was not home' (Lauter *et al.* 1994: 2060–1) and this inside-outside tension is explored in film and story. The attractions of the outside – of men, sexuality and self-identity – become threatening through the figure of Arnold Friend, her seducer, who says at the end of the story: 'This place you are now – inside your daddy's house – is nothing but a cardboard box I can knock down any time' (ibid.: 2170). The house that Connie desires to escape is now her very fragile protection against the presence of Friend, who has brought the seductive outside terrifyingly to life in a manner that reminds Connie of the crossroads of youth. Ironically, at the point of fear she longs to retreat to the safety of her 'daddy's house'.

Coupland's *Generation X* reflects playfully on the significance of the house:

> When someone tells you they've just bought a house, they might as well tell you they no longer have a personality . . . they're locked into jobs they hate . . . they're broke . . . they no longer listen to new ideas. . . . What few happy moments they possess are those gleaned from dreams of *upgrading*.
>
> (Coupland 1992: 143)

In Terrence Malick's film *Badlands* (1974), the house marks the boundary to be transgressed by its young runaways who see in it Coupland's sense of constraint. Kit (Martin Sheen) invades the house of the Father, kills him, burns his house and steals his daughter. The sequence ends with a long scene in which the house burns as a loud religious choral soundtrack underpins the sacrificial act that has taken place. This film's extremity contrasts with Chopra's *Smooth Talk*, on one level, but resembles it in its fascination with images of rebellion and the rejection of adult authority.

In *Badlands* the Father guards and watches his daughter, Holly, before his authority is destroyed by her lover Kit, who wants to liberate them from his control. As Michel Foucault asserts, 'in the first instance, discipline proceeds from the distribution of individuals in space' (Foucault 1977b: 141), and youth is constantly monitored by types of discipline and surveillance. Foucault discusses the ways in which 'enclosure' functions on the subject so that three elements can be ensured – 'knowing, mastering and using' (ibid.: 143). For Connie in *Smooth Talk*, as long as she is in the house of her parents, she cannot be what she wants to be and feels her own identity is compromised. Through the insistence of limits and sanctioned activities within these limits, subjects are correctly trained and normalised, to use Foucault's terms, and take up their places within the social order of adulthood. Youth texts in America have constantly entered into a dialogue with these sanctioned spaces and their

circumscribing boundaries, testing out the social order, to offer a sense of 'Otherness' to the ordained and acceptable 'norms' and at the same time, through their incorporation, re-inforcing and sustaining the hegemonic, adult framework.

Connie's entrapment as feminine and youth within the expectations of her culture echo Jo March in *Little Women*, who says she was

> tired of care and confinement, longed for change, and thoughts of her father blended temptingly with the novel charms of camps and hospitals, liberty and fun. Her eyes kindled as they turned wistfully toward the window, but they fell on the old house opposite, and she shook her head with sorrowful decision.
>
> (Alcott 1989: 213)

The contrast between the outside and inside is marked here and suggests the precise limitation to which Jo knows she must conform. The outside world, linked to 'liberty and fun', is contrasted with the 'house' and Jo 'must be proper, and stop at home', whereas Laurie, her male friend, 'was possessed to break out of bounds in some way' (ibid.) and move into the world beyond. Youth is constructed differently for feminine and masculine, as *Little Women* shows, for boys are permitted some boundary-breaking before being brought back into the fold. Thus, gender is a further boundary that restricts what young females may do within a society in which rules and boundaries are governed and maintained by adults 'whose presence limits the unlimited' (Foucault 1977b: 81).

Foucault's concepts of 'surveillance' and 'panopticism' explain how one group holds power over others and transforms human beings into subjects. The Panopticon, as described by Foucault, ensured a circumscribed world of surveillance in which the practices of the socially dominant group were instilled, 'subject to a system of rewards for good behaviour, but . . . viewed at all times by a guard at the centre of the circle whom they could not see . . . All their acts came under official regulation and inspection' (During 1992: 156). The Panopticon is 'power reduced to its ideal form' (Foucault 1977b: 205) instilling itself into the lives of people as if they were prisoners. That is, not knowing if they were being watched, they assumed they were and so conformed to the rules of the space. Such social control can be extended beyond the prison to all social institutions and 'render visible those who are inside it . . . to provide a hold on their conduct, to carry the effects of power right to them, to make it possible to know them, to alter them' (ibid.: 172). This kind of surveillance internalises control, transforming real walls and bars into the spatial boundaries of everyday life.

The surveillance, control and normalising power of the adult society represents a set of forces for conformity and repetition that are resisted

by youth, who seek their own space for expression and definition. Contained and delimited by the space that adults, parents and other institutions of control (school, church, law) have prescribed for them, youth struggles to find ways beyond these 'panoptic' forces.

## A MODEL YOUTH TEXT? *THE ADVENTURES OF TOM SAWYER*

In Mark Twain's *Tom Sawyer* (1898), Judge Thatcher represents the panoptic forces, standing for the laws of the adult community which eventually incorporate Tom, through a process in which the 'individual is carefully fabricated' (Foucault 1977a: 217). It is the fabrication of the subject, the 'rightly constructed boy's life' (Twain 1986: 152) and the institutions that seek to mould Tom – family, school, church and law – with which the novel is concerned. Twain dramatises judgement as an active communal control working on Tom. As Foucault has written:

> the judges of normality are present everywhere . . . the teacher-judge, the doctor-judge, the educator-judge, the 'social-worker' -judge; it is on them that the universal reign of the normative is based; and each individual, wherever he may find himself, subjects to it his body, his gestures, his behaviour, his aptitudes, his achievements.
>
> (Foucault 1977a: 304)

It is through such means that youth is trained, fabricated and managed, just as in *Tom Sawyer*, tokens reward the assiduous Church-goer able to recite the language of prayer and School uses the Examination as a repetitive, machine-like process aimed at training the young (Twain 1986: 137–8).

As a model of youth texts, *Tom Sawyer* contains the alternative impulse towards the transgressive and to all that exists outside the disciplined and controlled precincts of an adult society's rules and boundaries. Twain suggests this with an image rather like those discussed earlier, with the children contained in the church, 'under supervision' but looking at 'the open window and the seductive outside summer scenes' (ibid.: 37). Tom, like so much of youth, is caught between the pull of the outside and the comforting controls of supervision from the community. To actually transgress into the 'seductive outside' would be to move closer to Huck Finn's world of the 'lawless . . . outcast' (ibid.: 45–6) and ultimately into the world of Injun Joe who exists at the social margins. Tom, however, knows the boundaries and is never prepared to transgress them in any genuine way. Indeed, Tom's awareness of the limits and transgressions are interrelated and his skill is in keeping the two in balance for most of the novel. Twain's language repeatedly

emphasises Tom's concern for boundaries: 'Tom drew a line in the dust with his big toe, and said: "I dare you to step over that, and I'll lick you till you can't stand up"' (ibid.: 13). He is defending communal territory, its rules and codes of behaviour from the 'enemy' (ibid.: 14) outside and so acknowledges again the social space within which he moves. Thus, when really tested, Tom opts for the known, choosing to decorate the fence that encloses his world rather than to break it down.

Similarly, at McDougal's cave, a psychological space where 'it was not customary to venture much beyond this known portion' (ibid.: 177), all the elements that structure and order the discipline of Tom's society are replaced. It is a representation of youth's dilemma and Tom opts for the world of 'security' (ibid.: 203) where the norms are clear, rejecting the 'bloody-minded outcast' and true transgressor Injun Joe, who lies dead *in the cave*. Unlike Huck, who loathes being the 'target of everybody's gaze', Tom relishes being 'the spectacle' at its heart to the extent that he is willing to become the surrogate son to the community's controlling force, Judge Thatcher, who compares him with George Washington, Father of his Country, the very figure of America's sense of honesty, truth and goodness. The hegemonic enclosure of Tom into the world of the Judge continues with the programme for his future as 'a great lawyer or a great soldier ... trained in the best law school in the country, in order that he might be ready for either career or both' (ibid.: 217).

Tom accepts willingly 'the bars and shackles of civilisation [that] shut him in and bound him hand and foot' whereas Huck Finn resists since 'wealth ... protection ... society' threaten his need to live *outside* the community. Huck has to be 'dragged ... [and] hurled ... into it' (ibid.) and into all its disciplines and routines. To emphasise Tom's total conformity, it is he who takes on the policing parent role with Huck and 'urged him to go home' (ibid.: 218). By becoming the shadow of the Judge, Tom has undergone his fabrication into masculinity and the dominant social order.

> The boy makes peace with his father, identifies with him, and is thus introduced into the symbolic role of manhood. He has become a gendered subject ... [and] will now grow up within those images and practices which his society happens to define as 'masculine'.
>
> (Eagleton 1983: 155)

Twain suggests that youth can function in direct relation to the dominant adult culture, but as an Other, who tests out the boundaries of that social order, and through this process reinforces its rules. Within this pattern, rebellion is inherently vital to the way culture works because youth inter- acts, challenges and criticises the adult world, only to be incorporated into it in some form. As Acland writes, 'youth acts as an Other, distanced,

yet inseparable, from the social order . . . always dependent upon disgust and desire' (Acland 1995: 19). Just as Tom Sawyer is disciplined for his mischief, he is also a source of fascination for the townsfolk, who desire the freedoms and adventures that he has and the fun he enjoys on the margins of their adult-determined boundaries. Acland argues that 'youth . . . is simultaneously transgressive and revered' (ibid.), a tension, as we have argued, that can be seen in most representative youth texts.

## THE DREAM OF EDEN

J.D. Salinger's novel *The Catcher in the Rye* (1951), which has been read as a passionate study of youth alienation, longs for a vision of America that has been lost in the post-war rush into consumerism and technology. For Salinger's hero Holden Caulfield, the adult world is 'phoney', with the panoptic forces moulding and training the young to imitate the society they have created. Early on in the novel, Holden reports ironic-ally his school's mission of 'moulding young boys into splendid, clear-thinking young men' (Salinger 1972: 6), but he sees through the advertising image to the phoniness below. However, Holden's journey into the adult world of New York only confirms the fear he has that no one else can see the false values that he so detests, and it is he that is driven mad by their dominance.

Holden wants to 'hold on' to other values and, as in *Rebel Without a Cause*, at the centre of *Catcher* is a plea for sincerity, honesty and decency, which for Holden is associated with the past, indeed, with the dead and with the static. The psychologist Erik Erikson termed this the search for 'fidelity', for 'disciplined devotion in youth's roles as 'renewers of ethical strength, as rebels bent on the destruction of the outlived' (Friedenberg 1963: 10). In *Rebel*, Plato says that Jim 'doesn't say much, but when he does you know he means it, he's sincere' and Judy replies, 'Well that's the main thing'. Later, Jim's inadequate father tries to persuade his son to lie rather than tell about the fatal crash on the 'chicken run' – 'that's the main thing', he says. The film suggests that the gap between these versions of 'the main thing' is significant, contrasting youth's desire for sincerity with adult expediency and duplicity. Jim's father says 'you can't be idealistic all your life, Jim', but this is exactly what the film suggests youth wants to be. The phoney world, without trust and courage, is what Jim is confused by, just like Holden who clings onto his dead brother's memory and his catching mitt as if they contain the magic to connect him to a better, now lost, world of innocence and trust. Holden resists overt sexuality for it represents a movement into adult-hood and phoniness, responsibilities and choices, preferring instead that the world stand still, in an imaginary time of innocence, like the world he associates with his sister Phoebe and the museum that both she and

he have visited. The museum typifies a certain tendency in youth texts towards a celebration of the past and a desire for an unchanging reality. In one respect the museum is Holden's space outside of the rush of adult life, the place where 'everything stayed right where it was. Nobody'd move . . . Nobody'd be different' (Salinger 1972: 127). In *Rebel,* this is the space of the abandoned mansion before it is disrupted by the arrival of the gang and then the police. The sense of continuity is vital, replacing the rapid change of adulthood with a secure and predictable calm. For Holden the thought that Phoebe is repeating his experience is reassuring, but he knows that although the museum remains the same, she will 'be different every time she saw it' (ibid.: 128): 'Certain things they should stay the way they are. You ought to be able to stick them in one of those big glass cases and just leave them alone. I know that's impossible, but it's too bad anyway' (ibid.).

Texts like *Catcher, Rebel* and others transgress adult social codes because they believe them to be false and desire instead 'lost' values and an authentic world, which is, as Holden admits, 'impossible', because of the inevitability of time and change. Holden's dream of being the 'Catcher in the Rye', saving children from their 'fall' over the 'crazy cliff' into adulthood, is part of his longing to remain in the imaginary, time-less innocence of childhood.

This specific tendency is repeated in the novel *The Outsiders* by S.E. Hinton (1967), written when she was herself in her teens. Like Salinger, but without his humour and irony, the novel's 'family' of boys without parents is a mythic, surrogate community fulfilling one of the central fantasies of youth texts, namely to exist in a space beyond the adult world. For Hinton, however, the seeming fantasy is inadequate and imbalanced, producing troubled and violent youths who long for another kind of family. As with Holden Caulfield, it is the desire to return to a simpler, womb-like continuity beyond the class-ridden society of gangs and school: 'It seems like there's gotta be someplace without greasers or Socs, with just people. Plain ordinary people . . . In the country' (Hinton 1972: 39). Again the imagery of the 'seductive outside' is promi-nent, with the country representing a natural space beyond the confining world of the social institutions that mould and impose their values on the youthful characters. In *The Outsiders*, this new imagined space permits the rebirth of the dead parents: 'I brought Mom and Dad back to life . . . Mom would bake some more chocolate cakes and Dad would drive the pick-up out early to feed the cattle . . . My mother was golden and beautiful' (ibid.: 39–40). A static, golden world without death and change is once again the ideal, as in Francis Ford Coppola's film of *The Outsiders* (1983), where the utopian country is rendered visually in golden and bright colours, both echoing Ponyboy's memory of his mother and also linking to one of the central motifs in the book, a poem

by Robert Frost. Its refrain of 'nothing gold can stay' is a reminder, just like Holden's recognition that the static dream of the museum is impossible, that the boys cannot avoid adulthood and 'stay gold' and yet simultaneously celebrates the belief that 'you're gold when you are a kid' (ibid.: 127). As Johnny says, 'Too bad it couldn't stay like that all the time' (ibid.: 59), but they know change is inevitable and adulthood will claim them with all its divisions and falsities. This dream of 'Eden', as the Frost poem calls it, is precisely the dream of return to a continuity akin to the womb, to the relationship of unborn child to the Mother where everything co-exists and is part of a whole, total sense of being. Holden longs to be free of New York and fantasises about a cabin in the woods (Salinger 1972: 137–8, 205) that he and Jane would go to whilst they were young and before everything was 'entirely different' (ibid.: 138). Jacques Lacan, the French psychologist, termed this the Imaginary, pre-Oedipal phase, in which the child is undivided, coterminous with the mother and untroubled by the crises of sexuality (the Oedipal phase) and the institutions of the social order (Symbolic Order). It is no surprise that in all Hinton's novels mothers have important, however minor, roles and are often linked with the past and a sense of better times.

In *The Outsiders*, as in *Catcher*, there is a scene in which children are saved. In the case of Hinton's novel it is an actual event in which Johnny saves children from a burning church, whilst in *Catcher* it is Holden's fantasy of being the 'catcher in the rye'. However, they both represent the belief that childhood is a time of sincerity and goodness, one worth preserving, 'saving', from the 'fall/death' of adulthood. Johnny says 'It's worth saving those kids. . . . When you're a kid everything's new, dawn. It's just when you get used to everything that it's day' (Hinton 1972: 127). It's appropriate that Holden's favourite novel is *The Great Gatsby*, whose eponymous hero wants only to 'repeat the past' and reinvoke a lost dream of love, as the idea is at the heart of both Salinger's and Hinton's novels. A further reference to Fitzgerald comes later in the novel when Holden keeps trying to erase the words 'fuck you' from the walls so that the children will not be corrupted by the language, thus echoing Nick Carraway at Gatsby's mansion at the end of that novel attempting to preserve his friend's reputation. Both gestures are 'impossible' (Salinger 1972: 208) efforts to forestall time and change and cling to the 'capacity for wonder' (Fitzgerald 1974: 188).

Salinger's final scene is a powerful condensation of youthful desire for sincerity set against this terrible sense of inevitable change and corruption that eats away at the dream. Holden watches Phoebe on the carousel, going round and round in circles, in a perfect unchanging moment: 'I was sort of afraid she'd fall off. . . . The thing with kids is, if they want to grab for the gold ring, you have to let them do it' (Salinger 1972: 218). Although he prefers the security of her circularity,

he recognises the inevitable reaching for the future, for adulthood, and her incorporation into the world he detests and is resigned to do nothing except retreat into his own madness.

Douglas Coupland has a metaphor that captures this problematic desire in youth texts to halt time and keep the future at bay: the 'Kodak snapshot'. Looking at old photographs he sees that point at which 'the future is still unknown and has yet to hurt us, and also for that brief moment, our poses are accepted as honest' (Coupland 1992: 17). The association of honesty with static, unchanging points in time is redolent of Holden and Ponyboy's desire to retain their youth. As the high school valedictorian put it in the film *Say Anything* (Cameron Crowe, 1989), 'I have something to tell everybody. I've glimpsed our future, and all I can say is – go back'.

## THE SPACES OF SELF-CREATION

If one response of youth texts to the onslaught of the social order and adulthood is to hold onto a dream of return and to an Eden beyond its grasp, another has been to seek a measure of control and authority in a world that seems to deny youth this. Texts and cultural practices explore ways by which the young struggle to find a space for individual or group expression outside or alongside the adult mainstream. This has been achieved in many different forms – music, fashion, gangs, sub-cultural actions, writing and so on – all of which create a 'language' outside the immediate control of the adult world. As W.T. Lhamon Jr writes, the blues had long invented a 'vernacular doubletalk' to overcome the 'force fields of complex surveillance' (Lhamon 1990: 59), and youth culture learned much from oppressed communities elsewhere in America. In a famous scene in the film *The Wild One* (1955), an old barkeeper is bemused by the 'bebop' language of the motorcycle gang who 'jive-talk' to him. The sense of separation and difference is immense and suggests the emergence of youth 'languages' in the 1950s that permitted youth to 'reside in that excluded middle area which resists concrete interpretation' (ibid.: 62). In this 'middle area' youth created its own 'space', one outside the adult world and beyond its comprehension, often characterised by fluidity and forms that celebrate change and motion, for example dance, graffiti art and video games. As Donna Gaines comments about suburban 1980s youth, they 'fought back symbolically; articulating their dissent culturally, in their clothes, language, music, and attitudes . . . created autonomous spaces for self-expression, carved out a place for themselves on their own terms, and they survived' (Gaines 1992: 254).

Lhamon argues that youth culture disrupts temporarily 'polite culture' (Lhamon 1990: 106) and interacts with it through such things as laughter, critique and rage, effecting adjustments and change. He puts this

well, writing that young people 'asserted the principle of public self-definition, and made space for themselves and their idiom in prestigious discourse' (ibid.: 108). In literature this has become a popular youth theme, wherein young narrators aspire to be writers, reluctant to spout the established language of their parents, but anxious to construct a world in their own language. Ponyboy 'writes' the narrative that we read as *The Outsiders*, Holden longs to write, as do Jo March, Edmund White's narrator in *A Boy's Own Story* and Esther Greenwood in *The Bell Jar* (see Chapter 7). The French critic Julia Kristeva recognises this as a major factor in the 'adolescent novel', with the urge for 'a genuine inscription of unconscious contents within language . . . [and] utilizing, at last and for the first time in his life, *a living discourse,* one that is not "as if"' (Kristeva 1990: 9 – our emphasis). The 'dead' handed-down discourse of the adult world, Holden's 'phoniness', has to be cancelled out by the living expressions of a new, youthful language, whatever the mode of expression. Although Kristeva writes about the novel, her observations are useful as ways of seeing the various youth texts 'that facilitate . . . the ultimate reorganization of psychic space, in the time before an ideally postulated maturity' (ibid.: 10). Youth texts 'represented values and inculcated legends in the uninscribed places of minds looking for their own values' (Lhamon 1990: 109) and seek their own authority within a world that constantly tells them to keep quiet. The idea of 'authoring' the self, a common desire in oppressed groups (see Chapter 3 on African Americans), is a response to all those who would speak for you and dictate the terms of existence. To articulate is to order the world, to exercise power and to control aspects of reality, and this is why youth texts clamour to express themselves, to be heard rather than be trapped in an 'already defined place within a social narrative that was told before it arrived' (Grossberg 1992: 179). To write is to control material and empower the self and for powerless, unvoiced youth this is an attractive possibility. For Jo March in *Little Women* this is expressed when she says 'Oh, don't I wish I could fix things for you as I do for my heroines' (Alcott 1989: 157) and 'I hate to see things going all criss-cross, and getting snarled up, when a pull here, and a snip there, would straighten it out' (ibid.: 205). If life were like the fiction she controls, she could adjust and edit reality until she had a script she approved of, but in truth others have charge and construct the acceptable world of youth.

Rock music is an example of youth articulation. Emerging from a hybridisation of oppressed culture's musical forms, blues, jazz and country, it offered the possibility for self-expression in a new language. Rock could allow youth to 'live out its alienation in ways that would increase its own sense of control over its everyday life' (Grossberg 1992: 179). Youth music is a means of speaking a 'living discourse', of expressing a counter-voice to the adult society usually presented as the

ideal. This was another route to the 'seductive outside', beyond surveil-
lance, authority and control, through the creation and articulation of
'temporary differences' (ibid.: 180). These acknowledge what Ponyboy,
Holden and others come to see, that youth is brief and soon consumed,
but that in the moments between childhood and adulthood differences
can be signalled, pleasure achieved and challenges made. Music could
become 'the space of "magical transformations" in the face of youth's
own necessary transformation into its own other, adulthood' (ibid.: 180).
Likewise, dancing, losing oneself to the beat and the motion, 'opens up
a social space that is quite different from the public and private bound-
aries that hold our identities all too tightly in place' (Ross and Rose 1994:
11). Youth music, and its associated areas of dance and style, liberate
the body to express itself in a manner that counters the social controls
of adult society. A scene in the film *The Blackboard Jungle* marks this
precise disjunction between the music of the adult and the new voice
of youth culture when a teacher attempts to engage the class with his
treasured record collection. He pleads with them to appreciate the clar-
inet in one piece when they desire only to 'feel' the music, thus
confirming the gap between them as unbridgeable. They destroy his
collection and herald a new tradition and the very 'dislocation between
the cultures of two generations' (Gillett 1983: 16) that Chuck Berry would
focus upon in 'Roll Over Beethoven'. Berry's songs read like a saga of
youth anthems, intensely critical of established forms of adult life, with
appeals to the road, to young love, to free the body and to resist 'penned
adolescence' (ibid.: 81). Rock criticised the institutions, such as school
and the family, that were central to the limitations and boundaries that
checked and curbed youth, and expressed an 'antidomesticity', attacking
'the place in which its own youth is constructed' (Storey 1993: 188). Rock
constructed a space in which a new language could speak differently
about the world and 'tell the teenage story' (Gillett 1983: 101), like the
attack in Eddie Cochran's 'Summertime Blues' (1958) on parents, work
and government, who exist only to stand in the way of youth desiring
'somethin' else'. As Gillett has written, 'adolescents staked out their
freedom in the cities, inspired and reassured by the rock and roll beat'
(ibid.: viii) which they could now listen to on small transistors rather
than in the company and surveillance of the family on the living-room
radiogram. The intimate fantasies of rock 'n' roll transformed by this
youth space enhanced the articulation of a new language. The mirror in
the bedroom, the dance and the look all became inextricably linked to
the performance of rock in the youth world, so that the sounds of the
1950s, the youth films and the development of street culture began to
mingle in a way that produced new styles and voices. The integrative
process of rock into youth culture had begun and established lines of
power that would emerge and alter through the 1960s' counter-culture

and into 1970s' punk and new wave, as expressions capable of 'rocking the boat of culture and everyday life' (Grossberg 1992: 156). Even if rock could not change the world, it gave voice to protest, desire and pleasure and through that provided a 'disruption of everyday stability' (ibid.: 156). As with other youth texts, this was not necessarily a full rejection of social values but a temporary halt on them, a space for other questions and expressions to surface, and for an 'identification and belonging' (ibid.: 205) to take place in which youth could map out its own sense of values. It was, as Grossberg argues, the very same desire for authenticity that emerged as a core value in rock, providing a means by which youth could stake out a space for themselves in a world governed by others' boundaries, wherein the music 'spoke' or 'felt' about things that mattered, 'private but common desires' conveyed through performer to audience as an open, true channel of communication.

Youth music, in many forms, answered the surveillance and authority of the dominant culture with 'a counterculture of conspicuous display' that 'found a way to contest their erasure, to reintroduce themselves to the public by "throwing out" a new style that made other people take notice' (Lipsitz 1994: 20). Existing 'underneath the authorised discourses, in the face of the multiple disciplines of the family, the school and the workplace', youth music lingered in 'the space between surveillance and the evasion of surveillance' (Hebdige 1988: 35), making a deliberate spectacle of itself, flaunting its style. As Connie feels in 'Where Are You Going, Where Have You Been?', 'the music . . . made everything so good: the music . . . was something to depend upon' (Lauter et al. 1994: 2161).

This belief in music as an articulation of youth protest is central to the film *Pump Up the Volume* (Allan Moyle, 1990) the central character of which, Mark (Christian Slater), expresses his anxieties about the contemporary sterility of his dull, Arizona suburb through the medium of rock, transmitting secretly on a pirate radio station. The idea of the secret articulation, of stealing air-time from the official 'authorised discourse' (Hebdige 1988: 35) of adults is an interesting metaphor in itself, but the fact that the pirate DJ uses a disguised voice and rock to present his message suggests the power of the official culture to control alternative expression and force it underground.

The film articulates the 'secret histories . . . lived histories shared in places coded with secret meanings' (Gaines 1992: 47) of teenage suburban life in a society that professes to be concerned about standards, but only speaks in the place of the young themselves rather than allowing them any actual say. 'Hard Harry's' radio 'station' expresses the obverse to a social order built around the precepts 'make the grade, win the prize, play the game' (ibid.: 9) and combines speech, music and form to tell youth stories like those described in *Generation X* as the equivalent to

coughing up a piece of diseased lung: 'People want that little fragment, they need it. That little piece of lung makes their own fragments less scary' (Coupland 1992: 13).[1]

## AT THE EDGE: THE DARK MOOD

Donna Gaines's *Teenage Wasteland* (1992) is a study of 'suburbia's dead end kids' who find few comforts in a re-imagined past, or in the possibility of claiming authority over the self through expression, and who are much more cynical about its position in the world. As Gaines writes, 'These kids were actively guarding their psychic space because the adults controlled everything else' (ibid.: 38). Their options appear to be withdrawal and brooding or violence, destruction and pathology. Youth is, however, even in the darker materials we will examine here, not in total despair, but certainly channels of articulation and self-definition seem limited and receding rapidly. In the darkest scene in *Rebel Without a Cause*, the chicken run, Jim says to the ill-fated Buzz: 'This is the edge ... that's the end', as he gazes into the abyss below. In *Less Than Zero* (1985), written thirty years later in the midst of the Reagan years, Bret Easton Ellis's disaffected youth inhabit clubs called 'The Edge' and 'Land's End', and in one scene two characters stand, like Buzz and Jim, looking down into a canyon at the cars wrecked below. In the subsequent conversation, the sense of nihilism which emerges in many of these dark texts is established:

> 'Where are we going?' ...
> 'I don't know ... Just driving.'
> 'But this road doesn't go anywhere,' ... 'That doesn't matter.'
> 'What does?' ...
> 'Just that we're on it, dude,' he said.
>
> (Ellis 1985: 195)

One of the refrains in Ellis's novel is 'disappear here', as if to stand as a reminder of the emptiness of the world that surrounds these young characters. All values are gone, even the memory or dream of values, and the only trust in this society is on an Elvis Costello promotional poster tacked to the wall. But the refrain takes us back to *The Catcher in the Rye* in which New York's pavement is like an abyss and Holden is going 'down, down, down, and nobody'd ever see me again' (Salinger 1972: 204). His 'saviour' is his dead brother Allie to whom he appeals, 'don't let me disappear' (ibid.). Whereas Holden still believes he can be saved, by the time of *Less Than Zero* 'Gloom Rules' (Ellis 1985: 107), and as Gaines explains, 'The world "out there" is shrinking. The possibilities of suburbia are exhausted, and your capacity to dream has reached a

dead end' (Gaines 1992: 54). To 'disappear' in Gaines's 1980s America, was to 'burn-out', to become 'atomised', with each person suffering in isolation until 'you are lost – to those around you, to your loved ones, even to yourself' (ibid.: 101). Ironically, Gaines's youth find some level of 'self-preservation' (ibid.: 102) in 'disappearing' because it allows them to 'numb out ... by shutting down, denying access to your feelings' (ibid.: 101) so that they are alive and yet dead to the world around them: 'shut down, tuned out; you're gone' (ibid.).

*Badlands* set in motion a genre of film now much imitated by Hollywood (*Natural Born Killers, True Romance, Kalifornia*), but one that clearly belongs to the dark cinema of youth. Terrence Malick's film contains archetypal images suggestive of rebellion, discontent and psychic amputation, commencing with the killing of the authoritarian father. It is appropriate in the scheme of youth texts that the father is a sign-painter by trade, that is, the outward manifestation of Holden's 'phoniness'. Erasing the father not only 'frees' the children to wander the badlands, but also strikes at the social order and the lies it creates for itself. When we are told that Kit, the central character in the film, desires 'a magical world beyond the law', he is an extreme version of youth's wish for the seductive outside, beyond the father, the signs and the boundaries of adult laws. Kit's name suggests his efforts throughout the film to construct himself from the debris all around him, and his failure to assemble a coherent 'self' indicates the unaccommodated proto-type that he represents in this dark tradition. There is no father to integrate Kit at the end of the film, since all that remains is the law sent to enclose him and impose its definitions upon his ambiguous person-ality. As Holly says, 'We lived in utter loneliness, neither here nor there'. Kit's arrest marks his end, for he can no longer construct himself in motion, as he has been doing throughout the film, but has been reclaimed by the realm of the law to be what it wants him to be (the criminal). A prototype for many youth-outsiders, Kit resembles those youths Gaines wrote of in 1980s suburbia: 'disengaged, adrift, alienated. Like you don't fit in anywhere, there is *no place for you*: in your family, your school, your town – in the social order' (Gaines 1992: 253 – our emphasis). As the film ends, Kit flies off into 'no place' and with none of the comforts afforded to Tom Sawyer who is embraced back into the Judge's world. Having transgressed the boundaries of social space and social order, Kit's final destination is the incarceration of 'no place', where surveillance, control and limit are total, awaiting death itself. His last words suggest his misunderstanding of America as a place that values individualism:

> Policeman: 'You're quite an individual, Kit.'
> Kit: 'Do you think they'll take that into consideration?'

The extreme individualism exercised by Kit throughout the film is way beyond the acceptable limits of social definitions of self-expression and has to be brought under control, disciplined and punished (see Campbell 2003).

'I can't be what I want to be any more than you can' says Motorcycle Boy at the end of *Rumble Fish*, as if to reinforce Kit's tragic misreading of America. To be young is not to express your own sense of self; instead it is about learning to be what others have scripted for you. *Rumble Fish* (Francis Ford Coppola, 1983) was made back-to-back with Coppola's other S.E. Hinton adaptation, *The Outsiders*, in 1983, but represents the opposite, dark side of youth movies in contrast to the more optimistic and romanticised view of the latter film. *Rumble Fish* is a distorted, brooding film that emphasises certain aspects of the original novel through the character of the Motorcycle Boy (Mickey Rourke). In particular, all heroism and light are drained from the film, which is shot in iridescent black and white with a slow surreal quality to it. Whereas *The Outsiders* is like a 1950s remake, *Rumble Fish* is a meditation upon Hinton's major themes but produced with a sinister and menacing edge. One of these central concerns is the theme of time, but here it takes on a terrible threat, akin to the work of Ellis. In one scene in the film, a voice-over from the diner owner Benny (Tom Waits) comments that 'Time is a funny thing. Time is a very peculiar item. See when you're young you've got time, nothing but time . . . throw away a couple of years here . . . and there it doesn't matter'. For Motorcycle Boy, time is running out, just like his health – he is colour-blind and growing deaf – and the film constantly reminds the audience of time's influence. In a key scene Motorcycle Boy, echoing a Gaines 'burn-out', tells his adoring brother Rusty-James that he is 'tired' of being seen as a hero, a Robin Hood or a Pied Piper, because 'if you're going to lead people you've got to have somewhere to go'. This is reinforced in the following shots by a scene in which the brothers stand in front of a huge, surreal, armless clock-face that towers over them as a reminder of their fragility. With echoes of T.S. Eliot's 'The Waste Land', Coppola's film indicates a powerful sense of lost dreams and no salvation with its 'maimed king', the Motorcycle Boy, who will not be healed and whose 'kingdom' is a post-industrial urban desert with no prospect of renewal. Motorcycle Boy 'is living in a glass bubble and watching the world from it' (Hinton 1975: 69), isolated and detached from any hope from the past, and through him Coppola 'problematizes the teen film' (Lewis 1992: 148) by upsetting and dislocating the audience's expectations and denying familiar elements, presenting instead only darkness, death and ambiguity. One effect of the film is to oppose a romantic, mythic world of gangs and youth violence and to replace it with a slow, brutal recognition of change that pulls the young out of any sense they might have

of immortality or staticity and into time's realm. As the novel says of Motorcycle Boy, 'He had strange eyes – they made me think of a two-way mirror. Like you could feel somebody on the other side watching you, but the only reflection you saw was your own' (Hinton 1975: 27). The film reflects back not the golden images of *The Outsiders* with its darkness dispersed by hope and family, but figures that can barely remember a better time and certainly cannot reclaim it. As the film ends, Motorcycle Boy's last gesture is to free the 'rumble fish' from the pet store into the river, an act completed by Rusty-James, since his brother has been shot by the police. In his last speech, the Boy tells Rusty-James to take his bike and go, 'to leave ... to go clear to the ocean ... follow the river, clear to the ocean'. Rusty-James is, therefore, connected to the dream of freedom and a return to the primal ocean while his brother cannot be free and must die in the squalor of the claustrophobic city. The film closes with a brief sequence at the ocean, but leaves Rusty-James in the ambiguity of the threshold moment,[2] on the edge of land and ocean contemplating his future, which may be no future at all.

Motorcycle Boy's plea to his brother to follow the river suggests that the movement and fluidity might be a kind of freedom in an otherwise desolate and limiting world, but by *River's Edge* (Tim Hunter, 1987), any sense of liberation has been qualified by the use of the word 'edge', connoting both the marginal and precarious. Like *Badlands* and *Rumble Fish* the film employs images of waste and debris to suggest the futility of young lives being dramatised in the films themselves. In the case of *River's Edge* a human body is signified as waste, dumped by the side of the river with other detritus from this bleak, careless society. Although the familiar youth sub-texts of authenticity and sincerity are employed in the film, they have become threadbare and worthless. Lane says, 'We have to deal with it [the murder]. We've got to test our loyalty against all odds. It's kind of exciting. I feel like Chuck Norris'. As this suggests, loyalty has become unreal, like a movie itself, and within this film the group cannot maintain any loyalty in the face of the overwhelming tedium of their lives. All they have is the marginal space at the river's edge, a space beyond their fragmented, almost non-existent families and the depressing nostalgia of their school, and yet 'this place that is no place is theirs' (Acland 1995: 131). This despair is present in the work of Larry Clark, whose photographs of youth in Tulsa, Oklahoma (1971) had been very influential on Coppola's *Rumble Fish*. In particular, Clark claimed his raw and uncompromising film *Kids* (1995) aimed to answer the unreal and cynical films, like *Clueless* (1995), that Clark saw as 'bull-shit ... [and] made by grown-ups who just don't know'. Instead, he employed a semi-documentary style with a script by teenage skater Harmony Korine 'to make a movie that shows, from the kids' point of view, what kids are like when they're out of the house, when the parents

aren't around' (Clark 1995: 12). Clark's comments return us to *Badlands*, *River's Edge* and to Oliver Stone's *Natural Born Killers* (1995) which, in effect, explore youth 'out of the house, when their parents aren't around', engaged in transgressions that exist at the extremes of this idea, out beyond the edge of all established social order.

## CONCLUSION: GENERATION X/GENERATION Y

When Kurt Cobain killed himself in April 1994 one fan commented: 'He was the one man who sung a message that made me understand who I am' (reported in the *Observer*, 10 April 1994). In some respects his band Nirvana have come to epitomise a generation who had grown up without any sense of who they were or wanted to be. Youth identity had found temporary moorings in the 1960s counter-culture, in 1970s punk and as resistant to the 1980s yuppies, but into the 1990s there seemed to be new conditions prevailing. These were first charted and named by Douglas Coupland in his book *Generation X* (1992), but some of the sentiments were prefigured in the film *Pump Up the Volume* (Allan Moyle, 1990). The teenage pirate DJ 'Hard Harry' says: 'Consider the life of a teenager. You have teachers and parents and TV and movies telling you what to do – The terrible secret is that being young is sometimes less fun than being dead'. He claims to be part of the 'why bother generation' since 'all the great themes have been used up, been turned into theme parks'. Coupland's later novel, *Shampoo Planet* (1993), actually imagines an America where everything might be a theme park, epitomised by the vast 'HistoryWorld', with its motto 'INSTANT HISTORY'.

Coupland's work examines youth who have 'preferred not to', to borrow from Herman Melville's story of non-conformity 'Bartleby', turning their backs on the Reaganite economics and the yuppie competitiveness to live a subcultural existence 'neither simply affirmation nor refusal, neither "commercial exploitation" nor "genuine revolt" ... [but] a declaration of independence, of otherness, of alien intent, a refusal of anonymity, of subordinate status. It is an insubordination' (Hebdige 1988: 35). Like Bartleby, who reminds the complacent narrator of his reliance on his workers and of his own dubious values, *Generation X* acts to remind the adult, dominant culture that 'all you're doing with your life is collecting objects. And nothing else' (Coupland 1992: 11), and that its 'traditional templates' (Rushkoff 1994: 7) are no longer valid.

As if to displace these narratives of the official culture, the 'structured environments' (ibid.: 27) that society creates, X-ers instigate a 'policy' of story-telling aimed at cutting through the overload of history that has accumulated like a huge burden on the shoulders of youth. As Rushkoff puts it, the Xers are 'encumbered' with a 'legacy' from a past in which baby-boomers had transformed themselves from hippie to yuppies and

in so doing had run a society 'on financial credit and social debt', leaving 'a huge lump in the snake's digestive tract called American history' (ibid.: 3). This weight of expectations led Xers to demand 'less in life. Less past'; to step outside history and 'read the letter inside me' instead of the scripts handed down from others (Coupland 1992: 59). Coupland's characters are like computers overloaded with information from a tired 'accelerated culture' who must 're/con/struct/' themselves by erasing or 'downloading' their history and the materials that fill their lives up, so as to 'decomplicate' (ibid.: 77) life. This would become a central theme in his later novel *Microserfs* (1995), which examined the dishevelled lives of Silicon Valley Xers made good in the computer age.

The Xers have not become blind to all history, just to its devaluation, having seen it 'turned into a press release, a marketing strategy, and a cynical campaign tool', preferring to desire 'a connection to a past of some importance' (ibid.: 151). To replace a manufactured 'history' with the stories of lives and dreams is part of the 'connection' for Coupland, a way in which youth might inscribe itself into history and create 'a remarkable document and an enchanted space' (ibid.: 150). Yet unlike the darker texts discussed earlier, Xers face the world with irony and an attitude of playfulness that allows them to exist amongst the debris of postmodern America, its advertising, TV, muzak and McJobs (part-time, non-career jobs). Rather than whine, Xers have adapted and 'celebrate the recycled imagery of our media and take pride in our keen appreciation of the folds within the creases of our wrinkled popular culture' (Rushkoff 1994: 5). Fully aware of the cynicism of marketing and the market-place, they make an aesthetic out of 'slacking', that is, of living on the distanced edge of the dominant culture and engaging in 'grass-roots cultural hacking' in order to resist, like Bartleby, by 'apathy' 'the mind-numbing Muzak-intoned hypnotic demagoguery' of the adult world (ibid.: 8). Richard Linklater's film *Slacker* (1992)[3] demonstrates this with humour and observation and like Coupland seems to be answering Gaines's call to break out of the 'psychic holding pen for superfluous young people' (Gaines 1992: 254) into a new, ironic space for survival. *Generation X* begins in the 1970s with the 'darkness and inevitability and fascination', the mood 'held by most young people since the dawn of time' (Coupland 1992: 4), and suggests that by the mid-1980s the Xers have moved to the 'periphery' and chosen not to participate in a world that 'confuse[s] shopping with creativity' (ibid.: 11), preferring instead the silence and space of the desert. Here, outside the restrictive spaces of the 'veal-fattening pens', Coupland's image for city workplaces, they erase the history and expectations of the baby-boomers that burden them and rewrite their own lives through their own stories, in their own space. In the mode of so many youth texts, creativity and expression take on massive significance, for it is through

their stories that they reassess their own selves in opposition to those constructed by others. They long for 'a clean slate with no one to read it' (ibid.: 31). For example, Dag's ex-job in advertising is described as 'not creation . . . but theft' (ibid.: 27) for he feels he is stealing life through deceit, replacing human emotion and desire with simulation.

In a postmodern world, the novel suggests, the grand narratives have become worthless and what can stand in their place are the stories from lives actually lived, of people speaking for themselves in order to 're/con/struct' meanings in everyday terms.[4] As Claire says in the novel, 'Either our lives become stories, or there's just no way to get through them' (ibid.: 8). The Xers might reject the imposed burden of the past, but they seek 'to make [their] own lives worthwhile tales in the process' (ibid.). However, the next generation, the so-called Y generation (or Echo Boomers, or Millennium Generation), grew into a world of total commercialization of 'stories': 'They dream in Hi definition and Sony sound. Their signs and wonders are the bright logos that line the avenues and shopping malls . . .' (Quart 2003: xxv). Alissa Quart criticises the 'pretty vacant teen movies' she associates with Generation Y in 'makeover' films, like *She's All That* or *Clueless*, which promise 'a new self is merely a new slip dress or lip gloss away' and 'that claim that girls being powdered and primped and branded are becoming their "true" selves' whereas they are 'in fact, testifying to the power of constructed and artificial selves' (ibid.: 115–16). Teen films can be, according to Quart, commodities that 'brand' youth and deny opportunities to 'become', to learn 'how to be' and to tell their own stories (ibid.: 124). Instead of youth spaces of edge and possibility they give only 'bounded and superficial versions of their lives' – 'empty vessels slathered with beauty products' (ibid.: 125). One film that examines this Y anxiety is Catherine Hardwicke's *Thirteen*, which is summed up in the director's comment that 'I think popular culture gives a confusing message to kids: You should not be thinking about sex, but there's a huge Calvin Klein billboard with a stuffed package. How do you navigate?' In the film Tracey, a geekish outsider, falls into the High School 'in-crowd' led by Evie ('alluring, but toxic') and becomes transformed at a cost of disconnection from family, friends and school work, spiralling into a brash world of sex, drugs and consumption. In deconstructing Evie's Y-world the film examines self-harming, anorexia, teenage sexuality and family crisis, and offers only an unsettling and ambiguous conclusion that sees Tracey on a round-about in slow motion with the likelihood that she has not overcome the decline she has begun.

Texts like *Generation X* and films like *Thirteen* offer no easy conclusions about youth or how its ideals might survive in the murkiness of contemporary culture; instead they leave us with the 'stray smells' of youth with which we started this chapter. Deliberating upon yet another

story, Dag and Claire in *Generation X* are left with a frustratingly open ending of a young man whose 'fate remains a cliff-hanger' as he 'roams the badlands' (Coupland 1992: 173). Self-consciously or not, Coupland echoes earlier texts we have examined: *The Catcher in the Rye* and *Badlands* and prefigures Tracey in *Thirteen*, with images of staticity (the 'crazy cliff', the roundabout) and rebellion (badlands), before providing Andy's dream of a harmony beyond consumerism, where humanity and nature co-exist with 'grace' (ibid.: 173). The 'seductive outside', much cherished in youth texts, re-emerges here as an antidote to the world adults have created, replacing it with 'an instant family' of 'mentally retarded teenagers' (and so fixed in time), unafraid to show genuine emotion to Andy in an overwhelming 'crush of love . . . unlike anything [he] had ever known' (ibid.: 179). The surreal ending emphasises the novel's ulti-mately ambiguous idealism and counters only some of the darkness associated with *Generation X*, rekindling a sense of wonder at the radi-ance of youth and its capacity to replenish and to save, whilst simultaneously, as so often in youth texts, retaining a shadow presence of threat and the possibility of imminent decline.[5]

## NOTES

1　Rock music is not simply 'youth' music, since people of all ages listen to it, but the origins of it as a popular form, and its appeal to spaces beyond the everyday, are persistent and significant themes within it.

2　The concept of a 'threshold moment' is an important idea in youth texts, marking the liminal 'rite of passage' between the worlds of childhood and adulthood. It is a classic element in the endings of many texts such as Plath's *The Bell Jar* (see Chapter 7) or *Rebel Without a Cause*. For a useful discussion of liminality see Shields (1991: 83–101).

3　Other 'slacker' films have followed Linklater's original and warrant some consideration; *Singles, Reality Bites* and *Clerks* are examples, whilst Linklater's *Dazed and Confused* is an excellent retro-film that looks back at the 1970s in a similar way.

4　The idea of 'micronarratives' replacing the grand meta-narratives was first discussed by J.-F. Lyotard in *The Postmodern Condition* (1984) and function to legitimate diverse groups rather than a single voice, enabling a 'splin-tering of the social world [and] rather than confirming a monological conception of truth . . . they offer an alternative model of knowledge' (Clayton 1993: 100).

5　Examples of this shadow presence can be found in *Donnie Darko, Igby Goes Down* and *Elephant*.

## REFERENCES AND FURTHER READING

Acland, C. (1995) *Youth, Murder, Spectacle: The Cultural Polities of 'Youth in crisis'*, Boulder, CO: Westview Press.
Alcott, L.M. (1989) (first 1868) *Little Women*, London: Penguin.

Bernstein, J. (1997) *Pretty in Pink: The Golden Age of Teenage Movies*, New York: St Martin's Griffin.

Campbell, N. (1994) ' "The Seductive Outside" and the "Sacred Precincts": Boundaries and Transgressions in *The Adventures of Tom Sawyer'*, *Children's Literature in Education*, vol. 25, no. 2, pp. 125–38.

—— (2003) 'The Highway Kind: Youth, the Road and the West in Malick's *Badlands'*, in H. Patterson (ed.) *Poetic Visions of America: The Films of Terrence Malick*, London: Wallflower Press.

Campbell, N. (ed.) (2004) *American Youth Cultures*, Edinburgh: Edinburgh University Press.

Clark, L. (1995) in D. Witter, *New City* (Chicago), 27 July.

Clayton, J. (1993) *The Pleasures of Babel: Contemporary American Literature and Theory*, New York: Oxford University Press.

Coupland, D. (1992) (first 1991) *Generation X*, London: Abacus.

—— (1993) *Shampoo Planet*, London: Simon and Schuster.

During, S. (1992) *Foucault and Literature*, London: Routledge.

Eagleton, T. (1983) *Literary Theory*, Oxford: Blackwell.

Ellis, B.E. (1985) *Less Than Zero*, London: Picador.

Fass, P. (1977) *The Damned and the Beautiful: Adolescence in the 1920s*, New York: Oxford University Press.

Fetterley, J. (1973) 'The Sanctioned Rebel', in D. Kesterson (ed.) *Critics on Mark Twain*, Coral Gables: University of Miami Press.

Fiedler, L. (1960) *No(!) In Thunder*, New York: Stein and Day.

Fitzgerald, F.S. (1974) (first 1926) *The Great Gatsby*, Harmondsworth: Penguin.

Foucault, M. (1977a) *Discipline and Punish: The Birth of the Prison*, Harmondsworth: Penguin.

—— (1977b) 'Preface to Transgression', in D.F. Bouchard (ed.) *Language, Counter-Memory, Practice: Selected Essays and Interviews*, New York: Cornell University Press.

—— (1986) *The History of Sexuality: The Use of Pleasure*, London: Penguin.

Friedenberg, E.Z. (1963) *Coming of Age in America: Growth and Acquiescence*, New York: Vintage.

Gaines, D. (1992) *Teenage Wasteland: Suburbia's Dead End Kids*, New York: Harper Perennial.

Gillett, C. (1983) *The Sound of the City: The Rise of Rock and Roll*, London: Souvenir Press.

Grossberg, L. (1992) *We Gotta Get Out of this Place: Popular Conservatism and Postmodern Culture*, London: Routledge.

Hebdige, D. (1988) *Hiding in the Light*, London: Methuen.

Hinton, S.E. (1972) (first 1967) *The Outsiders*, London: HarperCollins.

—— (1975) *That Was Then, This is Now*, London: HarperCollins.

—— (1977) *Rumble Fish*, London: HarperCollins.

Howe, N. and Strauss, B. (1993) *13th Gen: Abort, Retry, Ignore, Fail?*, New York: Vintage.

Kristeva, J. (1990) *Abjection, Melancholia and Love: The Works of Julia Kristeva*, (ed.) J. Fletcher and A. Benjamin, London: Routledge.

Lauter, P. *et al.* (1994) *The Heath Anthology of American Literature*, 2 vols, Lexington: D.C. Heath.

Lawrence, D.H. (1977) *Studies in Classic American Literature*, Harmondsworth: Penguin.

Lears, J.L. (1981) *No Place of Grace: Antimodernism and the Transformation of American Culture, 1880–1920*, New York: Pantheon.

Lebeau, V. (1995) *Lost Angels: Psychoanalysis and Cinema*, London: Routledge.

Lewis, J. (1992) *The Road to Romance and Ruin: Teen Films and Youth Culture*, London: Routledge.

Lhamon, W.T. Jr (1990) *Deliberate Speed: The Origins of Cultural Style in the American 1950s*, Washington, DC: Smithsonian Institute Press.

Lipsitz, G. (1994) 'We Know What Time It Is: Race, Class and Youth in the Nineties', in A. Rose and T. Ross (eds) *Microphone Fiends*, London: Routledge.

Lowenthal, D. (1985) *The Past is a Foreign Country*, Cambridge: Cambridge University Press.

Lyotard, J.-F. (1984) *The Postmodern Condition*, Manchester: Manchester University Press.

Meyer Spacks, P. (1981) *The Adolescent Idea*, New York: Galaxy.

Pomerance, M. and Sakeris, J. (eds) (1996) *Pictures of a Generation on Hold: Selected Papers*, Toronto: Media Studies Working Group.

Quart, A. (2003) *Branded: The Buying and Selling of Teenagers*, London: Arrow.

Rabinow, P. (ed.) (1984) *The Foucault Reader*, London: Penguin.

Robertson, J.O. (1980) *American Myth, American Reality*, New York: Hill and Wang.

Ross, A. and Rose, T. (eds) (1994) *Microphone Fiends: Youth Music and Youth Culture*, London: Routledge.

Rushkoff, D. (ed.) (1994) *The Generation X Reader*, New York: Ballantine Books.

Salinger, J.D. (1972) (first 1951) *The Catcher in the Rye*, Harmondsworth: Penguin.

Sanford, C. (1961) *The Quest for Paradise*, New York: AMS Press.

Shary, T. (2003) *Generation Multiplex*, Austin: University of Texas Press.

Shields, R. (1991) *Places on the Margin*, London: Routledge.

Storey, J. (1993) *An Introductory Guide to Cultural Theory and Popular Culture*, London: Harvester Wheatsheaf.

Twain, M. (1986) (first 1898) *The Adventures of Tom Sawyer*, London: Penguin.

Witter, D. (1995) 'Teen Spirit', in *New City* (Chicago), 27 July, pp. 10–12.

## FOLLOW-UP WORK

1   We have not considered television in this section, but it is a rich source for the debates examined here. We suggest consideration of current and classic 'youth' television in two ways: first, an examination of shows that are aimed at the young but which are broadly 'realist' in approach, such as *My So-Called Life* (1994–5) which examines family tensions surrounding the teen dramas of Angela Chase, who in one episode said, 'Lately I can't even look at my mother without wanting to stab her repeatedly'. Explore its portrayals of youth 'types' and its self-conscious issue-led scripts that are dominated by a classic Hollywood need for resolution. Equally interesting are detailed ideological readings of *The Wonder Years*, *Dawson's Creek* or *Saved By the Bell*. Second, examine youth-orientated television such as MTV in terms of its style, modes of address and value systems.

2   Music video itself is an interesting area to consider as another source of the 'language' of youth. Analyse a popular video and discuss it in relation to the broad themes set out in this chapter. Consideration might be given to how it portrays rebelliousness and conformity, or how it articulates gender roles amongst the young or relations with institutions of power.

*Assignments and areas of study*

3   Consider the following:

(a) 'Sincerity opposes duplicity and honesty opposes hypocrisy in American youth cultural texts.' Discuss this comment and say to what extent it is a helpful way of interpreting the texts you have studied.

(b) How do any of the cultural texts you have studied demonstrate the confrontation between youth and social institutions, such as the family or education, and what are the consequences of the contest?

(c) Examine *Thirteen* in the light of Alissa Quart's comments referred to in this section and say to what extent you agree or disagree with her views.

(d) How does *Donnie Darko* conform to and challenge the parameters of the youth film?

# Chapter 9

# The spread of freedom

At this hour, a new generation of Americans is defending our flag and our freedom in the first war of the twenty-first century. The war came to our shores on September the 11th, 2001. That morning, we saw the destruction that terrorists intend for our nation. We know that they want to strike again. And our nation has made a clear choice: We will confront this mortal danger to all humanity; we will not tire or rest until the war on terror is won.

President George W. Bush, 11 November 2005

In his first inaugural address in January 2001 President George W. Bush inserted his administration into a developing American narrative: 'We have a place, all of us, in a long story – a story we continue, but whose end we will not see. It is the story of a new world that became a friend and liberator of the old, . . . the story of a power that went into the world to protect but not possess, to defend but not to conquer' (Bush 2001a). Implicit in his vision was the identification of the spread of freedom with America's international purpose. His words in many ways fitted with the conventional expectations of American inaugural rhetoric, but only a few months later both the meaning of his words and the nature of his presidency would be dramatically tested by the terrorist attacks of September 11th. America now had to 'go forward to defend freedom and all that is good and just in our world', he declared in his televised address to the American people that night, but it soon became clear that this commitment highlighted issues of immense significance for America both at home and abroad (Bush 2001b). What responsibility did the United States have to advance freedom beyond its borders? Should it seek to promote its values in partnership with others or should it be prepared to go it alone if necessary? How should it balance liberty and security in seeking to protect itself against future attacks? How should America act in the world? President Bush himself gave a range of answers to these questions over the next days and months, but at the heart of them was his assertion that his job was 'to lead this nation into

making the world a better place'. The course his administration had taken in prosecuting a 'War on Terror' would make America more secure and the world freer and more peaceful. As the greatest power on the face of the Earth, America had 'an obligation to help the spread of freedom'.

President Bush's rhetoric, of course, although it was about America's role in the world, was mainly aimed at a domestic audience in the aftermath of the shocks of September 11th. His words, however, were also heard around the globe, where surveys of international opinion suggested that American efforts to 'make the world a better place' received a cool and often hostile response. In June 2005, in much of Western Europe, with the exception of Britain, less than half of those canvassed had a favourable opinion of the United States. Even in Britain, positive ratings had declined from 83 per cent in 1999–2000 to 55 per cent. Elsewhere ratings were even lower. In Islamic countries such as Pakistan, Jordan and Turkey only just above 20 per cent viewed America in a positive light. Polls also indicated a strong feeling that the United States pursued a unilateral foreign policy, with large majorities in both Europe and the Middle East believing that the United States did not consider their countries' interests when making foreign policy decisions. Many people outside the United States saw administration rhetoric as evidence that their views did not count. Of those countries that were part of the US-led coalition during the war in Iraq only in Holland did majority opinion still support intervention. In countries that had refused to participate in the Iraq war, huge majorities in Europe and the Muslim world continued to believe that their governments were wise to stay out of the conflict (Pew 2005). Faced with similar criticism in 2001, President Bush professed his amazement 'that there is such misunderstanding of what our country is about. Like most Americans, I just can't believe it. Because I know how good we are' (Daalder and Lindsay 2003: 73).

This gap between official American rhetoric about selflessness, and external criticisms which suggest the very opposite, is a striking comment about the position in which America finds itself in the contemporary world. In this chapter we will explore some of the implications of this division, by first putting Bush's assertion of America's transparent 'goodness' and commitment to 'freedom' into the context of dominant themes in the ideology of American foreign policy. On one level, it may be argued, there is an essential continuity between the language and cultural assumptions of the Bush presidency and those of earlier administrations. At the same time, however, the recurring use of key terms may disguise some of the ways in which their meanings have shifted over time, in a way that may help to explain some of the difficulties Americans and others have in understanding each other. Disagreements over America's role in the world are also clearly affected by

contemporary debates about the nature of America's unparalleled power, and here the concept of continuity is much more controversial. For a number of observers, change characterises the Bush presidency rather than continuity, particularly if the focus is on the implementation of policy, rather than its rhetorical justification. The War on Terror, it is suggested, marks a significant departure in the conduct of American foreign policy. An interesting aspect of the debate over both continuity and change has been the way in which both sides of the argument have paid renewed attention to the concept of empire to support their case. One the one hand, it is argued, American history has always been marked by an imperialist urge; on the other hand there has been a dramatic turn to empire as part of the reaction to September 11th. As a coda, this chapter will also look at the implications of recent policy for America at home. The domestic and the foreign are always closely connected. What have been the consequences of September 11th for American politics and culture?

## THE MISSION OF FREEDOM

In his State of the Union address in 2004, President Bush declared that America was a nation with a mission, which stemmed from its most basic beliefs: 'We have no desire to dominate, no ambitions of empire.' Rather America's aim was a democratic peace – a peace founded upon the dignity and rights of every man and woman. 'America acts in this cause with friends and allies at our side, yet we understand our special calling: This great republic will lead the cause of freedom' (Bush 2004a). This vision of America's historic destiny in the world, with all its attendant ambiguities, has deep roots in American culture, and taps into a range of myths about the nation's values. It connects with a much noted theme in American history, a tendency to emphasise what is supposed to be exceptional about the national experience. America, from this perspective, has followed a different path from other countries, in which the signposts have been its own professed ideals. 'What happens within its borders' has been often seen to 'be of deeper importance than what happens within the space of other, lesser nations' (Cox 2005: 15). It is this exceptionalist sense of mission that lies at the heart of what Michael Hunt describes as the ideology of American foreign policy, and may be traced back to the early days of the Republic (Hunt 1988). The Americans, wrote Alexis de Tocqueville in 1835, 'have grown up unnoticed, and whilst the attention of mankind was directed elsewhere . . . have suddenly placed themselves in the front rank among nations'. They were proceeding 'with ease and celerity along a path to which no limit can be perceived' and were 'marked out by the will of Heaven to sway the destinies of half the globe' (de Tocqueville 1965: 286–7).

De Tocqueville's prophecies about future American greatness and his invocation of America's missionary role in the world tapped into a vein of political rhetoric which was well established by the 1830s and which survived to influence American foreign policy into the twenty-first century. 'We have it in our power to begin the world all over again,' wrote Thomas Paine in his pamphlet 'Common Sense' on the eve of American independence in January 1776. The overthrow of British rule would be the occasion of 'the birthday of a new world', through which the American continent would become 'the glory of the earth' (Hunt 1988: 20). Paine drew on a tradition of religious and republican thought in making his appeal, which only added to the force of his language. The idea of America as a nation with a strong sense of mission leant on such early statements as John Winthrop's famous sermon on the *Arbella* as it sailed across the Atlantic to the New World in 1630. Winthrop's invocation of America as a special place, where the holy commonwealth of Massachusetts would be as 'a city upon a hill', a model for the rest of mankind, underlined the importance of America's role in the world, from the earliest days of colonial foundation. Winthrop emphasised the exemplary purpose of the American experiment, but others who followed gave it more of a missionary slant, in a way that foreshadowed Paine. The Puritans, in Walter LaFeber's formulation, soon stepped down from the hill and began to take their values outside into the world where the irreligious might be subdued and their own territory extended (LaFeber 2002: 551). This process is also well illustrated, for instance, in John Adams's diary entry of February 1765: 'I always consider the settlement of America with reverence and wonder, as the opening of a grand scene and design in Providence for the illumination of the ignorant and the emancipation of the slavish part of mankind all over the earth' (Donoghue 1988: 229).

America from this perspective had a special purpose, one that was closely tied to the process of redemption. America would banish darkness with light, bring freedom in place of slavery and save the world from condemnation. Not only would America exemplify the virtues necessary for long-term success, but it would also apply those same virtues to other peoples and to the way in which nations dealt with each other on the international stage in the future. The general claims Paine made for America's historic role in the world would be amplified as the country grew rapidly during the nineteenth century in terms of territory and economic power and influence. Expansion across the American continent was justified because it would bring with it republican institutions and practices, in a way that made the spread of American borders qualitatively different from the expansionist policies of other nations. Throughout the process of the acquisition of new lands during the first

half of the nineteenth century, from the Louisiana Purchase of 1803 to the capture of California and the South-West from Mexico in the war of 1846–8, many Americans assumed that such a process was both benevolent and natural. These views were most vividly displayed in the rhetoric of Manifest Destiny: 'America', declared John L. O'Sullivan in 1839, 'had a blessed mission to the nations of the world ... to smite unto death the tyranny of kings, hierarchs, and oligarchs, and carry the glad tidings of peace and good will where myriads now endure an existence scarcely more enviable than that of beasts of the field' (O'Sullivan 1839).

This way of thinking about America's role in the world emerged during the nineteenth century, but it remained an abiding influence as the growth of American power more regularly involved the nation in European and Asian politics in the opening years of the twentieth century. Woodrow Wilson led the United States into the First World War with the declaration that right was more precious than peace, and that America would fight for the things it always carried nearest its heart – 'for democracy, for the right of those who submit to authority to have a voice in their own Governments, for the rights and liberties of small nations, for a universal dominion of right by such a concert of free peoples as shall bring peace and safety to all nations and make the world itself at last free' (Brinkley 1995: 630–1). When he campaigned in 1919 for American membership of the League of Nations he described the American soldiers who had died in the First World War as crusaders. They were not going forth to prove the might of the United States but to prove the might of justice and right. This would be their transcendent achievement. 'America', Wilson declared, 'had the infinite privilege of fulfilling her destiny and saving the world' (LaFeber 2002: 551). In defending American involvement in Vietnam in the 1960s Lyndon Johnson argued that America wanted nothing for itself, 'only that the people of South Vietnam be allowed to guide their own country in their own way' (Johnson, L.B. 1965). Concepts of mission were also a repeated part of the argument in the build up to the war on Iraq. The National Security Strategy statement of 2002 emphasised the duty of the United States to 'defend liberty and justice because these principles are right and true for all people' (National Security Strategy 2002). The war in Afghanistan was in part justified as an effort to rescue women and children from the grip of male Taliban oppression. 'At long last, efforts to protect and advance women's rights are where they belong – in the mainstream of American foreign policy', declared the State Department in 2002. As Emily Rosenberg has argued, this chimed with the concept of a 'social imaginary dominated by a masculinized national state that cast itself in a paternal role, saving those who are abused by rival men

and nations' (Rosenberg 2002: 457, 464). When President Bush visited London in 2003, in the aftermath of the Iraq war, he explicitly justified the American mission to advance freedom in the world, with reference to Wilson's idealism in search of justice and right (Bush 2003).

## CULTURAL SUPERIORITY

During the nineteenth century the commitment to the mission of freedom was often given an added gloss, as many Americans developed a way of thinking about other peoples and nations which linked the spread of liberty to assumptions about cultural superiority, often couched in terms of racial supremacy. Racial attitudes from the earliest days of the Republic were an integral part of the debates about America's proper role in the world, and frequently affected specific foreign policy decisions. Throughout the nineteenth century and well into the twentieth, American leaders often justified an expansionist foreign policy on grounds that assumed a hierarchy of racial values, arguing that the future of international civilisation depended on the spread of Anglo-American values and institutions into less fortunate parts of the world. Many Americans, for instance, assumed that skin colour and physical typology carried with them distinctive moral, spiritual and behavioural qualities. At the top of the racial order came whites or Anglo-Saxons, who embodied such attributes as leadership, energy, perseverance and independence. It was this race, Josiah Strong argued at the end of the nineteenth century, which was becoming 'more effective' in the United States than Europe, and which, with its unequalled energy, would spread itself over the earth (Ions 1970: 72).

These attitudes had a powerful influence on the making of foreign policy, as Michael Hunt has argued: 'by its grip on the thinking of the men who debated and determined these policies, by its influence over the press, and by its hold on the electorate, race powerfully shaped the way the nation dealt with other peoples' (Hunt 1988: 52). Race, from this perspective, provided an apparently clear and effective way to categorise other peoples both inside and outside the North American continent. It offered a link between attitudes towards Native Americans and African Americans at home, and policies towards the peoples of Asia, Europe and Latin America. At the same time it flattered the assumptions of those who made American policy, since most of them came from the Anglo-Saxon tradition within the United States, at the same time as it fitted in with the views of many ordinary citizens, who were susceptible, for a number of reasons, to appeals that took for granted the historic destiny of the white race. Many of these attitudes may be seen clearly in the relentless progress of the American nation to

the Pacific Ocean in the first half of the nineteenth century, and the subsequent settlement of the interior of the continent in the second half of the century (see Chapter 5). The defeat and dispossession of Native-American tribes were justified by arguments that, as part of an inferior race, they were doomed to 'vanish' in the face of a superior form of civilisation. Towards the end of the nineteenth century, as it became clear that pacification and reservation policy had assured the defeat of Native Americans, there was a temptation to give their demise a tragic dimension. Images of feckless and incapable Indians were accompanied by a more sentimental vision of noble savages who had failed to survive, not so much because they were inadequate, but because their simplicity, valiant as it might sometimes be, was bound to give way before the progressive march of a superior race. Attitudes towards Native Americans were repeated in encounters with other peoples as the United States advanced West. In the 1830s, as Americans came into open contact with Latin Americans in the South-West, a range of stereotypes emerged that provided a mix of justifications for the appropriation of territory or for intervention in Latin-American affairs. Latin Americans were, like Native Americans, backward-looking in their bigotry and corruption, and unfitted for the exercise of political responsibility, or essentially childlike and untutored, and thus in clear need of the training and education that Americans could provide. Both perspectives emphasised American superiority and Hispanic inferiority.

Such attitudes, while they have become progressively tempered by the way in which explicitly racialist thought has come under scrutiny throughout the twentieth century, nevertheless continued to act as a filter through which foreign policy leaders and many ordinary citizens saw foreign interventions, as well as how those interventions were represented in a range of cultural forms. During the Second World War, despite both official and unofficial American hostility to the legacy of European imperialism, many American politicians, military commanders and ordinary soldiers found it difficult to divest themselves of a racialist perspective, both with regard to their enemies in Asia, as well as those whom they were trying to protect against aggression. Christopher Thorne has commented that the Pacific War of 1941 to 1945 was to a considerable degree a racial war, not so much because of its immediate causes, but in the sense that Western suspicion of Japanese behaviour, both before and during the war, fed off a hundred years of explicitly racialist arguments about the characteristics of the Japanese people. American policy in an area like East Asia was often significantly affected by perceptions and prejudices which need to be examined alongside its long-held commitments to liberty and equality (Thorne 1979: 5–9). Americans brought to Vietnam, as they had brought to much

of Asia in their dealings with the region throughout the twentieth century, an ethnocentrism that frequently bordered on the explicitly racialist arguments for American power which figures like Strong had voiced in the nineteenth century. It is true that during the 1940s and 1950s American officials were cautious about being dragged into a 'white man's' colonial war in Vietnam, but under the pressure of events in late 1950s and early 1960s these concerns were often forced to give way to the more basic assumption that Americans knew what was best for the region. Richard Slotkin, amongst others, has argued that there have been strong continuities between the language and attitudes of Americans in Vietnam and the assumptions which lay behind Western expansion in the nineteenth century. GIs frequently called their Vietnamese enemies Indians, and the jungle in and out of which they moved quickly became Indian Country. This linked to the way in which American soldiers in Vietnam talked about 'slopes' and 'gooks' in a way that helped to dehumanise their enemies in a manner which drew on the racial epithets used against the Japanese in the Second World War (Slotkin 1998: 494–6). As Christian Appy has argued in his analysis of combat troops during the war, 'the point was not to know the enemy but to despise him'. Military training encouraged hostility towards all Vietnamese, whether members of the Viet Cong or non-combatants. As one veteran recalled, 'the only thing that they told us about the Vietnamese was that they were gooks; they were to be killed. Nobody sits around and gives you the historical and cultural background. They're the enemy. Kill, kill, kill' (Appy 1993: 107). The photographs taken of Iraqi prisoners at Abu Ghraib in 2003 in a range of humiliating poses clearly fit into the same kind of pattern. Although those responsible for the images themselves were a limited group of reservists, they appeared to have been part of a wider strategy to use physical coercion and sexual degradation in an effort to gain more intelligence about the insurgency. As Fred Halliday has noted, it was because the victims were from a subordinate people that they were subjected to their tortures (Halliday 2005).

## AMERICA AS A MODEL

Alongside notions of mission and cultural supremacy, Americans often assumed, when assessing the status of other nations, that the American pattern of development had some kind of general application. As Emily Rosenberg has suggested, 'To many Americans, their country's economic and social history became a universal model' (Rosenberg 1982: 7). If other countries, particularly those outside Europe, wanted to follow the path to modernisation, then they should seek to emulate the American experience. To those who guided American policy, this meant, amongst

other things, a suspicion of radical political change of a kind that threatened the stability deemed necessary for economic growth. Although the United States had been born out of a revolutionary struggle, this did not mean that all revolutions were of themselves good things, since they might undercut those conditions which would supposedly promote modernisation, such as private enterprise, plentiful cheap labour and unrestricted access to land development. Particularly after the Russian Revolution of 1917, when American forces had briefly intervened on the side of anti-Bolshevik forces, many American officials came to see revolutionary activity as a barrier to American influence, even when they might be in sympathy with, say, the anti-colonialist ambitions of those who were tempted to join such struggles. This, of course raised policy problems. As Rosenberg has put it: 'How could foreign countries who resisted American-prescribed "development" (often called "civilisation" or "modernisation") be handled without violating their "liberty" to try out competing ideas or techniques?' (ibid.: 234). One way around this dilemma was to argue that the United States could help such countries to see the light, and discard the blinkers which restricted their vision. American belief in the supremacy of its own missionary role would justify persuading peoples to accept American ways.

Allan Bloom revealingly argued in his best-selling work *The Closing of the American Mind* (1987) that what he called 'the American project' was not just for Americans: 'When we Americans speak seriously about politics, we mean that our principles of freedom and equality and the rights based on them are rational and everywhere applicable'. The Second World War was for Bloom not simply a struggle to defeat a dangerous enemy. It was 'really an educational project undertaken to force those who did not accept these principles to do so' (Bloom 1987: 153). The American occupation of Germany and Japan after the Second World War can be seen this light. Both societies had to be cleansed of aggression and militarism and reconstructed along American lines. President George W. Bush himself justified nation-building in Iraq by referring to both examples: 'Following World War II, we lifted up the defeated nations of Japan and Germany and stood with them as they built representative governments. We committed years and resources to this cause. And that effort has been repaid many times over in three generations of friendship and peace' (Ferguson 2004: 69). There was however another less positive precedent for the problems nation-building might entail. In the 1950s and 1960s considerable efforts had been made to create a viable state in South Vietnam that would provide a bulwark against communist expansion. It failed, in part, as Robert McNamara, one of its key architects, later argued, because Americans viewed the people and leaders of South Vietnam in terms of their own experience,

with a thirst for – and a determination to fight for – freedom and democracy. Americans, he concluded, 'did not have the god-given right to shape every nation in [their] own image as [they] chose' (McNamara 1999: 322–3). Graham Greene put it more mordantly in his indictment of the early stages of American involvement within Vietnam in his novel *The Quiet American* (1955), where an English journalist delivers a damning judgement on Alden Pike, the CIA operative at the heart of the story: 'I never knew a man who had better motives for all the trouble he caused' (Greene 1955: 63).

The concept of America as a model that needed to be implemented across the world was also reflected in 'The Statement of Principles' of The Project for the New American Century, the leading neo-conservative think tank, which argued in 1997 that the country needed 'to accept responsibility for America's unique role in preserving and extending an international order friendly to our security, our prosperity, and our principles'. Amongst its signatories were future key members of the George W. Bush Administration, like Secretary of Defence Donald Rumsfeld, Vice-President Dick Cheney and Deputy Secretary of Defence (and later President of the World Bank) Paul Wolfowitz (*Project for the New American Century* 2005). Perhaps unsurprisingly, the introduction to the National Security Strategy of 2002 was couched in similar language: 'The great struggles of the twentieth century between liberty and totalitarianism ended with a decisive victory for the forces of freedom – and a single sustainable model for national success: freedom, democracy, and free enterprise' (National Security Strategy 2002).

As much of this implies, and as Eric Foner has pointed out, the meanings that Americans attach to the concept of freedom have regularly changed over time. Freedom has not been a fixed concept, but one that has been continually debated and contested throughout American history. The rhetoric of American freedom could disguise profound disagreements about what the term actually implied, both in terms of the country's domestic history, but also in terms of its relationships with the outside world. This has been clear throughout Henry Luce's 'American Century', as encounters with a range of foreign 'others' have emphasised specific attributes of 'freedom' at one time and downgraded others. During the Second World War, for instance, Franklin D. Roosevelt's rallying cry of the Four Freedoms – freedom of speech, freedom of worship, freedom from want, and freedom from fear – began the process of committing the United States to a different kind of internationalist role, one that involved constructive engagement with the world. His Vice-President, Henry Wallace, in 1942, emphasized that this vision involved a strong element of social justice when he called for the 20th century to become 'the century of the common man'. During

the Cold War struggle against Soviet Communism, while 'freedom of speech' remained important, 'freedom from want', perhaps because it sounded too socialistic, gave way to the freedom to consume as a dominant concept that would ensure prosperity and happiness. Right at the end of the Cold War, Ronald Reagan regularly intoned the American mission to spread the idea of freedom, but by now it incorporated limited government and free enterprise, along with anti-communism (Foner 2000). In all these cases, clarification of what freedom might mean could be found in attempts to apply it in specific historical circumstances.

## AMERICAN POWER

As this suggests, identifying the continuity between George W. Bush's perspectives on the world and America's historic attachment to the concepts of mission, cultural superiority and the 'single model' is only part of the story. Rhetoric on its own is ineffective. What gave significant weight to Bush's language was the sheer scale of American power. The collapse of the Soviet Union left the United States without the constraints of significant challenges from other rivals, although for a while the full implications of this position were hidden by uncertainties about what the country's new role should be in a unipolar world. Paradoxically, it was a sign of America's vulnerability, the attack on New York and Washington of September 11th, 2001, that ignited the debate about American dominance. The nature of the government's reaction to September 11th displayed both the size of America's military capacity, as well as its willingness to use it in specific settings. As an essential component of this strategy, Congress approved a marked increase in the military budget, from $310bn in 2001 to a projected $441.6bn in 2006. By 2004 the United States was responsible for 43 per cent of world military expenditure, six times larger than that of the second highest spender, Russia. In 2005 it had 969 official military bases at home and 725 abroad, as well as an unspecified number of secret bases. The US Navy circled the world. The decline of the Russian nuclear arsenal left the United States as far and away the world's most potent nuclear power; agreements in the 2002 Treaty of Moscow to reduce its stocks were qualified by maintenance of tactical weapons at Cold War levels and continuing modernisation of a range of delivery systems. Moreover the size of the American military establishment was grounded in broad popular and bipartisan political support, as the 2004 election revealed. Social acceptance of the military was anchored in its serving as an avenue of social mobility for lower classes (Pieterse 2003: 76). Lieutenant General Ricardo Sanchez, head of coalition forces in Iraq, was a good example, having been brought up in a poor family in Rio Grande City, Texas, and educated at Texas A&M. Respect for the

military was also enhanced by its pervasive presence in Hollywood's output of feature films and in public ceremony. In economic terms also, although there was more of a debate here, American power remained significant. Its position in the international economy was clearly less dominant than at the end of the Second World War, when it was responsible for about half of global GNP and controlled 70 per cent of world financial resources, but in 2005 its economy remained nearly 40 per cent bigger than that of any of its rivals. This allowed it to spend a comparable percentage of its GDP on defence, despite its huge military outlays. It also had significant influence over the regulation of the sources and supply routes of the vital energy and raw material needs of even its most successful economic competitors (Cox 2005: 25). Already before September 11th, it is argued, America was a country 'wired for war'. The Cold War, in particular, had 'nurtured an ideology, a set of leaders, a network of bureaucratic and economic interests, and a cluster of habits ... which maintained the momentum for military strength' (Eisenberg 2005: 415).

## CONTINUITY AND CHANGE IN AMERICAN POLICY: PRE-EMPTION AND UNILATERALISM

Then came September 11th, with its profound impact on America's sense of its own security. For many Americans the attacks destroyed the sense of relative geographical safety they had enjoyed for much of their history. '9/11,' recalled Condoleeza Rice two years later, 'crystallized our vulnerability ... [It] changed the lives of every American and the strategic perspective of the United States' (Leffler 2005: 406). In his introduction to the National Security Strategy of 2002, President George W. Bush emphasised that 'in the new world we have entered the only path to peace and security is the path of action' (National Security Strategy 2002). By that time, he had already gone on the offensive. First, he determined not only to pursue Al-Qaeda, but also to confront Afghanistan, which provided support and bases for the group. No distinction would be made between the terrorists who committed the September 11th attacks and those who harboured them. In his address to Congress on 20 September 2001, Bush went further: 'We will pursue nations that provide aid or safe haven to terrorism. Every nation, in every region, now has a decision to make. Either you are with us, or you are with the terrorists. From this day forward, any nation that continues to harbor or support terrorism will be regarded by the United States as a hostile regime' (Bush 2001b). This argument was reflected in the decision to invade Afghanistan in 2001, but it would also be used in the subsequent justification to attack Iraq in 2003. At the heart of this strategy lay the argument that concepts of deterrence would be insufficient to

guarantee America's security in the future. Instead, any future threat had to be pre-empted by offensive action (ibid.). From the administration's point of view this meant not only seeking to destroy terrorist groups themselves, but also acting militarily against those states that sheltered them. At this point, John Lewis Gaddis has argued, the concept of pre-emption became entangled with the concept of prevention. Pre-emption involved the right, accepted under international law, to take action against a state about to attack. Prevention, far less accepted, involved a war against a state that might be a threat in the future. The National Security Strategy of 2002 talked about the right of the United States to act pre-emptively to 'to forestall or prevent . . . hostile acts by adversaries' but in a world where it was becoming increasingly difficult to foresee when terrorist attacks might occur, it became tempting to go after the states that might be helping them (ibid.). This conflation of prevention and pre-emption, however, was profoundly unsettling in an international order built on the key principle of national sovereignty. As Gaddis puts it, 'for the world's most powerful state suddenly to announce that its security requires violating the sovereignty of certain other states whenever it chooses cannot help but make all other states nervous' (Gaddis 2005: 3). This was clearly revealed in the war on Iraq, when the United States failed to gain the support it hoped for in its efforts to overthrow what it saw as an aggressive and destructive dictatorship which threatened not only its own people but also the international community. Foreign suspicion of its motives was encouraged by what was seen, once again, as the arrogance of American power, and the apparent willingness of the administration to act unilaterally if necessary, without either the approval of the United Nations or a broad-based international coalition. President Bush's assertions about the need to promote freedom, and America's essential goodness, however deeply felt they may have been, appeared as a simple cover for American self-interest. This was only reinforced by subsequent revelations that the justification of intervention in Iraq was based on intelligence information about both Iraq's links with Al-Qaeda and its capacity to threaten American security with weapons of mass destruction that was at best flawed.

One influential set of arguments holds that these events of Bush's first term amounted to a revolution in American foreign policy, not so much in terms of long-term goals, but more in the methods used to achieve them. It was this aspect in particular that alarmed many of America's allies and antagonised international opinion. The revolution, clearly outlined in the National Security Strategy, consisted of a reliance on

> the unilateral exercise of American power rather than international law, the championing of a pro-active doctrine of pre-emption at the

expense of deterrence and containment. It has turned away from treaties as a means of trying to control the proliferation of weapons of mass destruction, and instead opted for military strikes and the promotion of more sophisticated missile defence systems. It has resorted to regime change, as in Afghanistan and Iraq, at the expense of direct negotiations. In seeking to achieve its aims, it has depended less on existing formal alliances than on ad-hoc coalitions which it has used to support an essentially unilateralist strategy.

(Daalder and Lindsay 2003)

James Maan argues that the Strategy's emphasis on pre-emption involved 'an entirely new set of ideas and principles', which created 'a new conception of American foreign policy' of the same kind of significance as the Truman Doctrine of 1947 (Mann 2004: 329–30). 'At the extreme', it is argued, 'these notions form a neo-imperial vision in which the United States arrogates to itself the global role of setting standards, determining threats, using force and meting out justice. . . . America is to be less bound to its partners and to global rules and institutions while it steps forward to play a more unilateral and anticipatory role in attacking terrorist threats and confronting rogue states. The United States will use its unrivalled military power to manage the global order' (Ikenberry 2002: 49).

On the other hand it has been equally strongly argued that President Bush's ideological vision was marked by continuity as much as by radical change, and that it contained strong links with the perspectives of previous administrations, not only in the twentieth century but stretching back to the beginning of the Republic. For Walter LaFeber, American policy had always been characterised by unilateralism, in a way which allowed for 'freedom of action for diplomacy and military operations . . . over two centuries of American foreign policy' (LaFeber 2002: 558). Much of the language of the National Security Strategy enunciated in 2002 was very similar in tone to many earlier statements about America's role in the world, including, for instance, proclamations by the Clinton Administration about American policy. Melvyn Leffler, too, argues that 'unilateralism is quintessentially American', pointing out that pre-emption had a significant history as a strategy in American history, stretching back to intervention in the Caribbean and Central America during the early 20th century. Although the Cold War involved the creation of multilateral alliances and institutions, American presidents always retained the option to take the unilateral road should the situation demand it. 'Allied reluctance to act should not inhibit the United States from taking action including the use of nuclear weapons, to prevent Communist territorial gains when such action is clearly necessary to U.S. security', declared the Eisenhower Administration

in the mid-1950s (Leffler 2005: 398–9, 405). In 1994, Madeline Albright, American Ambassador to the United Nations, and later Secretary of State for President Clinton, declared that the United States would behave multilaterally when it could and unilaterally when it must.

Another approach to understanding both the difficulties the United States faces in Iraq, and its reputation in the world, is Leffler's argument that at times of national crisis, when the nation's security appears to be under threat, values and ideals tended to be asserted in ways that override a realistic assessment of interests. This is particularly the case when power appears to indicate that the means exist to realise those values. One consequence is a temptation to formulate policy in terms of overarching goals linked to deeply held beliefs, but without always appraising the full implications of what a specific policy might involve (Leffler 2005: 395–6). An example here has been the presentation of the War on Terror in terms of opposing binaries – 'good' versus evil, 'liberation' versus 'oppression', 'progress' versus 'the past', 'freedom' versus 'tyranny' – which were difficult to achieve and encouraged 'overreach.' In June 2002, for instance, President Bush emphasised the importance of 'the language of right and wrong.' There could be 'no neutrality between justice and cruelty, between the innocent and the guilty.' America was in 'a conflict between good and evil' (Bush 2002). The phrase 'War on Terror' itself encouraged a sense of open-ended commitment without a clear sense of specific aims that might indicate when the war had been successfully prosecuted. One result was to assume that military victory in Iraq would quickly lead to the realisation of the goals enunciated in pre-war rhetoric, and to underestimate the scale of reconstruction that would be needed after war was over. Undue emphasis on values and beliefs, of the kind discussed earlier in this chapter, blinded policy-makers both to the long-term dangers of unilateralism and to the potential problems involved in spreading freedom and democracy in the aftermath of war.

## EMPIRE

Whether the underlying unilateralism of American interventions in Afghanistan and Iraq marked a decisive change or not, it helped to encourage the growing disaffection with American policy outlined earlier in the chapter. To many outside the United States, the administration's apparent determination to go its own way, without either the approval of the United Nations or the support of a number of its allies, only seemed to demonstrate according to one representative critic, the former German Chancellor, Helmut Schmidt, that it was moving in an increasingly imperialist direction (Steinmetz 2003). This perspective chimed with a renewed debate, both within the United States and without, as

to whether 'empire' might not be the most appropriate way of describing contemporary American dominance, particularly as a way of undermining the traditional emphasis upon American exceptionalism. The experience of the United States, it is argued, has to be assessed using the same criteria as apply to other nations. Americans may say that they are different but that claim has to be understood as part of an articulation of national identity rather than as an empirical description of American power. Exceptionalism argues that America has somehow 'escaped' from history; what matters, many of these critics insist, is that America be reclaimed for history, be dragged 'into the historical mainstream' (Cox 2005: 26). For exceptionalists, of course, empire was the one thing America was not. When asked in an interview on the Arabic satellite television network Aljazeera whether the United States was 'empire-building' in the Middle East, Secretary of Defence Donald Rumsfeld replied, 'We don't seek empires. We're not imperialistic. We never have been' (Daalder and Lindsay 2003: 361). As this reveals, Americans have often disliked the term 'empire' because they feel it has derogatory implications and contradicts the official beliefs of the Republic as articulated in the Declaration of Independence and other founding statements of the new nation. 'Empire' involved succumbing to the temptations of power in a way that threatened civic virtue. The great historical example here was Rome, whose fate had to be avoided at all costs if republican political and cultural ideals were to prevail in the United States. For Americans to admit to empire would be to signal the end of the Republic. Critics have charged however that it is precisely such 'denial and disavowal of empire [which] has long served as the ideological cornerstone of U.S. imperialism and a key component of American exceptionalism' (Kaplan 2004: 3). Even a sympathetic advocate of American power has recently suggested that America is 'an empire in denial' (Ferguson 2004: 6–7).

As these last comments indicate, use of the concept of empire comes from a number of different directions. One aspect is an internal debate within America about the country's past, present and future. One set of arguments insists that American power is a threat both to the world and to America itself. Another argues that what the world needs is more sustained and effective American involvement. For a critic of America's international role like Chalmers Johnson, the American empire is 'based on the projection of military power to every corner of the world and on the use of American capital and markets to force global economic integration on our terms, at whatever the costs to others' (Johnson 2002: 7). Although he defines this empire as 'informal', and different in kind from empires of the past which are based on territorial domination, it is nevertheless marked by covert operations, secrecy, the indiscriminate use of violence and regular support for dictators (ibid.: 8–34). Disguising the

direction they were taking, American leaders cloaked their foreign policy in euphemisms such as 'lone superpower', 'indispensable nation', 'reluctant sheriff', 'humanitarian intervention' and 'globalization'. 'However, with the advent of the George W. Bush administration in 2001, these pretences gave way to assertions of the Second Coming of the Roman Empire. The result of this hijacking of the Republic would be 'endless war, the loss of Constitutional liberties, and financial ruin' (Johnson 2004: 1–13). 'America today *is* Rome', agreed Andrew Bacevich, in a thorough-going indictment of American militarism (Bacevich 2002: 244). On the other hand Max Boot, while accepting the concept of empire, makes a very different claim. Compared with the grasping old imperialism of the past, America's 'liberal imperialism' pursued far different, and more ambitious, goals. It aimed to 'instil democracy in lands that have known tyranny, in the hope that doing so [would] short-circuit terrorism, military aggression, and weapons proliferation' (Boot 2003: 361). Where European imperialism fought to subjugate 'natives', Americans 'fight to bring them democracy and the rule of law' (ibid.: 366). From this perspective American empire was a positive virtue, one which would be of immeasurable benefit to the rest of the international community. Niall Ferguson agreed that an American empire had a positive role to play in encouraging stability and the advancement of freedom. The world needed an effective liberal empire and the United States was the best candidate for the job. He was, however, less confident than Boot about the country's willingness to undertake the heavy personal and economic burdens such a role implied (Ferguson 2004: 301).

One way of circumventing this kind of debate may be to employ the term empire in a more dispassionate sense. A helpful formulation comes from John Lewis Gaddis in his re-assessment of the imperial rivalry of the Soviet Union and the United States after 1945, where he defines empire as 'a situation in which a single state shapes the behaviour of others, whether directly or indirectly, partially or completely, by means that can range from the outright use of force through intimidation, dependency, inducement, and even inspiration' (Gaddis 1997: 27). From this kind of perspective it is difficult to deny that America has frequently acted in an imperial manner for much of its history, but it does allow for more considered judgements about the extent, nature and effect of that activity. One problem with aspects of the polemical debates about the American empire as a force for good or for harm is that they assume that American influence actually works. In terms of Johnson's critique of American empire, for instance, almost every aspect of American involvement in the world is taken as a sign of America's ambition for imperial domination. However, as Michael Cox points out, 'under modern conditions, it is extraordinarily difficult for any single state to exercise preponderant influence at all times', even for one as powerful

as the United States (Cox 2005: 25). Describing those aspects of American power which are imperialistic, but being aware of the qualifications necessary in using the concept of empire, may be a more helpful approach when assessing the operation of American power than is allowed either in the exceptionalist argument or in wholesale denunciations or affirmations of American policy. The United States may have acted in an imperial manner in the run-up to the Iraq war, but despite its explicit power it still had difficulty in persuading even some of its allies to join it against Saddam Hussein. Both the American political system and American public opinion also work to undermine empire. Every 'imperial' president has to leave office within a specified time, along with his imperial advisers, while public opinion has proved reluctant to support military adventures for very long, particularly when positive results are not immediately achieved. The attacks of September 11th had encouraged an unprecedented degree of national solidarity, but it was not clear whether this amounted to a long-term mandate for interventionism or that the American people would not tire of the War on Terror before it was won, whenever that would be. Only two years after the end of the Iraq war, 42 per cent of Americans believed the United States should 'mind its own business internationally and let other countries get along the best they can on their own' (Pew 2005).

## IMAGE

The emphasis on values and beliefs could also backfire from another perspective. As a number of commentators have noted, September 11th transformed Bush's image as presidential leader. His approval ratings quickly soared to an unprecedented 90 per cent, as he put himself at the forefront of the national response to the attacks, through a series of dramatic images like his impromptu speech with a bullhorn in the ruins of the World Trade Centre and his subsequent televised addresses to the nation. As commander-in-chief at a time of national crisis, he would provide the heroism necessary to inspire the American people. Television and the other media could deliver the means to transmit the implementation of his idealistic vision of advancing freedom. As Jon Roper has argued, however, while television can often elevate presidential leadership, it can also help to undermine it (Roper 2005: 132–40). The warning here had been provided by Vietnam, where the television networks had relayed back into the nation's living rooms a devastating mix of American casualties, civilian suffering and North Vietnamese/ Viet Cong resistance, in a manner which did a great deal to damage the positions of both Lyndon B. Johnson and Richard Nixon. The Gulf War of 1991, in this respect, was constructed as part of a determined attempt to avoid the 'Vietnam syndrome', particularly through its presentation

*Plate 9* US President Bush ready to board S3 Viking Jet in San Diego, 2003
*Source*: Reuters/CORBIS

as a controlled and regulated media spectacle. This was achieved through limiting the war to the specific short-term objective of pushing Saddam Hussein out of Kuwait and back into Iraq, and restricting its duration to 100 days, in comparison to the 10,000 day conflict in Vietnam. In the case of the War on Terror that degree of control would prove far harder to achieve, because of the open-ended nature of war aims and the sheer difficulty of reaching a satisfactory outcome within a time-scale acceptable to opinion back in America. The carefully orchestrated image of President Bush preparing to fly to the USS *Abraham Lincoln* to announce the end of combat operations in Iraq, dressed as an USAF pilot, in the manner of Tom Cruise in *Top Gun*, would quickly be challenged by the televised pictures of relentless suicide bombings in the streets of Iraq's cities, not to mention the photographs from Abu Ghraib prison. It would also be undermined by the failure to find Saddam Hussein's weapons of mass destruction and sustained investigation of the accuracy of intelligence justifications for the war in the first place.

In February 2004, Bush declared in an interview: 'I am a war president. I make decisions here in the Oval Office in foreign policy matters with war on my mind', but only a year later it was becoming clear that maintaining the image of a successful war leader was extremely difficult under the scrutiny not just of the domestic media but also their counterparts in the rest of the world (BBC 2004).

## WAR AT HOME

As in the case of the war in Vietnam, the War on Terror had consequences for the domestic front, in a number of ways which raised questions about the balance between security and liberty. An important aspect of the reaction to September 11th was the proliferation of a range of new security measures at home in order to provide a degree of protection against possible attacks in the future. A central feature here was the introduction of a new Department of Homeland Security which was given responsibility for leading a unified national effort to secure America. At the same time, the USA Patriot Act was passed by Congress on 21 October 2001, to give the FBI and other agencies more investigative and surveillance powers with regard to forms of communication such as mobile phones and the Internet. It also extended the authority of the Attorney General to detain immigrants considered to be a potential threat, a move taken without approval from the courts. In November 2001, President Bush also signed an executive order legalising the trial of alien terrorists in military tribunals, outside the jurisdiction of criminal law. This approach was symbolised by the appointment of John Ashcroft as Attorney General. Ashcroft, a right-wing evangelical Christian, quickly developed a reputation as a robust defender of the need for security at all costs, even if it meant some restriction of civil liberty.

Although these measures at first had more or less complete support across the party political spectrum and in terms of public opinion, they also gradually revealed splits within the wider culture. In *Defending Civilisation*, for instance, a conservative pressure group, the American Council of Trustees and Alumni, argued that September 11th had revealed a deep divide between mainstream public opinion and that of intellectual elites. Moral relativism had taken over the country's universities to the extent that it had become commonplace to suggest that Western civilisation was the primary source of the world's problems. The report called for the reinstatement of courses in Western civilisation and American history that would give students a pride in 'our legacy of democracy and freedom' (Martin and Neal 2002). The online conservative magazine, *Front Page*, charged that 'most of the groups that adamantly oppose the USA Patriot Act are oriented toward worrying

more about terrorists' civil liberties than their murderous intentions' (*Front Page* 2003). President Bush himself strongly defended the Patriot Act during the 2004 election.

> Inside the United States, where the war began, we must continue to give homeland security and law enforcement personnel every tool they need to defend us. And one of those essential tools is the Patriot Act, which allows federal law enforcement to better share information, to track terrorists, to disrupt their cells and to seize their assets.
>
> (Bush 2004a)

From an opposing perspective, it was equally strongly argued that the crisis had led to an attempt to establish political conformity and the stifling of dissent. The US media had been negligent in failing to assess the strategies and rhetoric of the President and his advisers more carefully and their reporting was characterized by docility and compliance. It was not helped by the imposition of stringent restrictions on the press in terms of reporting on overseas campaigns (LaFeber 2002: 558). The *New York Times* admitted in 2004 that its coverage in the run-up to the Iraq war had not been 'as rigorous as it should have been' (Younge 2004). The relationship of the media with the administration, it was argued, could be seen as part of a military–industrial–entertainment complex that provided propaganda and legitimation for US military intervention. Furthermore, protecting 'homeland security' involved 'a highly illiberal rightwing law and order program of unleashing government agencies to surveil, arrest, and detain those suspected of being terrorists in what many see as the most outrageous assault on civil liberties and the open society in U.S. history' (Kellner 2003). The American Civil Liberties Union charged that the responses to dissent by many government officials threatened the underpinnings of democracy itself (ACLU 2005). For one critic this amounted to 'a Jihad on civil liberties, a systematic assault on democracy and constitutional balance of powers', headed by a 'Talibanesque Attorney General' in John Ashcroft (Kellner 2003: 101). The Bush administration was seeking to create 'a dictatorial police state where TV channels were becoming equally subservient to the wishes of the Texas Fuhrer as the fascist media had been to the dictates of the Third Reich' (ibid.: 102).

Amy Kaplan argued that the use of the term 'homeland', as in the Department of Homeland Security, had revealing connotations about the implications of the War on Terror for American society. Homeland, she suggested, 'appeals to common bloodlines, ancient loyalties, and often to notions of racial and ethnic homogeneity . . . a reliance on a shared mythic past engrained in the land itself' (Kaplan 2004: 8). In such a world, distinctions were inevitably drawn between those who could

claim America as their birthright and those who might hold a less secure place within the country, because of their status as recent immigrants with shared loyalties to other cultures, other places. The holding of almost 700 prisoners, mainly captives from the war in Afghanistan, at the US naval base at Guantanamo was also taken as evidence of the dangerous implications of the way in which the War on Terror had repercussions for human rights at home. It was a 'mobile, ambiguous space ... between the domestic and the foreign', which America controlled, but where the courts had limited power to protect the rights of prisoners. It reflected the 'authoritarian incursions [of the Bush administration] against civil liberties, the rights of immigrants, and the provision for basic human needs' (ibid.: 13–15).

Just as the rhetoric of President Bush echoed earlier themes in American attitudes towards the outside world, so too this kind of dissent had plenty of precedents. Generally these kinds of arguments sought to resist the claim that liberty and a full role in world affairs could go hand in hand. Pursuit of some kind of interventionist or imperialist role abroad would threaten the stability of the republic at home and endanger those virtues which distinguished the American experiment from the experience of other nations. The acquisition of empire would mean the development of a more powerful army, a stronger executive and a larger bureaucracy in a manner that would threaten the democratic and egalitarian nature of the American way of life. 'Militarism is an evil from which it has been our glory to be free', the American Anti-Imperialist League had declared in 1899, in opposition to the acquisition of the Philippines in the aftermath of the Spanish–American War. Randolph Bourne, in 1918, had warned that 'War is the health of the State. It automatically sets in motion throughout society those irresistible forces for uniformity, for passionate cooperation with the Government in coercing into obedience the minority groups and individuals who lack the larger herd sense' (Bourne 1992: 360). Martin Luther King, in his speech 'Beyond Vietnam: A Time to Break Silence', in 1967, spoke of the ways in which the injustice of the war in Vietnam was spilling out onto the streets of America's cities, with corrosive effects for America's values (King 1967).

## CONCLUSION

If we return here to President Bush's rhetoric about America's purpose in the world cited at the beginning of the chapter, it is clear that 'advancing the cause of freedom' contains with it a range of difficulties and ambiguities, both for effective policy and for America's reputation. The gap between idealised rhetoric and the harsher world of policy implementation leaves the United States open to charges of hypocrisy

and double standards (Cox 2005: 29). As a number of critics have pointed out, to dismiss these accusations is almost certain to be counter-productive. 'The more that others question America's power and purpose and priorities, the less influence America will have' (Daalder and Lindsay 2003: 375). Implicit in this judgement is the argument that America's best long-term interests will be served by returning to a more multi-lateral approach to the conduct of its foreign policy, which commits the United States to an 'international order organised around rules and insti-tutional cooperation' (Ikenberry 2003: 382). On the other hand such a prospect has to overcome what Ikenberry describes as lurking imperial temptation, supported by powerful feelings of national insecurity, and rationalised through an ideological framework which emphasises America's distinctive destiny (ibid.: 382).

## REFERENCES AND FURTHER READING

American Civil Liberties Union (2005a) *Civil Liberties After 9–11: The ACLU Defends Freedom*, at http://www.aclu.org/FilesPDFs/911_report.pdf (accessed 4/11/2005).

American Civil Liberties Union (2005b) *Freedom Under Fire: Dissent in Post-9/11 America* at http://www.aclu.org/safefree/resources/17281pub20031208.html

Ambrose, S. (1988) *Rise to Globalism*, London: Penguin.

Appy, C. (1993) *Working-Class War: American Combat Soldiers in Vietnam*, Chapel Hill: University of North Carolina Press.

Bacevich, A. (2002) *American Empire: The Realities and Consequences of U.S. Diplomacy*, Cambridge: Harvard University Press.

BBC News (2004) 'Bush Sets Case as "War President"' at http://news.bbc.co.uk/2/hi/americas/3470139.stm

Bloom, A. (1987) *The Closing of the American Mind*, New York: Simon and Schuster.

Boot, M. (2003) 'Neither New nor Nefarious: The Liberal Empire Strikes Back', *Current History*, vol. 102, no. 667, November, pp. 361–7.

Bourne, R. (1992) 'The State', in Hansen O. (ed.) *Randolph Bourne, Selected Writings, 1911–1918*, Berkeley: University of California Press.

Brinkley, A. (1995) *American History: A Survey*, New York: McGraw-Hill.

Burbach, R. and Tarbell, J. (2004) *Imperial Overstretch: George W. Bush and the Hubris of Empire*, London: Zed Books.

Bush G.W. (2001a) 'Inaugural Address', 20 January, at http://www.white-house.gov/news/inaugural-address.html

—— (2001b) 'Statement by the President in His Address to the Nation', 11 September, at http://www.whitehouse.gov/news/releases/2001/09/20010911–16.html

—— (2002) 'President Delivers Graduation Speech at West Point', 1 June, at http://www.whitehouse.gov/news/releases/2002/06.

—— (2003) 'President Bush Discusses Iraq Policy at Whitehall Palace in London' 19 November, at http://www.whitehouse.gov/news/releases/2003/11/20031119–1.html

—— (2004a) 'State of the Union Address,' 20 January, at http://www.whitehouse.gov/news/releases/2004/01/20040120–7.html

—— (2004b) 'President Addresses the Nation in Prime Time Press Conference' 13 April, at http://www.whitehouse.gov/news/releases/2004/04/20040413–20.html

Chomsky, N. (2004) *Hegemony or Survival: America's Quest for Global Dominance*, London: Penguin.

Cox, M. (2005) 'Empire by Denial: the Strange Case of the United States', *International Affairs*, vol. 81, no. 1, January, pp. 15–30.

Crockatt, R. (1995) *The Fifty Years War*, London: Routledge.

—— (2003) *America Embattled: Sept. 11th, Anti-Americanism and the Global Order*, London: Routledge.

Daalder, I. and Lindsay, J. (2003) *America Unbound: The Bush Revolution in Foreign Policy*, Washington, DC: Brookings Institution.

—— (2003) 'Bush's Revolution', *Current History*, vol. 102, no. 667, November, pp. 367–77.

De Tocqueville, A. (1965) *Democracy in America*, London: Oxford University Press.

Donoghue, D. (1988) 'The True Sentiments of America', in L. Berlowitz *et al.* (eds) *America in Theory*, New York: Oxford University Press.

Eisenberg, C. (2005) 'The New Cold War', *Diplomatic History*, vol. 29, no. 3, June, 423–27.

Ferguson, N. (2004) *Colossus: the Rise and Fall of the American Empire*, London: Allen Lane.

Foner, E. (2000) 'American Freedom in a Global Age', *American Historical Review*, vol. 106, no. 1, February, pp. 1–16.

FrontPageMagazine.com (2003) 'Anti-Patriot Feminists', 10 July.

Gaddis, J.L. (1997) *We Now Know: Rethinking Cold War History*, Oxford: Clarendon.

—— (2004) *Surprise, Security, and the American Experience*, Cambridge, MA: Harvard University Press.

—— (2005) 'Grand Strategy in the Second Term', *Foreign Affairs*, vol. 84, no. 1, pp. 1–8.

Gardner, L. (1984) *A Covenant with Power: America and World Order from Wilson to Reagan*, London: Macmillan.

Greene, G. (1955) *The Quiet American*, London: Heinemann.

Halliday, F. (2005) 'It's Time to Bin the Past', *The Observer*, 30 January.

Hayden, P. *et al.* (2003) *America's War on Terror*, Aldershot: Ashgate.

Hellman, J. (1986) *American Myth and the Legacy of Vietnam*, New York: Columbia University Press.

Hogan, M. (ed.) (1999) *The Ambiguous Legacy: U.S. Foreign Policy in the American Century*, Cambridge: Cambridge University Press.

Hunt, M. (1988) *Ideology and US Foreign Policy*, New Haven: Yale University Press.

Ikenberry, G. (2002) 'America's Imperial Ambition', *Foreign Affairs*, vol. 81, no. 5, Sept–Oct, pp. 44–60.

—— (2003) 'America and the Ambivalence of Power', *Current History*, vol. 102, no. 667, November, pp. 377–83.

Ikenberry, G. (ed.) (2002) *America Unrivaled: The Future of the Balance of Power*, Ithaca: Cornell University Press.

Huntington, S. (1998) *The Clash of Civilizations and the Remaking of World Order* London: Touchstone.

Ions, E. (ed.) (1970) *Political and Social Thought in America, 1870–1970*, London: Weidenfeld and Nicolson.

Johnson, C. (2002) *Blowback*, London: Time-Warner.

Johnson, C. (2004) *The Sorrows of Empire: Militarism, Secrecy, and the End of the Republic*, London: Verso.

Johnson, L.B. (1965) 'Peace Without Conquest', at http://www.lbjlib.utexas.edu/Johnson/archives.hom/speeches.hom/650407.asp

Kellner, D. (2003) *From 9/11 to Terror War: the Dangers of the Bush Legacy*, Lanham, MD: Rowman & Littlefield.

King, M.L. (1967) 'Beyond Vietnam: A Time to Break Silence', at http://www.stanford.edu/group/King/publications/speeches/Beyond_Vietnam.pdf

Kristol I., and Brooks, D., (1997) '' What Ails Conservatism,' *Wall Street Journal*, 15 September.

LaFeber, W. (2002) 'The Bush Doctrine', *Diplomatic History*, vol. 26, no. 4, pp. 543–58.

Leffler, M. (2005) '9/11 and American Foreign Policy', *Diplomatic History*, vol. 29, no. 3, pp. 395–413.

McCormick, T. (1995) *America's Half-Century: United States Foreign Policy in the Cold War and After*, Baltimore: Johns Hopkins.

McNamara, R. (1999) *Argument Without End: In Search of Answers to the Vietnam Tragedy*, New York: PublicAffairs.

Mann, J. (2004) *The Rise of the Vulcans: The History of Bush's War Cabinet*, New York: Viking.

Martin, J. and Neal, A. (2002) *Defending Civilisation: How Our Universities Are Failing America and What Can Be Done About It*, Washington DC: American Council of Alumni and Trustees.

National Security Strategy of the United States of America (2002) at http://www.whitehouse.gov/nsc/nss.html

Nye, J. (2003) *The Paradox of American Power: Why the World's Only Superpower Can't Go It Alone*, Oxford: Oxford University Press.

O'Sullivan, J. (1839) 'The Great Nation of Futurity', *The United States Democratic Review*, vol. 6, no. 23, pp. 426–30.

Pew (2005) 'U.S. Image up Slightly, but Still Negative', at *Global Attitudes Project* http://pewglobal.org/reports/display.php?ReportID=247 (accessed 6/11/2005).

Pieterse, J. (2003) 'Hyperpower Exceptionalism: Globalization the American Way', in Beck, U., Sznaider, N. and, Winter, R. (eds) *Global America? The Cultural Consequences of Globalization*, Liverpool: Liverpool University Press, pp. 76–91.

*Project for the New American Century* at http://www.newamericancentury.org/index.html

Roper, J. (2005) 'The Contemporary Presidency: George W. Bush and the Myth of Heroic Presidential Leadership', *Presidential Studies Quarterly*, vol. 34, pp. 132–40.

Rosenberg, E. (2002) 'Rescuing Women and Children', *Journal of American History*, vol. 89, no. 2, September, pp. 456–65.

Slotkin, R. (1998) *Gunfighter Nation*, New York: Atheneum.

Steinmetz, G. (2003) 'The State of Emergency and the Revival of American Imperialism: Toward an Authoritarian Post-Fordism', *Public Culture*, vol. 15, no. 2, pp. 323–46.

Stephanson, A. (1995) *Manifest Destiny; American Expansion and the Empire of Right*, New York: Hill & Wang.

Thorne, C. (1979) *Allies of a Kind*, Oxford: Oxford University Press.

Younge, G. (2004) '*New York Times* Admits Failures in Run-up to War', *Guardian*,
27 May.
—— (2005) 'America's Top Paper Rethinks its Journalism', *Guardian*, 10 May.

## FOLLOW-UP WORK

1   The concept of 'exceptionalism' has long guided how many Ameri-
cans have thought about their own history, but comparisons of the
American experience with those of other nations may suggest
common themes. How does the expansionist ideology of nineteenth-
century America fit with the imperialist rhetoric of European powers
during the same period? Has empire meant the same thing in
America as in Europe, and, if not, how has American empire
differed?

2   To what do extent has American foreign policy changed as a result
of the attacks of September 11th? How do the policies of President
George W. Bush compare with those of his predecessors? It may be
instructive here to compare specific examples, e.g. the Clinton
Administration's policies in the former Yugoslavia with that of the
Bush Administration in Iraq.

3   Examine the extent to which contemporary American power depends
on military strength. Recent works by Johnson (2004) and Bacevich
(2002) portray a country whose civic and political culture is threat-
ened by militarism. To what extent do you share these views? What
prospects do you see for a greater degree of accountability in terms
of the conduct of American military policies?

4   Examine the debate about the relative strengths of the American
economy in the early twenty-first century, and assess its implica-
tions for the future of American political and military power. What
responsibilities do you think the United States has to promote a
stable international economic order?

5   Explore a case study in American nation-building (e.g. South
Vietnam, Afghanistan, Iraq). What kind of problems arise when
attempts are made to create stable democratic societies in the after-
math of military intervention? What do you make of the American
commitment to the 'single model' of development?

6   Explore the ways in which the American military are depicted in
popular culture, particularly by Hollywood. To what extent are the
experiences of the American military overseas regularly represented
in terms of earlier American mythology? Although this chapter
hasn't looked at Vietnam, there is now a sizeable body of films
dealing with American intervention in Southeast Asia which repay
careful study.

*Assignments and areas of study*

1   Why is unilateralism so strong in the contemporary United States?
2   Assess Randolph Bourne's judgement that war tends to encourage an oppressive state.
3   How do you assess the open American commitment to the promotion of democracy in the world?

# The transmission of American culture

In 1901 the English journalist W.T. Stead published a short tract entitled *The Americanisation of the World* in which he welcomed the growing power of the United States, not only in military and economic terms, but also in the area of ideas, values and culture. American energy and vitality, through their relentless involvement in other countries, would restore the strength of the British Empire and ensure the continued triumph of the Anglo-Saxon race. Forty years later, writing on the eve of America's entry into the Second World War, Henry Luce, the publisher of *Life*, coined the phrase 'The American Century' as part of a determined attack on American isolationism. The 20th century was 'baffling, difficult, paradoxical, revolutionary'. If it was to come to life 'in any nobility of health and vigor, [it] must be to a significant degree an American century'. Like Stead, Luce stressed the importance both of American culture and values. 'American jazz, Hollywood movies, American slang, American machines and patented products', were already the 'only things that every community in the world, from Zanzibar to Hamburg, recognise[d] in common'. They must now be joined to a commitment to an internationalism 'of the people, by the people, and for the people'. The United States had a responsibility to spread 'great American ideals' and become 'the powerhouse of the ideals of Freedom and Justice'. Luce hoped that this kind of optimistic identification of American interests with those of the world would enhance 'the triumphal purpose of freedom' and that American internationalism would lift 'the life of mankind to 'a level a little lower than the angels'. It became clear, however, as the twentieth century developed, that the debates swirling round the process and impact of Americanisation suggested something much more ambiguous and complex than either he or Stead had anticipated (Luce 1999).

Clearly American products and American culture were often eagerly consumed in many different places, but their spread also aroused considerable distrust and suspicion, as well as accusations of imposition. In this chapter we shall examine different aspects of this history as

American popular culture has been variously welcomed, contested and challenged in the wider world. At the same time too, we will look at some of the ways in which the analysis of 'Americanisation', or American cultural influence, has been complicated by the increased prominence of the related concept of globalisation. Globalisation is a notoriously difficult concept to pin down but may be defined here as the process of increasing connectivity, through which ideas, capital, goods, services and people are transferred across national borders. It is revealing that the term is often used interchangeably with Americanisation. As Richard Crockatt has noted, 'America stands for many as a symbol of globalisation', perhaps because 'the expansion of American power happened at the same time as the growth of international capitalism'. (Crockatt 2003: 57, 122). This is certainly how it often seen by peoples outside of the United States. Globalisation, Thomas Friedman argues, is seen as wearing

> Mickey Mouse ears, eats Big Macs, drinks Coke or Pepsi and does its computing on an IBM PC, using Windows 98, with an Intel Pentium II processor, and a network link from Cisco Systems. . . . In most societies, people cannot distinguish anymore among American power, American exports, American cultural assaults, American cultural exports and plain vanilla globalisation.
>
> (Friedman, 2000, 382)

One approach that has been put forward is to argue that Americanisation has in a sense been overtaken by the processes of globalisation. Where Luce in the 1940s saw America as the decisive actor in the world, international culture has become increasingly deracinated as the forces of transnational communication have gathered pace by the beginning of the twenty-first century. For the purposes of this chapter, however, we want to retain both concepts here alongside each other. There have clearly been periods and places in the past when Americanisation has been particularly powerful (for instance Western Europe after the Second World War). Moreover the contemporary position of the United States (see Chapter 9) makes it difficult to dismiss the concept of Americanisation as a way of assessing America's role in the world. Despite the fact that the world is becoming an increasingly interconnected and interdependent place, it is American global power that has received renewed attention (Ang 2005: 268). At the same time, it is undeniable that globalisation has become a decisive force in the contemporary world, promoted by transformations in electronic technology. Globalisation, too, has a long history, one which has shaped America itself in significant ways since the early days of the republic, and which will continue to breach American borders, despite what is sometimes described as 'American

self-absorption and lack of awareness of the bigger world' (ibid.: 276). The widespread temptation to describe American culture in terms of the values of the administrations of President George W. Bush needs to qualified by an appraisal of some of the ways in which the United States itself will be unable to escape the implications of 'global connectivity' (Tomlinson 1999: 12).

Discussion of these issues is important because it has implications both for understanding American culture, as well as for the practice of American Studies. Exploring Americanisation is revealing because it can tell us something about the impact of American culture on the lives of those beyond America's national borders. How peoples have responded to the presence of 'America' in their lives reminds us that the assumptions that lie behind much American rhetoric and many American cultural products may be interpreted and understood in different ways. At the same time, analysing Americanisation can also help us interrogate America itself. One key theme in the country's experience has been a temptation to see itself as exceptional. (See also the Introduction and Chapter 1.) Determining what was American and what was un-American was a process carried out within America's borders. 'America' was defined as part of a national process of self-assertion. However, through analysing Americanisation, alternative definitions of America may emerge, which challenge and even question the power of 'domestic' versions of the country's experience. America's identity in the world becomes something constructed not only by Americans, but also by the interactions other peoples and cultures have had with the country. In this respect debates over Americanisation can have revealing consequences for the practice of American Studies itself, by contributing to the way in which it increasingly takes into account a range of relationships between 'America', however that term is defined, and the rest of the world. Examining Americanisation invites us as students of America to reflect critically on the role it plays in our lives.[1]

## AMERICAN POWER

One starting point here is to emphasise the scale of American commercial and political power, particularly in the second half of the 20th century, in aiding the spread of cultural products. Debates about cultural transfer have always taken place in the context of history, politics and economics. In 1945 the United States had approximately 6 per cent of the world's population but produced 46 per cent of the world's economic power and consumed 40 per cent of the world's energy. American businesses controlled 59 per cent of the world's oil reserves. The American share of world GNP was almost 50 per cent. Although this had declined to *c.*26 per cent by the 1970s, prompting a literature of imminent

American decline, it has since stabilised at around that figure and America looks likely to continue as the world's dominant economic power for the foreseeable future. The challenge of potential rivals such as Japan and the European Union has been affected by a range of factors, while China's potential remains to be fully realised. It is in this light that George Ritzer has emphasised the disproportionate and continuing significance of the United States as a source of goods, bodies of information and other cultural products in the post-Cold War world (Ritzer 2000: 84). In terms of cultural impact this can be seen most clearly in the case of Hollywood. In 1998 the thirty-nine most popular films across the world were American, and in many European countries the percentage of box-office takings on domestic products was in rapid decline to as low as 10 per cent in Germany and 12 per cent in Britain and in Spain. (Miller *et al.* 2001: 4). Hollywood's share of the world market effectively doubled between 1990 and 2000 (ibid: 5–6) Profits from selling films abroad grew by 124 per cent between 1985 and 1990, while during the same period the share of the American domestic market for foreign films fell from 7 to 1 per cent. Jack Valenti, head of the Motion Picture Association of America (MPPA) has offered a celebratory justification of the scale of American dominance:

> It is a fact, blessedly confirmed, that the American movie is affectionately received by audiences of all races, cultures and creeds on all continents amid turmoil and stress as well as hope and promise. This isn't happenstance. It's the confluent of creative reach, storytelling skill, decision making by top studio executives and the interlocking exertions of distribution and marketing artisans.
>
> (ibid.: 1)

One argument here, however, is that Hollywood's development after the Second World War has less to do with 'affectionate reception' than with the expansion of global capitalism, supported by Washington's trade policies, and the evolution of international agreements under GATT and WTO, which encouraged American access to foreign markets. The emphasis on media systems based on a market-led approach has favoured American cultural industries because of their inherent advantages in terms of size and flexibility. Hollywood, from this perspective, has maintained its international dominance not just through the appeal of its products but as much through its control of methods of production, and it has to be analysed in much the same way as other globalised industries such as electronics or textiles.

Economic muscle has also been regularly supported by state institutions. This was clearly the case, for instance, in Europe in the immediate aftermath of the Second World War, in occupied countries such as

Germany and Austria, where both the presence and the educational policies of the US army actively encouraged consumption of American goods and practices (Wagnleitner 1994, 1999). The special case of military occupation drew on a range of earlier precedents like the Creel Committee during the First World War, the Motion Picture Section of the Department of Commerce in the 1920s, and the close links between Hollywood and Washington during the Second World War, and as a result rapidly spread into much of the rest of Western Europe. It also included attempts to propagate the American way on the other side of the Iron Curtain. The Marshall Plan further integrated Western Europe into the American system by promoting the virtues of transnational communication as well as the promise of erasing social conflict through economic growth. At some point in the post-1945 era, Richard Kuisel argues, 'Americanisation became an essential aspect of American power' (Kuisel 2000: 513). Moreover, a continuing military presence in Europe, the Middle East and East Asia outlived the Cold War, as discussed in Chapter 9. At one level the subsequent proliferation of bases served as outposts of the American cultural economy. At another they provided a symbolic presence which local peoples often felt they were unable to contain. As part of the response to September 11th, moreover, cultural diplomacy was given renewed attention as an important aspect of the War on Terror. American beliefs and values needed to be promoted to support American interests in an increasingly antagonistic world (Kennedy 2003). The Bush administration also sought to discuss the role that Hollywood might play in the War on Terror (Spiegel 2004: 261).

## COMING TO TERMS WITH AMERICANISATION

Within this context, the presence of the United States has been felt in the lives of peoples beyond its borders both through military might, economic power and cultural influence, as well as through reflection on the very idea of America. As non-Americans examined the development of their own societies, 'America often served as a model for rejection or emulation, providing views of a future seen in either a negative or positive light' (Kroes 1999: 464). Marcus Cunliffe, amongst many others, has pointed out the vast literature of responses to the country, which have often fallen into a series of broad classifications despite variations according to time and place (Cunliffe 1964: 492–514). He grouped these responses into two main historical categories: the heroic, which included such images as 'the land of liberty', 'the earthly paradise' and the villainous, which emphasised America as a place of excess or libertinism. Both went back to the age of exploration. America in this sense was imagined as much as discovered. It was, however, the developing capacity of America to spread her culture beyond her own borders that

gave these images an added potency. As a range of American cultural products became increasingly widely dispersed throughout the world, partly through the energies of capitalist production and partly through the active encouragement of the United States government, particularly but not only during the Cold War, so the debate intensified about their impact on other cultures and peoples. When people in other countries worried, however, about the effects American culture was having on their own lives, they were not thinking of America's novels, sculpture or ballet. 'Americanization', as Richard Pells, has argued, 'generally meant the world-wide invasion of American movies, jazz, rock 'n' roll, mass circulation magazines, best-selling books, advertising, comic strips, theme parks, shopping malls, fast food, and television programs' (Pells 2000: 495). In this respect concern about 'America' was frequently linked to the on-going debate about the effects of popular culture in a way which often chimed with views expressed in America itself about its standardising tendencies.

These issues were raised, for instance, during the 1940s by American cultural critics such as Dwight Macdonald, who argued that mass culture was 'imposed from above' on audiences who were 'passive consumers' of material that 'mixes and scrambles everything together, producing what might be called homogenized culture' (Storey 2003: 30, 32). The effects of such a culture, for Macdonald, were 'narcotized acceptance ... as a substitute for the unsettling and unpredictable ... joy, tragedy, wit, change, originality and beauty of real life' previously captured in works of high culture. In place came 'standardization' and the 'spreading ooze of Mass Culture' (ibid.: 42) which was particularly associated with all things American. As the mass production techniques of industrial capitalism could reproduce endless copies of the same, standardised objects, for example sit-coms, records or paperbacks, fears grew that a similar process would occur in all cultural practices. The poet Allen Ginsberg asked in 1956, 'Are you going to let your emotional life be run by *Time* Magazine?' (Charters 1994: 75) and created the name 'Moloch' to characterise the interlinked technologies of consumerism, capitalism, weapons and the media that represented for him, and many during the 1950s and 1960s, a fearful imperial force threatening not only the health of the republic but also the rest of the world.

In Europe the spread of American popular culture provoked similar denunciations across the political spectrum. In Britain, for instance, the spread of American cultural products in the years after the First World War encouraged a widespread reaction on the Right to what was seen as a threat to established standards. Often, fear of cultural decline was explicitly conflated with anxiety about the full implications of democratisation. The literary critics F.R. and Q.D. Leavis quoted the words of the Victorian writer Edmund Gosse as part of their worries over the

impact of American values on British life: 'The revolution against taste, once begun, will land us in irreparable chaos' (Webster 1988: 180). America, from this perspective, became a symbol of both cultural and political levelling, in a manner that endangered educated values. These concerns found an alternative form of expression post-1945 amongst a number of cultural critics on the Left, who worried that the intervention of America into British working-class culture, in particular, would result in the promotion of a superficial consumerism, dominated by the market, at the expense of political solidarity and the cohesiveness of traditional patterns of community which nourished it. Richard Hoggart, in *The Uses of Literacy* (1957), described what he saw as the success of a 'shiny barbarism' associated with the import of American goods and values, which rendered its consumers less capable of responding openly and responsibly to life. This was reflected above all in the lifestyle of jukebox boys who spent their time 'listening in harshly lighted milk-bars to the nickelodeons ... living to a large extent in a myth world compounded of a few simple elements which they take to be those of American life'. For Hoggart, this was all a thin and pallid form of dissipation, 'a sort of spiritual dry-rot' which affected the 'quality of ordinary working-class life' (Hoggart 1957: 247–50). America was seen as 'the homogenising agent' in the modern world, serving as 'the image of industrial barbarism; a country with no past, and therefore no real culture, a country ruled by competition, profit and the drive to acquire' (Hebdige 1988: 47–54). Though Hoggart in 1957 retained some optimism that British workers still retained sufficient moral resources to resist the worst effects of mass consumerism, his position reflected a wider set of assumptions about the one-way process of cultural transmission across the Atlantic, which was shared in other European countries as well as Britain. In France plans to market Coca-Cola more widely during the late 1940s provoked opposition from across the political spectrum. For *Le Monde* Coca-Cola threatened the moral landscape of France. A Catholic newspaper warned that Coca-Cola was the avant-garde of an offensive aimed at economic colonisation. In 1951 the communist poet Louis Aragon condemned the United States as 'a civilisation of bathtubs and frigidaires', accusing it of being more arrogant than the Nazis through its substitution of the machine for the poet, Coca-Cola for poetry (Kuisel 1996: 24). As these comments suggest, across Europe from the 1930s to the 1950s, 'wherever elites stood politically, one thing united most of them; their cultural anti-Americanism' (Wagnleitner 1999: 511).

In other parts of the world the dangers of Americanisation called for stronger responses. In Egypt, the Islamic fundamentalist, Sayyid Qutb, who was executed in 1966 for plotting against President Nasser, used the example of America to argue for the creation of fundamentalist societies in the Middle East, where a purified Islam would regulate life

totally, in an effort to resist the social consequences of unrestrained individualism. After a two-year stay in America during the late 1940s he concluded that the churches were 'entertainment centres and sexual playgrounds'. The people 'had no faith in themselves or in life around them'. They were, on the one hand, as 'machines that move with madness, speed, and convulsion that does not cease', but they were also taken with 'indulgent pleasure'. Both trends had to be resisted if God's sovereignty was to prevail (Rippin 1993: 92). His writings would later have a strong influence on the Taliban in Afghanistan, as well as on al-Qaeda as it aimed for an international jihad that would implement Shari'a, or religious law. For Osama bin Laden, America had to be forced to leave the Arabian Peninsula, and the wider Islamic world, because its way of life was 'defiling the Islamic home' (Friedman 2000: 395).

If we turn to later periods, it is striking that many of these attitudes have persisted. Although the international reaction to September 11th focused on American foreign policy, a powerful strain of cultural antagonism was also apparent in a range of critiques of what America stood for in the world. *Why Do People Hate America?* Sardar and Davies asked in 2002. Among their answers was the assertion that 'America was taking over the lives of ordinary people in the rest of the world and shrinking their cultural space – their space to be themselves, to be different, to be other than America'. America projected itself on the rest of the world 'as though it were a hamburger: a commodity, a brand, out to capture all cultural space for itself' (Sardar and Davies 2002: 104–5). Harold Pinter, the 2005 Nobel Prize winner for Literature, bitterly linked what he saw as the brutalism of the 'Nazi' American military with the way in which the culture industry exercised control through propaganda (Chrisafis and Tilden: 2003). In France, a range of responses to September 11th linked it to the aggressive ambitions not only of the American state but also the country's popular culture (Roger 2005: 1).

Concern among politicians and cultural critics about Americanisation has also been accompanied by more sustained theoretical assessments of mass culture. In the vanguard, and influential in both Europe and America, was the Frankfurt School, exemplified by the work of Theodor Adorno and Max Horkheimer, who saw mass culture as a product of state monopoly capitalism which worked to deny genuine individualism. The media in this context ensured passivity by stifling oppositional criticism. In particular, they sought to mould the minds of ordinary citizens by encouraging false needs whilst diminishing alternative ways of thinking. The result was a 'culture industry' that ensured conformity in contemporary society by merchandising banality, and weakening high culture's ability to challenge reality. Combining standardisation with predictability, 'Its products encourage conformity and consensus which ensure obedience to authority, and the stability of the capitalist system'

(Strinati 1992: 64). Mass culture was a way of maintaining the status quo through channelling any desire for utopian or even alternative modes of expression into passive consumption. Herbert Marcuse called this idea 'one dimensionality', arguing that in advanced industrial societies, of which America was the prime example, the individual was reduced to acquiescence, alienated from the possibilities of his own liberation. 'The products [of mass culture] indoctrinate and manipulate; they promote a false consciousness which is immune against its falsehood ... it becomes a way of life ... and as a good way of life, it militates against qualitative change' (Marcuse 1967: 27). The American critic Theodore Roszak wrote of 'technocracy' and its intention to 'charm conformity from us by exploiting our deep-seated commitment to the scientific world-view' (Roszak 1970: 9).

Another term frequently assigned to this process was cultural imperialism, which has been developed as a key analytical concept in the assessment of Americanisation, and has stimulated considerable debate about the workings of popular culture. It is, however, a broad concept which has a range of different emphases, including media imperialism, the domination of one national culture by another, the global domination of capitalism and the critique of modernity (Gienow-Hecht 2000: 472–9). As it expanded into Europe and then other parts of the world, it is argued, American mass culture imposed its values on other societies and cultures, incorporating them into the values of the American state, to the detriment of local or national needs (see, for example, Schiller 1969, 1989). Hollywood, in particular, was singled out for the way in which it bedazzled whole cultures, leaving them susceptible to American manipulation: 'The Yanks have colonized our subconscious', one of the German characters says in Wim Wenders's 1976 movie, *Kings of the Road*. Whether it was Walt Disney in Chile (Mattelart and Dorfman 1975) or American movies more generally in Western Europe (de Grazia 1989: 2005), the result was the same – the integration of local, regional or national societies into a wider international economic system. Such a process might not take the form of 'older, cruder and obsolete methods of colonisation', but the incursion of the American model of commercial media amounted to a form of 'neo-imperialism' that brought the countries concerned into the orbit of the dominant power (Herman and McChesney 1997: 137, 153).

Another influential theoretical perspective on mass culture as a system of control has been the work of George Ritzer, who coined the phrase 'the McDonaldisation of society' to describe the rationalisation of contemporary life. For Ritzer, writing from a Weberian rather than a Marxist perspective, McDonald's provides the paradigm of 'the process by which the principles of the fast-food restaurant are coming to dominate more and more sectors of American society as well as of the rest of the world'

(Ritzer 2000: 1). It is a model for understanding a number of different aspects of modern societies beyond the fast food industry itself, including credit cards, the sex industry, marketing, leisure, education and the media. In particular, he argues that McDonaldisation encompasses four key concepts: increased efficiency, calculability, predictability and control. Efficiency is revealed in both consumer satisfaction and in the organisational rules and regulations of McDonald's itself. Calculability emphasises the quantitative aspects of products at the expense of quality. Predictability ensures that products and services will be the same over time and in different places. Surprise is avoided in favour of reliability. All of this leads to control over both those who enter McDonald's and those who work there. Control is especially reflected in the way in which people's actions in this kind of setting are increasingly shaped by non-human technology. While conceding that McDonaldisation has 'led to positive changes', he emphasises what amounts to a fifth aspect of rationalisation, 'the irrationality of rationality', and in particular the way in which it has encouraged a range of problems which overwhelm any advantages. These include 'inefficiency . . . relatively high costs, illusory fun and reality, false friendliness, disenchantment, threats to health and environment, homogenisation and dehumanisation' (ibid.: 145). While the processes of McDonaldisation were strongly linked to the more general phenomenon of modernity, it nevertheless remained the case, Ritzer argued, that they were originated and received their most thorough-going application in America. In subsequent work he has gone onto explore what he describes as 'the new means of consumption', which he defines as 'the proliferation of settings that allow, encourage, and even compel us to consume innumerable goods and services'. Under this heading Ritzer includes franchises, shopping malls, superstores, theme parks, cybermalls and home shopping television. Taken together such developments have 'dramatically transformed the nature of consumption'. Moreover, 'what is critical about [them] is that they are powerful representations of American culture and they all bring that culture to any nation to which they are exported (ibid.: 97–118).

If we reintroduce the theme of globalisation here, similar concerns have surfaced about its consequences for culture. It is true that just as the international influence of the United States was robustly asserted by Luce in the 1940s, so too globalisation has been strongly supported by many key figures in contemporary American life. Three months after the attack on the World Trade Centre in New York, former president Bill Clinton continued to defend globalisation against both its critics and its enemies. The global economy, the information technology revolution, scientific advance and 'the explosion of democracy and diversity within democracy', together would help 'to make the twenty first century the most peaceful, prosperous, interesting time in all human history'.

He admitted there were problems – global poverty, the global environment, the rise of global epidemics and hi-tech terrorism – but he declared a more general confidence in the progressive benefits that globalisation would bring (Clinton 2001). Others put it less diplomatically. Andrew Rothkop argued in 1997 that

> It is in the general interest of the United States to encourage the development of a world in which the fault lines separating nations are bridged by shared interests. And it is in the economic and political interests of the United States to ensure that if the world is moving toward common telecommunications, safety and quality standards, they be American; that if the world is becoming linked by television, radio and music, the programming be American; and that if common values are being developed, they be values with which Americans are comfortable.
>
> (Rothkop 1997: 5)

Another recent American assessment argues that 'a fair appraisal of [the] economic landscape suggests that struggling countries in general do not suffer from too much market liberalisation and exposure to international competition – they suffer from too little'. Nations fare better if they merge into the expanding global marketplace (Sorensen 2004: 405). In a survey published just after the attacks on the World Trade Centre, *The Economist* insisted that globalisation was the only cure for international poverty (*The Economist* 2001: 3).

Arguments, however, about the benefits of globalisation, are a notorious battlefield. What had already become clear both from protests at World Trade Organisation meetings during the late 1990s and the fall-out from September 11th, was that there was no general consensus about globalisation's potential benefits either on an international or a local scale, or about the way in which it might be used to promote the American example of development. Naomi Klein, the author of the influential *No Logo*, argued that 'the brutal economic model advanced by the World Trade Organization [was] itself a form of war' (Klein 2003). It encouraged global inequality by promoting privatisation and deregulation in a way that enhanced the fortunes of the richest fifth of the world at the expense of the poorest fifth. Globalisation, from this perspective, was anti-democratic because it denied popular choice in much of the world and favoured the interests of corporate elites. Fredric Jameson had made a similar point more trenchantly twelve years earlier: 'American, postmodern culture is the internal and superstructural expression of a whole new wave of American military and economic domination throughout the world: in this sense, as throughout class history, the underside of culture is blood, torture, death, and terror'

(Jameson 1991: 5). A corollary of the economic and political indictments of globalisation has been its supposed encouragement of cultural homogenisation. Even an (American) supporter of the phenomenon admits that it has 'tended to involve the spread [for better and for worse] of Americanisation' (Friedman 2000: 9). Others put it more strongly. Globalization involves 'a declaration of war upon all other cultures. And in cultural wars, there is no exemption for civilians; there are no innocent bystanders' (Seabrook 2004). It relentlessly works to impose cultural control over peoples and nations in a manner that stifles opposition and promotes sameness. The world becomes 'more Americanised, rationalised, codified, and restricted' (Ritzer and Ryan 2004: 42).

## ASSESSING AMERICANISATION

But is it enough to leave it there? For a start, the processes of globalisation themselves raise questions about the assumptions of a one-way model of cultural expansion. Ritzer argues that while it is undeniable that there are global processes, which operate free of any nation-state, one nation-state remains disproportionately important in globalisation. Globalisation is persistently tied to the United States and American culture. Nonetheless, it is also the case that although the United States is often seen as the key agent in the process of globalisation, it is itself also susceptible to the impact of globalisation. This has been true for much of its history. American political and social values originated in the transmission of European ideas across the Atlantic in the seventeenth and eighteenth centuries. The mass migrations of the eighteenth and nineteenth centuries created a 'globally sourced, multi-cultural and multiracial population for the United States' (Hodson 2001: 81). The same process can also clearly be seen in the recent upsurge in immigration. In 2001 one in ten American residents was foreign-born as the country re-emerged as a nation of immigrants. The increasing variety of the sources of immigration, particularly from the developing world, also has profound consequences for the future of American culture and society. The US Census Bureau projects that the non-Hispanic, white population will comprise just 50.1 per cent of the total population in 2050, compared with 69.4 per cent in 2000. The Hispanic population is expected to grow from 35.6 million to 102.6 million, an increase of 188 per cent, meaning that their share of the nation's population would nearly double, from 12.6 per cent to 24.4 per cent. American culture, too, has often been shaped by globalising influences. Hollywood has throughout its history regularly used actors, writers, musicians and directors from across the world. A recent example might be its 'borrowings of Asian film aesthetics, movie stars, concepts and screenplays' (Goss and Yue 2005: 254). A musical form like jazz, often described as quintessentially

American, has its roots in a mix of sources from Africa and Europe. Although it may have first become identifiable in the American South, as it developed it consistently drew on contributions from musicians and performance styles from across the world (Shipton 2001). The United States in this light may be seen as 'a participant in a global flow of people, ideas, texts, and products, – albeit a participant who often tries to impede those flows' (Fishkin 2005: 24). In such a world accepted notions of a clearly defined American national culture imposing itself on other cultures become increasingly contested by the ways in which the construction of the idea of America itself is constantly under challenge from both internal and external forces which are difficult to resist. This is not to deny that struggles will take place for the power to articulate American identity, but it is to suggest that those struggles themselves, in a globalised world, will inform how America is seen and understood by others. As Amy Kaplan argues 'the Americanisation of global culture is not a one way street, but a process of trans-national exchange, conflict and transformation' that may create new cultural forms which express their own dreams and desires (Kaplan 2004: 7).

At the same time it may be too simplistic to read cultural trends as simply reflecting both economic and political developments and the meanings invested by producers in their creations. In *Cultural Imperialism* (1991), John Tomlinson argues against the idea that there are straightforward connections between a cultural product, the ideas it represents and the manner of its consumption in places outside of its place of production. The mediated nature of global communication systems and their highly charged, complexly coded forms and representational practices and the variegated contexts in which a slew of images and ideas about America circulate across the world and are consumed non-passively by people who were not quite the 'target consumers' should warn us not to assume that American hegemony, and cultural imperialism, work in predictable, totalising ways. Shelley Fishkin makes a similar point: 'Cultural imperialism has turned out to be too simple a model to understand how culture works'. It may be more appropriate instead to place an emphasis on the way in which American popular culture abroad is in a constant state of negotiation with other cultures, and how societies outside the United States use it to negotiate with aspects of their own cultures (Fishkin: 2005: 33). The move away from a cultural imperialist model also helps to emphasise the significance of human agency. Both the Frankfurt School and cultural imperialism arguments, as well as Ritzer's iron cage of McDonaldisation, tend to portray those on the receiving end of American popular culture as objects, 'passive bod[ies] appropriated by hegemonic discourse' (Ang 1996: 152). At the same time, cultural imperialism, by assuming that self-contained and authentic national or local cultures are threatened by an 'equally

self-contained "dominant culture" ... often tends to collude with a defence of conservative positions of cultural Puritanism and protectionism' (ibid.: 152). Moving to a different kind of explanatory framework helps to 'understand contact, translation, exchange, negotiation, conflict and other dynamics that attend the constitution of social relationships across cultural and national borders' (Ngai 2004: 60–1). Cultural artefacts, it is argued, 'change their meanings, transform their messages, acquire local meanings and become new signifiers as soon as they cross borders' (Wagnleitner 1999: 500). This not to deny the comparative advantage of the United States in terms of the transfer of culture, but it is to link it to the processes of selection and adaptation.

As Rob Kroes has suggested, conventional notions of Americanisation may not be the most appropriate way of describing this process. Analysis of the 'motifs and organising views' of the producers of American cultural products remains important, but it needs to be accompanied by awareness of 'a freedom of reception, a freedom to re-semanticize and re-contextualize meaningful messages reaching audiences across national and cultural borders' (Kroes 1999, 463). Aspects of American culture could provide an encouragement to liberation in one context, while acting as a threat in another. Put another way, America provided itself as a text which contained its own ambiguities and contradictions, which allowed its readers to adopt and adapt meanings and pleasures for their own purposes. America, for the critic and novelist Malcolm Bradbury, looking back on his own education in the 1950s, provided a direction 'in which the mind might go to look for images of alternative and otherness' (Bradbury 1979: 120). This is not to deny the context within which American cultural products were produced or the resources which supported their availability, but it is to suggest audiences have often exercised discretion in using America in ways that suited them. They have often acted in this way moreover in the face of opposition or hostility from their own governments. In Fascist Italy, for example, efforts to impose nationalised codes of dress for women were ineffective as consumers chose to follow the American-influenced fashion industry instead (de Grazia 2005). As Arjun Appadurai argues, evidence suggests that 'the consumption of the media often provokes resistance, irony, selectivity, and in general, *agency*' (Appadurai 1996: 7). It is in this spirit that more specific examples may illuminate key aspects of the debate.

## CASE STUDY 1: THE MEDIA

The case of broadcast media is illuminating here. If the cultural imperialism model were accurate, Jeremy Tunstall has argued, 'false consciousness would be plugged into every human home' with the growth of media technology ensuring that American mass culture would

'rule the global village' (Tunstall 1994: 39, 18). However, he suggests it contains misleading assumptions about the ways in which popular culture operates at the point of consumption. The spread of American media in the world may not produce homogeneity at all, but respond to and facilitate 'the world ... splitting up into smaller units and ethnic identities'. New technical developments in the media will enable 'localism, separatism, talking back to, and switching off from, authority, the centre, the national and foreign media' (ibid.: 273–4). Under these conditions, the media, rather than moving towards some form of mono-lithic homogeneity, are felt at three different levels: the international dominated by Anglo-American products; small, local, ethnic and 'tradi-tional'; and finally 'national' in the sense of 'hybrid' forms involving some mix of the other two.

This argument has been developed by Morley and Robins (1995), who explore the tension between globalism and localism, stressing that the two can and do co-exist, and perhaps offer the 'possibility of reinventing and rearticulating international and local cultures and identities' (Morley and Robins 1995: 2). Rather than the threat of an imperialist media culture, with America at the centre, in which everything becomes the same, they suggest an alternative through which the local and the global can co-exist, namely, that the media offer the possibilities of empowerment as much as the downside of suppression. Although large multinational media corporations exercise enormous influence and control, 'what is doubted is the cultural implications of this presence' (Tomlinson 1991: 57). This is partly to do with how audiences receive these messages, as we shall see later, and also connected to the explosion of media technologies which have provided new avenues for communi-cation and expression to a wider base of people. This 'new regionalism' values 'diversity and difference of identities ... and seeks to sustain and conserve the variety of cultural heritages, regional and national' (Morley and Robins 1995: 17), especially through television. Newer media such as the Internet and digital technology have only increased the channels of communication that may work to resist and counter the potentially hegemonic, corporate power of the multinationals.

In terms of transnational television programming, for instance, it used to be asserted both by corporate executives and academic critics that technological innovation, particularly the development of satellites, would lead to the rapid expansion of American provision around the world. Both advocates and critics shared what has been described as 'a strong technological and economic determinism. ... [which] would automatically reinforce the reach and power of the major existing communications powers and corporations' (Straubhaar and Duarte 2005: 220). Audiences would be forced into a kind of cultural dependency as they passively consumed American products. The global would swamp

the local. In fact, a range of empirical studies on television programming in Latin America and Asia have suggested that these predictions remain unrealised. Audiences have retained an active and powerful role in making choices about what they want to watch. In particular, they have often preferred programmes reflecting their own culture or that of their neighbour. In Asia, News Corporation first developed Star TV as a transnational broadcasting system with a limited menu of five channels, but has been forced by audience demand to diversify into dozens of localised channels in order to succeed (ibid.: 221). In Latin America one recent study concludes, 'if the major systems want to grow their audiences, they will have to increase the number of locally produced channels they carry'. As this suggests, 'the American media industry has consistently had problems in determining what will sell, prospering, instead, by remaining competitive and eclectic, offering a multiplicity of icons and viewpoints that have different meanings for different audiences at different times in different countries' (ibid.: 248). Eric Hobsbawm has argued that 'tailoring the product to specific markets is the logic of the consumer global economy' and that 'at the consumer end globalisation needs diversification' (Hobsbawm 1998: 7). What some of this evidence suggests, however, is that the choices of consumers themselves have often formed a part of the resistance to standardisation as much as the hard-nosed business sense of those doing the selling.

As far as programmes themselves are concerned, their meanings are often as much about how they are received and used by their audiences and consumers as they are about the 'intentions' of the corporate 'sender' or provider. That is, we can read them in different ways so that their meanings are plural and provisional rather than single, monologic and fixed. In the 1980s the top-rated US soap opera *Dallas* was watched throughout the world as it took the realm of the family, with its struggles for power and influence, into extraordinary new territory. However, it became a focus for those like Jack Lang, French Culture Minister, who saw it as 'the symbol of American cultural imperialism' eating its way into French national life. Like McDonald's restaurants, *Dallas* was assumed to represent the worst facets of homogenised American culture, with all the fears of the Frankfurt School realised. However Ien Ang's analysis of audience responses to the programme suggested significant differences in the way the series was received and interpreted. Viewers also demonstrated an awareness of what she calls 'the ideology of mass culture', and in particular the negative image of the American mass media and its tailored ideological messages. They appeared to be fully aware of the 'norms and prescriptions [that] exert pressure on them' (During 1993: 415). The argument suggests that audiences come up with a range of 'strategies' to resist, to some extent, the hegemony of the

media. It is therefore misleading 'to pretend that the ideology of mass culture exercises dictatorial powers' since 'alternative discourses do exist which offer alternative points of identification' for *Dallas* watchers (ibid.: 416). Ang goes on to make an important point about the media, which is that it is 'talked about' in one way and yet in 'practice' may be used very differently. In consuming popular culture, people might mix, combine and 'pluralise' their use of the media in a manner that cuts across many of the theoretical groupings that appear to be significant and inject pleasure into the process. The satisfaction gained from watching *Dallas* or similar media products does not replace real life but exists alongside it, and 'need not imply that we are bound to take up . . . positions and solutions in our relations to our loved ones and friends, our work, our political ideals, and so on' (Ang 1985: 135). Ang's findings suggest that arguments about the manipulative abilities of the mass media position may be misleading, particularly when scrutinised as part of the process of reception. Plural and diverse audiences use the media in a range of ways which resist the expectations of mass culture theorists (ibid.: 136).

This kind of finding has also been reflected in studies of the reception of Hollywood in specific settings. Studio products might be carefully designed to appeal to mass markets, both at home and abroad, but they were often appropriated by audiences in different places and at different times, in ways which connected with local needs. In Britain, for instance, in the 1930s and 1940s, the success of American cinema was based on its 'idealism, its depictions of glamour and abundance, and its democratic story lines, which featured ordinary men and women in a sympathetic light'. Its approach contrasted with 'the flatness and rigidity' of many British films in which class-bound expectations governed how feelings were expressed (Nava 1999: 86). Hollywood's appeal was particularly attractive to working-class female audiences. Contemporary critics, like the socialist novelist John Summerfield, might declare that they were simply 'silly girls', with 'synthetic Hollywood dreams, pathetic silk stockings and lipsticks, [and] foolish stirrings', but as Mica Nava has persuasively argued, films provided an opportunity to resist 'the constraints of femininity as well as Englishness' (Nava 1999: 88–9). The readiness of American films to tackle such issues as 'crime, corruption, passions and violence' made them 'more adequate vehicles for contemporary emotions and expression than the insular universe of the British cinema' (Chambers 1988: 42). These arguments are echoed in a range of other studies which suggest that, while audiences for Hollywood films were certainly targeted as part of a global market, the narrative of their reception is more one of adoption and adaptation than of domination (Jancovich and Faire 2003; Stokes and Maltby 2005).

## CASE STUDY 2: THE INTERNET

The inaugural European edition of the magazine *Wired*, published in April 1995, had on its cover a startling fluorescent image of Tom Paine, the radical eighteenth-century writer, with the famous line from his pamphlet, 'Common Sense': 'We have it in our power to begin the world over again'. The magazine sought to reclaim Paine for the age of the Internet as a 'patron saint' of the new worlds of cyberspace and computer technology. The magazine developed connections between Paine's vision and the potential of the Internet as a new means of democratic global communication. His words were used as a clarion call for a new age born out of technological revolution, one in which the free flow of information. could 'spread ideas, . . . allow fearless argument, . . . challenge and question authority, [and] set a common social agenda' (Katz 1995: 64). Just as Paine had employed the rotary press of the 1770s to disseminate radical opinions, so too could the Internet be used to challenge corporate and governmental authority. This anti-authoritarian stance was also reflected in the 'mission statement' of the Electronic Frontier Foundation, founded in 1990, which spoke of 'a new world arising in the vast web of digital, electronic media which connects us . . . These communities without a single, fixed geographical location comprise the first settlements on an electronic frontier' (Rucker 1993: 88). The Foundation's aim was to make the Internet 'truly useful and beneficial not just to a technical elite, but to everyone' so that it 'threaten[ed] the hegemony of the government/corporate paradigm by empowering millions of individuals' (ibid.: 88). As this suggests, there was in its early days almost a counter-cultural fervour surrounding the Internet, or 'cyberspace' in its more mystical form, one that harked back to the 1960s when new technologies could operate as a form of 'radical politics that could bypass institutions and nations and go directly to the people (Mellencamp 1992: 56). It could offer the possibility of sidestepping hierarchical modes of communication through the creation of a decentred system of information flow, 'potentially making for an equivalence of senders and receivers' (Kroes 2003: 237).

On the other hand, the growth of the Internet has clearly become entwined in the processes of Americanisation. It is argued, for instance, that the Internet has been dominated by the United States from its very inception in terms of infrastructure, servers, users and content. While it is based on the 'supposedly genuine American values of open access to information, liberalization, and privatization', this access 'is provided, guided, and controlled by multinational media and telecommunications companies'. From this perspective communication is 'more akin to a one-way street rather than to a dialogue of equals' (Wagnleitner). America is effectively at the centre of the map of the Internet with other nations

at the periphery. Domain names in nations other than the USA always have a two-letter suffix and although an American suffix exists, it is rarely used. The Internet, argues Rob Kroes, may be 'only the latest medium for the global transmission of a culture crucially cast in an American mould. Rather than being a vehicle for a multiplication of people' affiliations, it may narrow their options, subjecting them to an Americanization by stealth' (Kroes 2003: 236). American domination of the Internet is also reflected in the way in which English is its primary language and in the way in which the increasing commercialisation of the Internet may negatively affect the free flow of information.

However, whereas in 1995 users in the US constituted more than two thirds of all Internet users worldwide, that figure had dropped to c.50 per cent in January 2000, and was down to 23.2 per cent by November 2005. Every prognostication suggested that percentage was likely to fall further very rapidly. By 2005 68 per cent of the American population were Internet users, compared to 9 per cent of Asians, and yet Asians made up almost 34 per cent of world users. If the early growth of the Internet has been identified as a renewed means of spreading American cultural products across the globe, then it may be that this period is soon likely to come to an end (Internet World Stats 2005). What in its origins may have been developed in an American context, with an American imprint, is increasingly being used by a range of groups across the world, groups marked by significant differences in language and culture (Lull, 2001).

This is what gives the debates within the United Nations (UN) and elsewhere in 2004–5 about the governance of the Internet such resonance. Since its inception, the United States has regulated the Internet's basic infrastructure through its control of the Internet's domain name systems, which have been maintained by organisations contracted to the US Department of Commerce. Allocation and coordination of the names and numbers from a central authority are crucial to linking the multiple, scattered networks that constitute the Internet. A number of countries have argued that such regulation would be more appropriately managed by an international body under the auspices of the UN in an effort to try to gain more control over how the Internet operates. Michael D. Gallagher, US Assistant Secretary of Commerce for Communications and Information, articulated the American position: 'We embrace [the] concepts of the private sector, the marketplace and freedom of expression' rather than international bureaucratic management. Maintenance of the Internet was safer in the hands of the United States (Sparshott 2005). There were clear echoes here of the American battle with UNESCO in the 1970s and 1980s over the creation of a New World Information Order that would circumscribe the power of the Western media in order

to ensure 'the right of each nation to protect its cultural and social identity against . . . false or distorted information which may cause harm'. At the World Summit on the Information Society (WSIS), held in Tunis in November 2005 aimed at exploring the governance of the Internet, among those arguing for a greater degree of input by other nations into control of the Internet were the leaders of Zimbabwe, Iran and China, where state censorship already existed in other areas of the media. Indeed, by 2005 China was able to use filtering technology in an increasingly successful way to control access to Internet information by its citizens. The Tunis Summit maintained the status quo, but it raised the intriguing picture of an Americanised (commercialised) Internet committed to the market and free expression, in contrast to a more Balkanised version where national authorities sought to retain a degree of supervision over its use. But nothing is straight forward here. While it is the 'Americanised' Internet that anti-globalisation protestors use so successfully to co-ordinate protests against what they see as the rampant aggression of the market, American Internet companies, like Microsoft and Google, are prepared to strike deals with Chinese censors, presumably because it helps their profits (BBC News 2005).

## CASE STUDY 3: MUSIC

Another revealing case study is the spread of American popular music through the twentieth century. At one level, by the end of the century, the popular music industry was marked by a relentless process of mergers on a global scale, resulting in a market dominated by a small number of giant corporations that captured 76 per cent of the five main national markets (the United States, Germany, the United Kingdom, France and Japan), which themselves made up 70 per cent of world record sales (Leyshon 1998: 10). One consequence, some critics have argued, was the creation of a homogenous popular music culture dominated by American products, which stifled national or local alternatives. At the 2005 World Music Awards, presented to the world's best-selling acts, the winners in nine out of ten categories were American. However, an alternative perspective suggests that it is misleading to treat both America as undifferentiated threat and the consumers of its products as uncritical and unquestioning. European audiences, for instance, frequently proved adept at selecting and adapting those elements in American culture that had meaning and value for them in their own lives, while rejecting other aspects that they distrusted, and the same has been true of other non-European societies. It is mistaken, as Roy Shuker has argued, to see the popular music audience as a mass of passive recipients. Such a view 'is totally at variance with contemporary

audience studies which suggest that the consumption of music is an active rather than a passive process', one which contains oppositional possibilities (Shuker 2001: 23).

American popular music as it spread to Europe clearly offered alternatives to existing forms of provision, which was a great part of its appeal. Jazz, for Eric Hobsbawm, was democratic and classless, the sound of modernity and urban culture, and thus offered a challenge to accepted tradition (Hobsbawm 1998: 267). Paul Oliver has noted how in the aftermath of the Second World War in Britain 'jazz had become a symbol of the irrepressible creative spirit of Blacks in the face of racial and economic oppression . . . a symbol of revolt against their parents, against war, against commercialism'. This had paradoxical political implications, as what was, after all, an American cultural form was taken up by the Left as the Cold War got under way (Oliver 1990: 80–1). In Paris in the early 1940s, French youth, or Zazous, also used jazz as a form of cultural resistance to the German military occupation. Mica Nava talks about the way in which American popular music and dance provided opportunities for young women in England during the 1930s and 1940s to confront assumptions about acceptable behaviour: 'America operated psychically . . . as an imaginary somewhere else; as a refuge and a fantasy of a better future, as a means of breaking away from the constraints of class and parental conventions of deference, denial and despair' (Nava, 1999: 76). Across Europe, in successive generations after the Second World War, the young, in particular, while on the receiving end of American popular music, regularly adapted it to their own ends (Kroes 1999: 516). In Britain, for instance, Peter Wicke has argued that 'Rock and Roll promoted the utopia of a distant America, a utopia which could encourage the everyday experiences of British working-class teenagers with all their longings, desires, hopes, frustrations and leisure needs. . . . [It] achieved a significance in Britain which it never possessed in America' (Wicke 1993: 61–2). The foreignness of the music itself provided an opportunity to challenge conventional assumptions about place, class and parental authority within the narrow confines of British society. In the late 1950s and early 1960s the popularity of the blues as a musical form had a profound influence upon a generation of musicians, reinvigorating British popular music by providing it with a sense of liberation and energy. Its downside was a tendency to 'minstrelsy', and often what amounted to a parody of black performance styles, but at its best for a good number of performers, playing the blues was a first step, in the context of British life, to finding their own voice. The Beatles 'started off by imitating Elvis, Buddy Holly, Chuck Berry, Carl Perkins, Gene Vincent, the Coasters, the Drifters – we just copied what they did. . . . The people we copied were all American,

of course, because there was no one good British' (Wicke 1993: 64). Both British blues bands and the Beatles, of course, re-exported what they had learned back to America, transforming it along the way into distinctive fresh forms which in their turn would have a dramatic impact on American popular culture.

In France in the 1980s, the rapid growth of hip hop was initially inspired by American performance styles, but it quickly adapted them to local circumstances. French rappers performed in their own language, developed their own forms of dance and graffiti/tagging and incorporated a range of African influences into their music. In particular it provided the opportunity for the children of immigrants from Algeria, Morocco or Tunisia to negotiate their own identities within the context of wider French culture. By 2000 France had become the second biggest market for rap after the United States. Moreover, just as American rap had crossed borders, French rap influenced artists in the rest of the Francophone world, especially western Africa and Quebec (Durand 2002). A recent study of hip hop in Germany has emphasised how it is used 'to define ... personal identity and, hence, for individualization' (Winter 2003: 212). Similarly, Paul Gilroy has shown how aspects of American culture provided 'powerful sources of solidarity and pleasure as well as a means to organise themselves' for black minority groups in Britain. African America, in particular, was 'a source of cultural and political raw material for UK blacks in the post-war period' (Gilroy 1992: 171). It was not only the narrative of black political protest that acted as an inspiration here, but also the cultural expressiveness which developed alongside it, through a range of musical forms like soul, jazz and rap, 'which exported to Europe the idea that black communities in the inner city, particularly the young, could define themselves politically and philosophically as an oppressed "nation", bound together in the framework of the diaspora by language and history' (ibid.: 184). In a very different vein, while country music is often identified with a strong sense of American patriotism, one aspect of its appeal in Britain was to working-class and regional groups who did not fit easily into conventional notions of mainstream British culture, and who used the music to assert a sense of identity. Difference, in these varied cases, is expressed 'by using, and at the same time enjoying, mainstream music' (Winter 2003: 214).

As these examples suggest, audiences were often ready to adopt and adapt American popular music for their own ends. Of course, these were not always in conditions entirely of their own choosing, and the power of American record companies to promote particular artists or styles abroad always remained significant. Even here, however, it was not always the case that a narrowing of musical expression has resulted

from the increasing consolidation of the music industry. Alex Seago, for instance, argues that 'we can no longer sensibly define the music market in nationalistic terms with some countries such as the United States imposing their culture upon others', suggesting that there is a 'contradiction between the rapid centralisation and rationalisation of the music industry and the development of a global culture in which the relationships between identity, locality, and nationality are becoming disembedded' (Seago 2000: 134). New technologies and forms of communication have both weakened distinctive national identities and encouraged cooperative, localised patterns of resistance to mainstream culture. The music industry may well wish to create global cultural products, but it has frequently found itself confronted with musical trends, developed in a diverse range of locales that create new kinds of fusions by drawing on an eclectic mix of sources and styles. George Lispitz has warned that 'inter-cultural communication does not automatically lead to inter-cultural cooperation especially when participants in the dialogue speak from positions of highly unequal access to power, opportunity, and life chances', but he nevertheless concedes that it can speak 'to currents of culture and politics emerging from fundamentally new geopolitical realities' (Lipsitz 1994: 5).

## CONCLUSION

Many of these examples and approaches indicate that ambiguity and variety often characterise responses to the spread of American culture. Different groups have often accepted, altered or rejected it according to the specific circumstances in which they have found themselves. This process has of course to be seen in the context of the scale and potency of American cultural production, but it must also take into account its attractiveness and flexibility. This perspective makes it clear that 'a process such as Americanization does not run uniformly and is not imposed from above. It leads to heterogeneous answers and different accentuation' (Sznaider and Winter 2003: 5). Both positions need to be explored alongside each other. This involves examining how people incorporate American culture into their fantasies and values, as well as the 'multifarious and contradictory meanings' they attach to it. The official definition of 'Americanisation' as an unambiguous threat should be relativised by looking at the 'contradictory losses and opportunities allowed by it' (Ang 1996: 148). Moreover, as some of the examples cited above suggest, the forces of globalisation have thrown up new departures and connections that complicate explanations of cultural transfer and problematise, in particular, the scenario of prolonged American cultural hegemony.

## NOTES

1   George McKay has provocatively asked whether American Studies outside of America exists 'solely or primarily in order to maintain American cultural, economic – even, let's go for it, imperial – hegemony?' One response here may be to emphasise the importance of arguments over Americanisation as a counter to uncritical acceptance of what he describes as an exported 'cultural chauvinism' (McKay 1998: 29–30).

## REFERENCES AND FURTHER READING

Ang, I. (1985) *Watching Dallas: Soap Opera and the Melodramatic Imagination*, London: Methuen.

—— (1996) *Living Room Wars*, London: Routledge.

—— (2005) 'De-Americanising the Global: Overcoming Fundamentalism in a Volatile World', *Comparative American Studies*, vol. 3, no. 3, September, pp. 267–82.

Appadurai, A. (1996) *Modernity at Large: Cultural Dimensions of Globalization*, Minneapolis: University of Minnesota Press.

BBC News (2005) 'Microsoft Censors Chinese blogs' at http://news.bbc.co.uk/1/hi/technology/4088702.stm (accessed 18/11/05).

Beck, U., Sznaider N. and Winter, R. (eds) (2003) *Global America? The Cultural Consequences of Globalization*, Liverpool: Liverpool University Press.

Bradbury, M. (1979) 'How I Invented America', *Journal of American Studies*, vol. 14, no. 1, pp. 115–46.

Campbell, N., Davies J. and McKay, G. (eds) (2004) *Issues in Americanisation and Culture*, Edinburgh: Edinburgh University Press.

Chambers, I. (1988) *Popular Culture: the Metropolitan Experience*, London: Methuen.

Charters, A. (1994) *The Penguin Book of the Beats*, Harmondsworth: Penguin.

Chrisafis, A. and Tilden, I. (2003) 'Pinter Blasts "Nazi America" and "deluded idiot" Blair' *Guardian*, 11 June.

Clinton, W. (2001) 'The Struggle for the Soul of the 21st Century', *BBC Richard Dimbleby Lecture*, at http://www.clintonfoundation.org/121401-nr-sp-cf-spe-spe-wjc-at-bbc-richard-dimbleby-lecture.htm (accessed 5/10/2005).

Crockatt, R. (2003) *America Embattled: Sept. 11th, Anti-Americanism and the Global Order*, London: Routledge.

Cunliffe, M. (1964) 'European Images of America', in Schlesinger, A. and White M. (eds) *Paths of American Thought*, London: Chatto and Windus.

de Grazia, V. (1989) 'Mass Culture and Sovereignty: The American Challenge to European Cinema, 1920–1960', *Journal of Modern History*, vol. 61, no. 1, March, pp. 52–87.

—— (2005) *Irresistible Empires: America's Advance Through Twentieth-Century Europe*, Cambridge: Harvard University Press.

Durand, A-P. (2002) *Black, Blanc, Beur: Rap Music and Hip-Hop Culture in the Francophone World*, Lanham, MD: Scarecrow.

During, S. (ed.) (1993) *The Cultural Studies Reader*, London: Routledge.

*Economist* (2001) 'Globalisation and its Critics', 27 September.

Ellwood, D. *et al.* (1994) 'Questions of Cultural Exchange: The NIAS Statement on the European Reception of American Mass Culture', *American Studies International*, vol. 32, no. 2, pp. 33–47.

Fishkin, S. Fisher (2005) 'Crossroads of Culture: The Transnational Turn in American Studies', *American Quarterly*, vol. 57, no. 1, March, pp. 17–58.

Friedman, T. (2000) *The Lexus and the Olive Tree*, New York: Anchor.

Gienow-Hecht, J. (2000). 'Academics, Cultural Transfer and the Cold War – A Critical Review', *Diplomatic History*, vol. 23, no. 3, Summer, pp. 465–515.

Goss, J. and Yue, M. (2005) 'De-Americanising the Global': Cultural Studies Interventions from Asia and the Pacific', *Comparative American Studies*, vol. 3, no. 3, September, pp. 251–66.

Hebdige, D. (1988) *Hiding in the Light*, London: Methuen.

Herman, E. and McChesney, R. (1997) *The Global Media: the New Missionaries of Corporate Capitalism*, London: Cassell.

Hobsbawm, E. (1998) *Uncommon People*, London: Weidenfeld & Nicholson.

—— (1998a), 'The Nation and Globalisation', *Constellations*, vol. 5, pt. 1, pp. 1–9.

Hodson, J. (2001) '"Intercourse in Every Direction": America as Global Phenomenon', *Global Networks*, vol. 1, no. 1, pp. 79–87.

Hogan, M. (ed.) (2000) *The Ambiguous Legacy, U.S. Foreign Relations in the American Century*, Cambridge, Cambridge University Press.

Hoggart, R. (1958) (first 1957) *The Uses of Literacy*, Harmondsworth: Penguin.

Ignatieff, M. (2003) 'The American Empire: The Burden', *New York Times Magazine*, 5 January, p. 22.

Internet World Stats (2005) at http://www.internetworldstats.com/stats.htm accessed 21/10/05.

Jameson, F. (1991) *Postmodernism, or, The Cultural Logic of Late Capitalism*, London: Verso.

Jancovich, M. and Faire, L. (2003) *The Place of the Audience*, London: British Film Institute.

Kaplan, A. (2004) 'Violent Belongings and the Question of Empire Today', *American Quarterly*, vol. 56, no. 1, March, pp. 1–18.

Kaplan, A. and Pease, D. (eds) (1994) *Cultures of United States Imperialism*, Durham, NC: Duke University Press.

Katz, J. (1995) 'The Age of Paine', *Wired*, vol. 1, no. 1, April, pp. 64–9.

Kennedy, L. (2003) 'Remembering 9/11: Photographic Diplomacy', *International Affairs*, vol. 79, no. 2, March, pp. 315–26.

Klein, N. (1999) *No Logo*, London: Flamingo.

—— (2003) 'Free Trade is War', at http://www.nologo.org/

Kroes, R. (1996) *If You've Seen One, You've Seen the Mall: Europeans and American Mass Culture*, Chicago: University of Illinois Press.

—— (1999) 'American Empire and Cultural Imperialism: A View from the Receiving End', *Diplomatic History*, vol. 23, no. 3, pp. 463–77.

—— (2003) 'The Internet: An Instrument of Americanization?' in Beck, U., Sznaider, N. and Winter, R. (eds) *Global America? The Cultural Consequences of Globalization*, Liverpool: Liverpool University Press.

Kuisel, R. (1996) *Seducing the French: the Dilemma of Americanization*, Berkeley, CA: University of California Press.

—— (2000) 'Americanisation for Historians', *Diplomatic History*, vol. 24, no. 3, Summer, pp. 495–502.

Lauter, P. (2001) *From Walden Pond to Jurassic Park: Activism, Culture and American Studies*, Durham: Duke University Press.

Leyshon, A., Matless, D. and Revill, G. (eds) (1998) *The Place of Music*, London: Guilford Press.

Lipsitz, G. (1994) *Dangerous Crossroads*, London: Verso.

Luce, H. (1999) 'The American Century', *Diplomatic History*, vol. 23. no. 3.

Lull, J. (2001) 'Superculture for the Communication Age', in J. Lull (ed.) *Culture in the Communication Age*, London and New York: Routledge, pp. 132–63.

McKay, G. (1998) *Yankee Go Home (And Take Me With U): Americanization and Popular Culture*, Sheffield: Sheffield Academic Press.

Marcuse, H. (1967) *One Dimensional Man*, London: Paladin.

Mathe, S. (ed.) (2000) *Anti-Americanism at Home and Abroad*, Aix-en-Provence: University of Provence Press.

Mattelart, A. and Dorfman, A. (1975) *How to Read Donald Duck: Imperialist Ideology in Disney Comic*, New York: International General.

Mellencamp, P. (1992) *High Anxiety: Catastrophe, Scandal, Age and Comedy*, Bloomington: Indiana University Press.

Miller, T., Govil, N., McMurria, J. and Maxwell, R. (2001) *Global Hollywood*, London: British Film Institute.

Morley, D. and Robbins, K. (1995) *Spaces of Identity: Global Media, Electronic Landscapes and Cultural Boundaries*, London: Routledge.

Murphy, R. (ed.) (2000) *British Cinema of the 90s*, London: British Film Institute.

Nava, M. (1999) 'Wider Horizons and Modern Desire: the Contradictions of America and Racial Difference in London 1935–45', *New Formations*, no. 37, Spring, pp. 71–91.

Ngai, M. (2004) 'Transnational and the Transformation of the "Other"' *American Quarterly*, vol. 57, no. 1, March, pp. 59–66.

Oliver, P. (ed.) (1990) *Black Music in Britain*, Milton Keynes: Open University Press.

Pells, R. (1997) *Not Like Us: How Europeans Have Loved, Hated, and Transformed American Culture*, New York: Basic Books.

—— (2000) 'Who's Afraid of Steven Spielberg', *Diplomatic History*, vol. 24, no. 3, Summer, pp. 495–502.

Ritzer, G. (2000) *The McDonaldisation of Society*, Boston: Pine Forge Press.

Ritzer, G. and Malone, E. (2000) 'Globalisation Theory: Lessons from the Exportation of McDonaldisation and the New Means of Consumption', *American Studies*, vol. 41, nos. 2/3, pp. 97–118.

Ritzer, G. and Ryan, M. (2004) 'Americanisation, McDonaldisation and Globalisation', in Campbell, N., Davies, J. and McKay, G. (eds) *Issues in Americanisation and Culture*, Edinburgh: Edinburgh University Press.

Roger, P. (2005) *The American Enemy: The History of French Anti-Americanism*, Chicago: Chicago University Press.

Rosenberg, E. (1982) *Spreading the American Dream*, New York: Hill & Wang.

Roszak, T. (1970) *The Making of the Counter Culture*, London: Faber and Faber.

Rothkop, D. (1997) 'In Praise of Cultural Imperialism? Effects of Globalisation on Culture', *Foreign Policy*, 22 June, pp. 1–9.

Rucker, R. (ed.) (1993) *Mondo 2000: a User's Guide to the New Edge*, London: Thames & Hudson.

Sardar, Z. and Davies, M. Wyn (2002) *Why Do People Hate America?* Cambridge: Icon Books.

Schiller, H. (1960) *Mass Communications and American Empire*, New York: A.M. Kelly.

Schiller H. (1989) *Culture Inc.: The Corporate Takeover of Public Expression*, Oxford: Oxford University Press.

Seabrook, J. (2004) 'Localizing Cultures' *Korean Herald*, 13 Jan. at http://www.globalpolicy.org/globaliz/cultural/2004/0113jeremyseabrook.htm (accessed 8/11/2005).

Seago, A. (2000) '"Where Hamburgers Sizzle on an Open Grill Night and Day" (?): Global Pop Music and Americanisation in the Year 2000', *American Studies*, vol. 41, nos. 2/3, pp. 119–36.

Shipton, A. (2001) *A New History of Jazz*, London: Continuum.

Shuker, R. (2001) *Understanding Popular Music*, London: Routledge.

Slater, D. and Taylor, P. (eds) (1999) *The American Century: Coercion and Consensus in the Projection of American Power*, Oxford: Blackwell.

Sznaider, N. and Winter, R. (2003) 'Introduction' in Beck, U., Sznaider, N. and Winter, R. (eds) *Global America? The Cultural Consequences of Globalization*, Liverpool: Liverpool University Press.

Sorensen (2004) 'The Global Liberal Order: A Progress Report', *Current History*, vol. 103, no. 677, pp. 403–07.

Sparshott, J. (2005) 'U.S. Domination in Internet Regulations under Fire', *Washington Times*, 25 October.

Spiegel, L. (2004) 'Entertainment Wars: Television Culture after 9/11', *American Quarterly*, vol. 56, no. 2, June, pp. 235–70.

Stead, W.T. (1901) *The Americanisation of the World: The Trend of the Twentieth Century*, London: Horace Markey.

Stokes, M. and Maltby, R. (eds) (2005) *Hollywood Abroad: Audiences and Cultural Exchange*, London: British Film Institute.

Storey, J. (2003) *An Introductory Guide to Cultural Theory and Popular Culture*, Edinburgh: Edinburgh University Press.

Storey, J. (ed.) (1998) *Cultural Theory and Popular Culture: A Reader*, London: Prentice Hall.

Straubhaar, J. and Duarte, L. (2005) 'Adapting U.S. Television Channels to a Complex World: From Cultural Imperialism to Localisation to Hybridisation', in Chalaby, J. (ed.) *Transnational Television Worldwide: Towards a New Media Order*, London: I.B. Tauris.

Strinati, D.(1992)' The Taste of America: Americanisation and Popular Culture in Britain', in Strinati, D. and Wagg, S. (eds) *Come on Down? Popular Media Culture in Post-war Britain*, London: Routledge.

Tomlinson, J. (1991) *Cultural Imperialism: a Critical Introduction*, Baltimore, MD: Johns Hopkins University Press.

—— (1999) *Globalisation and Culture*, Oxford: Polity.

Tunstall, J. (1994) *The Media are American: Anglo-American Media in the World*, London: Constable.

Tyler May, E. and Wagnleitner, R. (eds) (2000) *'Here, There and Everywhere': The Foreign Politics of American Popular Culture*, London and Hanover, NH: University Press of New England.

US Census Bureau http://www.census.gov/Press-Release/www/releases/archives/population/001720.html (accessed 2/11/2005).

Wagnleitner, R. (1994) *Coca-Colonisation and the Cold War: The Cultural Mission of the United States in Austria After the Second World War*, Chapel Hill: University of North Carolina Press.

—— (1999) 'The Empire of the Fun, or Talkin' Soviet Union Blues: The Sound of Freedom and American Cultural Hegemony in Europe', *Diplomatic History* vol. 2, no. 3, Summer, pp. 499–524.

—— (2005) 'United States Culture and Communications Policy and the Internet at the End/the Beginning of the "American Century"' at http://www.sbg.ac.at/ges/research/projekte/wagnleitner.htm (accessed 21/11/05).

Webster, D. (1988) *Looka Yonder, the Imaginary America of Populist Culture*, London: Routledge.

Wicke, P. (1993) *Rock Music: Culture, Aesthetics and Sociology*, Cambridge: Cambridge University Press.

Willett, R. (1989) *The Americanisation of Germany, 1945–1950*, London: Routledge.

Winter, R. (2003) 'Global Media, Cultural Change and the Transformation of the Local: The Contribution of Cultural Studies to a Sociology of Hybrid Formations' in Beck, U., Sznaider, N. and Winter, R. (eds) *Global America? The Cultural Consequences of Globalization*, Liverpool: Liverpool University Press.

World Music Awards (2005) http://www.worldmusicawards.com/index.html.

## FOLLOW-UP WORK

1   Paul Lauter has argued that 'the globalization of American culture requires the localization of its study' (Lauter 2001: 35). Explore the implications of this statement with regard to the workings of an aspect of American popular culture in the world in which you live. In particular, pay attention both to the production process as well as to the act of consumption. To what extent is consumption constrained by the way in which a specific cultural product is structured and distributed? How do specific historical, political or social contexts affect the reception of American culture.

2   Examine Arjun Appadurai's suggestion that 'images of the media are quickly moved into local repertoires of irony, anger, humour, and resistance' (Appadurai 1996: 7). How might this relate to the consumption of cultural products such as music, television and film?

3   To what extent do you think the re-assertion of American military power in the world after the September 11th attacks has affected arguments about how American culture is consumed? Try to make connections between the issues discussed in Chapter 9 about the exercise of American political and military power, and the processes of Americanisation.

4   Using your local environment as a resource, go out with a digital camera and record how the cultural landscape has been Americanised. Examine leisure, retail, fast food outlets, supermarkets, billboards and fashion. All these are sources of imagery and ideas that can then be analysed in the light of readings and debates suggested in this chapter. Produce a photographic essay with analysis on the themes of local Americanisation.

# Index

Routledge History

# American Civilization

## 4th Edition

### David Mauk and John Oakland

American studies with the perfect background and introductory information on contemporary American life.

Brought bang up to date with new illustrations and case studies, the book even examines the second Gulf War, the War on Terror and the 2004 presidential election.

Like its three excellent predecessors, this new edition covers all the central dimensions of American society from geography and the environment, government and politics to religion, education, media and the arts.

*American Civilization:*

- covers all core American studies topics at introductory level
- contains essential historical background for American studies students at the start of the twenty-first century
- analyzes gender, class and race, and America's cosmopolitan population
- contains photos, case studies, questions and terms for discussion, and suggests websites for further research.

This is *the* text for all students of American studies who want to lay solid and sound foundations in their degree course.

ISBN10: 0–415–35830–2 (hbk)     ISBN13: 978–0–415–35830–9 (hbk)

ISBN10: 0–415–35831–0 (pbk)     1SBN13: 978–0–415–35831–6 (pbk)

Available at all good bookshops
For ordering and further information please visit:
www.routledge.com

Routledge History

# British Civilization
# An Introduction

## 6th Edition

## John Oakland

The sixth edition of this highly praised textbook has been rigorously updated and revised.

*British Civilization* provides a comprehensive introduction to a wide range of aspects of today's Britain, including its country and people, politics and government, education, the economy, the media, arts and religion.

It includes:

- discussion of recent developments and topics of specific interest in British society at the moment such as GM foods, immigration and Britain's relationship with the US and the EU and the war against terror
- new illustrations, cartoons, diagrams and graphs and tables
- expanded chapters
- a companion website.

*British Civilization* is a vital introduction to the crucial and complex identities of Britain.

For supplementary exercises, questions and tutor guidance, go to www.routledge.com/textbooks/0415365228.

ISBN10: 0–415–36521–X (hbk)     ISBN13: 978–0–415–36521–5 (hbk)
ISBN10: 0–415–36522–8 (pbk)     1SBN13: 978–0–415–36522–2 (pbk)

Available at all good bookshops
For ordering and further information please visit:
www.routledge.com

Routledge History

# Europe: A Cultural History  2nd Edition
## Peter Rietbergen

Following on from his highly acclaimed first publication, Peter Rietbergen's excellent second edition brings the reader up to date with Europe's current cultural trends.

Rietbergen examines the many varied cultural building blocks of Europe, their importance in the continent's cultural identity, and how the perception of Europe has changed over the centuries.

Working chronologically from the beginnings of agricultural society in Africa before Christ, right up to today's mass culture, the author studies culture through the media of literature, art, science, technology and music.

With thorough revisions on the late twentieth and early twenty-first century, a wide selection of excerpts, lyrics from contemporary songs, and illustrations, this book is an excellent student resource for both historical and cultural studies.

ISBN10: 0–415–32358–4 (hbk)  ISBN13: 978–0–415–32358–1 (hbk)
ISBN10: 0–415–32359–2 (pbk)  1SBN13: 978–0–415–32359–8 (pbk)

# British Cultural Identities  2nd Edition
## Edited by Peter Childs and Michael Storry

*British Cultural Identities* analyzes contemporary British identity from the various and changing ways in which people who live in the UK position themselves and are positioned by their culture today. Each chapter covers one of the seven intersecting themes:

- place and environment
- education, work and leisure
- gender, sex and the family
- youth culture and style
- class and politics
- ethnicity and language
- religion and heritage.

ISBN10: 0–415–27860–0 (hbk)  ISBN13: 978–0–415–27860–7 (hbk)
ISBN10: 0–415–27861–9 (pbk)  1SBN13: 978–0–415–27861–4 (pbk)

Available at all good bookshops
For ordering and further information please visit:
www.routledge.com

Routledge History

# British Culture: An Intorudction 2nd Edition

## David Christopher

In the new millennium Britain is changing rapidly. Exploring a wide range of areas including literature, film, TV, magazines, sport and popular music, David P. Christopher observes and investigates key movements and issues, placing them in a clear, historical context. This creates a comprehensive introduction which allows students of British society to understand, study and enjoy a fascinating range of unique cultural material.

This second edition of David P. Christopher's book offers a wider range of topics, and gives special emphasis to outstanding artists and developments in the field. The new edition features:

- fully revised and updated chapters
- new chapters on sport, newspapers and magazines
- authentic extracts from novels, plays and TV series
- discussion of recent developments such as the greater commercialisation of cultural life and wider public participation through increased exposure in the mass media
- follow-up activities and suggestions for further reading to strengthen study skills.

This book is an engaging study of contemporary life and arts, and is essential reading for every student of modern Britain.

ISBN10: 0–415–35396–3 (hbk)     ISBN13: 978–0–415–35396–0 (hbk)
ISBN10: 0–415–35397–1 (pbk)     1SBN13: 978–0–415–35397–1 (pbk)

# British Civilization: A Student's Dictionary

## John Oakland

'This would be an excellent resource for any Modern Studies class . . . John Oakland should be congratulated for providing such a thorough overview of British society.'

*History Teaching Review*

*British Civilization: A Student's Dictionary* is an invaluable reference guide to the British way of life. It explains the often puzzling and confusing terms and phrases used routinely in Britain and by British people. This easy reference alphabetical guide sheds light on a comprehensive selection of words, phrases, organizations and institutions.

ISBN10: 0–415–30776–7 (hbk)     ISBN13: 978–0–415–30776–5 (hbk)
ISBN10: 0–415–30777–5 (pbk)     1SBN13: 978–0–415–30777–2 (pbk)

Available at all good bookshops
For ordering and further information please visit:
www.routledge.com